Lumen Naturae

Lumen Naturae

Visions of the Abstract in Art and Mathematics

Matilde Marcolli

The MIT Press
Cambridge, Massachusetts
London, England

This book was set in Times New Roman by the author. Printed and bound in the United States of America.

Library of Congress Cataloging-in-Publication Data.

Names: Marcolli, Matilde, author.
Title: Lumen naturae : visions of the abstract in art and mathematics / Matilde Marcolli
Other titles: Visions of the abstract in art and mathematics
Description: Cambridge, Massachusetts : The MIT Press, 2020. |
Includes bibliographical references and index
Identifiers: LCCN 2019030795 | ISBN 9780262043908 (hardcover)
ISBN 9780262358316 (ebook) | ISBN 9780262358323 (ebook)
Subjects: LCSH: Art and science. | Art, Modern–Themes, motives. | Space and time in art. | Cosmology in art.
Classification: LCC N72.S3 M37 2020 | DDC 709.04-dc23
LC record available at https://lccn.loc.gov/2019030795

10 9 8 7 6 5 4 3 2 1

To Paolo Aluffi

Contents

List of Figures

1 Introduction

I am not an art critic or an art historian, although I grew up among them. I am a scientist, primarily a mathematician and theoretical physicist, who also works on information theory and computational linguistics. This is not a book about art history or art theory, although it is a book about art. It is also a book about mathematics and physics, although it is not a math or physics popularization book. It is a series of thoughts, articulated along the lines of a series of lectures I delivered over the past few years, on how modern art and modern science continuously explore themes such as the concept of space, the notion of randomness, entropy and complexity, the void, the geometry of numbers, the shape of the cosmos, and the structure of matter.

This book came into existence with a twofold purpose. To begin with, I have often seen scientifically trained colleagues express a complete incomprehension of modern and contemporary art. Comments like "a child could do it," which one would not normally expect to hear from a reasonably educated person, are all too frequently uttered. Yes, a child who knows random processes and non-euclidean geometry, Gestalt psychology, and the scientific theory of chromatic systems could probably do it. That child could do a lot of other things while she's at it. Scientists should be the first ones to know that ignorance of a subject does not put one in the best position to express opinions about it, but they tend to easily forget this basic wisdom when it is not applied to their own field of expertise. Thus, this is a book about art (mostly contemporary art, and especially abstract art) for scientists, science students, and scientifically minded people. Several of the lectures collected here were delivered at Century Books in Pasadena, California, a quaint, European-style second-hand bookstore with a small art gallery on the upper floor, located a few blocks away from Caltech. The audience was typically an interesting combination of different communities, usually including a group of Caltech scientists and students, as well as some of the local artists that exhibit in the gallery and

patronize the bookstore. Thus, the lectures became as much about explaining modern art to the scientists as about presenting some concepts of modern science to the artists. Since both communities in attendance appeared to be reasonably satisfied with the result, the lectures were transformed into a book. I have been writing this volume by trying to retain as much as possible the informal style of the lecture series, and without attempting to turn it into a more standard academic publication.

The book's title, *Lumen Naturae*, refers to a concept derived from the history of alchemy. It describes a form of Enlightenment that proceeds not from supernatural causes, like divine intervention, but fully from an immanent investigation of nature and matter. This nonsupernatural Enlightenment is what one may envision as a form of higher insight and awareness that emanates from poetry and art, or from the contemplation of the beauty of abstract concepts. It is the elegance of the natural universe described by physical laws, and the poetic imagination of abstract mathematics. It is a purely immanent Enlightenment, which does not involve religion or any transcendental form of spirituality.

The structure of the book is organized as follows. Chapter 2 presents a novel interpretation of the still life genre in painting, from the historical Flemish school of the 17th century to its use by contemporary artists. I argue that, far from being a lesser form of art, as was often argued by critics, the still life genre is, in fact, a broad and deep philosophical reflection on the concepts of space and time, which evolved throughout the course of art history to reflect parallel changes in the scientific understanding of these concepts. In chapter 3 I discuss the notion of space in mathematics, in its many different manifestations, and understood as different kinds of structures: linear spaces, projective spaces, topological spaces, smooth spaces, metric spaces, singular spaces, measure spaces, fractal spaces, aperiodic orders, and noncommutative spaces. I accompany the discussion of each different notion of space with an analysis of artworks by contemporary artists that, in our view, best represents a similar understanding of the notion of space. This chapter can be seen as a general introduction to the mathematical concepts that will be referred to in later chapters. Chapter 4 revisits a theme famously discussed by Rudolf Arnheim in the 1970s: the relation between entropy and art. However, I wish to go beyond the Arnheim analysis, which is critically discussed at the end of the chapter, and delve into different manifestations of the concept of entropy, from thermodynamics to information, including ongoing investigation on the emergence of spacetime geometry from quantum information. I analyze how these different versions of entropy have been adopted and elaborated in con-

temporary art. In chapter 5 I argue that one of the most significant innovations in contemporary art is the extensive use of randomness as a mode of artistic expression. I trace the historical roots of this phenomenon to the traumatic experience of World War II and its aftermath, and I analyze how different mathematical forms of randomness have been used by contemporary artists to obtain very different effects. In chapter 6 I analyze the notion of emptiness, the void, and how this concept is understood in modern science (empty space in gravitational theories, the quantum vacuum state and virtual particles, the Casimir effect and the energy of the vacuum, the vacuum states of the Higgs field in particle physics, the multiverse landscape in cosmology) and in contemporary art (from Suprematism to Abstract Expressionism, and by artists like Yves Klein and Mark Rothko). In chapter 7 I analyze how contemporary art, especially Conceptual Art, has been dealing with the concept of number and with the geometric aspects of the theory of numbers, and I discuss the use of ideas from theoretical physics to approach mathematical problems in number theory in a geometric way. In chapter 8 I focus on the physical theory of matter and forces, the Standard Model of elementary particles, and the historical process of the "geometrization of physics." I observe how contemporary artists who have been drawn to this theme often come from a tradition of figurative rather than abstract art, such as various forms of Neo-Impressionism. I discuss how the concepts of abstraction and representation play out in the context of the relation between mathematics and theoretical physics, as well as in different trends in contemporary art. In chapter 9 I discuss how geometry has been applied historically to describe the regularities of celestial phenomena, and how the quest for regular geometric structures in the cosmos has moved, in contemporary science, from the astronomically small scale of the solar system to the cosmologically immense scale of the Cosmic Microwave Background radiation. I discuss how the theme of regular geometric structures in the cosmos has been viewed in several different ways by contemporary artists. Chapter 10 analyzes what I refer to as "Visionary Modernity," a vision of revolutionary techno-optimism that developed at the beginning of the 20th century in the avant-garde artistic movements, especially in (the progressive side of) Futurism and in the different facets of the Russian avant-garde. I focus in particular on three symbolic aspects of this vision: trains as a symbol of collective progress and connectedness, the mechanized body and the boundaries between the human, the animal, and the machine, and the imagination of urban environments and its links to the aspirations toward cosmic exploration that preceded and ushered in the Space Age. I emphasize the continuity between these historical artistic movements and contemporary philosophical

movements such as Anarcho-Transhumanism. In chapter 11 I discuss the relation between graphical illustration and scientific text, from the ancient forms of manuscript illumination, to the *Red Book* of Carl Gustav Jung and the work of contemporary artists such as Max Ernst and Sonya Rapoport. The chapter ends with a discussion of examples taken from my own watercolor "illuminations" of mathematical notebooks.

The book is designed so that it is possible to read it at many different levels. This required making some choices as to the way in which to present the scientific concepts and also the artwork and its context. Making choices necessarily means sacrificing completeness and some level of accuracy.

The way I chose to treat the mathematical content and the ideas from theoretical physics throughout the book is the aspect that is most likely to generate controversy, especially among the scientists, not because I have avoided discussing explicit mathematics, but because I haven't. Mathematicians have the general tendency to worry excessively about the willingness of a broader audience to engage with a text that contains advanced mathematical concepts and terminology. This may reflect some (perhaps unconscious) elitism on the side of the mathematical community, but this attitude is certainly responsible for the typical lack of engagement of mathematicians with the general public, which over time has had very bad and dangerous effects on the public perception of the subject. The commonly held idea that any text aimed at a cultured audience of nonspecialists should necessarily avoid any mention of more advanced mathematical concepts is responsible for the vapid and often unreadable nature of many books of science popularization.

After decades of experience as a professional mathematician, I am a lot more optimistic about this issue. There is absolutely no reason to expect that an intelligent, educated, and intellectually curious person would run away screaming at the first sight of a mathematical expression. Yes, there are concepts mentioned in the book, and formal ways of expressing them, that may be unfamiliar to some readers. The text, however, is structured in such a way that it is possible to jump over explicit mathematical expressions at first reading and continue without losing sight of what is being discussed, since a more intuitive (and perhaps more vague and less accurate), plain-text explanation is given of what is also included in a more precise mathematical form. In this way, readers can adjust to their personal level of comfort regarding their mathematical background. The scientifically more savvy reader will be able to appreciate more details, while a reader with a background that is more centered on the arts will also be able to follow by just skipping over formulas and more technical discussions.

Encountering something one does not immediately understand should always be regarded as a stimulus for the natural intellectual curiosity that all human beings are endowed with and as an occasion to investigate further and gain a better understanding. Inserting in the text all the necessary steps needed to bridge between a brief nontechnical illustration of a mathematical concept and its full technical description would not be possible. However, for the readers who may be interested in delving deeper into some of the mathematics and physics mentioned in the book, at the end of each chapter I have added a bibliographical guide, which is subdivided into main topics. These bibliographical lists are dedicated to specific mathematics and physics subjects and organized in increasing level of complexity: this means that the first reference in each list is usually a science popularization text that is accessible to everybody regardless of their background. The remaining references start with textbook-level introductions and moving on toward research-level publications. In this way, again, readers can identify their preferred level for further reading.

On the art side, the book certainly suffers from an almost complete lack of context in the discussion of the artwork. I do not discuss artists' biographies and I provide very little background in terms of historical framework, cultural and political critique, or issues of gender, race, sexuality, and class. This is obviously a serious limitation. On the other hand, there are many excellent art theory and art history books that center these important issues, so I tried to keep the focus of this work more narrowly on certain specific concepts and ideas and their representation in works of art. However, in order to compensate for the missing views of the broader picture, at the end of each chapter, I have added a list of references for suggested further reading about each of the artists mentioned in the text (in order of appearance in each chapter) and about the broader context, including the art movements and related art theory issues.

The interpretation I provide of some of the art is closely tied up with my own personal viewpoint as a scientist. While it is true that in every reading of a work of art there is always a danger of "overinterpretation," it is also true that there are always many different levels at which it is possible and legitimate to read a painting (or another form of art), and this is all the more true in the context of abstract art. There is no problem if the reader, or other commentators, would come to a very different reading of a particular painting: a painting is not a theorem, even if occasionally both may express ideas about abstract notions such as space and geometry. Paintings, by their very nature, never have a unique, unambiguous reading. It is also important that readers keep in mind that the works of art discussed in the text are not literal illustrations of scientific concepts and were never intended to be. Readers should

not expect a literally perfect matching between the art and the science: if that were the case, we would not even be considering them as two different fields of knowledge. The point is about how certain ideas can be expressed, albeit through the use of different modes of representation that employ very different forms of expressive language. Art and mathematics are two distinct forms of human creativity that obey different rules: one should not expect to see a one-to-one correspondence between them, but rather fluid analogies and an interest in common general themes as well as a common preoccupation with certain important abstract concepts.

About the order of the chapters: throughout the book I have attempted to maintain a back-and-forth balance between the amount of space dedicated to the arts and that dedicated to mathematical physics. Chapters such as "Still Life as a Model of Spacetime" (2), "The Train and the Cosmos: Visionary Modernity" (10), and "Mathematical Illuminations" (11) center more on the arts, while chapters such as "The Geometry and Physics of Numbers" (7) and "Matter and Forces" (8) center more on the science. Other chapters, such as the three central chapters "Entropy and Art: The View beyond Arnheim" (4), "Structures of Randomness" (5), and "Plentiful Nothingness: The Void in Modern Art and Modern Science" (6), and the later "Can You Hear the Shape of the Cosmos?" (9) have a more internally balanced content. While "The Train and the Cosmos: Visionary Modernity" could easily be placed at the beginning of the book, together with the chapter about still life, in order not to create an unbalance in the internal structure of the book, I preferred not to have all the art-centered chapters in the beginning part and all the science-centered chapters toward the end, but rather wanted to allow the readers to move back and forth between the two viewpoints as they advance through the book. So the book is designed to have an initial art-centered chapter, followed by one science-centered chapter (which also overviews several of the science concepts that are needed in later chapters), followed by a set of three chapters that have a balanced art/science internal content, then by two chapters that are again more science centered, one more balanced chapter, and two final chapters that (like the beginning one) return to a more art-centered viewpoint. I feel in this way a reader would start and return to the art world via a voyage through the science perspective. This is not the only way in which the book can be read, however. One alternative possible itinerary would be to first read chapters 2, 10, and 11, followed by chapters 4, 5, and 6, followed by chapters 3, 7, 8, and 9, for example. I encourage the readers to design their own preferred path through the book.

2 Still Life as a Model of Spacetime

Still life is the most philosophical genre of traditional figurative painting. Although it saw some of its most famous manifestations in the Flemish tradition of the 17th century, it evolved and survived as a meaningful presence through much of 20th-century art, when it was adopted by avant-garde movements such as Cubism and Dadaism.

The purpose of this chapter is to dig into the philosophical meaning behind the still life painting and show how this genre can be regarded as a sophisticated method to present, in a pictorial and immediately accessible visual way, reflections on the evolving notions of space and time, which played a fundamental role in the parallel cultural developments of Western European mathematical and scientific thought, from the 17th century up to the present time.

A challenge for the artists of today becomes, then, how to continue this tradition. Is the theme of still life, as it matured and evolved throughout the dramatic developments of 20th-century art, still a valuable method to represent and reflect on the notions of spacetime that our current scientific thinking is producing, from the extra dimensions of string theory to the spin foams and spin networks of loop quantum gravity, to noncommutative spaces, and to information-based emergent gravity? Some people may feel that the notions of spacetime that contemporary physics and mathematics deal with nowadays are too remote from the familiar everyday objects that form the basic jargon of still life paintings. However, much the same could be said about the notions of relativistic spacetime and the bizarre world of quantum mechanics that were trickling down to the collective imagination in the early 20th century, and yet the artists of the avant-garde movements of the time were ready to seize on to concepts such as non-Euclidean geometry, higher dimensions, and the like, and bring them into contact with a drastic revision of what it means to "represent" the everyday objects that surround us, and that in this way come to occupy a profoundly altered concept of space and time. So, I believe, the chal-

lenge is a valid one, even in the light of the ever more complex landscape of today's thinking about the concepts of space and time, and I take the occasion to make an open call to the practicing artists, to take up the challenge and paint a new chapter of the "still life" genre, that is more suitable for the minds of the current century.

2.1 Time and Transience

As it is well known, the other technical name of the "still life" genre is *vanitas*. This word more aptly describes the philosophical nature of these deceivingly simple images of compositions of objects of everyday life, as conceptual representations of the nature of time. *Vanitas* refers primarily to the transient nature of time, the fugitive instant, the brevity of life, the ephemeral pleasure of enjoying the reality of instantaneous moments that do not and cannot last. Upon this basic theme, tempus fugit, there lies a multilayered analysis of what one can understand as time, an elaboration that, as we shall see, parallels the many aspects of time as we have learned to distinguish them within the tradition of scientific discourse.

2.1.1 Time as a Collection of Instants

First and foremost, there is the idea, which all of us maintain, that time is a collection of instants, each a still image, which is immediate and immanent but without extension: the very idea of instantaneous—something that does not last. A way of representing pictorially this notion is by presenting a collection of everyday objects chosen for their quality of embodying the very notion of something transitory, which exists only in a brief instant of time.

A good example involves floral compositions (see figure 2.1). These form an important element throughout the history of the still life genre. In the Flemish compositions, the idea of time as a collection of instants is often expressed by inserting in the composition a floral arrangement made of flowers known to bloom in different seasons, at different times of the year. This produces the effect of representing time not as a linearly ordered succession of events, or by means of a single simultaneous instant (which would have the effect of abolishing time completely), but through the coexistence of a plurality of instants belonging to different times. This is consistent, as modern neuroscience teaches, with the internal representation of time in our memory, which we imagine stores a faithful recording of the linear ordering of events, but which in fact resembles far more the floral compositions of the Flemish still lifes, with a simultaneous superposition of unordered but distinct time events.

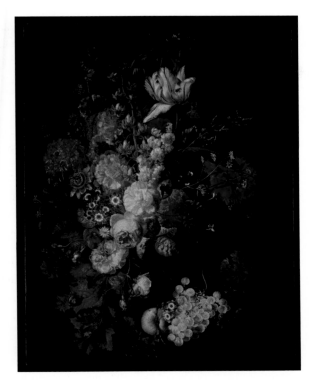

Figure 2.1
Margareta Haverman, *Still Life: A Vase of Flowers*, 1716.

The theme of floral composition as a representation of instantaneous existence in time, and as an embodiment of the concept of *vanitas*, reaches its apex with the contemporary artist Ori Gersht, with the *Time after Time* series (see figure 2.2), obtained by building three-dimensional models of 19th-century traditional still life floral compositions by Henri Fantin-Latour and then exploding them and photographing them right at the moment of explosion.

We know today, thanks to the fast advancing technique of of femto-photography, that one can push this idea of capturing the instant of time to the point of photographing light itself in the process of moving at its extraordinary but finite speed through various materials. One can view this as the modern evolution of the idea the still life painters of the 17th century were trying to convey with their "collection of instants," as embodied by perishable flowers in multiseasonal floral compositions.

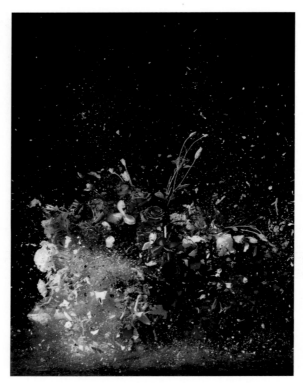

Figure 2.2
Ori Gersht, *Time after Time: Blowup N.3*, 2007.

Other typical elements inserted in still life compositions to represent the tran-
sient instants of time are seafood (especially oysters) and fresh fruit (see fig-
ure 2.3). These also convey the idea of the perishable, captured in its brief
moment of existence before decay, suspended in an instant, frozen in eternity.
The use of seafood in still life as an emblem of the perishable persists well
into the 20th-century redefinition of the genre. It makes frequent appearances
in Picasso's still lifes and continues to be a referent for the genre, through
other artistic movements, such as Pop Art, well into the second half of the 20th
century, as in the work of Roy Lichtenstein (see figure 2.4).

2.1.2 Linear Time as Process

In addition to the representation of time as a collection (a bouquet) of dis-
tinct, individual, instantaneous moments, another view of time pervades the
traditional Flemish still life paintings, one that relates best to our understand-

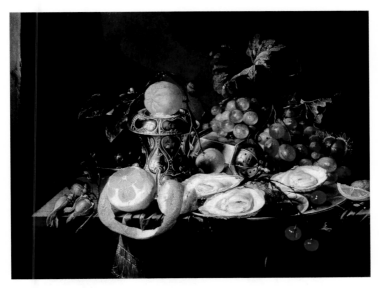

Figure 2.3
Cornelis de Heem, *Still Life with Oysters, Lemons and Grapes*, ca. 1660.

ing of time as a process of transformation. This image of time corresponds to mathematically representing time as an oriented line, with its linear ordering providing a meaning to the notions of before and after and of simultaneity. Much as this may appear as a very natural notion, one should keep in mind that it is precisely its implicit notion of "simultaneous events" that was challenged and transformed by the advent of relativity theory in the early 20th century.

A way of representing linear time as a transformation process is to include in the painting elements that unambiguously point to a before and an after. Such are the depictions of half-eaten fruits or slices of cake, half-peeled lemons with part of the peel still pending, and toppled glasses (see again figure 2.3). Each of these images describes a process of evolution in time, which is caught in the act of becoming: an action is taking place, an action that was begun in the past and that awaits completion in the future.

One can see this type of time representation in Pieter Claesz's *Tabletop Still Life* (see figure 2.5), where, in addition to the perishables like oysters and fresh fruit, already discussed in the previous section, several items on the tabletop display stand "in the process of becoming": a half-eaten mince pie, a half-peeled and sliced lemon, a partly sliced loaf of bread, a half-empty glass.

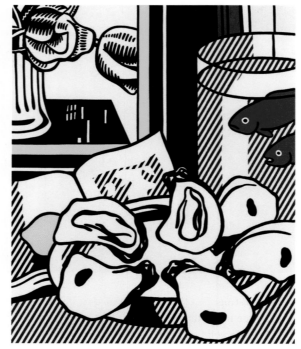

Figure 2.4
Roy Lichtenstein, *Still Life with Oysters, Fish in a Bowl and Book*, 1973.

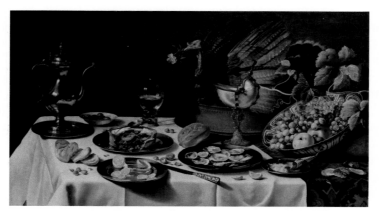

Figure 2.5
Pieter Claesz, *Tabletop Still Life*, 1625.

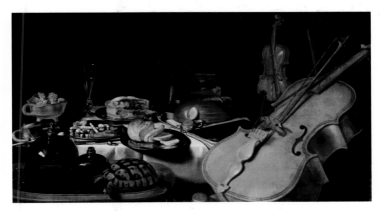

Figure 2.6
Pieter Claesz, *Still Life with Musical Instruments*, 1623.

2.1.3 The Flow of Time and Music

Time is also perceived and described as a flow, and the most frequently used method for incorporating the concept of the *flow of time* in still life paintings is through a reference to music. There are various aspects of music that link it to time: unlike the appreciation of the visual art, which is essentially simultaneous and atemporal, and that one may classify as spatial perceptions (though of course, a changing point of view in looking at a sculpture may form an important part of its aesthetic appreciation), music can only be perceived in time and through time.

Of all the traditional arts, music is the most closely tied up to time. In the contemporary world, one could argue that other art forms, such as cinema, also have a fundamental temporal component and that so did theater already in the earlier times, but music, being more abstract, and having essentially no spatial component to it, embodies better than any other art form the image of the flow of time. In times when there was no method to store a musical performance acoustically (nor in the written form of a score), music would also exemplify something that dissolves in time without leaving behind any tangible trace of its existence, and hence connecting back to the more general themes of tempus fugit and *vanitas*.

It should therefore not appear surprising to see the insertion of musical instruments in compositions of edible goods and flowers, as all these things collaborate in creating a complex and multilayered description of the nature of time (see figure 2.6).

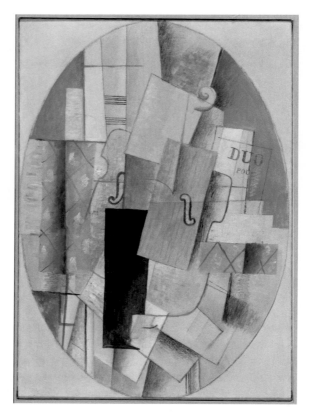

Figure 2.7
Georges Braques, *Still Life with Violin*, 1914.

In the more modern form of the early 20th century avant-garde movement,
the composition of still life paintings centered around musical instruments was
broadly explored by the cubist painters: Braques and Picasso most of all, but
also Gris and Léger (see figures 2.7 and 2.8). The musical instruments in
their composition are at the center of an insect's-eye perspective of multiple
viewpoints, which suggests multiple observers in space as well as multiple
instants of time, as seen through a more modern viewpoint whereby time and
space have started to blend into two concepts that are no longer separate. Music
is then, no longer a purely temporal art, but also an embodiment of movement,
which is viewed as a change of observer viewpoint through both time and
space.

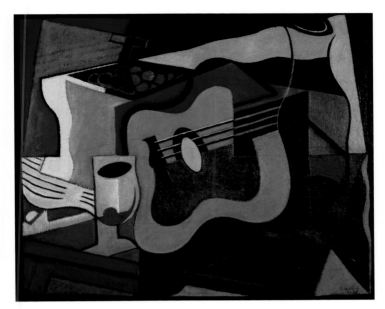

Figure 2.8
Juan Gris, *Still Life with Guitar*, 1920.

2.1.4 Decay and Thermodynamic Time

Among the notions of time that modern scientific thought developed, perhaps the one that comes closest to our subjective perception, as well as to the notion of *vanitas* we have been discussing here, is the concept of *thermodynamic time*. What is meant by this is the formalization, through the mathematical notion of *entropy* in thermodynamics, of time as consumption and decay, and the irreversibility of the arrow of time.

This notion was implicitly there throughout the history of the still life genre, through the idea that a *vanitas* is a reminder of death and of the transient nature of life. The element of decay is often introduced in still life paintings through a skull image placed among the ordinary objects of the tabletop arrangements, as the ultimate symbol of what is left of life after time has run its course and completed its process of slow consumption and decay. The skull is the ultimate pointer to the irreversibility of the time arrow (see figures 2.9 and 2.10).

2.1.5 The Algorithmic Time of Seashells

There is yet another way in which we have come to understand the unfolding of time, which is through the processing of an algorithm, as expressed in

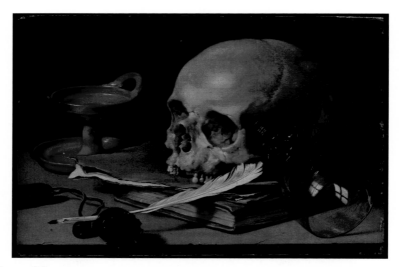

Figure 2.9
Pieter Claesz, *Still Life with Skull and Writing Quill*, 1628.

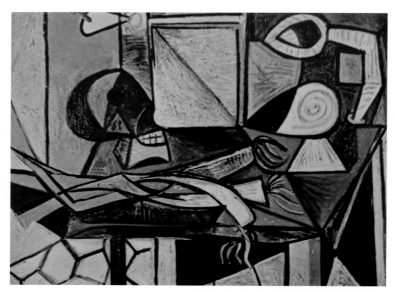

Figure 2.10
Pablo Picasso, *Still Life*, 1945.

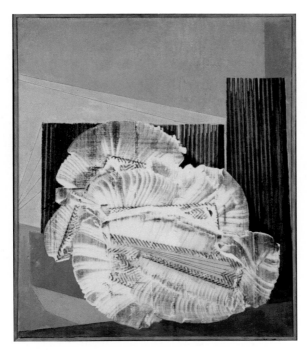

Figure 2.11
Max Ernst, *Sea Shell*, 1928.

modern information theoretic language. This is a natural process of growth that follows an algorithmic regularity, which we nowadays like to think of in terms of cellular automata and discrete dynamical systems: a typical example is the growth of a seashell. The algorithmic regularity of geometric forms and patterns in seashells have long fascinated scientists and naturalists alike. The frequent insertion of seashells as a theme in still life can be seen as describing yet another aspect of time, which is in stark contrast with its view as thermo-dynamic decay and slow destruction. In fact, the regular geometric growth of seashells is an example of time evolution that encodes and does not lose infor-mation, which is to say, it does not represent an increase of entropy but of its opposite, information (see figures 2.11 and 2.12).

The algorithmic growth of seashells is a process that represents, once again, the unfolding of time, but now in a creative rather than destructive form: the creation of structure and the execution of a code, a program, into a mechanism of growth. It is a process of creation and evolution of form through time.

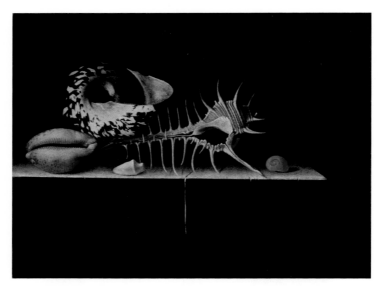

Figure 2.12
Adriaen Coorte, *Still Life with Seashell*, 1698.

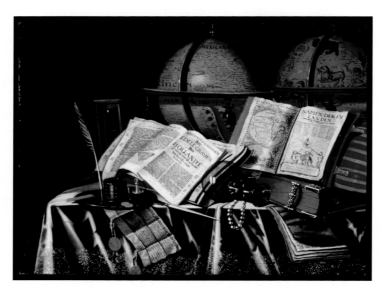

Figure 2.13
Adam Bernaert, *Vanitas*, 1660.

2.1.6 The Flow of Time as a Flow of Knowledge

Time is also perceived as the vehicle for the accumulation and transmission of knowledge, as represented by the reading and writing of books: the most efficient instruments for the storage and acquisition of knowledge ever devised in human history.

Several still life paintings include collections of books, partly opened as if in the process of being read, and often accompanied by writing instruments, representing the process of transformation that leads to the production of new knowledge (see figure 2.13).

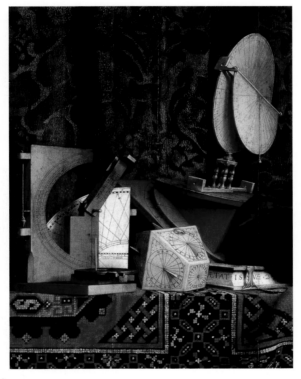

Figure 2.14
Hans Holbein, *The Ambassadors* (detail), 1533.

Altogether, all these different representations of time encoded in various collections of objects in the still life compositions reveal a remarkable complexity of philosophical concepts, completely in tune with the thinkers of the time, be it Descartes or Spinoza in the 17th century or Boltzmann and his concept

of entropy between the 19th and the 20th centuries, and later Einstein and the newly emerging notions of spacetime in the early 20th century. We have, so far, focused on concepts of time. We now turn our attention to how the still life genre has been expressing the concept of space.

2.2 Space and Time

The 16th and 17th centuries saw a profound revolution in our understanding of the concept of space, which sees its focal point in Descartes and the origin of our modern idea of *analytic geometry*: the idea of space as a quantifiable entity, as specified by coordinates, by a frame that permits us to make quantitative measurements of relative positions, and not only of distance and extension.

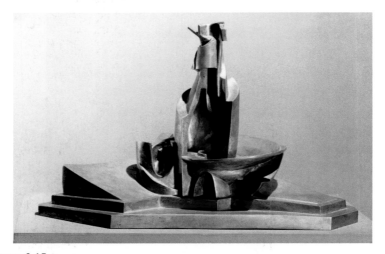

Figure 2.15
Umberto Boccioni, *Development of a Bottle in Space*, 1913, cast 1950.

Instruments for the representation of space thus began to appear in still life compositions, as in the detailed tabletop arrangement of mathematical instruments in Holbein's famous painting *The Ambassadors* (see figure 2.14). This painting itself is not a still life, but it incorporates compositions in the still life genre, along with the portrait and the prominent skull anamorphosis (which we will return to in the next chapter), in an elaborate dialog of spatial connections.

As part of the Cartesian concept of coordinate frames, one acquires the possibility of describing space as *dynamical*, and positional relations as evolving in time according to laws of motion. Over time this developed into the edifice of *classical mechanics*, with its Lagrangian and Hamiltonian formalism, with

position and phase space, and with motion described by trajectories of points in a coordinate frame.

By the end of the 19th century, this conception of space had evolved to a very high level of sophistication, with curved spaces (Riemannian manifolds) and their non-Euclidean geometries coexisting with the original flat and homogeneous Euclidean space. It is against this background of geometric knowledge that the novelty of special and general relativity in physics came to establish a new conception of spacetime, but this also set the stage on which the language of modern art was developed. The concept of space as evolving and unfolding in time became a crucial theme in the art of the early 20th century, especially through Futurism, and the use of the familiar objects in the still life representation became a way of exploring the dynamical properties of space, as in Boccioni's famous "development of a bottle in space" (see figure 2.15).

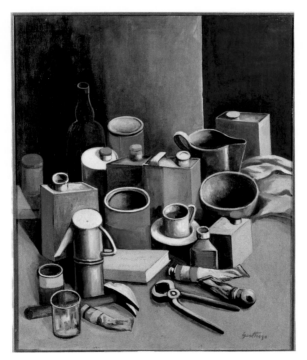

Figure 2.16
Renato Guttuso, *Still Life with Cans*, 1966.

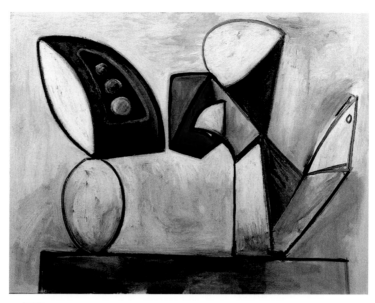

Figure 2.17
Pablo Picasso, *Still Life*, 1947.

In the Dutch still life of the 17th century, a great deal of attention is given to spatial relations between the displayed objects, where they stand in relation to one another, relative to an absolute background coordinate frame fixed by the environmental elements: the tabletop, the walls. In the transition to 20th-century art, the objects of still life compositions begin to define space itself through their properties of volume (Cézanne) or color (Matisse).

The idea of defining space through the volumetric and relational properties of the displayed objects persisted well into the century. Guttuso creates a space primarily through a relational representation of volumes realized by a collection of everyday objects, but the presence of a barely sketched background, where a dark area on the right side suggests the opening up of a larger space behind, creates a dialog between the relational space and an absolute frame of reference (see figure 2.16). He makes an additional political statement by transferring the mundane objects of still life composition from bourgeois households to proletarian workplaces.

On the other hand, the 1947 Picasso still life (see figure 2.17) achieves a further level of abstraction in the genre, whereby the depiction of space is openly seen as the ultimate goal. The objects are transformed into unrecognizable volume-shapes whose manifest purpose is the creation of space, along the line

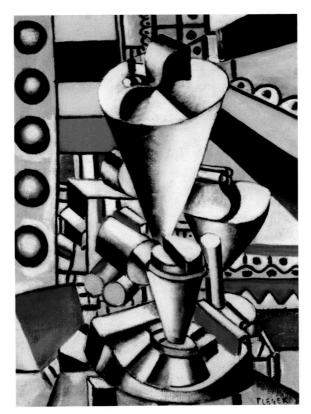

Figure 2.18
Fernand Léger, *Nature morte aux éléments mécaniques*, 1918.

of our relativistic conceptions, according to which matter bends the geometry of space, and hence creates gravity, which in turn influences matter in a dynamical way. Space in this still life is created by massive volumes with no other meaning left but their bending of spacetime itself.

Along with the traditional elements of still life compositions, artists in the 20th century introduced new "objects," especially machines. Fernand Léger, who in his *Ballet Mécanique* had explored the poetry and musicality of machines and their essential ability to define space through their movement and shape, resorted frequently to the use of the machine as an element of still life composition, precisely for the purpose of creating a conceptualization of space. Space becomes defined *by* the machine and resides *in* the machine, which is

again a dynamical entity, based on rhythmic movement and repetition (see figure 2.18).

2.2.1 Existence as Space without Time

In contrast with the dynamical space of the futurists, there is an absolute stillness, which can only be defined as space in the absence of time, that emerges in the many still life paintings of Morandi: mostly arrangements of bottles, vases, and glass containers on a barely defined tabletop, and usually with no other clear delimitation of surrounding space. It is an indefinite space, the Greek concept of *apeiron*, as far as the background framing is concerned, while it is a tightly bound image of proximity relations in the cluster of objects occupying and defining the center stage of the painting. There is little room for either volume or color to play a role in these paintings, where the depth of space is meager and a diffused light permeates a muted balance of ochre tints. Space here is absolute stillness (see figure 2.19).

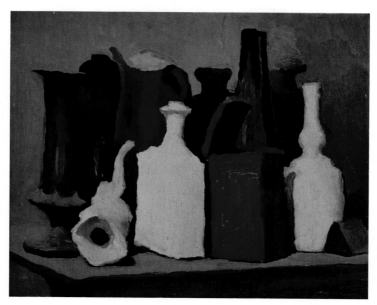

Figure 2.19
Giorgio Morandi, *Still Life*, 1929–1930.

2.2.2 Cézanne's Curved Space

Throughout the history of philosophical thinking about space, as well as in the concepts of modern physics, one repeatedly encounters a dialectical counterposition between a *relational* and an *absolute* notion of space. In the relational viewpoint, space itself is created by the interactions between matter and forces, in the sense that there is no absolute reference frame, but the frame itself is bent and transformed by the bodies that occupy it. Measurements of space are measurements of events that happen in space. In contrast, there is a point of view in which space itself is an entity of interest even in the absence of anything else: the vacuum is one of the most interesting phenomena of modern physics, with its own energy due to the bubbling of virtual particles, as will be discussed at length in chapter 6. Empty space can be curved into interesting and nontrivial geometries, even in the absence of any actors on its stage of existence.

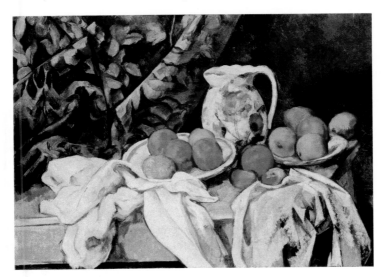

Figure 2.20
Paul Cézanne, *Nature morte avec rideau et pichet fleuri*, 1899.

In the still life of early 20th-century art, a relational notion of space also began to play an interesting role. The framing of the scene is no longer an absolute coordinate system, but now is created by the relations between objects: their volumes and their masses make the space measurable and concrete. In Cézanne's *Nature morte avec rideau et pichet fleuri* (see figure 2.20), the background drapery is no longer just a fixed frame. It becomes another ob-

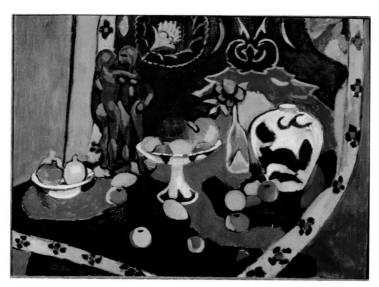

Figure 2.21
Henri Matisse, *Fruits and Bronze*, 1910.

ject of the composition, in active dialog with the others. There is no external reference frame, no absolute set of coordinates, other than relative positions and relative masses. The geometry of space that emerges from these representations, in turn, tends to be curved around the objects, as if they would bend the surrounding space. Modern art arose in the wake of the late-19th-century thought about space, with the development of curved geometries playing a central role that led to a richer formulation of classical mechanics, where phase space is naturally curved by the kinetic energy, and paved the way to Einstein's revolution, where it is spacetime itself that is bent and curved by masses and gravity.

2.2.3 Matisse's Emergent Flat Space

A notion that also developed in 20th-century scientific thought, and that is very much at the center of current developments in the theory of gravity is the idea that space (or spacetime) need not be a primary concept, but may instead be an *emergent* phenomenon, which may be of *information* theoretic origin.

One may perhaps see traces of an idea of "emergent" space in still life paintings when one looks at how Matisse dealt with themes and compositional elements very similar to those we just saw in Cézanne, but approached from a completely different viewpoint. Space, as represented in Matisse's paintings, is

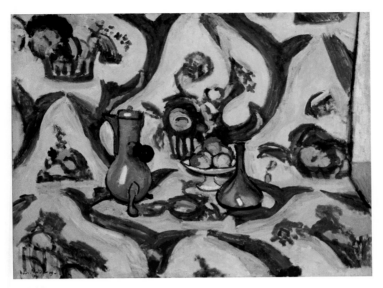

Figure 2.22
Henri Matisse, *Still Life with Blue Tablecloth*, 1909.

not tied up with volumes and masses. Everything is perfectly *flat* and deprived of any reference to three-dimensionality, and yet space emerges from relations and interactions, not of spatial locations, but of *colors*. Thus, in Matisse's approach, it is the spectrum of light, with the contrast created by juxtaposed masses of color, that creates space (see figures 2.21 and 2.22).

From a scientific viewpoint, it would appear that color, which means light and electromagnetism, has little to do with space, which means gravity, and yet that is clearly not the case in Einstein's theory of relativity. This is not only because Maxwell's equations of electromagnetism are already intrinsically relativistic, but also because light bends with gravity and because the properties of light, like its finite propagation speed, are crucial to determining properties of spacetime in the context of relativity theory.

Of course, this brief excursion into modern physics and relativity is far remote to what had been on Matisse's mind in creating his color-based emergent space, and it is only meant to bring to the reader's attention the fact that our modern scientific understanding of space and time is connected to light just as much as it is connected to gravity.

More to the point of the discussion of the Matisse paintings, it is worth mentioning that our visual perception of light and colors very often contributes

substantially to the generation of our own subjective and psychological perception of space.

2.2.4 The Cubist Spacetime

Much has been said about possible relations between the development of the cubist movement in modern art and the almost simultaneous development of the two main pillars of modern physics: relativity and quantum theory. Although it is generally understood that there was no direct influence of the scientific texts on the group of artists, it seems that a body of scientific knowledge that preceded those developments and that was very actively popularized in the late 19th century, having to do with curved spaces and higher dimensions, might have reached the art world more directly by the time Cubism began to flourish.

What appears certainly true is that some of the *concepts* about space and time that were being discussed actively by the cubist artists were also at the same time receiving a lot of attention within the development of relativity theory. Among these, the concept of *simultaneity*. A typical cubist painting exhibits a subject as seen simultaneously from the point of view of many observers in different spatial and temporal positions (see figure 2.23). Shapes appear broken and superimposed on themselves; the scene is static, and at the same time it evolves. Most significantly, perhaps, the strict distinction between space and time appears to be broken. Of course, we cannot help but look at these paintings from the perspective of our modern postrelativist conceptions; hence, it is natural for us to see in them a portrait of spacetime, rather than a space and time, and one where the notion of simultaneous observers is brought into question.

2.2.5 Dadaism: Spacetime as Information

The still life genre also makes an appearance in one of the most unlikely places within the landscape of the 20th-century avant-garde: Dadaism.

Within Dadaism still life becomes *conceptualized* and abstract. The space defined by a still life composition is a purely informational space. The shapes no longer, or barely, belong to everyday objects, and when they do, they have undergone a process of redefinition that alienates them from their everyday role and renders them unrecognizable, except as concepts. Other artistic movements of the time, like Metaphysics in Italy, which had contacts with several European movements, including Cubofuturism and likely the early Dadaism, adopted similar ideas about "conceptualized" still life compositions.

When Morandi, before turning to his better known realist still lifes, composed his early still life in 1918 (see figure 2.24), he definitely created a vision

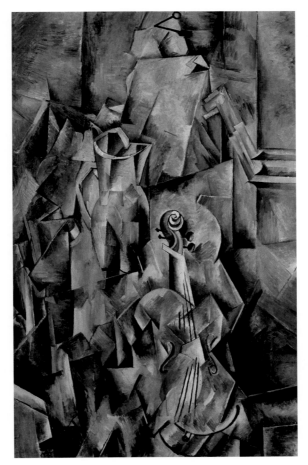

Figure 2.23
Georges Braques, *Still Life with Violin and Jug*, 1910.

of space. Three abstract shapes float suspended inside a frame. Space perception, thickness, and volume are generated through the artifact of shadows that each shape, as well as the frame itself, casts on a background wall, whose existence is only highlighted by its role as the recipient of the projected shadows. The shapes are purely abstract, and yet the central one, which mediates between the curved and the flat, is vaguely reminiscent of a chess piece. The relational positions between these shapes, which complete an invisible triangle delineated by the shadow lines on the floor, is what generates the perception of a dynamical form of space.

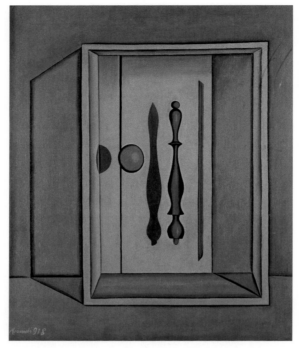

Figure 2.24
Giorgio Morandi, *Metaphysical Still Life*, 1918.

Morandi's version of Metaphysics is significantly different from De Chirico's. Morandi joined the movement only after 1917, at a time when Dadaism had already developed. The Metaphysics works of Morandi have a definite Dadaist aesthetic to them (clearly visible in the still life of figure 2.24), which is lacking in other painters in the same movement. Whether Morandi was explicitly in touch with Dadaism by 1918 is not directly documented, but it is very likely, given that Morandi had certainly been explicitly aware of other avant-garde movements outside Italy (especially Cubism and Cubofuturism, in which he himself participated), so it is very likely that by 1918 he would have been aware of Dadaism as well.

Equally interesting is Man Ray's take on the still life theme (see figure 2.25), in which a tabletop composition of elements appears to fit more closely within the traditional compositional rules of the genre. Yet the objects themselves are highly conceptualized shapes, with mathematical polyhedra (in themselves an excellent representation of space, and which were also used in the old paint-ings, as in the Holbein example we discussed earlier), accompanied by an as-

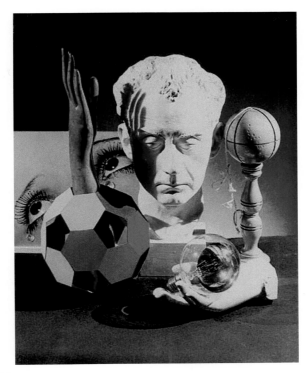

Figure 2.25
Man Ray, *Still Life Composition for "Minotaure,"* 1933.

sortment of lightbulbs, children toys, and mannequin hands. More than a still life this is, of course, a portrait: a self-portrait translated into a Dadaist reconfiguration of the language of still life painting. As such, it should perhaps be regarded more as a representation of an inner space rather than an external, physical one.

2.2.6 Theoretical Spacetimes

As the art movements of the 20th century arose and evolved, one after the other, they rarely forgot the power of the still life composition to provide an arena for philosophical discussions about the notions of space and time and a conceptual laboratory for theoretical models of representation.

De Chirico, whose art movement is aptly termed "Metaphysics," devoted considerable attention to the concept of space, especially through his famous perspectives on solitude in monumental urban spaces. He also adopted the still life language to address the question of space representation (see figures 2.27

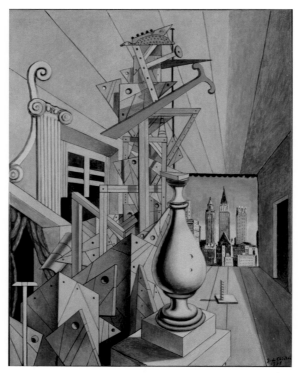

Figure 2.26
Giorgio De Chirico, *Metaphysical Vision of New York*, 1975.

and 2.26). In his *Metaphysical Vision of New York* (see figure 2.26), build-
ings seen in the distance across a window frame echo the "building" of space
itself inside the framed space of the room, which is constructed using a pile
of instruments of mathematical measurement and technical drawing, resem-
bling straightedges, T-squares, and triangles. A similar conceptual frame-
work appears in the other still life painting, (see figure 2.27), which shows the
same type of instruments balancing on a tabletop tilted at a sliding angle, and
crowned by a perspective fugue through a triangular window, paying homage
to the history of the genre with Cézanne-like voluminous shapes of fruits oc-
cupying and defining the center of the composition. The reference within the
reference is hinted at by the presence of a still life painting of grapes within
the still life painting itself, which is the representation of a representation, or a
second level of conceptualization.

Figure 2.27
Giorgio De Chirico, *Still Life*, ca. 1920.

2.2.7 Cornell's Cosmic Dioramas

It is finally with the assemblage works of Joseph Cornell that the notion of space defined by the relational positions of still life compositions merges with space in the cosmic sense, which is the outer space of astronomical and cosmological vastness. Confined within an extremely narrowly defined frame, that of a box, the cosmic dioramas of Joseph Cornell explode this reference frame into perspectives of cosmic scale. The confined space of the boxes is transformed into windows opening on vistas of constellations and galaxies and a vertigo of depth of astronomical distances. Yet, at the same time, the new elements brought in to refer to modern science, through graphics and stellar charts, blend with compositions of glasses and corks and cut-up newspapers, all well established elements in the early 20th-century vocabulary of still life compositions (see figure 2.28).

Thus, by the 1970s, modern art was using the latest incarnation of the still life genre to connect to visions of space popularized by astronomy and cos-

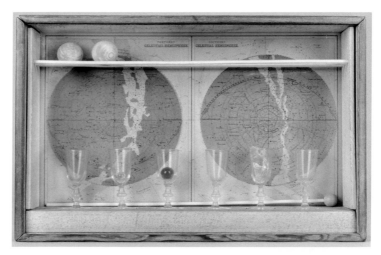

Figure 2.28
Joseph Cornell, *Planet Set, Tête Etoilée, Giuditta Pasta (dédicace)*, 1950.

mology. The debate on the structure of space continued to undergo intense bursts of activity in mathematics, physics, and cosmology, all through the 20th and now into the 21st century. Cornell has shown us that visions of space at the cosmic scale are not incompatible with a genre of artistic expression that was born in the Dutch kitchens of the 17th century. We await similar artistic expressions tackling the scientific visions of space at the infinitesimally small scales, where high-energy physics dwells, along with the varieties of space structures developed and explored by modern mathematics.

Chapter Appendix: Bibliographical Guide

A.1 Guide to Still Life and the Artistic Movements

The reader interested in a more in-depth historical view of the Dutch still life paintings will find some useful references in the following books, including different possible interpretations of the *vanitas* theme, a discussion of how, over time, gender issues in society have negatively affected the interpretation of the still life genre, and the theme of death in still life. A detailed presentation of some of the major works in this school of paintings is given in Meijer's catalog, while a broad overview of still life in the Dutch tradition and in the early days of modernism is given in the last reference listed here.

- Harry Berger, *Caterpillage: Reflections on Seventeenth Century Dutch Still Life Painting*, Fordham University Press, 2011.
- Norman Bryson, *Looking at the Overlooked: Four Essays on Still Life Painting*, Reaktion Books, 2013.

- Kristine Koozin, *The Vanitas Still Lifes of Harmen Steenwyck: Metaphoric Realism*, Edwin Mellen Press, 1990.

- Fred G. Meijer, *The Collection of Dutch and Flemish Still-Life Paintings Bequeathed by Daisy Linda Ward: Catalogue of the Collection of Paintings*, Ashmolean Museum, 2003.

- Victoria Charles, *Still Life*, Parkstone International, 2014.

Regarding the more modern artists, this section lists some general overviews of the artistic avant-garde of the early 20th century, as well as introductory essays to some of the movements discussed in more detail in this chapter, such as Cubism, Dadaism, and Metaphysics. It also includes some references that provide more historical context on these artistic movements, as well as on the broader panorama of modern art, and a few monographs about individual artists discussed in this chapter, listed in the order in which they appear in the text.

- Timothy Stroud and Emanuela Di Lallo, *Art of the Twentieth Century. 1900–1919: The Avant-Garde Movements*, Skira, 2006.

- Ale Erjavec, *Aesthetic Revolutions and Twentieth-Century Avant-Garde Movements*, Duke University Press, 2015.

- Alex Danchev, *100 Artists' Manifestos: From the Futurists to the Stuckists*, Penguin, 2011.

- Mario De Micheli, *Le Avanguardie Artistiche del Novecento*, Feltrinelli, 1988.

- Giulio Carlo Argan, *L'Arte Moderna: 1770–1970*, Sansoni, 1970.

- Carol Armstrong, *Cézanne in the Studio: Still Life in Watercolors*, Getty Publications, 2004.

- Erle Loran, *Cézanne's Composition: Analysis of His Form with Diagrams and Photographs of His Motifs*, University of California Press, 1963.

- Christian Brouder and Rene Percheron, *Matisse: From Color to Architecture*, Abrams, 2004.

- Catherine Bock-Weiss, *Henri Matisse: Modernist against the Grain*, Pennsylvania State University Press, 2009.

- Guillaume Apollinaire, *The Cubist Painters*, University of California Press, 2004.

- Neil Cox, *Cubism*, Phaidon, 2000.

- David Cottington, *Cubism in the Shadow of War: The Avant-garde and Politics in Paris 1905–1914*, Yale University Press, 1998.

- Thomas Vargish and Delo E. Mook, *Inside Modernism: Relativity Theory, Cubism, Narrative*, Yale University Press, 1999.

- Arthur J. Miller, *Einstein, Picasso: Space, Time, and the Beauty That Causes Havoc*, Basic Books, 2008.

- Anna Vallye, Christian Derouet, Maria Gough, Spyros Papapetros, and Jennifer Wild, *Léger: Modern Art and the Metropolis*, Yale University Press, 2013.

- Naomi Sawelson-Gorse, *Women in Dada: Essays on Sex, Gender, and Identity*, MIT Press, 2001.
- Ilaria Schiaffini, *Arte Contemporanea: Metafisica, Dada, Surrealismo*, Carocci, 2011.
- Anne Umland and Adrian Sudhalter, *Dada in the Collection of the Museum of Modern Art*, The Museum of Modern Art, 2008.
- Werner Spies, *Max Ernst Collages: The Invention of the Surrealist Universe*, Abrams, 1991.
- M. E. Warlick, *Max Ernst and Alchemy: A Magician in Search of Myth*, University of Texas Press, 2013.
- Karen Wilkin, *Giorgio Morandi: Works, Writings and Interviews*, Polígrafa, 2007.
- Flavio Fergonzi and Elisabetta Barisoni, *Morandi: Master of Modern Still Life*, Phillips Collection, 2009.
- Ara H. Merjian, *Giorgio de Chirico and the Metaphysical City: Nietzsche, Modernism, Paris*, Yale University Press, 2014.
- Olga Sáenz, *Giorgio de Chirico y la Pintura Metafísica*, Universidad Nacional Autonoma de Mexico, 1990.
- Juan José Gómez Gutiérrez, *The PCI Artists: Antifascism and Communism in Italian Art, 1944–1951*, Cambridge Scholars Publishing, 2015.
- Kirsten A. Hoving, *Joseph Cornell and Astronomy: A Case for the Stars*, Princeton University Press, 2009.
- Lynda Roscoe Hartigan, Walter Hopps, and Richard Vine, *Joseph Cornell: Shadowplay, Eterniday*, Thames and Hudson, 2012.
- Julie Joyce, Carol M. Armstrong, and Michele Robecchi, *Ori Gersht: Lost in Time*, Santa Barbara Museum of Art, 2011.
- A. Miner, R. Baer, and Y. Rinon, *Ori Gersht: History Repeating*, Lund Humphries, 2012.

Themes of influence and affinity between ideas of modern and contemporary art and the scientific developments of the time have been variously explored. The reader can find further discussions in the following references, as well as some more philosophical reflections on space perception in science and in art.

- Linda Dalrymple Henderson, *The Fourth Dimension and Non-Euclidean Geometry in Modern Art*, MIT Press, 2013.
- Michele Emmer, *Mathland: From Flatland to Hypersurfaces*, Springer Verlag, 2004.
- Patrick A. Heelan, *Space-Perception and the Philosophy of Science*, University of California Press, 1989.
- Jimena Canales, *The Physicist and the Philosopher: Einstein, Bergson, and the Debate That Changed Our Understanding of Time*, Princeton University Press, 2015.
- Gaston Bachelard, *The Poetics of Space*, Penguin Classics, 2014.
- Umberto Eco, *The Open Work*, Harvard University Press, 1989.
- Renato Barilli, *The Science of Culture and the Phenomenology of Styles*, McGill-Queen's Press, 2012.

A.2 Guide to the Science of Space and Time

On the general debate between relative and absolute notions of space and time, we recommend the following discussions.

- John Earman, *World Enough and Space-Time: Absolute versus Relational Theories of Space and Time*, MIT Press, 1989.
- Adolf Grünbaum, *Absolute and Relational Theories of Space and Space-Time*, University of Minnesota Press, 1977.
- John Earman, Clark N. Glymour, and John J. Stachel, *Foundations of Space-Time Theories*, University of Minnesota Press, 1977.

There are many excellent books on general relativity and relativistic spacetimes, depending on the level of mathematical background of the reader. This list of references is presented in increasing order of technical sophistication, from popularization to more specialized literature. The list is by no means exhaustive, but it provides some general guidelines.

- Albert Einstein, *The Meaning of Relativity*, Princeton University Press, 2014.
- Stephen Hawking and Roger Penrose, *The Nature of Space and Time*, Princeton University Press, 2010.
- Kip S. Thorne, *Black Holes and Time Warps: Einstein's Outrageous Legacy*, W. W. Norton, 1994.
- Yvonne Choquet-Bruhat, *General Relativity and the Einstein Equations*, Oxford University Press, 2008.
- Charles W. Misner, Kip S. Thorne, and John Archibald Wheeler, *Gravitation*, Macmillan, 1973.
- S. W. Hawking and G. F. R. Ellis, *The Large Scale Structure of Space-Time*, Cambridge University Press, 1975.

On a general discussion on the nature of time and its role in modern physics, I recommend the following references. These are also listed in increasing order of technical difficulty.

- Adrian Bardon and Heather Dyke, *A Companion to the Philosophy of Time*, John Wiley and Sons, 2013.
- Huw Price, *Time's Arrow and Archimedes' Point: New Directions for the Physics of Time*, Oxford University Press, 1997.
- Julian Barbour, *The End of Time: The Next Revolution in Physics*, Oxford University Press, 2001.
- Roberto Mangabeira Unger and Lee Smolin, *The Singular Universe and the Reality of Time*, Cambridge University Press, 2014.
- Charles H. Lineweaver, Paul C. W. Davies, and Michael Ruse, *Complexity and the Arrow of Time*, Cambridge University Press, 2013.
- Sergio Albeverio and Philippe Blanchard, *Direction of Time*, Springer Verlag, 2013.

- Laura Mersini-Houghton and Rudy Vaas, *The Arrows of Time: A Debate in Cosmology*, Springer Verlag, 2012.

On the related notion of entropy and the thermodynamical arrow of time, the following introductory references can be useful. These provide a precise technical exposition of the concept of entropy and its relation to time. The relation between entropy and information is also discussed. We will discuss entropy at length in chapter 4.

- Don S. Lemons, *A Student's Guide to Entropy*, Cambridge University Press, 2013.
- Michael C. Mackey, *Time's Arrow: The Origins of Thermodynamic Behavior*, Dover, 2012.
- Juan Roederer, *Information and Its Role in Nature*, Springer Verlag, 2006.

The idea that spacetime may be emergent from information, which is mentioned in the chapter, refers to recent research on entanglement in quantum information and its relation to spacetime geometry through the "holographic correspondence" of string theory. The first reference is a summary of these ideas, while the others are more technical.

- Ron Cowen, "The Quantum Source of Space-Time," *Nature* 527 (2015): 290–293.
- Shinsei Ryu and Tadashi Takayanagi, "Holographic Derivation of Entanglement Entropy from the Anti-de Sitter Space/Conformal Field Theory Correspondence," *Physical Review Letters* 96 (2006): 181602.
- Mark Van Raamsdonk, "Building up Space-Time with Quantum Entanglement," *General Relativity and Gravitation* 42, no. 10 (2010): 2323–2329.
- Jennifer Lin, Matilde Marcolli, Hirosi Ooguri, and Bogdan Stoica, "Locality of Gravitational Systems from Entanglement of Conformal Field Theories," *Physical Review Letters* 114 (2015): 221601.

On algorithmic processes in nature, such as the growth of seashells discussed in this chapter, and the associated discrete time of cellular automata, I refer the reader to the following additional material.

- Hans Meinhardt, *The Algorithmic Beauty of Sea Shells*, Springer Verlag, 2013.
- Helen Scales, *Spirals in Time: The Secret Life and Curious Afterlife of Seashells*, Bloomsbury Publishing, 2015.
- Alan M. Turing, "The Chemical Basis of Morphogenesis," *Philosophical Transactions of the Royal Society*, Series B, 237 (1952): 37–72.
- Andrew Ilachinski, *Cellular Automata: A Discrete Universe*, World Scientific, 2001.
- Howard Gutowitz, *Cellular Automata: Theory and Experiment*, MIT Press, 1991.

Relations between music, the notion of time, and algorithmic structures are discussed more in depth in the following references. This list is obviously very approximate and incomplete and only reflects the specific taste of this particular author.

- Roger Mathew Grant, *Beating Time and Measuring Music in the Early Modern Era*, Oxford University Press, 2014.
- Barbara R. Barry, *Musical Time: The Sense of Order*, Pendragon Press, 1990.

- Edward Campbell, *Boulez, Music and Philosophy*, Cambridge University Press, 2010.
- Gareth Loy and John Chowning, *Musimathics: The Mathematical Foundations of Music*, MIT Press, 2011.
- John Fauvel, Raymond Flood, and Robin J. Wilson, *Music and Mathematics: From Pythagoras to Fractals*, Oxford University Press, 2006.

Readers can learn more about the science of femto-photography and its applications to art in the following references.

- Andreas Velten, Di Wu, Adrian Jarabo, Belen Masia, Christopher Barsi, Chinmaya Joshi, Everett Lawson, Moungi Bawendi, Diego Gutierrez, and Ramesh Raskar, "Femto-Photography: Capturing and Visualizing the Propagation of Light," *ACM Transactions on Graphics* 32, no. 4 (2013): art. 44.
- Andrew Weiner, *Ultrafast Optics*, Wiley, 2009.

3 The Notion of Space in Mathematics through the Lens of Modern Art

The main purpose of this chapter is to discuss the notion of *space*, as modern mathematics has come to conceive of it. The reader is not supposed to have familiarity with advanced mathematics, though some parts of the text may be more easily accessible than others, in the absence of any prior exposure to the subject. The bibliographical appendix will provide a guided introduction to further readings, starting at a nontechnical level and progressing to more advanced material, for all the topics mentioned in this chapter. The various sections can easily be read independently, so the readers should feel free to skip the parts they find least appealing to their taste and jump directly to the parts they find most interesting.

3.1 Space as Structure

In mathematics, the word *space*, much like the word *number*, never comes alone. It is always decorated by some adjective that specifies what *kind of space*, or what *kind of number* one is talking about. This phenomenon may be generally more familiar in the case of numbers: there are *natural* numbers, 1, 2, 3, \cdots; *integer* numbers, \cdots, -3, -2, -1, 0, 1, 2, 3, \cdots; there are also *rational* numbers, like $2/3$ or $-11/26$, which are ratios of integer numbers; there are *irrational* numbers like $\sqrt{2}$, which are also *algebraic* numbers (roots of polynomial equations with rational coefficients), and irrational numbers like π or e, which are, instead, *transcendental*. There are complex numbers like $i = \sqrt{-1}$, and other, slightly more exotic types of numbers, such as p-adic numbers or finite fields.

What distinguishes these classes of numbers is their *structure*. The type of operations one can do with them is different: addition and multiplication make the set \mathbb{N} of natural numbers into a *semigroup* or a *monoid*, but when the same operations are extended to the set \mathbb{Z} of integer numbers, the fact that addition has inverses (subtraction) but multiplication does not makes this set into a

ring, while in the set \mathbb{Q} of rational numbers one also has multiplicative inverses (division) and this makes it a *field*. Real numbers (which include both the rational and the irrational numbers) are also a field, and so are complex numbers and *p*-adic numbers. Although these are different types of numbers, they have the same structure when it comes to operations that can be done with them. What distinguishes various fields of numbers (for example, the field of rational numbers from other fields obtained by including algebraic numbers that are solutions of polynomial equations with rational coefficients) is the more subtle fact that they have different *symmetries*. The symmetries of numbers are described by a beautiful chapter of algebra known as Galois theory.

Our focus here is on the geometry of space, rather than on the different types of numbers with their structures and symmetries, but the comparison serves as a good guideline on what to expect in the geometric setting. Geometry and numbers are interconnected in some deep ways, as I will discuss in chapter 7. Indeed, the situation with the notion of space is very similar to what I just described in the case of numbers. The word "space" always comes with an accompanying adjective, which specifies what kind of *structure*, or in other words, what relational properties of space one is focusing on.

We are going to take a quick excursus through some of the most common types of space one encounters in mathematics. They are distinguished, as in the case of numbers, by the type of transformations one can perform on them and by their symmetries. In particular, we will encounter linear spaces, projective spaces, topological spaces, metric spaces, measure spaces, noncommutative spaces, and so on.

3.1.1 What Is Structure?

Often one describes spaces by first identifying a *set*, which comprises what will be the points of space, and then describing the *relational* properties of space in terms of certain operations one can perform on the set of points, which in turn satisfy a list of defining properties.

The presence of an underlying set of points is not strictly necessary. Several modern developments in mathematics favor a different viewpoint, where the underlying set describing space is not necessarily identifiable with points, but rather with functions or other more elaborate objects (sheaves, etc.), and one can conceive of spaces that can have no points at all. We will encounter examples of this sort later on in this chapter, when I briefly mention the example of noncommutative spaces.

The *operations* one introduces as part of the definition of space vary according to what kind of space one is considering. They may have the form of addition of vectors, cutting and pasting operations, measuring the size of cer-

tain regions, measuring distances, taking intersections and unions, and so on. What matters in each case is to identify the basic formal properties that each operation satisfies.

Several of the intuitive notions one associates ordinarily with the idea of space can be realized through formal operations of this sort. For example, one can make sense of *proximity relations*, such as neighborhoods, closeness, convergence, and distance.

The fact that different operations can sometime be defined over the same underlying set creates a *hierarchy of structures*. This means that certain notions of space are more refined than others, or, to put it differently, spaces of certain sorts are automatically also spaces in any of the underlying coarser notions. Thus, for example, among the structures we will encounter shortly, a smooth manifold is also a topological space, or a metric space is also a topological space. Usually none of these implications can be reversed; namely, there are topological spaces that cannot be made into metric spaces and topological spaces that are not smooth manifolds.

All the different structures we are going to encounter come with associated *symmetries*: these are all the allowable transformations that preserve all the structure. Naturally, symmetries are very different for different kinds of spaces.

One of the main problems in geometry (which, by definition, is the study of all mathematical notions of space) is the classification problem. Once a good notion of space has been identified, one wants to be able to discern spaces of that type, namely, to understand in how many genuinely different ways that kind of space structure can manifest itself. This means being able to describe spaces up to isomorphism, where the notion of isomorphism in each case depends on the type of transformations preserving the structure (symmetries). An isomorphism is an invertible transformation in the class of transformations that are compatible with the assigned structure.

Usually, one does not have a complete classification of all possible spaces, simply because there are too many nonequivalent forms for a given type of space. However, an efficient way to tell inequivalent forms of space apart is to construct *invariants*. These are usually algebraic objects, numbers, or other, more refined algebraic structures, that have the properties of being discrete and computable by explicit algorithms, and that have the same value for spaces that can be obtained from one another by isomorphism. Thus, while computing an invariant typically does not suffice to tell if two spaces are isomorphic (the invariants may accidentally be the same even if the underlying spaces are not isomorphic), finding different values of an invariant certainly suffices to tell

that the two spaces cannot be isomorphic. Invariants are a tell-tale sign of genuinely inequivalent spaces.

Much work done by mathematicians in the various branches of the field of geometry involves constructing invariants that are sophisticated enough to tell as many as possible of the inequivalent forms of space apart and at the same time simple enough that they can be explicitly computed.

3.1.2 Philosophical Digression: Erlangen Program

Implicit in the general approach (described here) to define various notions of space in mathematics is a dichotomy that had been intrinsically present in the philosophical tradition since ancient times, namely, the distinction between an absolute and a relational view of space. (I already mentioned this conceptual difference in chapter 2 and the bibliographical guide at the end of that chapter includes some discussions of this problem in the context of physical space-time.)

This same tension has manifested itself, at different times through history, as either a static or a dynamical (transformational) view of space. It would be too long, as well as outside the main focus of this volume, to embark on a detailed overview of the notion of space in the Western philosophical tradition, but one can simply mention, on the relational or transformational side, the names of philosophers such as Heraclitus, Democritus, Descartes, Leibniz, and Bergson, and on the side of an absolute or static view of space, starting from the Eleatic school with Parmenides and Zeno, the names of philosophers such as Aristotle, Kant, Newton, and Comte.

The mathematical view, in its modern formulation, is largely independent of these philosophical ancestors, but an echo of this older philosophical debate was still discernible in a mathematical document that had a lasting influence on the notions of space as described routinely in the modern mathematical language: the Erlangen program of Felix Klein, written in 1872. This programmatic document on geometry was the first to focus on understanding space through its symmetries and transformations, and it opened the way to many profound developments in the mathematics of the 20th century.

The notion of symmetry is crucial to both modern mathematics and modern physics. The Erlangen program suggested the innovative viewpoint according to which understanding a geometric object means understanding its transformations, its symmetries. The entire edifice of modern theoretical physics, and especially our understanding of elementary particles and forces (to which we will return in chapter 8), is based on the mathematical theory of symmetries, and in particular on Noether's theorem, which states that symmetries of physical laws give rise to conserved quantities. For instance, momentum conserva-

tion, energy conservation, and the conservation of angular momentum all have a geometric explanation. The gauge symmetries of particle physics play a crucial role in describing what kinds of forces and matter constitute the Standard Model of elementary particle physics. The entire progress of modern theoretical physics can be understood in terms of a progressive geometrization of physics, where symmetries determine geometry, and the converse is also true.

Figure 3.1
Annarosa Cotta, *Signs*, 1986.

In mathematics the concept of symmetry is expressed in terms of the concept of *group action*. A group G acting on a set X is a collection of transformations of the set, which permute the elements of the set X. Two such transformations T_1 and T_2 can be composed into a new transformation $T = T_1 \circ T_2$, obtained by applying them one after the other, subject to an associative law $(T_1 \circ T_2) \circ T_3 = T_1 \circ (T_2 \circ T_3)$. Each transformation is invertible: in order for it to be a symmetry, it should be possible to undo it and obtain the trivial symmetry (the

identity transformation), which does not change anything. It is always possible to describe group actions on a set in terms of permutations of the elements of the set.

The notion of symmetries as permutations can be seen in the conceptual art-work *Signs* of Annarosa Cotta, in figure 3.1, where the group S_4 consisting of the 24 different permutations of a set of four elements is displayed. Here the different permutations represent different possible order relations, in the process of artistic creation, between "matter" (the "prima materia" of the al-chemical process), "hand" (manual realization, embodied cognition), "idea" (abstraction), and "sign" (coding, representation).

In the following discussion, I will focus on illustrating how the different mathematical notions of space can be seen at play in the development of mod-ern and contemporary art, which is itself an exploration of the concept of space, and often explicitly borrowed from the contemporary developments in scien-tific thought.

3.2 Linear Spaces

The first example of space that we are going to discuss in this chapter is what mathematicians refer to as *linear space* or *vector space*. This type of geom-etry, which is often simply called *linear algebra*, is routinely encountered in high school or early college education, often without much emphasis on its power to illustrate, in a relatively simple example, the way in which modern mathematics envisions geometry and the notion of space in general.

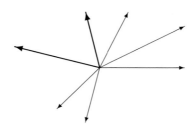

A linear space consists of a set of *vectors*, which are subject to two types of possible operations: *dilation* of vectors and *composition* (vector addition). More precisely, combining these two operations provides the possibility of forming *linear combinations* of vectors, which are sums of dilated vectors with different factors of dilation. The sum of vectors, in the simplest case of vectors in the plane, is given by the parallelogram rule: one slides one of the vectors along the other so as to obtain a parallelogram whose diagonal is the vectors'

sum (equivalently, this corresponds to addition on the x and y coordinates of the vector tips).

Examples of vector spaces include a straight line, a plane, and the set of all polynomials with rational coefficients. As one can easily see, it is possible to construct examples of an increasing level of complexity, yet the basic formal structure (being able to form linear combinations) remains the same, and that is what makes them all examples of the same type of space. The operations of forming linear combinations of vectors have found many important applications, such as computing equilibria of forces in classical mechanics.

The association of vector calculus with the equilibrium of forces is the key to Paul Klee's 1922 painting *Unstable Equilibrium* (see figure 3.2), where the instability is portrayed in terms of a set of arrows (force vectors) associated with various compositional elements in the picture, with the property that their vector sum does not add up to zero (instability, lack of equilibrium). The painter chooses to depict the intensity of the force by the thickness of the arrows rather than by their length. The choice of the word "equilibrium" in the title is intentionally misleading, since the scene depicted is, in fact, a lack of equilibrium where a total nonzero force vector is applied. Even without a precise quantitative rendering of vectors and their intensity, the viewer instinctively perceives that the number of arrows pointing leftward in the painting is not balanced by those pointing rightward; hence, the immediate perception of incipient motion that accompanies the scene. The illusion of an instant of "unstable equilibrium" is produced by the fact that the painting illustrates an instantaneous picture of a system subject to a dynamical evolution. One should read it as an initial configuration with zero initial velocity but subject to forces, as depicted by the arrows of the vectors. The viewer of the painting can then imagine letting time flow and envision the dynamical change of this initial configuration as it moves according to the Newtonian laws of classical mechanics under the effect of the forces. *Unstable Equilibrium*, in this respect, is a very interesting illustration of how a static medium (a painting on canvas) can be used to portray a dynamical process, by means of mathematical language.

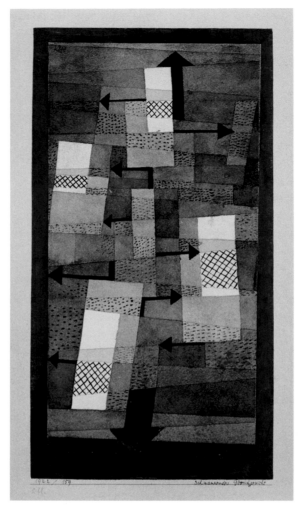

Figure 3.2
Paul Klee, *Unstable Equilibrium*, 1922.

There is another observation implicit in the notion of linear combination of vectors, which is the basic structure defining linear spaces, namely, the inter-play between geometric and algebraic structures. This has been a dominant theme in modern mathematics at least since the time of Descartes. In fact, when talking about expressions of the form $\lambda_1 v_1 + \cdots + \lambda_N v_N$, one is relying upon having fixed a class (more precisely, a *field* when one accounts for all the

necessary operations) of numbers λ_i that act as possible dilation coefficients. For example, if the dilations are real numbers, one is extending the length of the vector (and possibly changing its orientation), while if the dilation coefficients are complex numbers, one is also rotating the vector by a phase (an angle). Thus, vector spaces over different fields (real numbers versus complex numbers, for example) exhibit different geometric properties.

3.2.1 Mathematics of Linear Spaces

It is worth looking more closely at the mathematical definition of a vector space to see more explicitly the interplay between algebraic operations and geometric concepts.

A *field* is a set F with two operations, addition and multiplication, that satisfy the following properties:

- Addition is associative: $(a + b) + c = a + (b + c)$ for all choices of elements a, b, c in F.
- Addition is commutative: $a + b = b + a$ for all a, b in F.
- Addition has a zero element: $a + 0 = a = 0 + a$ for all a in F.
- Addition has inverses: $a + (-a) = 0 = (-a) + a$ for all a in F.
- Multiplication is associative: $a(bc) = (ab)c$ for all a, b, c in F.
- Multiplication is commutative: $ab = ba$ for all a, b in F.
- Multiplication has a unit: $a1 = a = 1a$ for all a in F.
- Nonzero multiplication has inverses: $aa^{-1} = a^{-1}a = 1$, for all $a \neq 0$ in F.
- Multiplication distributes over sum: $a(b + c) = ab + ac$ for all a, b, c in F.

Rational numbers (fractions with integer numerator and nonzero integer denominator) form a field called \mathbb{Q}; real numbers form a field called \mathbb{R}; complex numbers $x + iy$, with $x, y \in \mathbb{R}$ and $i = \sqrt{-1}$, also form a field called \mathbb{C}. There are other fields, such as finite fields \mathbb{F}_q, where the number of elements $q = p^n$ is a power of a prime number p.

A *vector space* over F is a set V with two operations: *vector addition* and *dilation by a field element*, with the following properties:

- Vector addition is associative: $u + (v + w) = (u + v) + w$ for all u, v, w in V.
- Vector addition is commutative: $u + v = v + u$ for all u, v in V.
- Vector addition has a zero element: $v + O = O + v$ for all v in V.
- Vector addition has inverses: $v + (-v) = O$ for all v in V.
- Dilation distributes over vector sums: $a(u + v) = au + av$ for all a in F and all u, v in V.
- Dilation distributes over field sum: $(a + b)v = av + bv$ for all a, b in F and all v in V.

- Dilation is compatible with field multiplication: $a(bv) = (ab)v$ for all a, b in F and all v in V.
- The field unit acts as identity on vectors: $1v = v$ for all v in V.

This definition expresses precisely the concept, previously described heuristically, that vectors can be combined (by a generalization of the parallelogram rule shown previously) and can be dilated by a factor given by an element in the "field of coefficients" F of the vector space V.

What one should appreciate in the mathematical formulation is that it does not simply say there are these two operations, but rather spells out a complete and minimal set of "rules of the game" that are needed in order to perform these operations and manipulate expressions involving them.

Figure 3.3
Mitchell Chan, Studio F Minus, *Realization of Sol LeWitt's Wall Drawing 118*, 2013

A very interesting illustration in art of the repeated application of vector calculus (a name for the "rules of the game," listed previously for performing operations in vector spaces) is provided by Sol LeWitt's *Wall Drawing 118* (see figure 3.3). The artist provided a set of instructions for the generation of this artwork. Several of these instructions amount to drawing vectors on a wall surface and performing associated vector sums. Recently several artists have produced versions, both physical and computerized, of this piece. The vectorial equilibrium of forces is, again, the crucial concept in this work, and its intricate, multilayered structure reveals the visual complexity that can be achieved through very simple operations of vector composition.

3.3 Projective Spaces

As a second example of a different notion of space, I will briefly discuss *projective spaces*. These originated historically in the geometry underlying the development of Renaissance perspective drawing, which culminated in the masterpieces of artists such as Piero della Francesca, Leonardo da Vinci, Michelangelo, and Raffaello. The painting *The Ideal City*, which was once erroneously attributed to Piero della Francesca (figure 3.4), provides a typical example of Renaissance perspective drawing. One important point to keep in mind in all the different notions of space we are going to encounter is that very often they originated historically as a way to extract the basic structure underlying some intuitive properties of geometry, such as the need to derive rigorous rules for perspective drawing in the Italian Renaissance.

Figure 3.4
Uncertain attribution, *The Ideal City*, ca. 1480.

However, once the essential mathematical structure has been identified, one begins to recognize the same structure at play in different contexts, which are no longer covered by the same original intuition. This is how many new discoveries and important developments come about in mathematics, by recognizing a similarity of structure at play in new and diverse contexts, and therefore being able to transpose results developed in one context into a new domain. This, in turn, ultimately justifies the exercise of translating into formal abstract rules the operations we intuitively understand at the level of visual geometry. In fact, far from being just a formal exercise, this reformulation into a more abstract algebraic language makes it possible to extend the domain of applicability of those same operations, from an intuitive and elementary geometric level to more difficult and abstract realms, where they deliver genuinely new and otherwise nonintuitive results. This is how important developments of modern science, such as quantum mechanics and general relativity, became possible. The language in which they are expressed is a combination of geometric structures and abstract notions of space that came about following the kind of mental itinerary we are illustrating here, by which the known is abstracted to

Figure 3.5
Richard Southwell, *Projective Geometry*, documentary, 2014.

the point where it provides a language that is transparent and powerful enough
to help us describe the unknown in familiar terms.

3.3.1 Perspective and Anamorphosis

The notion of projective space was develop to express precisely the idea of "the
space of all directions emanating from a point," and this explains why it was so
relevant for Renaissance perspective drawing. Projective transformations have
the properties that they map lines to lines and preserve incidence relations (in-
tersecting lines will be mapped to intersecting lines, for instance), although
they do not preserve parallelism. The mapping of a three-dimensional scene
to a two-dimensional drawing surface according to the rules of Renaissance
perspective happens through a projective transformation, which maps parallel
lines to lines that are no longer parallel in the image but meet at a point (usu-
ally called the "vanishing point" in perspective), which is a point at infinity in
projective space.

A one-dimensional projective space is a line completed (compactified) by
the addition of a single point at infinity. One writes $\mathbb{P}^1 = \mathbb{A}^1 \cup \mathbb{A}^0$, where
\mathbb{P}^1 stands for a projective line (one-dimensional projective space) and \mathbb{A}^1 is
an affine line (a one-dimensional vector space, up to a choice of the point
at which to place the origin of vectors) and \mathbb{A}^0 is just a point (the point at

Figure 3.6
Rebecca Norton and Jeremy Gilbert-Rolfe, *Awkward X2*, 2010.

infinity). A projective plane is a plane together with a projective line at infinity, $\mathbb{P}^2 = \mathbb{A}^2 \cup \mathbb{P}^1 = \mathbb{A}^2 \cup \mathbb{A}^1 \cup \mathbb{A}^0$, where \mathbb{A}^2 is an affine plane (that is, a two-dimensional vector space, up to the choice of the origin of vectors). One can similarly construct higher dimensional projective spaces as compactifications of affine (vector) spaces, $\mathbb{P}^n = \mathbb{A}^n \cup \mathbb{P}^{n-1} = \mathbb{A}^n \cup \mathbb{A}^{n-1} \cup \mathbb{A}^{n-2} \cup \cdots \cup \mathbb{A}^1 \cup \mathbb{A}^0$, where everything but the top-dimensional \mathbb{A}^n constitutes the part that lies at infinity (on the infinite horizon of the perspective). Lines that are parallel in \mathbb{A}^2 intersect in \mathbb{P}^2, but their intersection lies on the infinite horizon \mathbb{P}^1. This principle is illustrated in the image of figure 3.5, which is taken from Richard Southwell's documentaries about projective geometry. As I discuss further, one can think of projective spaces as describing the set of all possible directions in a vector space.

So far, the main applications of projective geometry to the history of art have been for perspective and anamorphosis. Perspective can be regarded as a computational device for drawing based on the axioms of projective geometry. The use of projective transformations for the purpose of perspective drawing played

a crucial role in the art of the Italian Renaissance, but the same techniques also continue to be widely used in modern and contemporary paintings, as the work of Rebecca Norton and Jeremy Gilbert-Rolfe (figure 3.6), shown here, readily illustrates. In this painting, the use of perspective is rendered more subtle by the use of a combination of different simultaneous perspective horizons where "parallel" lines converge, which are superimposed in the same composition.

Anamorphosis is also a computational technique for deforming shapes according to projective transformations. Unlike perspective, whose purpose is to represent three-dimensional views on two-dimensional surfaces using the geometry of foci and horizons in projective spaces, anamorphosis allows the artist to deform shapes in ways that are precisely controlled, so that the deformation can be undone, and the original shape restored, either by turning the view at an angle or by the use of curved mirrors, a kind of "encryption" of images by projective geometry. There are different kinds of anamorphosis, depending on the type of deformation used: cylindrical anamorphosis, for example, is a widely used technique that allows the viewer to restore the original form by viewing its reflection on the surface of a cylindrical mirror placed at the center of the image. In Renaissance art, one of the most famous example of anamorphosis is the distorted skull inserted in Holbein's *The Ambassadors* painting (figure 3.7). In this case, the deformation is undone by viewing the picture at an appropriate angle, as shown in figure 3.7.

Anamorphosis continued to be used by modern and contemporary artists, both in painting and in sculpture, to create distorted regions and controlled deformation effects. The sculpture *Reflection Anamorphosis* by Jean-Max Albert (figure 3.8) uses the reflection in the water, viewed at an appropriate angle, to undo the deformation of the anamorphosis, while the paintings of Linda Besemer (figure 3.9) and Sara Willett (figure 3.10) use planar projective transformations to distort regular, straight patterns into more interesting, curved figures.

3.3.2 The Notion of Projective Space

This notion of space illustrates an important general principle, namely the fact that certain structures naturally "grow" on top of other, preexisting and underlying structures. In a way, we have already seen this phenomenon in the formal definition of a vector space described in the previous sections. In fact, in order to make sense of the scaling operation on vector spaces, one needs to have already available the notion of a field, in which the scaling factors exist. This is why one talks about a "vector space over a field." One needs the notion of field first, and then uses that in constructing vector spaces. Another way of seeing this fact, in the case of vector spaces, is by realizing that a vector v in a vector

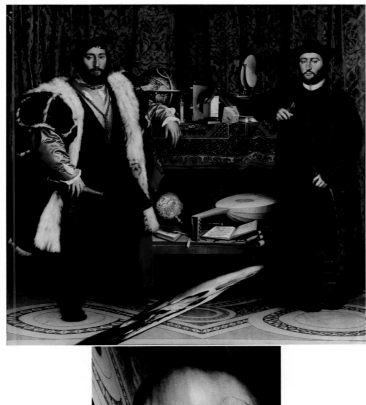

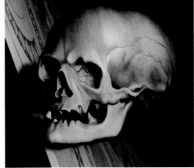

Figure 3.7
Hans Holbein, *The Ambassadors*, 1533; with detail of the skull undistorted.

space V can be specified completely by a set of coordinates $v = (v_1, \ldots, v_n)$, just like the coordinates (x, y) that determine a point in the plane, or the N-S and E-W coordinates that determine an intersection on a city map. These coordinates are simply numbers, and they also exist in the underlying field of numbers over which the vector space is constructed. In the plane (seen as a

Figure 3.8
Jean-Max Albert, *Reflection Anamorphosis*, 1985.

vector space), a vector is simply determined by the coordinates $v = (x, y)$: in the arrow representation, v is the arrow that starts at $(0, 0)$ and has its tip at the point of coordinates (x, y). Multiplication by a scalar λ dilates the vector v by replacing it with $\lambda v = (\lambda x, \lambda y)$.

The notion of a projective space goes one step further: it develops on top of the notion of vector space already introduced. More precisely, one again considers vectors in a vector space, but this time one is interested not in the particular *length* of a vector but only in the *direction* in which it points. This means that, first of all, one needs to discard the zero vector in the vector space: a vector with zero length cannot point in any direction. Of all the remaining vectors, we simply group together all those that lie on the same line and consider them as the same thing: as the information we wish to retain. This means, for example, that if the vector space one starts with is the three-dimensional

Figure 3.9
Linda Besemer, *Big Corner Bulge*, 2008.

space, whose vectors have three coordinates $v = (x_1, x_2, x_3)$, then, as long as v is nonzero (which means that at least one of the three coordinates is nonzero) and a real number λ is also nonzero, the vector $v = (x_1, x_2, x_3)$ and the vector $\lambda v = (\lambda x_1, \lambda x_2, \lambda x_3)$ point along the same straight line and we consider them as being the same point of our projective space. In other words, a *point* in a projective space is a *line* in a vector space, and what matters is the line itself, not a particular choice of a vector lying along that line.

3.3.3 Different Kinds of Projective Spaces

As soon as one starts to unravel what this notion means geometrically, one finds some nice properties: for example, a one-dimensional real projective space is a circle: the set of all directions in the plane (a two-dimensional vector space over the field of real numbers). To be more precise, as this observation will be useful in a moment, one first looks at the circle in the plane with center at the origin: a direction out of the origin crosses the circle in two antipodal points. So these two points determine the same direction: in the projective space we should view them as the same point, but a bit of thinking shows that what we obtain in this way has again the shape of a circle. Thus, we see that indeed the one-dimensional real projective space is a circle. If nonzero vectors in the two-dimensional real plane have coordinates (x, y), when we think of them up to a scale factor, we can identify them with either the point $(z, 1)$, with $z = x/y$ when $y \neq 0$, or with $(1, 0)$, when $x \neq 0$. This gives a real line in the variable z

Figure 3.10
Sara Willett, *Anamorphosis*, 2010.

together with a point at infinity, when $y = 0$, which returns the decomposition $\mathbb{P}^1(\mathbb{R}) = \mathbb{A}^1(\mathbb{R}) \cup \mathbb{A}^0(\mathbb{R}) = \mathbb{R} \cup \{\infty\}$, where we write $\mathbb{P}^n(F)$ for the projective space built as the set of directions in an $(n + 1)$-dimensional vector space over the field F.

However, the one-dimensional complex projective space $\mathbb{P}^1(\mathbb{C})$ is a sphere. This is because the underlying *field F* has changed from real numbers, \mathbb{R}, to complex numbers, \mathbb{C}. Complex numbers have two real coordinates, so a line of complex numbers becomes a plane of real numbers, and so on. On the

other hand, a two-dimensional real projective space is the set of all directions (lines) inside a three-dimensional real vector space. It may look at first like this should also be a sphere, but that is *not* the case, because antipodal points on the sphere belong to the same straight line through the center of the sphere, so they should be identified. Thus, the resulting geometric figure is a shape obtained by gluing together antipodal points on a sphere, or equivalently, by taking a single hemisphere and closing it up by identifying antipodal points on the boundary. There is no way to show the resulting surface in three dimensions without giving the impression that it is crossing itself (figure 3.11), but if we could envision it in four dimensions, it would not have any self-intersection.

Figure 3.11
Real projective plane $\mathbb{P}^2(\mathbb{R})$ immersed in \mathbb{R}^3 with self-intersections (image drawn with `Mathematica`).

The fact that the notion of projective space depends on that of vector space, which in turn depends on the notion of field of numbers, makes it possible to obtain a variety of different examples of projective spaces $\mathbb{P}^n(F)$, by varying either the vector space dimension n, the field F, or both, in many different ways and performing the same operation of identifying nonzero vectors that differ by multiplication by a scalar. Some very nice examples can be obtained in this way, which at first look very different from the cases mentioned concerning circles, spheres, and the surface of figure 3.11. These are examples that come from changing the underlying field to a *finite field*, which is a field that has only a finite number of elements in it. This means that there is only a finite choice of scales that one can use to rescale vectors. The vector spaces themselves that are constructed over these finite fields will consist of a finite number of points, unlike our usual intuition about lines, planes, and three-dimensional spaces extending indefinitely in their various directions. As an example, the

Fano plane is the projective plane $\mathbb{P}^2(\mathbb{F}_2)$ where \mathbb{F}_2 is a finite field with only two elements 0 and 1. In general, there are $q^n + q^{n-1} + \cdots + q^2 + q + 1$ points in a projective space $\mathbb{P}^n(\mathbb{F}_q)$ of dimension n over a finite field \mathbb{F}_q with q elements, hence $\mathbb{P}^2(\mathbb{F}_2)$ has $4 + 2 + 1 = 7$ points. These points, together with all the projective lines $\mathbb{P}^1(\mathbb{F}_2)$ (each containing three points) that lie in the plane $\mathbb{P}^2(\mathbb{F}_2)$ are drawn in the following diagram, where the projective lines $\mathbb{P}^1(\mathbb{F}_2)$ are drawn either as straight segments or as circles.

Throughout mathematics there is an interesting conceptual dichotomy between *the continuum* and *the discrete*. By continuum, we understand everything that changes gradually, where one can move by arbitrarily small amounts in all directions, while by discrete we mean structures where one can move from one point to another only by jumps. The line of real numbers is a continuum, but the integer numbers $1, 2, 3, 4, \ldots$ form a discrete set. Linear spaces and projective geometry over fields like the real numbers \mathbb{R} or the complex numbers \mathbb{C} gives us continuous objects (circles, spheres, surfaces, and so forth) where one can move in arbitrarily small steps, while finite fields \mathbb{F}_q that contain only a finite number of elements give rise to vector spaces and projective spaces that are discrete objects: one can only jump from one point to another point, without taking any shorter intermediate steps.

While it looks at first like the continuum and the discrete inhabit very different worlds, it is surprising to discover that one can often treat both cases with the same conceptual tools. The examples of projective spaces we have discussed are an illustration of this general phenomenon. A finite projective line $\mathbb{P}^1(\mathbb{F}_q)$ is a case of discrete geometry with $q + 1$ points, but it is constructed with the exact same procedure with which we obtained a circle or a sphere (both examples of continuum geometry), except by changing the underlying field of coefficients. In particular, such finite geometries represent relations of incidence, such as lines passing through points or contained in planes, planes intersecting along lines, and so forth. In contemporary mathematics it is largely understood that the dichotomy between the continuum and the discrete is largely illusory.

Figure 3.12
Sarah Walker, *Extrapolator*, 2010.

Projective geometry is especially suitable to describe relational properties such as lines passing through given points, lines intersecting, planes containing lines, and so on. Over the past two centuries, projective geometry has developed into a very sophisticated tool to study questions of incidence, tangency, order of contact, and intersection between geometric loci cut out from inside projective spaces by various kinds of polynomial equations. We will return briefly to describe this type of geometric spaces (called *algebraic varieties*) in section 3.8. Algebraic geometry (of which projective geometry is an aspect) can be formulated similarly on fields like \mathbb{C} or on fields like \mathbb{F}_q. The possibility of applying geometric methods born in the realm of the continuum to discrete problems has made algebraic geometry an extremely successful tool in the history of contemporary mathematics, and in particular in addressing problems of number theory, whose discrete nature often hides a geometric formulation that closely resembles the more intuitively visible world of continuum geometry.

Such discrete incidence geometries also find a significant place in modern art. The paintings by Sarah Walker in figures 3.12 and 3.13 illustrate relational

Figure 3.13
Sarah Walker, *Everywhere Is Always*, 2010.

properties of a discrete projective geometry, detailing the incidence relations
between points and lines.

3.4 Topological Spaces

A very different notion of space, which plays a crucial and central role in
modern mathematics, is that of *topological space*. This topological notion of
space formalizes the relation of "being near" a point. It is important to stress
the fact that "near" is a qualitative, not a quantitative, notion. We do not specify
how near (in miles, parsecs, or any other unit of length), but we want to devise
some notion that, without having to measure distances, tells us right away what
is near what, or what is connected to what.

Another important observation is the fact that such a qualitative notion of
nearness would also necessarily be an *open condition*, by which we mean the
fact that small perturbations will not affect it. If two points are near, and I move
them just slightly, it is natural to still consider them near each other. Thus,
topology develops a notion of *open* sets, where moving around by a small
amount does not cause one to leave the set, and a notion of *closed* sets, which

formalizes the intuitive idea of regions that have a sharp boundary. Being on the border between two different regions is not an open condition: a movement, however small, in one direction would take you inside one of the two regions, in another direction, inside the other one.

Figure 3.14
Salvador Dalí, *The Persistence of Memory*, 1931.

These concepts can also be expressed in a "transformational way": one allows for all kinds of continuous deformations of spaces to take place. An old joke has it that a topologist is a person who cannot distinguish between a doughnut and a cup of coffee, because when viewed from a topological point of view, all that matters is that both objects have a handle, which cannot be eliminated without a drastic cutting or breaking transition. When one allows only for continuous deformations, the doughnut can change shape into a cup, but not, say, into a sphere. Consider the well known painting by Salvador Dalí, *The Persistence of Memory* (figure 3.14). It shows several images of clocks, deformed to soft and almost fluid shapes, hanging from tree branches, and sliding off the edges of solid structures in the background. Yet each of these deformed shapes is undeniably a clock, and the relative position of the hands that measure time is still recognizable in the deformation. This is a good depiction of a topological transformation, where no part of the shape is severed and torn apart, but different parts of the shape can be deformed in different

ways, so that straight lines are bent and lengths are stretched or shortened at will.

3.4.1 Topology: A Closer Look

The more precise mathematical formulation of the notion of a *topological space* is given in the following way.

A topological space is a set X together with a collection $\mathcal{V} = \{V\}$ of subsets $V \subset X$ with the properties that:

- The empty set \emptyset and the set X itself belong to the collection \mathcal{V}.
- Any arbitrary union $\bigcup_\alpha V_\alpha$ of sets V_α in \mathcal{V} is also a set in \mathcal{V}.
- Any finite intersection $V_1 \cap \cdots \cap V_n$ of sets V_i in \mathcal{V} is also a set in \mathcal{V}.

A collection of subsets \mathcal{V} that satisfies these properties is called a *topology* on X and the sets V in \mathcal{V} are called *open sets*.

One can see right away that, in the topological case, the structure of space is given, not by operations on its points (as in the addition and scaling of vectors in the case of vector space), but rather by operations such as unions and intersections that one performs on subsets. The properties listed previously identify what kinds of subsets can be used to provide a qualitative notion of proximity: the open sets that contain a certain point of X are its *neighborhoods*: they describe which points of X are in proximity to the chosen point. Notice also that, in the definition of topological space, there is an asymmetry between the operations of union and intersection of sets: in the case of unions, an arbitrary union (either finite or infinite) of open sets is still open, while for intersections, only a finite intersection of open sets is still open, while infinite intersections of open sets need no longer be open.

In the following section I discuss briefly some interesting classes of topological spaces that are widely studied by mathematicians and that occur prominently in other sciences. I will show how they also occur in modern and contemporary art.

3.4.2 Knots from Art to DNA

A very interesting class of topological spaces, which appears at first remarkably simple, but which in fact is extremely rich and complex, involves *knots* and *links*. A knot is more or less what one imagines by commonsense intuition: a piece of string tied up into a knot, only here our pieces of string are infinitely elastic and their endpoints are made to coincide. So the simplest knot is called the unknot and it is simply a circle of unknotted string. However, as one sees from the table presented here, which illustrates some of the simplest examples of knots, there are lots and lots of interesting nontrivial examples. The main

point about these examples is that they are all *different*, where different means that no matter how you stretch and bend one of them, you will not be able to transform it into another one in the table (as long as you don't cut the string and glue it back in a different way, which would be cheating, that is, applying transformations that are not part of the continuous rules of topology). There are infinitely many different knots that cannot be transformed one into the other by continuous transformations. It is important to notice here that what makes a knot trivial (the unknot) or actually knotted is not the curve itself (which by itself is just topologically a circle), but rather the way in which it sits inside the ambient three-dimensional space. Knottedness is, in fact, a property of the knot complement (the rest of the ambient space around the knot) rather than of the knot in and by itself.

A link is, similarly, made up of a combination of different knots, which not only can be each knotted, but can also be connected to one another in ways that cannot be untangled without cutting. There are also infinitely many topologically different links, which cannot be deformed one into the other without cutting. A few of them are shown in the bottom part of figure 3.15, with the different strands (knots) in each link shown in different colors. In the example labeled 6^3_2, known as the Borromean rings, any two of the three circles are unlinked, but the three circles together are nontrivially linked and cannot be pulled apart.

In recent years, the study of knot theory has found interesting applications to biology. In fact, the double helix DNA molecules that form the code of life on Earth form long strands that can tie themselves up in knots. There are enzymes (called topoisomerases) in our cells that perform geometric operations on these knots, so that the DNA can reproduce itself by separating out into two identical (or nearly identical) chains, which should not remain linked to one another in some complicated two-knot component link, but rather should be able to migrate into two different sides of a reproducing cell. It is a nontrivial biological and mathematical problem to understand how that unknotting of DNA prior to replication can happen. Besides its intriguing applications to biology, knot theory is an extremely interesting subject in itself from the mathematical point of view. It is a very difficult problem to tell knots apart, that is, to answer the question of whether two given knots can be transformed one into the other without cutting the string. Thus, one approaches the question by trying to compute *invariants* of knots, namely, discrete quantities (such as an integer number, or a group, or another algebraic structure) that would take the same value on any two knots that can be deformed into one another. If one has a good supply of such invariants available, one can often identify knots that

Figure 3.15
Rob Scharein, *A Table of Knots and Links*, 1998–2003.

cannot be deformed one into the other, by showing that some invariant takes different values on the two knots. Of course, knowing that an invariant takes the same value on two knots does not say much, as there could be, in principle, a more refined invariant that tells the two knots apart. A coincidence of some invariants need not be a sign that the two knots really can be deformed into one another.

Knots have a long history as decorative motifs in art. However, their depiction as mathematical objects is a relatively new phenomenon in contemporary art. An example is provided by the sculpture of Attilio Pierelli, in fig-

Figure 3.16
Attilio Pierelli, *Theory of the Universes: Knots A, B, C*, 1986.

ure 3.16, where a knot is depicted along with its Seifert surface, which is a two-dimensional surface of which the knot is the boundary. This work of art also hints at the occurrence of knots and links in the structure of spacetime (hence their occurrence in relation to a "Theory of Universes"). It is indeed the case that knots and links play a role also in certain models of quantum gravity.

3.4.3 Triangulations and PL Spaces

There is another very interesting class of topological spaces, called *PL spaces*, where PL stands for *piecewise linear*. These have the property that they can be constructed out of a mesh of triangles, or the higher dimensional analogs of triangles (called simplexes). A typical example of a PL space is a polyhedron: it is subdivided into faces, which are polygons. These can, in turn, be subdivided into triangles. Such a subdivision into triangles (or higher dimensional simplexes) is called a *triangulation*. Not all topological spaces admit triangulations, so the class of PL spaces is smaller than the class of all topological spaces. A reason why it is a very desirable property for a topological space to

admit a triangulation is that one can view it as being nicely approximated by chunks that look like pieces of a vector space. This makes it possible to use techniques from linear algebra (the theory of vector spaces) to describe properties of these topological spaces. This is used extensively in computer graphics, for example, where one uses good approximations of surfaces by collections of triangles to create realistic-looking images out of discrete samplings, creating a mesh.

Figure 3.17
Gego (Gertrude Goldschmidt), *Untitled*, 1970.

Triangulations and PL topological spaces occur in various forms in the work of 20th- and 21st-century artists. Consider the drawing by Gego in figure 3.17, for instance, which depicts a triangulation of a planar region. Notice how several of the tiles in Gego's drawing are, in fact, not triangles, but rather other more general polygonal shapes. It is in fact possible, in the theory of PL spaces, to relax the requirement that the tiles must be simplexes (triangles

Figure 3.18
Gego (Gertrude Goldschmidt), *Reticulárea*, 1975.

Figure 3.19
Marcus Sendlinger, *Tristar*, 2008.

and their higher-dimensional analogs) and use more general polygons (poly-
hedra or polytopes in higher dimension) as long as the shapes of the tiles are
contractible (can be shrunk to points). Indeed, such tiles can always be tri-
angulated so the class of spaces considered is not altered by allowing these
more general tiles. Notice how the variable sizes and shapes of the tiles of
the triangulation are used to create an impression of curvature of this region
of space. Indeed, PL spaces can be endowed with a discretized version of cur-
vature, which can be used in computations as a convenient replacement of the
continuous versions of curvature of smooth spaces that I will discuss later in
this chapter. This curvature effect produced by the triangulation is even more
prominent in the work of Gego in figure 3.18. Regge calculus in general rela-
tivity, the "dynamical triangulations" techniques in quantum gravity, and "spin
networks and spin foam" models of quantum gravity are all relying on this idea
of triangulations endowed with discretized versions of curvatures as models of
spacetime.

Another example is provided by the *Tristar* painting of the *White Paintings*
series by Marcus Sendlinger (figure 3.19). Here, unlike in Gego's drawing,
we see that the main triangular shapes are arranged in a way that violates the
mathematical rules of triangulations, according to which any two triangles in
the tiling should have either no intersection, or else intersect either at a sin-
gle vertex or at two vertices and along the edge joining them. In Sendlinger's
painting, some of the triangles are incident to each other according to the tri-
angulation rules, while others touch each other with one vertex of one triangle
placed in the middle of an edge of another triangle. The painting, however, also
hints to a resolution of this inconsistency: the triangles are shown as being sub-
divided into smaller triangles, in a procedure that recalls what topologists refer
to as the barycentric subdivision of a triangulation. In particular, such a proce-
dure can be used to obtain a triangulation from an arrangement of triangles as
depicted in this painting with some vertices touching internal points of edges.
Thus, one can think of this painting as showing a dynamical process, through
which a triangulation is being constructed, but has not yet been achieved. The
use of different lighting effects and color elements further emphasizes the dy-
namical nature of the image.

3.4.4 Graphs and Networks

An extremely useful class of topological spaces is given by *graphs*. These
spaces are defined by a discrete set of data, consisting of vertices and of edges
connecting them. With such data the notion of proximity between points is
expressed by the presence of an edge connecting them. Graphs are the sim-
plest class of PL spaces, with the edges (segments) playing the role of "one-

dimensional triangles" (more precisely, one-dimensional simplexes) of a triangulation.

One can think of the vertices of a graph as "nodes" and the edges of a graph as connections that tie these nodes together according to a certain plan. Such a depiction of graphs can be seen in the work of rope artist Hajime Kinoko (figure 3.20), where knots inserted into configurations of rope determine the vertices of a graph and rope strings stretched between them correspond to the graph's edges.

We encounter frequent examples of graphs in our daily lives, and it is easy to illustrate with some familiar examples what kind of information the topology of the graph encodes. Take the example illustrated in figure 3.21. They are graphs representing the subway systems of two major cities, San Francisco and Moscow. The vertices of the graph are the stops on the subway lines, and the edges are the stretches of the lines that connect one stop to another. Just by looking at these two graphs, one readily sees some evident topological differences. The Moscow subway system is a graph with many more loops. The presence of loops means that there is more than one way to go from a station A to a station B, by different combinations of lines and intermediate stations. This is a clear advantage in terms of the efficiency of a transportation system, compared with a graph like the one of the San Francisco BART system, which does not have any loops. In fact, one can imagine a situation where a stretch of tracks of some subway line would be interrupted for some reason. In a graph with many loops, this may create some delay as passengers must take a longer detour, but people would still, for the most part, be able to reach their destination using the subway system. In a graph with no loops, a single interruption completely blocks traffic. The number of loops in a graph is called the *first Betti number* of the graph, and it is a topological invariant.

Although the concept of a graph looks remarkably simple, graphs can, in fact, be extremely complicated. Perhaps the most complicated graph we en-

Figure 3.20
Hajime Kinoko, *Cell*, 2014.

counter in our daily life is the World Wide Web (figure 3.22). This is an extremely complex graph whose topology changes continuously as new connections are opened while other connections go offline. Extremely complex graphs also occur in the study of the connectivity between different regions of the human brain (the human connectome). For graphs of very large size, one no longer studies the topology of the whole graph, but rather focuses only on large-scale phenomena. For example, a single node, or even a small set of nodes becoming disconnected from the graph will likely not affect the overall properties of a very large graph, while a large component becoming disconnected will make a significant difference. Among individual nodes, some are, in effect, more *central* to the network and very highly connected (like a big hub of air traffic at a major airport), while other nodes are more peripheral. The structure of very large graphs is studied mostly with statistical techniques.

Figure 3.21
Subway system in San Francisco and in Moscow.

The study of large graphs, and the statistical behavior of subgraphs inside these large networks, is a very active research field in mathematics with important applications to network connectivity, which focuses on identifying the structure, as well as the strengths and vulnerabilities, of important large networks like the internet and the brain.

Figure 3.22
Matthew Gress, *Internet Graph*, 2014.

3.4.5 From Graphs to Polyhedra

Polyhedra form another large class of PL topological spaces, and can be seen as higher-dimensional generalizations of graphs, in the sense that they are also described by discrete combinatorial data of incidence, not just of edges and vertices, but of two-dimensional faces and edges, and of higher-dimensional faces and their lower-dimensional boundary strata. These data define graphs in one dimension, arrangements of polygons in two dimensions, and polyhedra in three dimensions, as well as higher dimensional polytopes. Polyhedral

shapes have a long history in art, from the ancient fascination with the Platonic and Archimedean solids, to Renaissance perspective drawings of polyhedral shapes. The theme has been variously interpreted in contemporary art. Consider, for example, the painting *Double Star* by Matjuska Teja Krasek (figure 3.23).

Figure 3.23
Matjuska Teja Krasek, *Double Star AG*, 2003.

This painting depicts a higher-dimensional polyhedral shape, whose two-dimensional faces are tiles of the Penrose aperiodic tiling of the plane, which we will discuss more at length later in this chapter. The fivefold symmetry typical of Penrose tilings is manifest in this polyhedral shape. The mathematical property emphasized by this painting is the fact that aperiodic tilings of the plane can originate by projection from higher-dimensional regular polyhedral shapes. This is a very interesting property of aperiodic tilings, with physical applications to the structures known as quasicrystals, which relates regular periodic ordering (arrangements of points along regular lattices) in a higher dimension, to aperiodic arrangements when projected down to a lower dimen-

sion. Painting is always a projection from a higher-dimensional world onto a two-dimensional surface. Contemporary artists such as Matjuska Teja Krasek have realized that, in mathematics, many interesting phenomena can happen in this process of projection, including the creation of aperiodic tilings. This is only alluded in the painting, as the Penrose tiling itself is not explicitly shown, and one only sees a depiction of how the tiles are obtained by projection of a regular structure in a higher dimension.

3.4.6 Surfaces and Orientability

Another class of topological spaces are the two-dimensional surfaces. These have an interesting property: there is a single, very simple topological invariant that classifies them. This is in stark contrast to the case of knots and links, where a complete classification is an extremely difficult problem, and invariants typically only capture some aspects of the topology (different invariants distinguish topologically inequivalent knots but knots with the same invariants in general need not be equivalent). The invariant that distinguishes surfaces is the *Euler characteristic*. It can be computed by choosing a triangulation of the surface and then counting faces, edges, and vertices according to the formula

$$\chi = \#Faces - \#Edges + \#Vertices.$$

The interesting fact is that this is indeed a topological invariant, which in particular means that it does not depend on the specific choice of a triangulation, but only on the topological properties of the underlying surface. Surfaces include the sphere and the real projective plane, as well as the Klein bottle and surfaces of genus 1 (torus) and higher. The Klein bottle and a surface of genus 4 are shown in figure 3.24. As in the case of the real projective plane, the Klein bottle, when pictured in a three-dimensional space, shows apparent self-intersections.

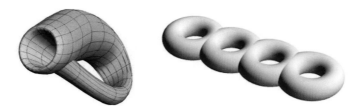

Figure 3.24
Klein bottle and genus 4 surface (drawn by `Mathematica`).

Some examples of computation of the Euler characteristic are given in the following list.

- Sphere: $\chi = 2$, orientable
- Real projective plane: $\chi = 1$, nonorientable
- Klein bottle: $\chi = 0$, nonorientable
- Torus: $\chi = 0$, orientable
- Genus g surface: $\chi = 2 - 2g$, orientable

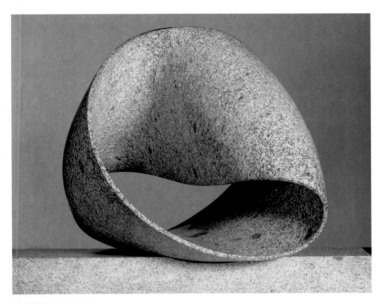

Figure 3.25
Max Bill, *Endless Ribbon*, 1953.

Notice that we have two cases in the list, the torus and the Klein bottle, that have the same Euler characteristic $\chi = 0$. These two surfaces, however, are not topologically equivalent, because one of them (the torus) is *orientable* while the other (the Klein bottle) is nonorientable. For a two-dimensional surface, orientability is the property of having an inner and an outer face that are distinct: if you are walking on the hollow inside of a sphere, you can't find yourself on the outside without cutting a hole through the surface of the sphere, while if one walks around a Möbius band (as depicted in Max Bill's sculpture in figure 3.25) or a Klein bottle, one can reach every point of its surface without ever having to cut through it, which is the tell-tale sign of nonorientability.

Thus, a complete topological classification of two-dimensional surfaces is obtained by first checking their orientability and subdividing them into two big classes: the orientable and the nonorientable ones, and then, within each class, separating out the various possible cases by computing the Euler characteristic.

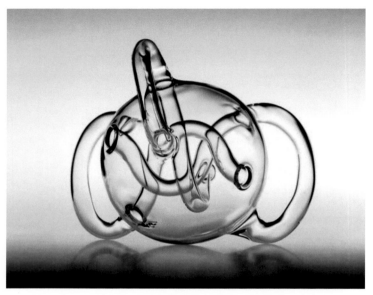

Figure 3.26
Alan Bennett, *Single Surface*, 1995.

In the case of orientable surfaces without a boundary, the Euler characteristic is equal to $\chi = 2 - 2g$, where the *genus g* is the number of handles attached to a sphere to obtain the surface, as in figure 3.26, which depicts a genus 3 surface. In the nonorientable case, the Euler characteristic is equal to $\chi = 2 - h$, where the nonorientable genus h counts handles and cross-caps attached to a sphere to obtain the surface. A cross-cap is the surface obtained by zipping a Möbius band to a disc. A sphere with a cross-cap attached to it is a real projective plane, and a sphere with two cross-caps attached is a Klein bottle. Cases of more complicated (nonorientable) surfaces with higher (nonorientable) genus are represented in Alan Bennett's glass sculptures in figures 3.26 and 3.27.

3.5 Smooth Spaces

A smooth manifold is a topological space that is locally indistinguishable from a vector space. For example, the surface of the Earth is topologically a sphere,

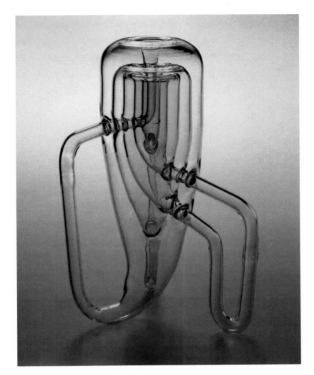

Figure 3.27
Alan Bennett, *Klein Bottle*, 1995.

but to a person standing at ground level it appears indistinguishable from a flat plane. This approximating linear spaces are called the *tangent spaces*: at each point on a smooth space there is a best linear approximation to the shape of the surrounding space, which is the tangent space. When moving the observation point around the smooth space, all these tangent spaces fit together consistently in a larger structure, called the *tangent bundle*.

On a smooth space, one can give local coordinates to specify the location of points. In many examples, a smooth space arises as a set of constraints on the possible motion of a physical system: local coordinates are, then, the number of independent parameters describing the physical system. The dimension of a smooth space is the dimension of its tangent space as a linear space, that is, the number of independent directions in this space.

Smooth spaces illustrate another important dichotomy in mathematics: that between *local* and *global* properties. These spaces are locally indistinguishable from a vector space, but globally they are not equivalent to vector spaces

because they can be inequivalent as topological spaces. The examples of the two-dimensional surfaces discussed earlier can be revisited in this light: all the two-dimensional surfaces we have encountered (spheres, tori, Klein bottles, higher-genus surfaces, real projective spaces) are also smooth spaces, but none of them is globally topologically equivalent to a vector space, although all of them are locally so.

A very interesting manifestation of this difference between the local and the global behavior is the problem of cosmic topology, which we will consider more in depth in chapter 9. What is the topology of cosmic space (the three-dimensional spatial sections of four-dimensional spacetime)? Space can be flat locally, yet globally given by a three-dimensional (flat) torus, or positively curved and globally given by one of several possibilities: a three-dimensional sphere, a Poincaré dodecahedral space (obtained by gluing together opposite faces of a solid dodecahedron), an octahedral space, and so forth. It can be negatively curved and be one of a large class of topologically inequivalent three-dimensional hyperbolic manifolds. General relativity only gives information on the local structure of spacetime, not on its global topology, hence possible signatures of different topologies are sought by cosmologists in the structures of the anisotropies of the Cosmic Microwave Background (CMB), which is the echo of radiation emitted by the Big Bang, and the largest-scale structure that we can observe in the universe.

While all smooth spaces are also topological spaces, the converse is not always true. The two-dimensional surfaces discussed earlier are a class of topological spaces all of which admit a smooth structure, but if one considers higher-dimensional analogs, in the form of the four-dimensional topological manifolds, two important new phenomena occur, which make dimension four extremely interesting and complex. Not all four-dimensional topological manifolds admit a smooth structure: some are so "rugged" that they cannot be smoothable at all. It is still possible to make sense of the notion of dimension, but the local coordinates that would make the manifold look like a vector space cannot be smoothed out. Moreover, even by looking only at those topological four-manifolds that admit smooth structures, one finds the surprising fact that there can be many (even infinitely many) different smooth structures on the same manifold that are not equivalent. This phenomenon is known as "exotic smoothness." For example, four-dimensional flat space \mathbb{R}^4 has infinitely many different smooth structures (a result of Donaldson). These can be distinguished into two classes: "small" exotic \mathbb{R}^4s that are contained inside an ordinary flat space, and "large" exotic \mathbb{R}^4s that do not fit inside ordinary space. Constructions of exotic smooth structures can be obtained with the "Casson

Figure 3.28
Torsten Asselmeyer-Maluga and Jerzy Król, *Stages of a Casson Handle*, 2018.

handles" method, an iterative attachment of four-dimensional two-handles, as in figure 3.28, that gives rise to a configuration that is topologically equivalent to a topological two-handle, that is, the product of a two-dimensional disc and a plane (Freedman) but not smoothly equivalent (Donaldson).

Some physicists, such as Asselmeyer-Maluga (see the references at the end of this chapter), hypothesize that exotic smoothness may affect our understanding of the distant universe by affecting gravitational lensing, the way massive bodies bend light according to general relativity. The presence of regions of exotic smoothness (like a small exotic \mathbb{R}^4) may simulate the presence of matter in the way the path of light is bent, so light passing through the region containing the small exotic \mathbb{R}^4 may bend even without the presence of any matter, inducing possible errors in the estimates of the matter content of the universe.

In dimension three, the Poincaré conjecture (solved by Perelman) states that there is only one type of three-dimensional sphere. In dimension four, the smooth Poincaré conjecture is unsolved. In higher dimensions, a result by Milnor showed that there are inequivalent smooth structures on the seven-dimensional sphere S^7 (see figure 3.29).

How can one detect exotic smoothness? It cannot be done using topological invariants such as the Euler characteristics, as we are dealing with smoothly inequivalent spaces with the same underlying topological space. It turns out that

Figure 3.29
Niles Johnson, *A Slice of S^7*, 2012.

a very effective way of distinguishing between smoothly inequivalent four-manifolds is by looking at the behavior of particle physics on these four-dimensional spacetimes. This discovery (due to Donaldson) marked one of the most interesting interactions between mathematics and theoretical physics of the past century. Exotic smoothness is detected by counting solutions of the equations of motion of elementary particle physics. This gives invariants, such as the Donaldson invariants (1980s), based on electroweak forces, or the Seiberg–Witten invariants (1990s), based on string theory.

This deep relation between exotic smoothness and particle physics is a theme in the painting *Collisions II* by Dawn Meson, (see figure 3.30), where particle interactions are depicted in the background of the complicated folds of a smooth space, in a way that suggests that the motion of particles is closely tied up with the shape of the smooth space.

3.6 Metric Spaces

Metric spaces are topological spaces where it is possible to quantitatively measure the distance between points. In other words, it is not only possible to have a notion of nearness specified by the open sets of the topology but also a way to determine precise distances.

For example, given a set of points in the plane (centers), one can subdivide the plane into regions consisting of those points that are closer to one of the

Figure 3.30
Dawn Meson, *Collisions II*, ca. 2000.

centers. These are called Voronoi cells. An example of Voronoi tessellation is given by the map that shows weather stations around the world and the regions they cover, shown in figure 3.31.

A metric space is a set X with a distance function (or metric) $d : X \times X \rightarrow \mathbb{R}_+$, which assigns to a pair of points in X a nonnegative real number, in such a way that

- $d(x, y) \geq 0$ for all x, y in X and $d(x, y) = 0$ if and only if $x = y$ (the distance between two points is zero means that the two points coincide).
- $d(x, y) = d(y, x)$ for all x, y in X (the distance measured by going from x to y is the same as the distance measured by going from y to x).
- $d(x, y) \leq d(x, z) + d(z, y)$, for all $x, y, z \in X$ (triangle inequality: going from x to z and then from z to y covers at least as much distance as just going from x to y).

Figure 3.31
Will Hohyon Ryu, *Voronoi Map of World Weather Stations*, 2011.

The last condition, the triangle inequality, is intuitively reasonable, given our notion of how distances should work: we think of the distance between two points as measuring the length of the shortest path connecting them, hence adding a destination in between is likely to make the path longer than the shortest possible choice. However, there are important generalizations in mathematics, such as "ultrametric spaces" where the triangle inequality is replaced by other, less intuitive, rules. Metric space, with the definition given previously, are all topological spaces. However, not all topological spaces can be endowed with a metric.

Figure 3.32
The unit ball in the ℓ_2 and ℓ_4 metric (drawn by `Maple`).

Given a metric space (X, d), the unit ball $B(x, d)$ in the metric d around a point x in X consists of all points of X that have distance at most 1 from x,

$$B(x, d) = \{y \in X : d(x, y) \leq 1\}.$$

An interesting example of metric space is a fountain located of Sergel's Square in Stockholm, which was designed by the mathematician and artist Piet Hein. It is shaped like the unit ball in the metric

$$d((u_1, v_1), (u_2, v_2)) = ((u_1 - u_2)^4 + (v_1 - v_2)^4)^{1/4}.$$

The usual Euclidean metric in the plane would be

$$d((u_1, v_1), (u_2, v_2)) = ((u_1 - u_2)^2 + (v_1 - v_2)^2)^{1/2}$$

and the unit ball in this metric would simply be a round disc, as shown in figure 3.32. The metric used by Piet Hein, which is one case in a larger family of metrics,

$$d_p((u_1, v_1), (u_2, v_2)) = ((u_1 - u_2)^p + (v_1 - v_2)^p)^{1/p},$$

replaces the exponent $p = 2$ of the Euclidean metric with the exponent $p = 4$. This has the effect of turning the round shape of the disc into a more distorted shape that is still smooth but at the same time "resembles" a square, as one can see in figure 3.32. The larger the exponent p becomes, the more the unit ball looks like a square.

3.6.1 General Relativity

Smooth spaces can always support the structure of a metric space, where the distance function itself varies smoothly: the resulting spaces are called Riemannian manifolds. The most prominent application of Riemannian geometry is general relativity, where four-dimensional curved spacetimes are smooth spaces with a metric. The metric is the gravitational field, and gravity affects geometry by bending spacetime and introducing curvature. Light moves along the shortest paths (geodesics) in curved spacetime, hence its motion is affected by gravity.

The notion of metric space, in the physically relevant case of spacetime, needs to be modified by allowing negative values: these are called Lorentzian rather than Riemannian manifolds, but the general mathematical formalism underlying both cases is very similar. The reason for this modification, allowing for the "indefinite signature" Lorentzian metrics, lies in the fact that in relativity there is a distinction between space-like vectors (positive metric directions), light-like vectors (null-directions: the light cone), and time-like vectors (neg-

Figure 3.33
Kjell André, *Light Cones in Minkowski Space*, 2004.

ative metric directions), as shown in figure 3.33. This structure is necessary
to correctly account for causality in spacetime: the causal future of a point in
spacetime consists of all points contained in its light cone.

An interesting attempt by an artist to depict the bending and warping of
spacetime by gravity in general relativity can be seen in the warped room in-
stallation by Peter Kogler (see figure 3.34), where the viewer walks through
a space where the curved geodesics of light moving in a strong gravitational
background have been depicted, showing the variable curvature of space.

3.7 What Kind of Space Is Space?

The problem of cosmic topology is a question about the topology of the space-
like sections of four-dimensional spacetime, under assumptions of homogene-
ity and isotropy of spacetime at large scales (a standard cosmological hypothe-
sis). I introduce it here briefly and will discuss it more extensively in chapter 9.

General relativity, as discussed previously, determines the metric on space-
time. In particular, this determines the curvature. In a homogeneous isotropic
case, a three-dimensional positively curved space will look locally like a three-
dimensional sphere, a flat three-dimensional space will look locally like a
three-dimensional torus, and a negatively curved three-dimensional space will

Figure 3.34
Peter Kogler, *Untitled*, 2011.

look locally like another homogeneous and isotropic model case, given by the three-dimensional hyperbolic space. Cosmological observations of the recent years have shown that the possibility of a negatively curved space is not favored by the data. This is, in a sense, surprising, because hyperbolic three-manifolds are the "typical" case from the mathematical viewpoint, while the spherical and flat cases are rare. The measurements of the Cosmic Microwave Background (CMB) radiation are consistent with either a nearly flat geometry (seen as confirmation of the theory of cosmic inflation) or one that is very slightly positively curved.

This would result in a three-dimensional manifold that locally resembles a three-dimensional sphere or a three-dimensional torus. There is a complete catalog of all these possibilities, which are compatible with maintaining homogeneity and isotropy. A candidate that has been regarded by theoretical cosmology as very promising is the Poincaré *dodecahedral universe*: a three-dimensional manifold obtained by gluing together opposite faces of a solid dodecahedron. Simulation of the CMB sky in a dodecahedral topology have been analyzed by cosmologists: they would exhibit patterns of regions of the CMB sky that match according to the gluing rules of the opposite faces of the dodecahedron.

A similarly obtained octahedral space is considered among the possible candidates for a cosmic topology. A sculpture inspired by the idea of a cosmos shaped according to the octahedral topology was included in the *Theory of the Universes* series of Attilio Pierelli (see figure 3.35).

Figure 3.35
Attilio Pierelli, *Theory of the Universes: Octahedral Universe*, 1979.

3.8 Singular Spaces

Algebraic varieties are spaces defined by the set of solutions to polynomial equations, such as

$$yx(x^2 + y - z) = 0.$$

If the polynomial is homogeneous (all terms have the same degree) then the set of solutions can be seen as a subspace of a projective space. Thus, algebraic varieties can be viewed as a far-reaching generalization of projective geometry. In general algebraic varieties are not smooth: they can have various kinds of singularities, which are a crucial and very interesting aspect of the geometry.

The use of shapes defined by algebraic equations occurs in the work of several contemporary artists. For example, several of the sculptures–installations by Kazuko Miyamoto are based on shapes of algebraic varieties. This particular type of algebraic varieties, as in the *Black Poppy* installation shown in figure 3.36, have a special kind of structure, called a ruling, which means that the surface can be covered with a family of lines. Indeed the installation is constructed using this property: the viewer sees clearly the shape of the variety even through what is physically present in the sculpture is only some of the lines of the ruling. The resulting variety is curved, although each line of the ruling is straight: it is the varying relative position of the lines in the family that determines the resulting curved shape of the variety.

Figure 3.36
Kazuko Miyamoto, *Black Poppy*, 1978.

3.9 Measure Spaces and Fractals

A measure space is a kind of geometry where it is possible to assign a size to regions of space: areas, volumes, lengths. Measure spaces are also related to the possibility of measuring probabilities of events (which are identified with the size of certain regions in the space describing possible events). The theory of observables in quantum mechanics is also covered by the setting of measure spaces, through a quantum generalization of the classical measure spaces called *von Neumann algebras*. The theory of measure spaces also makes it possible to define the size of objects that extend "in between" a one-dimensional length and a two-dimensional area, or between a two-dimensional area and a

three-dimensional volume. Such objects are called *fractals*. The Cantor set depicted here below is a prototypical example of a fractal object.

3.9.1 Fractal Geometry

The study of fractal geometry was introduced and largely developed by Mandelbrot in the 1980s. In the case of fractals, the notion of dimension, which I have so far described in terms of the number of independent directions at a point in space, acquires a more interesting property. Most fractals are obtained through some iterative procedure that constructs the fractal space using a recursive structure based on the fundamental property of self-similarity, namely, the fact that fractal spaces look locally like scaled copies of themselves. Ordinary spaces also have a similar, but less evident structure, which manifests itself in the fact that, for example, when a planar figure is dilated by a factor λ, its area correspondingly changes by a factor of λ^2. In three dimensions, the volume of a scaled region of space changes by a factor of λ^3, while on a one-dimensional line lengths just change by a factor λ. This corresponds to the fact that a cube is covered by eight subcubes of half the side, a square by four subsquares of half the side, and a line segment by two subsegments of half the size. The dimension is manifesting itself in the exponent of these scaling factors. In a fractal X that is obtained by putting together scaled copies of the same figure, with scaling factors $\lambda_1, \ldots, \lambda_n$, the dimension is the exponent s that satisfies the self-similarity equation

$$\sum_{i=1}^{n} \lambda_i^s = 1$$

The solution $s = \dim_H(X)$, which is the Hausdorff dimension (or fractal dimension) of X, is, in general, not an integer, but rather a real number. For example, in the case of the Sierpinski gasket,

the figure is equal to a union of three copies of itself scaled down by a factor of two, so the dimension satisfies $3 \cdot 2^{-s} = 1$, which gives dimension $\dim_H(X) = \frac{\log 3}{\log 2} \sim 1.585$. This is an example of a space that is more than one-dimensional but less than two-dimensional. Correspondingly, the measure, which is the size of a space of Hausdorff dimension s, scales like λ^s when the space is dilated by a factor of λ.

Figure 3.37
Fractal art generated with Scott Draves's `ElectricSheep`, 2017.

The self-similar structure of fractals and the recursive procedure used to generate fractal spaces are especially suitable for computer generation. Indeed, it is not a coincidence that the mathematical theory of fractal geometry flourished in the era of computers, unlike the theory of smooth spaces that was developed almost a century earlier. The possibility of generating fractal shapes by computer, together with the intrinsic beauty of many self-similar structures, have made fractal geometry very attractive to artists. There are currently some very interesting distributed computing projects aimed at animating and evolving fractal geometries for the use of artists, for example, `Electric Sheep` (see figure 3.37). The hypnotic and intricate nature of self-similarity has drawn close connections between fractal art and the psychedelic movement.

3.9.2 Measure Spaces

More precisely, the notion of a measure space can be formalized in a way that is apparently quite similar to the formal definition of a topological space discussed earlier in this chapter, although with some major differences. First, one needs to define a suitable class of measurable subsets of a space X. There is an important point here: not all possible subsets of a measure space are measurable, that is, not all subsets admit a notion of area/volume/length and so forth. This is not just the obvious fact that, say, a line can have some length but zero area, or a two-dimensional region can have some finite area but infinite one-dimensional length. In such cases, the notion of measure itself is defined, but the value happens to be either zero or infinity, which are among the allowed possible values for a measure, as I will show next. The problem here is more drastic: there are usually certain subsets of a measure space for which the very concept of measure does not make sense. In other words, they cannot be measured at all, and they do not have a size of any kind. The existence of nonmeasurable sets is a complicated issue: on the real line with the usual measure of length, for example, nonmeasurable sets exist, provided one accepts a certain strong assumption in mathematical logic (the axiom of choice). As I will discuss below, the existence of nonmeasurable sets leads to some seemingly paradoxical consequences.

The way one specifies a class of measurable sets is similar to the way one specifies the class of open sets in a topology. A class of measurable sets is called a *sigma algebra*. This consists of a collection \mathcal{V} of subsets V of X with the following properties:

- The empty set \emptyset and the whole space X itself belong to the collection \mathcal{V};
- If a set V belongs to \mathcal{V} then its complement $V^c = X \smallsetminus V$ also belongs to \mathcal{V};
- Countable unions and countable intersections $\bigcup_{n=1}^{\infty} V_n$ and $\bigcap_{n=1}^{\infty} V_n$ of sets V_n in \mathcal{V} also belong to \mathcal{V}.

While apparently similar to the definition of a topology, there are two important differences. The first is the operation of taking the complement of a set. In the case of a topology, the complement of an open set is, in general, not an open set, but in the case of a measure space, if one can assign a measure to a set, then one should also be able to assign a measure to its complement. This property reflects the fact that one expects measures to be additive: namely, the measure of a set and that of its complement should add up to the measure of the whole space. This is compatible with our intuition of how lengths, areas, and volumes behave. The second main difference between this definition of measurable sets and the definition of a topology is the fact that now the role

of union and intersections is symmetric. This is necessarily the case, since passing to complements of sets interchanges these operations. Moreover, instead of allowing arbitrary unions and finite intersections, as in the case of a topology, we only allow unions that are countable (which means either finite or countably infinite), and we correspondingly extend the case of intersections from finite to countable.

After having specified the class of sets to which a notion of measure can be assigned, one needs to specify the actual measure. This is given by a function μ from the collection \mathcal{V} of measurable sets to the set of nonnegative real numbers and infinity, $\mathbb{R}_+ \cup \{+\infty\}$, such that the empty set has a measure of zero, $\mu(\emptyset) = 0$, and

- Given a countable collection V_n of measurable sets that are pairwise disjoint, the measure is additive

$$\mu\left(\bigcup_{n=1}^{\infty} V_n\right) = \sum_{n=1}^{\infty} \mu(V_n).$$

3.9.3 Transformations of Measure Spaces

Despite an apparent similarity between the definitions of topological and of measure spaces, one can see that the way these two types of spaces transform is profoundly different. For topological spaces, the notion of a topological equivalence consists of a deformation of a topological space where points that are originally near each other (as measured by open sets in the topology) remain near each other at the end of the transformation. This means deforming spaces without ever tearing them apart. Such transformations can stretch and bend the shape of space arbitrarily and are not expected to preserve lengths, areas, or volumes. On the contrary, an equivalence of measure spaces is a transformation that preserves the measure of subspaces. The transformation can cut and tear apart pieces of the whole space and move them far away from each other, as long as the total area of the pieces is preserved. The prototypical example of such a measure preserving transformation is the rearrangement of pieces in a sliding puzzle. Examples of such transformations are provided by equidecomposable figures: pairs of polygonals and polyhedral shapes that are obtained from one another by cutting into a set of pieces and rearranging them in a different order by transformations given by rigid motions that preserve the area or volume of all the pieces (see figure 3.38).

The existence of nonmeasurable sets has seemingly paradoxical consequences in terms of equidecomposable figures. The Banach-Tarski paradox shows that it is possible to cut a three-dimensional ball of a given volume into finitely many pieces and reassemble them using only rotations and translations (which

Figure 3.38
Attilio Marcolli, *Deconstruction of Red*, 1986.

are volume-preserving transformations) to form another three-dimensional ball
with a volume twice as large. Of course, this would not make sense if all pieces
were measurable, and in physical terms it would violate conservation of mass
and energy (but physics really applies only to measurable sets). However, if
the decomposition can take place along nonmeasurable sets, the whole notion
of measure ceases to make sense on these pieces and so conservation laws
no longer apply. The existence of such paradoxical decompositions really de-
pends on the properties of rigid motions in a three-dimensional space and, in
a more subtle way, on the *axiom of choice* in logic, which states the possibil-
ity of performing an infinite set of choices of one element out of each set in
an infinite collection of possibly infinite sets. This axiom is invoked in the
construction of the paradoxical sets in the Banach-Tarski decomposition of the
ball, in selecting a union of orbits under the action of a subgroup of rigid mo-
tions of the sphere. The existence of phenomena such as the Banach-Tarski
paradox shows that the notion of measure is more subtle and less intuitively
clear than it seems at first.

Figure 3.39
Penrose tiling.

3.10 Aperiodic Order

Quasiperiodic tilings have a long history in art: they were used in *zellij* and *muqarnas* decorations in traditional Islamic architecture. Physical systems arranged according to aperiodic tilings, called quasicrystals, were only discovered in 1982, by Dan Schechtman. However, the modern mathematical theory of aperiodic tilings was developed earlier, in the 1960s and 1970s, by Hao Wang and Roger Penrose. A class of aperiodic tilings of the plane constructed using two tiles with specific gluing conditions were introduced by Penrose and are known as the Penrose tilings (see figure 3.39).

3.10.1 Noncommutative Spaces

A new notion of space in mathematics was developed in recent years with the aim of incorporating quantum mechanical uncertainty relations into geometry. The concept of a *noncommutative space*, developed by Connes in the 1980s, describes a space where the local coordinates satisfy a quantum mechanical Heisenberg uncertainty principle. The latter states that positions and velocities cannot be simultaneously measured, with the resulting measurement error of a size controlled by the value of the Planck constant \hbar:

$$\Delta x \cdot \Delta v \geq \hbar.$$

An equivalent mathematical way to state the Heisenberg uncertainty principle is the fact that positions and velocities, in quantum mechanics, are variables that do not commute: the value of their product depends on the order in which the product is taken, so $x \cdot v \neq v \cdot x$. There are many examples of spaces that satisfy this type of quantum mechanical uncertainty principle in their local coordinates. Such examples arise from geometry, dynamical systems, and number theory. Other examples of noncommutative spaces arise in models of particle physics and in condensed matter physics, in describing quantum Hall systems, and more recently, topological insulators. Many examples of noncommutative spaces arise from equivalence relations: these are recipes on how to glue together points in a topological, smooth, metric, or measure spaces. The result of such gluing procedure is often best interpreted as a noncommutative space. An interesting example of this kind arises in the mathematical modeling of quasicrystals and aperiodic tilings of the plane.

Figure 3.40
Matjuska Teja Krasek, *Quasicube*, 2005.

Consider the set of all possible Penrose tilings of the plane, identifying those that can be obtained from one another by rigid motions of the plane. The

resulting space is exactly one of those spaces obtained by identifications that are best described as noncommutative spaces. A detailed description of the quantum nature of the space of Penrose tilings is outside the scope of this book, but the quasicrystal shapes themselves are very interesting objects to discuss in relation to their occurrence in contemporary art.

3.10.2 Aperiodic Tilings in Contemporary Art

While the use of aperiodic tilings in ancient Islamic art is well documented, there does not seem to be any known occurrence of quasiperiodic tilings in art until the recent times, after the modern mathematical development of the theory of Penrose tilings and the discovery of physical quasicrystals. Afterwards, quasicrystals and Penrose tilings again started to be used in art and in architecture. They occur in the paintings of Matjuska Teja Krasek (see figure 3.40), one of whose quasicrystal-related works (figure 3.23) I have already analyzed. As architectural motifs, they occur in the work of Tony Robbin, who also used them as patterns in paintings (figure 3.41).

Figure 3.41
Tony Robbin, *Pattern 1999–4*, 1999.

These paintings capture some important properties of the aperiodic tilings. One of them, as mentioned in relation to Matjuska Teja Krasek's *Double Star*

in figure 3.23, is the fact that, while aperiodic tilings appear to be a very different geometric object from ordinary periodic tessellations, many constructions of aperiodic tilings are obtained by starting with a periodic lattice inside a higher dimensional space and projecting it onto a lower dimensional space at an irrational angle, so that the resulting pattern in the lower-dimensional space loses the regularity of the periodic tiling, but retains just enough regularity to account for the interesting symmetries of quasiperiodic structures. The paintings of Matjuska Teja Krasek and Tony Robbin reproduced here aim at emphasizing the presence of symmetry (especially fivefold symmetry) in planar quasiperiodic patterns (see the Matjuska Teja Krasek painting of figure 3.40), as well as the relation between the two-dimensional tiles of the quasiperiodic tiling and regular tiles in a higher-dimensional space, hinted to in the Robbin painting of figure 3.41 and in the Matjuska Teja Krasek painting of figure 3.23. For a more in-depth discussion of Tony Robbin's *Pattern*, we invite the reader to consult the Robbin's own work "4D and I" (see the bibliography in Appendix A.1 at the end of this chapter).

3.11 Why Do We Need So Many Notions of Space?

This chapter has presented an overview of several very different notions of space in mathematics. It is natural to wonder whether one really needs to maintain a whole array of different notions of space rather than unifying them into some kind of single, more manageable notion. In fact, the point is really that all these different notions are needed for different purposes, and what is often important is the interplay between all these different levels of structure. Topological spaces can be smooth in different ways or not at all (the exotic smoothness phenomenon). Topological spaces acquire a new notion of dimension when seen as measure spaces (as in the case of fractals). Riemannian manifolds (such as spacetimes in general relativity) can be locally isometric but globally different due to topology (the cosmic topology problem). Different physics takes place on different spaces, as in the case of the solutions of the equations of motion of particle physics models (Yang-Mills theory) on different smooth four-manifolds, which give rise to invariants of the smooth structure, capable of detecting exotic smoothness. All these are examples of properties specific of a particular notion of space and depending on the interaction of different structures (topological and smooth; smooth and metric; topological and measurable, etc.) on the same space.

Contemporary art, especially abstract art, is also an exploration of the concept of space, hence it is not surprising that the different mathematical notions of space have found echoes and often even direct references in the work of

contemporary artists, One hopes that deeper phenomena such as the ones mentioned here that involve the interplay between different notions of space will also similarly draw attention from contemporary artists and enter the artistic language.

Chapter Appendix: Bibliographical Guide

A.1 Guide to the Art and Artists

About the relation between Renaissance perspective drawing and the development of projective geometry in mathematics, the following references are a useful resource.

- Charles Bouleau, *The Painter's Secret Geometry: A Study of Composition in Art*, Allegro, 2014.
- Alessandro Marchi and Maria Rosaria Valazzi, *La Città Ideale: L'Utopia del Rinascimento a Urbino tra Piero della Francesca e Raffaello*, Electa, 2012.
- Daniel Pedoe, *Geometry and the Visual Arts*, Dover, 1983.

Here the reader will find here more detailed information about some of the artists whose work is presented in this chapter.

- Paul Klee, *Das bildnerische Denken*, Schwabe Basel, 2013.
- Pierre Boulez, *Le Pays Fertile: Paul Klee*, Gallimard, 1989.
- Christianna Bonin and Erica DiBenedetto, *Sol LeWitt: The Well Tempered Grid*, Williams College Museum of Art, 2013.
- Gary Garrels, *Sol LeWitt: A Retrospective*, San Francisco Museum of Modern Art, Yale University Press, 2000.
- Rebecca Norton, *Hot Mess: Breaking the Skin*, Black Sun Lit, 2014 (online).
- Jeremy Gilbert-Rolfe, *Beauty and the Contemporary Sublime*, Skyhorse Publishing, 1999.
- Jeremy Gilbert-Rolfe and Rebecca Norton, *Chaos, Complexity and Double Vision*, Abstract Critical, 2014 (online).
- Jean-Max Albert, *L'espace de profil*, Editions de la Villette, 1993.
- Linda Besemer, "Abstraction: Politics and Possibilities," *X·TRA Contemporary Art Quarterly*, 2005 (online).
- Sara Willett, *City Kaleidoscope*, Being 3 Gallery, Beijing, 2016.
- Sara Willett, *Kunstforment der Poundland*, Deptford X, London, 2012.
- Dennis Kardon, "Quantum Fields and Cellular Processes: Sarah Walker at Pierogi," *ArtCritical*, 2013 (online).
- Kenneth Baker, "Walker Uses Abstraction to Characterize Complex Reality," *San Francisco Chronicle*, 2008 (online).
- Carme Ruiz, "Salvador Dalí and Science. Beyond a Mere Curiosity," Dalí Foundation, 2010 (online).

- Gillo Dorfles, *Jeu et rigueur dans l'avant-garde Italienne*, L'Oeil, 1966.
- Gillo Dorfles, *Ultime Tendenze nell'Arte d'Oggi dall'Informale al Concettuale*, Feltrinelli, 1976.
- Marcel Joray, *Attilio Pierelli: The Sculpture of the Twentieth Century*, Editions du Griffon, 1983.
- Peter Weibel and Nadja Rottner, *Gego 1957–1988: Thinking the Line*, Hatje Cantz, 2006.
- María Elena Huizi and Josefina Manrique Cabrera, *Sabiduras and Other Texts: Writings by Gego*, Houston International Center for the Arts of the Americas, 2005.
- Mari Carmen Ramírez and Héctor Olea, *Inverted Utopias: Avant-Garde Art in Latin America*, Yale University Press, 2004.
- Marcus Sendlinger, *Lost Reality*, Kerber Verlag, 2010.
- Hajime Kinoko, *Red*, Myway Publishing, 2015.
- Matjuska Teja Krasek, "Homage to Escher" (ed. Michele Emmer) *Leonardo* 33, no. 1 (2000).
- Valentina Anker, *Max Bill ou la recherche d'un Art Logique*, L'Age D'Homme, 1979.
- Raven Hanna, "Dawn Meson: Orders of Magnitude," *Symmetry Magazine*, 2005 (online).
- Eva Maria Stadler, *Peter Kogler*, Galerie Mezzanin, Wien, 2007.
- Walter Seidl, *Peter Kogler—Kunst für ein neues Zeitalter*, Folder, Wien, 2007.
- Tatiana De Pahlen, *Kazuko Miyamoto Circuit, Lausanne*, Flash Art, 2015 (online).
- Biezunska, Wiktoria, *Abstrakcje Kazuko Miyamoto*, Art & Business Warsaw, 2014.
- Attilio Marcolli, *Per un'architettura anatopica*, Centro Di, 1987.
- Attilio Marcolli and Annarosa Cotta, *Teoria del Campo*, Sansoni, 1971.
- Tony Robbin, *Shadows of Reality: The Fourth Dimension in Relativity, Cubism, and Modern Thought*, Yale University Press, 2006.
- Tony Robbin, "4D and I," 2011 (online)
- Linda Dalrymple Henderson et al., *Tony Robbin: A Retrospective: Paintings and Drawings 1970–2010*, Hudson Hills, 2011.

A.2 Guide to Space and Symmetry in Mathematics

The role of symmetries in determining the structure of space has been mentioned briefly in this chapter. It is a very important topic in modern mathematics and is worth a much more detailed discussion. In addition to the role of Felix Klein's Erlangen program in shaping the idea that spaces should be studied through their transformations, Emmy Noether's theorem on symmetries and conservation laws related the study of geometry through symmetry to the crucial role that symmetry play in modern physics: the existence of conservation laws associated with symmetries is crucial to the entire edifice of our understanding of particle physics today. Some references covering some of these

topics are given here, starting with Hermann Weyl's 1952 essay, and listed in increasing order of mathematical sophistication.

- Hermann Weyl, *Symmetry*, Princeton University Press, 2015.
- Leon M. Lederman and Christopher T. Hill, *Symmetry and the Beautiful Universe*, Prometheus Books, 2011.
- Francesca Biagioli, *Space, Number, and Geometry from Helmholtz to Cassirer*, Springer Verlag, 2016.
- I. M. Yaglom, *Felix Klein and Sophus Lie: Evolution of the Idea of Symmetry in the Nineteenth Century*, Birkhäuser, 1990.
- Dwight E. Neuenschwander, *Emmy Noether's Wonderful Theorem*, Johns Hopkins University Press, 2017.
- Lizhen Ji and Athanase Papadopoulos, *Sophus Lie and Felix Klein: The Erlangen Program and Its Impact in Mathematics and Physics*, European Mathematical Society, 2015.

A.3 Guide to Linear Spaces

A discussion of linear algebra, the mathematics of vector spaces, and its geometric interpretation, as well as applications ranging from quantum mechanics to differential equations, can be found in these general references.

- Alexei I. Kostrikin and Yuri I. Manin, *Linear Algebra and Geometry*, Gordon and Breach Science Publishers, 1997.
- Alexander Givental, *Linear Algebra and Differential Equations*, American Mathematical Society, 2001.

A.4 Guide to Projective Geometry

A general overview of projective spaces and projective geometry, in relation to the geometry of perspective drawing and recent applications to computer graphics can be found in the following references.

- C. R. Wylie, Jr., *Introduction to Projective Geometry*, McGraw-Hill, 1970.
- M. Penna and R. Patterson, *Projective Geometry and Its Applications to Computer Graphics*, Prentice Hall, 1986.
- Jürgen Richter-Gebert, *Perspectives on Projective Geometry: A Guided Tour through Real and Complex Geometry*, Springer Verlag, 2011.

A.5 Guide to Topology

Some general references about topology that the reader may wish to consult are given here. More specific references about the different classes of topological spaces (knots and links, graphs, surfaces, polyhedra, and more general piecewise linear spaces) follow.

- Anatolij T. Fomenko, *Visual Geometry and Topology*, Springer Verlag, 1994.

- George K. Francis, *A Topological Picturebook*, Springer Verlag, 2007.
- Stephen Huggett and David Jordan, *A Topological Aperitif*, Springer Verlag, 2009.

We have seen that knots and links form a very important class of topological spaces. Here I provide a few additional references on knot theory and its applications, ranging from the modeling of DNA and other molecules in biology to the physics of quantum gravity.

- Colin Conrad Adams, *The Knot Book: An Elementary Introduction to the Mathematical Theory of Knots*, American Mathematical Society, 2004.
- Andrew D. Bates and Anthony Maxwell, *DNA Topology*, Oxford University Press, 2005.
- Erica Flapan, *Knots, Molecules, and the Universe*, American Mathematical Society, 2015.
- Rodolfo Gambini and Jorge Pullin, *Loops, Knots, Gauge Theories and Quantum Gravity*, Cambridge University Press, 2000.
- Michael F. Atiyah, *The Geometry and Physics of Knots*, Cambridge University Press, 1990.

The next class of topological spaces discussed includes piecewise linear (PL) spaces and the geometry of triangulations. It is surprising that there are many topological manifolds (locally, like a Euclidean space) that do not admit a triangulation (and hence are not PL spaces). The first reference gives an overview of this result for the general public. Triangulations also play an important roles in models of quantum gravity, as well as in finite element methods for the numerical solution of equations using a discretization of space on a mesh (a triangulation). Recently triangulations and associated invariants (homology, Euler characteristic) have also played an important role in data analysis, through the method of "persistent topology." The following references provide an overview of some of these themes.

- Kevin Hartnett, "A proof that some spaced can't be cut," *Quanta Magazine*, 2015 (online).
- Jan Ambjorn, Mauro Carfora, and Annalisa Marzuoli, *The Geometry of Dynamical Triangulations*, Springer Verlag, 2009.
- Jesus De Loera, Joerg Rambau, and Francisco Santos, *Triangulations: Structures for Algorithms and Applications*, Springer Verlag, 2010.
- Valerio Pascucci, Xavier Tricoche, Hans Hagen, and Julien Tierny, *Topological Methods in Data Analysis and Visualization: Theory, Algorithms, and Applications*, Springer Verlag, 2010.
- Claes Johnson, *Numerical Solution of Partial Differential Equations by the Finite Element Method*, Dover, 2012.

Graphs and networks have been studied extensively both as abstract mathematical objects and for their many modeling applications, especially in the study of large networks, from the internet to the brain. Some references covering graph and network theory are listed here.

- Nora Hartsfield and Gerhard Ringel, *Pearls in Graph Theory: A Comprehensive Introduction*, Dover, 2013.
- Olaf Sporns, *Networks of the Brain*, MIT Press, 2010.
- Mark Newman, Albert-László Barabási, and Duncan J. Watts, *The Structure and Dynamics of Networks*, Princeton University Press, 2011.
- Ginestra Bianconi, *Multilayered Networks*, Oxford University Press, 2018.

Polyhedra (and higher dimensional polytopes) are a special case of PL spaces. Regular and semiregular polyhedra are especially singled out for their rich symmetries and have been a presence in art since ancient times. Here I list some references on various aspects of the geometry and symmetry of polyhedra and polytopes.

- Marjorie Senechal, *Shaping Space: Exploring Polyhedra in Nature, Art, and the Geometrical Imagination*, Springer Verlag, 2013.
- Rona Gurkewitz and Bennett Arnstein, *3D Geometric Origami: Modular Polyhedra*, Dover, 1995.
- L. Christine Kinsey and Teresa E. Moore, *Symmetry, Shape and Space: An Introduction to Mathematics through Geometry*, Springer, 2006.
- Peter R. Cromwell, *Polyhedra*, Cambridge University Press, 1999.
- H. S. M. Coxeter, *Regular Polytopes*, Dover, 2012.

Concerning the topology of surfaces and their classification, the reader can find here a reference for the general public that discusses the Euler characteristic, followed by more advanced references on the topology of surfaces and other spaces.

- David S. Richeson, *Euler's Gem: The Polyhedron Formula and the Birth of Topology*, Princeton University Press, 2008.
- L. Christine Kinsey, *Topology of Surfaces*, Springer Verlag, 2012.
- I. M. Singer and J. A. Thorpe, *Lecture Notes on Elementary Topology and Geometry*, Springer Verlag, 1967.

A.6 Guide to Smooth Geometry

In this chapter I mentioned that smooth geometry can differ significantly from topology, especially in the world of four-dimensional spaces (including spacetime). The subject of exotic smoothness in four-dimensions and invariants constructed from solutions of motion of particle physics, especially the Yang-Mills and Seiberg-Witten theories, is a very technically demanding subject. There does not seem to be, as of now, any good popular literature on the subject. However, there are many useful references at a more advanced level, which cover the construction and properties of smooth invariants and their relation to physical theories. I list some of them here.

- Torsten Asselmeyer-Maluga and Carl H. Brans, *Exotic Smoothness and Physics: Differential Topology and Spacetime Models*, World Scientific, 2007.
- Alexandru Scorpan, *The Wild World of 4-Manifolds*, American Mathematical Society, 2005.

- Charles Nash, *Differential Topology and Quantum Field Theory*, Academic Press, 1991.

- Michael F. Atiyah, *The Geometry of Yang-Mills Fields*, Scuola Normale Superiore, 1979.

- Matilde Marcolli, *Seiberg-Witten Gauge Theory*, Hindustan Book Agency, 1999.

- Daniel S. Freed and Karen K. Uhlenbeck, *Instantons and Four-Manifolds*, Springer Verlag, 2012.

A.7 Guide to Metric and Riemannian Geometry

I provide a few references on metric geometry, covering, in particular, various models of non-Euclidean geometries, and more generally Riemannian geometry, with its application (in the indefinite-signature Lorentzian generalization) to general relativity.

- Maria Helena Noronha, *Euclidean and Non-Euclidean Geometries*, Pearson, 2001.

- Leonor Godinho and José Natário, *An Introduction to Riemannian Geometry with Applications to Mechanics and Relativity*, Springer, 2014.

A.8 Guide to Algebraic Geometry and Singularities

A general introduction to algebraic geometry, including the notions of algebraic varieties, singular varieties, and projective algebraic geometry mentioned in this chapter, can be found in these references.

- Kenji Ueno, *An Introduction to Algebraic Geometry*, American Mathematical Society, 1997.

- Igor R. Shafarevich, *Basic Algebraic Geometry 1: Varieties in Projective Space*, Springer Verlag, 2013.

Spaces with singularities can be studied using a combination of methods from algebraic geometry and topology. The theory of singularities in mathematics lead to applications such as catastrophe theory. The following list of references covers some overview literature on singularities.

- René Thom, *Structural Stability and Morphogenesis*, Westview Press, 1994.

- Tim Poston and Ian Stewart, *Catastrophe Theory and Its Applications*, Dover, 2014.

- Vladimir I. Arnold, *Catastrophe Theory*, Springer Verlag, 2012.

- Vladimir I. Arnold, *The Theory of Singularities and Its Applications*, Cambridge University Press, 1991.

A.9 Guide to Fractal Geometry and Measure Theory

We collect here some useful references about fractal geometry and its applications, as well as relations to other areas of mathematics, like geometric group theory (the limit sets of Kleinian groups). We also include some references on some more general aspects of measure theory, inlcuding the Banach-Tarski paradox.

- Kenneth J. Falconer, *Fractals: A Very Short Introduction*, Oxford University Press, 2013.
- Benoit B. Mandelbrot, *The Fractal Geometry of Nature*, Henry Holt, 1982.
- Michael Frame and Amelia Urry, *Fractal Worlds: Grown, Built, and Imagined*, Yale University Press, 2016.
- David Mumford, Caroline Series, and David Wright, *Indra's Pearls: The Vision of Felix Klein*, Cambridge University Press, 2002.
- Yakov B. Pesin and Vaughn Climenhaga, *Lectures on Fractal Geometry and Dynamical Systems*, American Mathematical Society, 2009.
- Kenneth J. Falconer, *Fractal Geometry: Mathematical Foundations and Applications*, John Wiley and Sons, 2013.
- Grzegorz Tomkowicz and Stan Wagon, *The Banach-Tarski Paradox*, Cambridge University Press, 2016.
- Frank Morgan, *Geometric Measure Theory: A Beginner's Guide*, Academic Press, 2016.

A.10 Guide to Mathematical Quasicrystals

The reader will find here some references on the mathematical study of quasicrystals and on the geometry of tilings, both periodic and aperiodic.

- Marjorie Senechal, *Crystalline Symmetries: An Informal Mathematical Introduction*, Taylor & Francis, 1990.
- B. Grunbaum and G. C. Shephard, *Tilings and Patterns*, Dover, 2015.
- Marjorie Senechal, *Quasicrystals and Geometry*, Cambridge University Press, 1996.

Here are a few references on noncommutative spaces and noncommutative geometry.

- Alain Connes, *Géométrie noncommutative*, InterEditions, Paris, 1990.
- Masoud Khalkhali, *Basic Noncommutative Geometry*, European Mathematical Society, 2013.
- Joseph C. Várilly, *An Introduction to Noncommutative Geometry*, European Mathematical Society, 2006.
- Masoud Khalkhali and Matilde Marcolli, *An Invitation to Noncommutative Geometry*, World Scientific, 2008.
- Alain Connes, *Noncommutative Geometry*, Academic Press, 1994.

4 Entropy and Art: The View beyond Arnheim

In 1971 art theorist Rudolf Arnheim published one of his most famous essays, "Entropy and Art: An Essay on Disorder and Order." In this influential booklet, Arnheim emphasized the ideas of entropy as disorder versus information as order. Among the artworks discussed therein, an example that figures prominently is Hans Arp's *Three Constellations of Same Forms*, where, in three wooden relief compositions from his larger *Constellations* series, identical forms are disposed *randomly* on a uniform background in varying configurations: the information content lies in the mutual distances and the relative weights of these different shapes. Another work of Hans Arp's *Constellations* series that exhibits similar features is shown in figure 4.1. An important question associated with Arnheim's analysis of Arp's works, which I will discuss at length in this chapter, is whether one should regard randomness as order or disorder, as measured in terms of entropy/information. Although our intuition is naturally inclined to view randomness as disorder, we will see that randomness has structure and complexity and that there are different kinds of randomness (see chapter 5). We will see, in both this and the next chapter, how the notion of randomness, in its multiplicity of forms, has played a crucial role in the development of contemporary art.

4.1 Thermodynamic Entropy

The concept of entropy originates in *thermodynamics*. It is introduced as a state function S (this indicates a function that depends only on the present state of the system, regardless of which intermediate states the system went through to get to the present one), which measures the incremental transfer of heat energy Q into the system at a given temperature T. More precisely, one sets

$$\Delta S = \frac{\Delta Q}{T}.$$

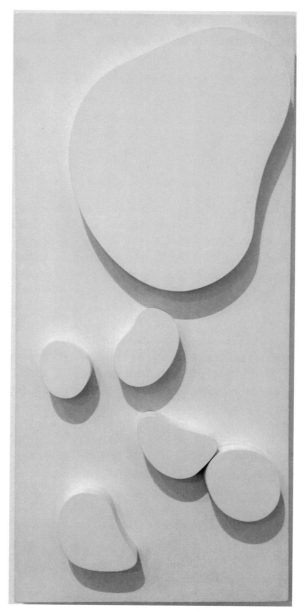

Figure 4.1
Hans Arp, *Constellation III*, 1932.

The laws of thermodynamics, which describe the main properties of energy and entropy, are formulated in the following way.

1. Conservation of energy: the total energy of an isolated system is constant in time.
2. Increase of entropy: the total entropy of an isolated system does not decrease in time.

The first law states that (in an isolated system) energy cannot be created or destroyed, but only transformed from one form to another. The second law, in a slightly different but equivalent reformulation, states that the increase in entropy measures how much energy degrades toward less and less "usable" forms. The laws of thermodynamics are the reason, for instance, why no perpetual motion machine can ever exist.

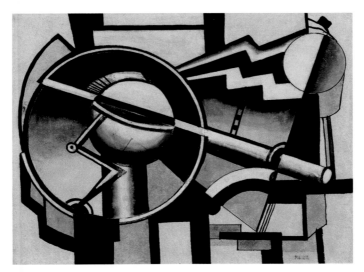

Figure 4.2
Fernand Léger, *Mechanical Composition (Movement Cart)*, ca. 1925.

Indeed, thermodynamics historically developed out of the need to understand the efficiency of machines turning energy into work: *entropy limits the efficiency of mechanical machines*. Thermodynamics is, in this way, a science ultimately tied up with the technological era of engines and mechanical devices. In this form, it appears in implicit references throughout the works of the cubist, Dadaist, and Futurism avant-garde movements, with their fascination with machines and mechanisms, with engines and energy. The example

of Léger's *Composition Mécanique (Mouvement de Charrue)* (see figure 4.2) shows a machine seen as a bubble in itself, an isolated system in the sense of the first law of thermodynamics, existing by itself, without any apparent connection to the outside world nor any apparent utility. The machine is transforming energy into movement ("Mouvement de charrue," as the painting title specifies). The second law of thermodynamics then ensures that this is indeed an impossible machine, at least if we imagine it to run forever, as the painting insinuates, given its self-sufficient nature. The laws of thermodynamics here are implicitly invoked in the painting in order to suggest its eerie and paradoxical nature.

Figure 4.3
C. Anthony Huber, *Entropy IVa*, Abstract Constructionism series, 2014.

The thermodynamic notion of entropy is closely related to the notion of the arrow of time. One can distinguish physical processes into reversible and irreversible processes. In thermodynamic terms this means:

- Reversible process: $\Delta S = 0$ (entropy stays the same)
- Irreversible process: $\Delta S > 0$ (entropy increases)

In this sense, one thinks of the arrow of time simply as the direction of increasing entropy.

Although at the microscopic level, the laws governing the motion of particles in a gas are reversible, and hence at that level, it would be impossible to detect if a movie of particles motion were played in reverse, certainly at the larger macroscopic level one can see that if particles of a gas confined in half of a container are released, they will gradually diffuse into the rest of the container: a movie showing the particles naturally grouping together all on one side, leaving the other side empty, would immediately appear unnatural with respect to the perceived direction of the arrow of time. This example reveals an important difference between the individual microscopic behavior of a single particle subject to reversible laws of motion and the collective macroscopic behavior of the gas in the container, which exhibits a clearly determined preferred direction of the arrow of time.

Figure 4.4
Roberto Quintana, *QnTm/FM 2043*, Quantum-Foam series, 2014.

The view of entropy as a measure of irreversible processes and of disorder is captured in some of the paintings of the *Abstract Constructionism* series of the artist C. Anthony Huber, such as *Entropy IVa* (see figure 4.3). The overlapping splashes of paint convey the image of a typical irreversible process, while the two large regions of white and black hint at the usual portrayal of irreversibility in terms of the two chambers with particles randomly moving across the partition, as in the process we discussed earlier.

One typically distinguishes between "high-entropy states," which are disordered, and "low-entropy states," such as a crystal structure, which are highly ordered. An irreversible process, then, transitions from ordered states to increasingly disordered states.

Figure 4.5
C. Anthony Huber, *Entropy II*, Abstract Constructionism series, 2014.

The irreversible transition between order and disorder is one of the key concepts in entropy. There are many works of art that deal with transitions between ordered and disordered structures. For example, one can see the "melting" of an ordered crystal lattice into a disordered phase portrayed in the piece *QnTm/FM 2043* from the *Quantum-Foam* series by Roberto Quintana (see figure 4.4). In this painting, a regular (ordered) arrangement of microstates gives way to a larger amorphous single (disordered) macrostate. A similar overlapping of ordered and disordered structures, with splashes of paint used to signify irreversibility, can be seen in another piece, *Entropy II* of the *Abstract Constructionism* series of C. Anthony Huber (see figure 4.5).

However, it is important to point out some subtleties in the identification of entropy and disorder. There are situations in physical systems where entropy does not necessarily lead to a disordered phase. In experiments and simulations carried out by Damasceno, Engel, and Glotzer (see the bibliographical appendix to this chapter), it was observed that particles find a maximal entropy arrangement which, if there is enough space, will look like a disordered phase, but in a more crowded setting, such a configuration may lead to an "ordered" crystal structures, although it is a high-entropy state. Figure 4.6 illustrates one such high-entropy crystal phases.

Figure 4.6
P. F. Damasceno, M. Engel, S. C. Glotzer, *High Entropy Ordered Structure*, 2012.

4.1.1 Probabilistic Description of Entropy

An important development in the theory of entropy, in the context of thermodynamics as described earlier, is a formulation in probabilistic terms (Ludwig Boltzmann). As mentioned, one typically encounters situations where the laws governing physics at the microscopic level are time reversible, while at the macroscopic level, irreversible processes are clearly present, which determine our sense of an arrow of time pointing to the direction of increasing entropy.

Figure 4.7
Roberto Quintana, *QnTm/Fm 230*, Quantum-Foam series, 2014.

The relation between microscopic and macroscopic properties of a physical system is understood within the context of statistical mechanics.

The view of entropy based on statistical mechanics can be summarized as follows.

- Entropy measures the amount of uncertainty remaining in a system after fixing all its *macroscopic* properties, such as temperature, pressure, and volume.
- Entropy arises from the *microscopic states* (degrees of freedom) of the system: it is a measure of the number of different ways in which a system can be arranged.
- Entropy is proportional to the natural logarithm of the number of possible microscopic configurations,

$$S = -k_B \sum_i p_i \log p_i \,,$$

where the sum is over microstates (with a probability p_i of finding the system in that state), and with the Boltzmann constant k_B as a proportionality factor.
- If all the microstates are equally probable, then the probability is uniform, $p_i = 1/N$, and the entropy is simply given by

$$S = k_B \log N \,,$$

where N is the number of microstates (the number of degrees of freedom at the microscopic level).

In this light, we can revisit the artwork in the *Quantum-Foam* series of Roberto Quintana. As we see in *QnTm/Fm 230* in figure 4.7, ensembles of microstates concur to determine the larger-scale macroscopic structure, and the observed properties at macroscopic level (order/disorder) depend on the counting of all different possible microstates within the macrostate.

Figure 4.8
Roberto Quintana, *QnTm/FM 2040*, Quantum-Foam series, 2014.

4.1.2 The Gibbs Measure

If all the microstates were equally probable, then the entropy would simply be $S \sim \log N$, proportional to the logarithm of the number of degrees of freedom. However, in a typical physical system, the probability of occurrence of a certain microstate is determined by the *energy*,

$$p_i = \frac{e^{-\beta E_i}}{Z(\beta)},$$

where E_i is the energy level of that microstate, and the partition function,

$$Z(\beta) = \sum_i e^{-\beta E_i} = \mathrm{Tr}(e^{-\beta H}),$$

is the normalization factor that makes the previous expression a probability and that accounts for the distribution of energy levels across all the possible microstates. The variable β in this expression is an inverse temperature (up to a conversion factor given by the Boltzmann constant, $\beta = \frac{1}{k_B T}$). This means that, at low temperature, the probability is concentrated on states of lowest energies, while at higher temperatures higher energy states also contribute. The *Gibbs measure*, obtained in this way, has the property that is maximizes the "entropy density" for a fixed "energy density."

Different microscopic states of the system are weighted according to their energies: at low temperature, high-energy states are inaccessible and the Gibbs measure is concentrated on the ground state; at higher temperatures, higher-energy states also become accessible. Again, we can interpret in this light Quintana's *QnTm/FM 2040* (see figure 4.8), as a state space subdivided into a series of possible microstates, which are weighted differently (here, color coded) to signal a lower or a higher corresponding energy state.

4.2 Entropy and Cosmology

The universe is an isolated system. Thus, according to the second law of thermodynamics, its entropy is increasing. This implies, going backward in time, and assuming the current standard cosmological model, that the original Big Bang must have been a state of extremely low entropy. Projecting forward in time, instead, one envisions a scenario of slow "heat death of the universe," where all the energy reduces to a homogeneous distribution of thermal energy.

Gravity causes stars to form, and it causes sufficiently massive ones to eventually collapse into black holes. Black holes themselves have a form of entropy (the Bekenstein-Hawking black hole entropy) which is proportional to the area of their event horizon (maximally entropic states). In the case of a closed universe, which starts with a Big Bang and recollapses into a Big Crunch, the initial Big Bang state is at very low entropy, while the final Big Crunch state should be at very high entropy. A significant contribution to this high entropy is due to all the black holes that formed in the evolution of the universe. Roger Penrose's *Weyl curvature hypothesis* shows that, in such a closed universe, the entropy grows like a component of the curvature (the Weyl curvature tensor). The history of the universe, as depicted in this model, starts out at a uniform low-entropy Big Bang with zero Weyl curvature and ends at a high-entropy Big Crunch with a very large Weyl curvature, which has been contributed to by a congealing of black holes.

However, one should keep in mind that there are several problems with applying the notion of thermodynamical entropy to cosmology. First, this notion

Figure 4.9
Ruth Asawa, *Untitled S065*, early 1960s.

depends on a notion of equilibrium, which does not directly apply to a dynamical spacetime. This is related to the problem of "entropy gap" in an expanding universe. Moreover, when discussing states like the Big Bang or black holes, quantum effects are likely to become relevant in a combination with general relativity that would require a good model for quantum gravity, which is still a main open problem in theoretical physics.

We can see pictures analogous to such evolving universes depicted in the crocheted wire sculptures of Ruth Asawa. In the sculpture *Untitled S065* (see

Figure 4.10
Ruth Asawa, *Untitled S039*, 1959.

figure 4.9), one can see an evolving universe that is undergoing a series of expansions and collapses. Such cosmologies have been studied extensively since the 1970s, based on particular solutions of the Einstein field equations known as Kasner metrics, and a dynamical system that combines a series of these Kasner metrics. They exhibit a chaotic behavior that alternates phases of expansion and collapse, which I will discuss again in chapter 9. Other forms of cyclic cosmologies have been recently proposed by Penrose, in his model of Conformally Cyclic Cosmologies, which are also referred to as "cycles of time."

In the sculpture *Untitled S039* of figure 4.10 instead, we see an evolving universe more similar to the Penrose Weyl curvature hypothesis model, where a large quantity of Weyl curvature is injected in a background smooth space, through many singularities that open up in the fabric of spacetime, like black holes in the Penrose model. While Asawa's sculptures are often analyzed in terms of organic forms, such as nests and vegetal growth structures, the artist stressed the importance of the line as compositional element in her wired sculptures and the space created by their nested forms. The comparison to cosmological elements, cosmic bodies floating in space, sketches of the cosmos and cosmological evolutions, was already made in several previous analyses of Asawa's work (see the bibliography at the end of the chapter).

4.3 Entropy and Information

In 1948 mathematician Claude E. Shannon published the seminal article "A Mathematical Theory of Communication," republished as a book with Warren Weaver in 1949. This work introduced the information theoretic meaning of entropy and ushered in the modern era of information theory.

While thermodynamic entropy limits the efficiency of machines (engines), information theoretic entropy limits the efficiency of communication. In every form of communication, a signal is encoded, transmitted, and decoded: the main problem is how to optimize the efficiency of communication. For instance, efficiency is improved if instead of using uniformly long codings for all letters, one uses a shorter coding for frequently occurring letters and a longer one for rarely occurring ones. This shows that optimizing is related to frequencies, and hence to probabilities.

The Shannon entropy is defined as

$$S = -\sum_i p_i \log(p_i).$$

The Shannon entropy is uniquely determined by some axiomatic properties (Khinchin axioms), up to an overall multiplicative constant, which corresponds to choosing a base for the logarithm. When thinking of information in terms of bits, it is customary to use the base 2 logarithm. Due to the presence of the logarithm function, information is additive over independent events:

$$\log(p_1 p_2) = \log(p_1) + \log(p_2).$$

This definition can be compared with our previous discussion of Boltzmann entropy. Shannon information is then defined as *negative entropy*.

The *Negative Entropy* series of artist Mika Tajima (see figure 4.11) was produced by recording sounds of old Jacquard loom factories in Pennsylvania and

Figure 4.11
Mika Tajima, *Negative Entropy*, 2012.

turning the sound recording into digital image files, which are then, in turn, woven into the resulting artworks. The use of Jacquard looms in Tajima's art is a profound reflection on the historical dawn of the Information Age. The programmable Jacquard loom was the historical precursor, and the direct inspiration, of the punchcards used to program the first generation of computers. One of the crucial links in the history of technology, the Jacquard loom can be seen as the last of the age of machines and the first of the age of computers. It marks the transition between thermodynamic entropy and information theoretic entropy. With her cycling through the physical looms, the digital-

ization of their sound, the transformation of the digital file into a code, and the expression of this code into a woven pattern of texture, the artist portrays this back-and-forth exchange and reinvention of technological language at the threshold between the mechanical and the informational, as embodied in the looms.

4.3.1 The Park Place Gallery Group

A group of abstract artists in 1960s New York, known as the Park Place Gallery Group, derived their inspiration from various branches of contemporary science, ranging from cosmology and general relativity, which inspired the explicit "Reimagining Space" theme of the group, to information and entropy, all revisited, in their own words, "with a grain of salt and a lot of irony."

Figure 4.12
Dean Fleming, *Tunis*, 1964.

A passage from Bridgman's thermodynamics reference (see the bibliography at the end of this chapter), which was quoted as a source of inspiration by this group of artists, points out how energy and entropy are ways of measuring what happens when one state of a system is transformed into a different one. At the same time, the artists of the Park Place Gallery Group were also influenced by Buckminster Fuller's ideas on geometry and synergetics. An analysis of the

Figure 4.13
Tamara Melcher, *Untitled*, 1965.

role of entropy in 1960s American abstract art is given in Robert Smithson's essay "Entropy And The New Monuments," which is available in his collected works.

Here we will consider two paintings from the Park Place Gallery Group: one by Tamara Melcher (figure 4.13) and one by Dean Fleming (figure 4.12). Both consider ordered information patterns, with Fleming's painting akin to a crystal structure. We can read Melcher's painting in the sense of the theory of communication. There are several patterns of regularity in the painting, determined by the different superimposed systems of parallel directions, at an angle to each other, and the different pattern of emergence of one stratum over the other in their intersections creates a nontrivial message with a higher information content, in the sense of Shannon, than the underlying uniform pattern.

Figure 4.14
Vladimir Bulatov, *Bending Hyperbolic Kaleidoscopes*, 2011.

4.4 Quantum Information and Entanglement

Suppose a fair coin is tossed repeatedly and the outcomes recorded. One can denote by the symbols 0 and 1 the two possible outcomes. After tossing the coin N times, the possibilities are 2^N and the Shannon entropy $S = \log_2(2^N) = N$ counts the number of *bits* that are needed to describe the output.

In passing from classical to quantum information, one replaces the classical notion of a *bit*, which is a single 0 or 1 output, with the quantum mechanical notion of a *qbit* (sometimes written also as *qubit*). The fundamental difference between the classical bit and the quantum mechanical qbit is that, while the former is a discrete variable taking only two possible values, 0 or 1, the latter is a quantum mechanical state, which exists in a superposition of zero and one, $|\psi\rangle = \alpha|0\rangle + \beta|1\rangle$, so that it ouputs 0 with probability $|\alpha|^2$ and 1 with probability $|\beta|^2$, with the normalization condition $|\alpha|^2 + |\beta|^2 = 1$. The set of qbits is a sphere (the Bloch sphere). Thus, while the classical bit is a discrete 0/1 switch, a qbit exists on a sphere of possibilities. The *measurement* operation collapses a qbit to a classical bit: the outcome of measurement on a qbit is a classical bit *with probabilities* assigned to the 0/1 outcomes.

The Shannon entropy of the classical theory is generalized to quantum information by the von Neumann entropy,

$$S = -\text{Tr}(\rho \log \rho),$$

where the classical probability distribution (p_i) is replaced by a quantum mechanical density matrix ρ, with the trace of matrices replacing the sum.

The quantum state for a system of two particles does not always separate out into a separate contribution for each particle: it can be *entangled*. This is a fundamental quantum mechanical property, which is at the basis of the theory of quantum communication. The amount of entanglement in a physical state can be measured using the von Neumann entropy.

4.4.1 Holography: Entropy and Spacetime

The holography principle in string theory is a conjectural equivalence between a certain kind of physical theory, conformal field theory, on a *boundary* space and gravity on an associated *bulk* space that is a negatively curved anti de Sitter (AdS) spacetime. This correspondence is referred to as "holography" because, like holography reconstructs a three-dimensional object from its image stored on a two-dimensional surface, this correspondence of physical theories reconstructs gravity on the bulk space from a field theory that lives on the lower dimensional boundary. The negatively curved geometry of AdS spacetime plays a crucial role in this type of reconstruction results.

Figure 4.15
Hans Hinterreiter, *Kreis Komposition*, 1978.

AdS spacetime is a Lorentzian geometry. Its analog in Riemannian geometry is the hyperbolic space. The two-dimensional hyperbolic space (hyperbolic plane) was historically one of the first models of non-Euclidean geometries. It can be visualized as a disc (Poincaré disc) with a metric that puts the boundary at infinite distance from the interior points, and where paths of shortest length are not straight lines but circles that encounter the boundary perpendicularly. It can also be represented as a hyperboloid with the projection to the disc recovering the Poincaré model, or by a upper half plane where the metric puts the boundary line at infinite distance. There are similar higher dimensional versions of hyperbolic spaces. The hyperbolic metric can be visualized by considering regular tilings of the hyperbolic plane, like the ones shown in figure 4.14. In each of these tilings the individual tiles are all of the same size, when the size is computed in the hyperbolic metric, although we see them as different sizes with respect to the usual Euclidean metric of the plane. In the hyperbolic metric it is then clear that the boundary is at infinite distance: in

order to reach the boundary of the disc one has to traverse an infinite number of tiles of equal size, hence to travel an infinite distance.

The geometry of the hyperbolic plane was explored in depth the the artist Hans Hinterreiter, who produced a series of drawings and paintings based on the use of different tessellations of the hyperbolic plane and patterns obtained from walks along parts of various hyperbolic tessellations (see figure 4.15).

Entanglement entropy plays a fundamental role in the current models of holography in string theory. The recently proposed Ryu-Takayanagi conjecture predicts that the entanglement entropy of quantum states corresponding to a region in the conformal boundary at infinity is proportional to the *area* of the minimal surface in the bulk space that has the same region as boundary. This far-reaching idea would make it possible to reconstruct gravity (Einstein equations) on the bulk space from the properties of entropy on the boundary space. The picture of this bulk/boundary correspondence and the role of entanglement entropy become more complex when there is a black hole in the bulk space, in which case different surfaces in the bulk with the same boundary region would either wrap around the black hole horizon or avoid it, leading to different contributions and more complicated geometries, such as the following.

The Hinterreiter-type visions of hyperbolic geometries could incorporate visual effects computed geometrically to produce an analog of the black holes bending of the bulk spacetime. Works like *Opus 1* (see figure 4.16), with the details of the geometric construction made evident in the accompanying pencil drawing, can be read in the light of our understanding of the relation between bulk geometry and boundary entanglement.

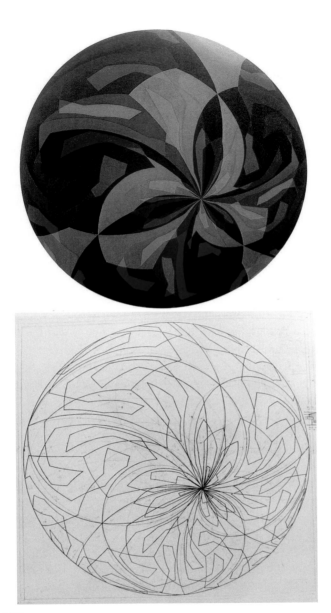

Figure 4.16
Hans Hinterreiter, *Opus 1* (painting and pencil construction), 1945.

4.5 Entropy versus Complexity

Entropy and complexity are two related but *different* mathematical concepts. The *Kolmogorov complexity* of an object is the *shortest length of an algorithmic description* of that object, that is, the length of the shortest program that produces that output. Thus, for example, a number like 10^{100} has very low complexity compared to a random 100-digits numbers, because it has a very short algorithmic description: for example, "raise the number 10 to the power 100" is much shorter than having to write out 100 digits. The behavior of complexity in relation to the length shows dips corresponding to objects whose complexity is much smaller than their description length, as in the case of the number 10^{100}. Clearly, any lossless compression algorithm gives an approximate version of Kolmogorov complexity, because the shortest algorithmic description must, in particular, be no longer than any such algorithm. However, despite the existence of good approximations (by excess) given by compression algorithms, there are no ways to predict exactly where dips in complexity will occur; in other words, there are no sufficiently good computable approximations from below. This problem is related to the unsolvability of the *halting problem* in the theory of computation: it is impossible to predict whether a program on a given input will output in finite time or will run forever. The reason why the unsolvability of the halting problem affects the computability of Kolmogorov complexity can be seen in the following way. Suppose we are given an algorithm that produces a desired output, whose complexity we wish to compute. The length of any such algorithm gives us an upper bound on the complexity of its output: it gives an upper bound only, because there may still be another, shorter program that produces the same output. However, since we cannot predict whether a program will output or run forever, we cannot a priori tell whether any of the possible shorter programs will give the output we are considering (hence lowering its Kolmogorov complexity) or whether the one we have is really the shortest one. For this intrinsic reason, Kolmogorov complexity is a *noncomputable* function. Saying that something is noncomputable seems to be saying it is useless: what good is a function that cannot be computed? However, the existence of good approximations from above generally makes the use of complexity feasible. Moreover, there is a relation between Kolmogorov complexity and Shannon entropy, which shows that entropy is an "averaged version" of complexity. This also generally makes it possible to obtain estimates on the behavior of complexity in an average, probabilistic sense.

There is, however, an aspect of Kolmogorov complexity that is counterintuitive with respect to the heuristic intuitive notion of complexity that we all

have in our experience and perception of the world. Kolmogorov complexity is maximal for *completely random* patterns. This is not what one would expect: the intuitive idea of complexity is related to the existence of "structures" that are sufficiently intricate, but not completely random.

Following this idea of what complexity should be measuring, Murray Gell-Mann proposed a notion of *effective complexity*, which measures the Kolmogorov complexity of all "regular sub-patterns" in a given pattern. Effective complexity is high in an intermediate region between total order and complete randomness.

For instance, let us consider again the two paintings of the Park Place Gallery Group by Dean Fleming and Tamara Melcher (figure 4.12 and figure 4.13). We can say that the painting by Tamara Melcher has a higher effective complexity, in the sense of Murray Gell-Mann, than the painting by Dean Fleming, because Fleming's painting has a simpler structure with fewer very regular patterns, while Melcher's painting has a richer structures of sub-patterns, each of which has a greater Kolmogorov complexity.

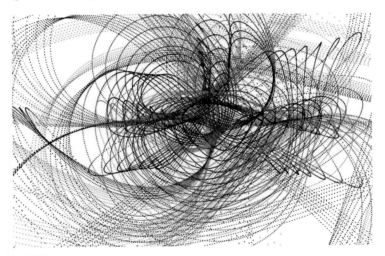

Figure 4.17
Dennis M. Callahan, Jr., *Desired Constellations*, 2010.

One finds explicit use of notions of complexity theory in the Generative Art movement. We refer the reader to the "Recovering Infinity" site for a forum of Generative Art, and to the writings of Philip Galanter. Generative Art is seen as living in between the "highly ordered" patterns of traditional art, and the "highly disordered" patterns that emerged in modern art through the adoption

of randomization in artistic expression ranging from the visual arts to music. The Generative Art movement proposes to focus artistic expression on the intermediate region of high Gell-Mann effective complexity, as can be seen in realizations such as the computer generated works of Dennis Callahan (figure 4.17).

4.6 The Problem with Arnheim

We have explored the landscape of the mathematical notions of entropy and complexity and parallel forms of artistic expression where such notions manifest themselves. Coming back to the old essay by Arnheim on "Entropy and Art," it is worth pointing out some of its main shortcomings and inaccuracies. Although he certainly contributed a very influential essay, Arnheim failed to understand some of the nuances in the mathematical notion of entropy, failed to correctly and consistently interpret the notions of "order" and "structure," and gave some serious misrepresentations of the artistic movements of the time. Some of these criticisms are already formulated in Peter Lloyd Jones' essay in the bibliographical appendix. We discuss some of the main issues in Arnheim's "Entropy and Art."

First of all, there are problems with the scientific notion of entropy. Arnheim *overly* emphasizes the identification of entropy with "disorder." Moreover, he confuses the concepts of "equilibrium" and "order." These are definitely not the same thing: a physical system can be in equilibrium in a highly disordered state. Also, Arnheim appears to miss entirely the fact that Shannon's "information content" is a *statistical* notion. He confuses the notion of *entropy/information* with the notion of *complexity*. As discussed in the previous section, although Shannon entropy can be viewed as an averaged version of complexity in an appropriate sense, entropy and complexity are two very different mathematical concepts. Arnheim also refers incorrectly to the notion of *redundancy* in information theory.

There are also serious problems with the notion of "order." Arnheim's discussion of "order" seems based on several different and at times incompatible meanings. He proposes a point of view based on Gestalt psychology's notions of "tension reduction" and "field process" to describe "order" and "structures." This is problematic, since, unlike scientific definitions, these are not *predictive* notions. Gestalt psychology certainly does have some interesting relations to the mathematics of *pattern theory*, but has far fewer to the notion of thermodynamic entropy that Arnheim repeatedly refers to.

Arnheim also seems unaware of where in the artistic movements of his time Gestalt psychology had really played a central role, that is, in the "Arte Cinetica

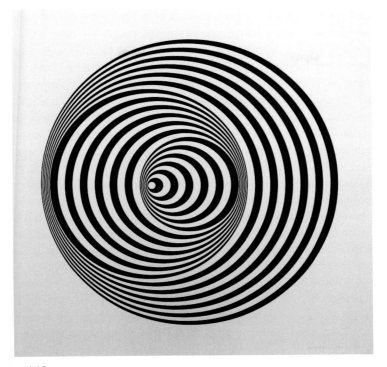

Figure 4.18
Marina Apollonio, *Circular Dynamics 4S*, 1968.

e Programmata" movement, which was developed in Italy in the 1950s, 1960s, and 1970s by artists like Bruno Munari, Giovanni Anceschi, Gianni Colombo, Getulio Alviani, Marina Apollonio, and Yacoov Agam. Gestalt psychology was a crucial component of the chosen language of expression of these artists and the whole movement was influenced by the psychologist Gaetano Kanizsa, with whom the artists of this group maintained close connections.

An example where Gestalt psychology is explicitly used can be seen in the work *Circular Dynamics 4S* by Marina Apollonio (see figure 4.18), realized with enamel on wood. It incorporates a rotating mechanism, designed so that the perceived movement effect in the observer correspond to well studied aspects of the theory and psychology of perception.

There are many other dubious art history statements and interpretations of specific artworks in Arnheim's essay. He certainly misinterprets Andy Warhol's work: in Warhol's repetitions of images what matters are the details that are *not* identical, and that's where the semantic meaning lies, along with the criti-

cal message about the mass consumerist society. There are similar widespread misinterpretations of the Minimalist Art movement.

Perhaps the aspect of Arnheim's essay that is most valuable is the analysis of the role of information in between perfect predictable order and maximal randomness, and those probability distributions for which the Shannon entropy is neither maximal nor minimal, as a range that is particularly interesting from the aesthetic viewpoint of artistic expression. Returning to the analysis of the *Constellation* series of Hans Arp (see figure 4.1), Arnheim points out how Arp experimented with the laws of chance (which I will discuss further in the next chapter) in obtaining arrangements of forms by letting shapes fall into place on the underlying surface, and at the same time proceeded to select these random compositions for optimal effects of balance of the weight and distance relations between these forms, aiming in this way for a range in between ordered pattern and randomness. He also mentions, in the same analysis, the example of the randomness of Jackson Pollock's paintings, about which I will say much more in the next chapter, and how their random distribution of colors and patterns is "controlled by the artist's visual order." Indeed, as I will discuss in the next chapter, there is a particular signature in the randomness of the Pollock paintings, which can be characterized in terms of their "entropy dimension."

Overall, Arnheim should be praised for initiating an important reflection on the theme of entropy and art. An in-depth analysis of this topic is certainly useful and even necessary to navigate the landscape of the postwar contemporary art movements. However, such a reflection requires a more subtle and precise handling of the correct scientific notions: the different forms of entropy and the different notions of complexity. Here I hope to stimulate this reflection further.

Chapter Appendix: Bibliographical Guide

A.1 Guide to the Art Theory and the Artists

Some references about Arnheim's original essay and its criticism are listed here, including some broader perspective on Arhnheim and his relation to Gestalt psychology, and on the theme of entropy in art, including the possible use of entropy as a basis for an algorithmic form of aesthetics.

- Rudolf Arnheim, *Entropy and Art: An Essay on Disorder and Order*, University of California Press, 1971.
- Peter Lloyd Jones, "Some Thoughts on Rudolf Arnheim's Book 'Entropy and Art,'" *Leonardo* 6, no. 1 (1973): 29–35.
- Bruce Clarke and Linda Dalrymple Henderson, *From Energy to Information: Representation in Science and Technology, Art, and Literature*, Stanford University Press, 2002.

- Charissa N. Terranova, *Art as Organism: Biology and the Evolution of the Digital Image*, I. B. Tauris, 2015.
- Ian Verstegen, *Arnheim, Gestalt and Art: A Psychological Theory*, Springer Verlag, 2005.
- George Stiny and James Gips, *Algorithmic Aesthetics: Computer Models for Criticism and Design in the Arts*, University of California Press, 1979.
- Higor Y. D. Sigaki, Matjaž Perc, and Haroldo V. Ribeiro, "History of Art Paintings through the Lens of Entropy and Complexity," *PNAS* 115, no. 37 (2018): E8585–E8594.

In this section the reader can find some monographs and additional critical writings about the work of the artists and the themes discussed in this chapter.

- Eric Robertson, *Arp: Painter, Poet, Sculptor*, Yale University Press, 2006.
- Bibiana Obler, *Intimate Collaborations: Kandinsky and Münter, Arp and Taeuber*, Yale University Press, 2014.
- Anna Vallye, Christian Derouet, Maria Gough, Spyros Papapetros, and Jennifer Wild, *Léger: Modern Art and the Metropolis*, Yale University Press, 2013.
- Felicia M. McCarren, *Dancing Machines: Choreographies of the Age of Mechanical Reproduction*, Stanford University Press, 2003.
- Andreas Broeckmann, *Machine Art in the Twentieth Century*, MIT Press, 2016.
- Kate Mothes, *C. Anthony Huber*, Young-Space (online).
- Roberto Quintana, *Quantum Foam Series*, Art & Soul Productions (online).
- Daniell Cornell, *The Sculpture of Ruth Asawa: Contours in the Air*, University of California Press, 2006.
- Robert Storr and Jonathan Laib, *Ruth Asawa: Line by Line*, Christie's, 2015.
- Robert Storr, *Ruth Asawa: Sketches of the Cosmos*, in Storr and Laib, *Ruth Asawa: Line by Line*, pp. 19–37.
- Roberta Smith, "Mika Tajima: 'Negative Entropy,'" *New York Times*, March 27, 2014, Art in Review section (online).
- Kareem Estefan, "Mika Tajima," *BOMB Magazine* 128, 2014 (online).
- Matthew Lyons, *Total Body Conditioning: Mika Tajima*, Black Dog Publishing, 2015.
- Linda Dalrymple Henderson, *Reimagining Space: The Park Place Gallery Group in 1960s New York*, Blanton Museum of Art, 2009.
- Liza Kirwin, *Art and Space: Park Place and the Beginning of the Paula Cooper Gallery*, Archives of American Art, 2007 (online).
- Dean Fleming, *Paintings 1992–2004*, Libre, 2004.
- Tamara Melcher, *Interdimensional Landscapes*, Blurb, 2010.
- Robert Smithson, *The Collected Writings*, ed. Jack Flam, University of California Press, 1996.

- Linda Dalrymple Henderson, *The Fourth Dimension and Non-Euclidean Geometry in Modern Art*, MIT Press, 2013.
- Hans Hinterreiter, *Die Kunst der reinen Form*, Ediciones Ebusus, 1978.
- E. Makovicky, "The Crystallographic Art of Hans Hinterreiter," *Zeitschrift für Kristallographie* 150 (1979): 13–21.
- Hans Joachim Albrecht and Rudolf Koella, *Hans Hinterreiter: A Swiss Exponent of Constructive Art*, Waser, 1982.
- Philip Galanter, *What Is Generative Art? Complexity Theory as a Context for Art Theory*, 2003 (online).
- Dennis Callahan, "The Importance of Being Creative," *The STEAM Journal* 1, no. 2 (2014).
- Matt Pearson, *Generative Art: A Practical Guide Using Processing*, Manning, 2011.
- Frank Popper, *L'arte cinetica*, Einaudi, 1993.
- Lea Vergine, *Art on the Cutting Edge: A Guide to Contemporary Movements*, Skira, 2001.
- Bruno Munari, *Design e comunicazione visiva*, Laterza, 1968.
- Gaetano Kanizsa, *Grammatica del vedere: saggi su percezione e Gestalt*, Il Mulino, 1997.
- Marina Apollonio, "Retrospective Exibition" (catalog), 10 A.M. Art, 2014.
- Cristina Celario, "Marina Apollonio: Sintesi e Complessità," in *Marina Apollonio—Dadamaino—Marcello Morandini—Jorrit Tornquist. Fuori dal Coro*, Cortina Arte Edizioni, 2013.

A.2 Guide to the Science of Entropy and Information

This section contains a few references on the mathematical notion of entropy and its role in physics and in information theory. As in the previous chapters, we try to list the references in increasing order of mathematical sophistication, so that the readers can select their preferred level.

The first list of references discusses entropy in the context of thermodynamics. I have included a few references at the beginning relating the physics of thermodynamics to the broader cultural context of its time. I also included the reference to Bridgman's book, which was an explicit inspiration to the artists of the Park Place Gallery Group who were discussed in this chapter.

- Barri J. Gold, *ThermoPoetics: Energy in Victorian Literature and Science*, MIT Press, 2012.
- Bruce Clarke, *Energy Forms: Allegory and Science in the Era of Classical Thermodynamics*, University of Michigan Press, 2001.
- P. W. Bridgman, *The Nature of Thermodynamics*, Harvard University Press, 1941.
- C. Truesdell, *The Tragicomical History of Thermodynamics, 1822–1854*, Springer Verlag, 1980.

- Don S. Lemons, *A Student's Guide to Entropy*, Cambridge University Press, 2013.
- Dilip Kondepudi and Ilya Prigogine, *Modern Thermodynamics: From Heat Engines to Dissipative Structures*, John Wiley & Sons, 2014.

The following list of references discusses the transition between the thermodynamical and the informational notions of entropy, with some attention to the specific role of the Jacquard loom as a crucial link in the history of modern technology, between the age of thermodynamical engines and the age of computers.

- James Essinger, *Jacquard's Web: How a Hand-loom Led to the Birth of the Information Age*, Oxford University Press, 2007.
- Paul J. Nahin, *The Logician and the Engineer: How George Boole and Claude Shannon Created the Information Age*, Princeton University Press, 2013.
- Harvey S. Leff and Andrew F. Rex, *Maxwell's Demon: Entropy, Information, Computing*, Princeton University Press, 2014.
- Claude E. Shannon and Warren Weaver, *The Mathematical Theory of Communication*, 1949; reprint University of Illinois Press, 2015.

On entropy and disorder in physical and biological systems, including the recent result of Damasceno, Engel, and Glotzer on highly ordered max-entropy states, mentioned in this chapter, the reader can consult the following references. I have also included references on entropy and statistical physics.

- Juan Roederer, *Information and Its Role in Nature*, Springer Verlag, 2006.
- John Harte, *Maximum Entropy and Ecology: A Theory of Abundance, Distribution, and Energetics*, Oxford University Press, 2011.
- James Sethna, *Statistical Mechanics: Entropy, Order Parameters, and Complexity*, Oxford University Press, 2006.
- P. F. Damasceno, M. Engel, and S. C. Glotzer, "Predictive Self-Assembly of Polyhedra into Complex Structures," *Science* 337 (2012): 6093.

The reader can find detailed information about entropy in cosmology and the Penrose Weyl curvature hypothesis, in the following references.

- Roger Penrose, "Cosmology and the Arrow of Time," chapter 7 of *The Emperor's New Mind: Concerning Computers, Minds, and the Laws of Physics*, Oxford University Press, 1999.
- Roger Penrose, "Singularities and Time-Asymmetry," in *General Relativity: An Einstein Centenary Survey*, Cambridge University Press, 1979, 581–638.

The following references discuss quantum information and entanglement and its application to quantum computing.

- Seth Lloyd, *Programming the Universe: A Quantum Computer Scientist Takes on the Cosmos*, Knopf, 2006.
- Eleanor G. Rieffel and Wolfgang H. Polak, *Quantum Computing: A Gentle Introduction*, MIT Press, 2011.

- Gregg Jaeger, *Entanglement, Information, and the Interpretation of Quantum Mechanics*, Springer Verlag, 2009.

On entanglement and spacetime geometry in the "holographic correspondence," I refer the reader to the following references, some of which were already mentioned in chapter 2.

- Ron Cowen, "The Quantum Source of Space-Time," *Nature* 527 (2015): 290–293.
- Tatsuma Nishiokaa, Shinsei Ryuc, Tadashi Takayanagi, "Holographic Entanglement Entropy: An Overview," *Journal of Physics A*, 42 (2009): 504008.
- Mukund Rangamani and Tadashi Takayanagi, *Holographic Entanglement Entropy*, Springer Verlag, 2017.
- Shinsei Ryu, Tadashi Takayanagi, "Holographic Derivation of Entanglement Entropy from the anti-de Sitter Space/Conformal Field Theory Correspondence," *Physical Review Letters* 96 (2006): 181602.
- Mark Van Raamsdonk, "Building up Spacetime with Quantum Entanglement," *General Relativity and Gravitation* 42, no. 10 (2010): 2323–2329.
- Jennifer Lin, Matilde Marcolli, Hirosi Ooguri, Bogdan Stoica, "Locality of Gravitational Systems from Entanglement of Conformal Field Theories," *Physical Review Letters* 114 (2015): 221601.

The following bibliographical list contains references on the theme of entropy and complexity.

- Murray Gell-Mann, *The Quark and the Jaguar. Adventures in the Simple and the Complex*, W. H. Freeman and Company, 1994.
- Jean-Paul Delahaye, *Complexité aléatoire et complexité organisée*, Éditions Quae, 2009.
- Roberto Livi and Angelo Vulpiani, *L'héritage de Kolmogorov en physique*, Belin, 2003.
- Pieter Adriaans and Johans van Benthem, *Philosophy of Information*, Elsevier, 2008.
- Murray Gell-Mann and Seth Lloyd, "Effective Complexity," in *Nonextensive Entropy: Interdisciplinary Applications*, Oxford University Press, 2004, 387–398.
- Ming Li and Paul Vitányi, *An Introduction to Kolmogorov Complexity and Its Applications*, Springer Verlag, 2008.

5 Structures of Randomness

There is no other concept that was more influential in the history of contemporary art of the post-World War II era than "randomness." Starting with the postwar years, the concept of randomness penetrated the collective consciousness of European culture as it never had before. It profoundly altered its main modes of expression in both the arts and the sciences. This coming to terms with the concept of randomness caused a major shift in consciousness and world view.

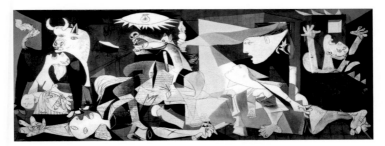

Figure 5.1
Pablo Picasso, *Guernica*, 1937.

It is not hard to see the defining moment when the notion of randomness forcefully intruded in every conceivable description of the world. Europe at the end of World War II looked like an enormous pile of rubbles, an entire continent in ruins. With city after city razed to the ground and nothing left standing, a whole civilization appeared to have been obliterated. Devastation on such a scale had never visited on the continent before. Any sign of order, of structure, appeared lost and broken down into incomprehensible fragments of its previous existence. Most of the destruction of European cities during the war was caused by aerial bombings. These were a novel form of warfare

at the time. Although previously used in colonial wars, bombing was first experienced within Europe only a few years earlier, with the bombing of Guernica, by German and Italian war planes, during the Spanish Civil War in 1937, famously portrayed in Picasso's painting (see figure 5.1). Randomness determined what an aerial bombing would destroy or spare, which houses would be left standing, who lived and who died: a form of destruction that was so utterly complete and yet that was not aimed, not targeted, just *random*. It has been observed many times that World War II marked the end of religion in Europe, at least as far as a large part of the European intelligentsia was concerned: the concept of a personal God ceased to make sense after the horrors and the destruction of the first half of the century. Einstein is alleged to have said about God that only his nonexistence can excuse him, and that certainly reflects how a large part of Europe felt at the time. It was not only organized religion that essentially disappeared in the wake of that enormous wave of destruction, however. A broader sense of the predictability of life had come to an end as well. The tradition of the European Enlightenment had already significantly moved away from religious thinking, embracing instead the vision of a mechanical and predictable universe, run by deterministic laws of physics, where motion is entirely specified by its initial conditions. Meditating upon the ruins of Europe at the end of World War II (see figure 5.2), people saw the deterministic view of the Enlightenment crumble, replaced by a new understanding of the dominant force of nature: mindless, blind *chance*.

5.1 Traces

At the end of World War II, only traces of humanity were left amid the desolation. European art began to come to terms with the need for an entirely new language of expression, articulating remnants and traces in the surrounding chaos resulting from the arbitrariness of destruction.

Several artistic movements began, for the first time in art history, to incorporate randomness in their modes of expression. The movements Arte Informale/Art Informel in Italy and France and Lyrical Abstraction in France and England, with artists such as Alberto Burri, Emilio Vedova, Georges Mathieu, and Antoni Tàpies, created a new language for artistic expression, and in the process developed a new, lyrical vision of hope for the future, which grew and bloomed over the ruins of Europe.

Even though America was largely spared the destruction of the war on its own territory, the Abstract Expressionism movement developed a parallel investigation into the use of randomness as a mode of expression for the new era, with artists including Hans Hofmann, Janet Sobel, Jackson Pollock, and Lee

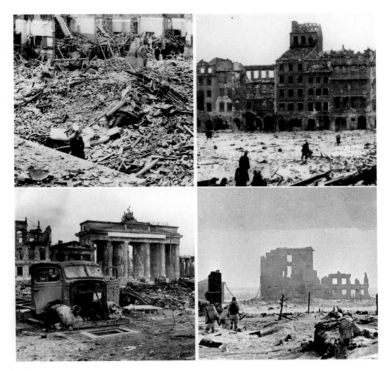

Figure 5.2
World War II in London (1944), Warsaw (1945), Berlin (1945), and Stalingrad (1943).

Krasner. In an often quoted statement, Pollock explicitly remarked that "new needs need new techniques, and the modern artists have found new ways and new means of making their statements: the modern painter cannot express this age, the airplane, the atom bomb, the radio, in the old forms of the Renaissance or of any other past culture."[1] There is a clear sense, in this generation of artists, that the world they live in has gone through a dramatic change of perspective, and just as Adorno remarked that "to write poetry after Auschwitz is barbaric,"[2] these visual artists understood that using art as a representational image of a deterministic world was no longer possible after the experience of World War II. Other artistic movements followed, moving away from the figurative, and embracing both abstraction and the language of randomness: from

[1] Jackson Pollock, interview with William Wright, 1948.
[2] Theodor W. Adorno, "Cultural Criticism and Society," 1983.

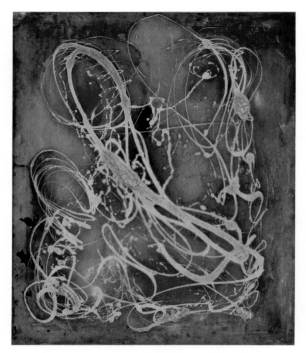

Figure 5.3
Georges Mathieu, *Evanescence*, 1945.

the Conceptual Art of Sol LeWitt to the Generative Art of Ellsworth Kelly and Hiroshi Kawano. Randomness also developed, during the same period of time, as a new compositional form in music and literature.

The French movement of Lyrical Abstraction often presents visions of "random calligraphy," remnants of a human presence, gestures, captured on a background that alludes to sand or dust, or rubble: remnants of human action on the stage of history, devoid of meaning. Mathieu's *Evanescence* (see figure 5.3) is a representative example of this style. The remarkable aesthetics of these abstract gestures is the closest European art ever got to the beauty of calligraphy, a form common to Islamic art and Asian cultures. There is no intelligible text behind the calligraphy of Lyrical Abstraction, yet there is a form of abstract poetics expressed fully through its randomness.

For other artists of the postwar years, the experience of World War II was tied up to an active role in the militant antifascist Resistance. This is the case, for instance, with the Italian painter Emilio Vedova, whose abstract art, which loosely fits in the broader Arte Informale movement, was deeply connected to

his experience of the war and the Resistance fight as well as his political activism in the postwar years. He was a signatory of the 1946 "Beyond Guernica" manifesto, where the inextricability of the new art movements and the experience of the war and the political commitment were explicitly stated. While other artists in the same group opted for a return to the figurative, Vedova's abstract compositions remain some of the most powerful work produced within this movement (see figure 5.4). The title of Vedova's work in figure 5.4, *Immagine del tempo (Sbarramento)*, or *Image of Time (Barrier)*, points again to the use of abstract art as a language to express the concepts of space and time, while at the same time it refers to deeper concerns centered on social and political upheaval, street protests, and class struggle.

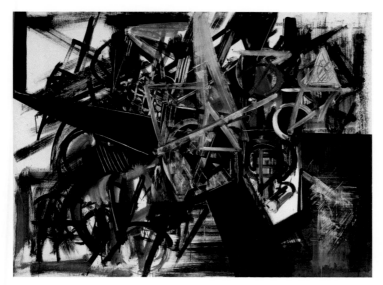

Figure 5.4
Emilio Vedova, *Image of Time (Barrier)*, 1951.

5.2 Randomness and the Cosmos

For the postwar artists, randomness also became a poetic way of reconnecting a devastated humanity to the cosmos, in a universe where the illusion of a supernatural god was no longer sustainable. One sees themes explicitly hinting at this cosmic connection in the work of various artists. A typical example is given by the painting *Milky Way* by the Abstract Expressionism artist Janet Sobel (see figure 5.5), which was painted in 1945, right at the end of the war

Figure 5.5
Janet Sobel, *Milky Way*, 1945.

years. The randomness of this painting is compared to a cosmic structure, the galaxy, seen as the larger home of humanity, our home in the universe, in a larger perspective that moves away from the devastation of nation-states at war.

The view of cosmic structures shown in Janet Sobel's painting is closer to our modern understanding of cosmology than one might have imagined at the time, not on the scale of the Milky Way, which is a single galaxy, but on a much larger scale that we now call *The Cosmic Web* (see figure 5.6).

Until recently, astronomers believed that galaxy clusters were uniformly distributed in the universe. In 1989 Margaret Geller and John Huchra discovered a larger-scale structure, which they named the "Great Wall." This discovery

Figure 5.6
Volker Springel, *Millennium Simulation—The Cosmic Web*, 2005.

releaved the surprising fact that galaxies accumulate along two-dimensional structures. Since then walls and filaments of galaxy clusters have been observed, separated by large voids: the foam-like structure of the Cosmic Web.

5.3 What Is Randomness?

What exactly is randomness, this new language of our era? I will review some of the main aspects of the mathematics of randomness and how these manifest themselves in the artistic movements of the postwar years.

5.3.1 Probabilities and Frequencies

Consider a finite set, used as an alphabet, $A = \{\ell_1, \ldots, \ell_N\}$. This could mean the labels on the faces of a dice, or a set of graphical symbols used to compose words or musical phrases. We will call the symbols in the alphabet A letters, even though they may be numbers, or any other type of signifier, as long as they are the minimal units out of which messages will be composed. We assign to each letter ℓ_i of the alphabet A a probability p_i, so that we have a list of probabilities associated to A,

$$\{p_1, \ldots, p_N\}, \quad p_i \geq 0, \quad p_1 + \cdots + p_N = 1.$$

In the case of a fair coin, with an alphabet $A = \{1, 2\}$ labeling the two possible outcomes, fairness means that the probability is uniform, $p_1 = 1/2 = p_2$. Over longer and longer sequences in the alphabet, the *frequencies* of occurrences of the symbols approach the *probabilities*: this is the *law of large numbers* of probability theory.

Figure 5.7
Lee Krasner, *Composition*, 1949.

The Shannon entropy, discussed in the previous chapter, measures the amount of information by the quantity

$$S = - \sum_{i=1}^{N} p_i \log(p_i).$$

This is the average amount of information (in bits, taking the binary logarithm) contained in an event drawn randomly, according to the assigned probability distribution.

The Shannon entropy is maximal, with value $\log(N)$, for the uniform probability $p_i = 1/N$: it is very difficult to predict the outcome when the probability is uniform. The entropy, on the contrary, is minimally equal to zero for the least uniform probabilities, which assign probability one to one of the outcomes and zero to all the others, $p_1 = 1$ and $p_i = 0$ for all i not equal to 1. In such a case it is very easy to predict the outcome. Thus, the Shannon entropy can be seen as a measure of the level of "unpredictability" of a certain outcome.

Figure 5.8
Regina Valluzzi, *Structure Evolution*, ca. 2010.

Artists realized very clearly that, from an aesthetic viewpoint, the chosen frequencies/probabilities are most "interesting" when they are neither uniform nor extremal, that is, when they fall into an intermediate nonuniform range where the Shannon entropy is neither maximal nor minimal. For example, consider the painting *Composition* by Lee Krasner (see figure 5.7). It shows a pattern created by a list of graphical symbols, where some of the symbols repeat identically or nearly identically in different positions. What makes the pattern interesting to observe and the painting aesthetically appealing is the fact that the pattern is neither fully uniformly random, nor simply the repetition of a single or a small number of symbols in a very easily detectable, completely regular, identically repeating pattern. The painting captures exactly this "in-between" region where the Shannon entropy is neither very small, but also not near its maximum. This demonstrates that an interesting pattern should be neither entirely predictable nor entirely unpredictable. Another example is given by the painting *Structure Evolution* by Regina Valluzzi (see figure 5.8), where we see several different patterns, some very predictable and some seemingly a lot closer to uniform randomness, with transitions between different types of patterns in the painting creating regions of different Shannon entropy and an overall effect of transition between randomness and order, which the artist relates to the formation of structures.

5.3.2 Markov Chains

Markov chains are random processes with one-step memory (as in a chain, the last link added is connected only to its immediate predecessor). In a Markov process, there is a list of possible states the process can be in at a given time. Time ticks in discrete units, like seconds or minutes on a clock, and at each new step the system can move to a new state or remain in the same state, with a certain probability. Let p_{ij} denote the probability of going from state i to state j (or remain in the same state for $i = j$). These satisfy $p_{ij} \geq 0$ and $\sum_j p_{ij} = 1$, which simply means that they are indeed probabilities. This is usually illustrated with a graph as in the following figure, where the circles represent the possible states of the system and the arrows represent the possible transitions, each with a given probability. In the example depicted here, the probability of remaining in the same state is zero and the probabilities of moving to another of the three possible states are as indicated on each arrow.

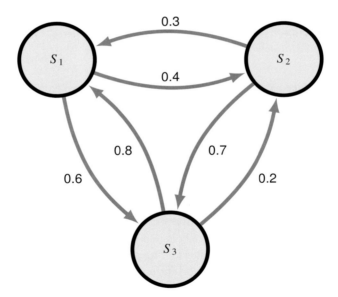

The initial state of the system is also likely to be one of the listed states with a certain probability, and we denote by π_i the probabilities of having i as initial state. Again, since these are also probabilities, they satisfy $\pi_i \geq 0$ and $\sum_i \pi_i = 1$. Moreover, the one-step rule of the Markov chain states that the probabilities p_{ij} and π_i satisfy the relation

$$\sum_i \pi_i p_{ij} = \pi_j.$$

This means that the probability of the system being in a given state at the next step depends on where it was in the previous step and with what probability and on the probabilities of the transitions. The sum is the sum over all the possible one-step histories of the system. The entropy of a Markov process is

$$ S = - \sum_i \pi_i \sum_j p_{ij} \log(p_{ij}). $$

Figure 5.9
Hiroshi Kawano, *Design 3-1: Color Markov Chain Pattern*, 1964.

Generative Art was the first postwar artistic movement that seriously incorporated these ideas. The mode of expression these artists adopted included art produced with the intervention of autonomous agents—computer programs, cellular automata, neural networks—and significantly involving random processes. Hiroshi Kawano was a leading early exponent of this tendency. Figure 5.9 is an example of Kawano's paintings produced using Markov chains as a way of determining the resulting pattern of shapes and colors.

5.3.3 Brownian Motion and Stochastic Processes

A serious interest in investigating randomness in science began in the late 19th century with the study of Brownian motion, rigorously explained by Einstein in 1905.

Figure 5.10
Paths of Brownian motion.

Brownian motion is the random "dance" of particles in a fluid. It was first described by Lucretius in his *De Rerum Natura* to describe dust particles in the air (Book 2, 113–140). Lucretius (correctly) proposed Brownian motion as a verification of the existence of atoms. In a typical trajectory of Brownian motion, as illustrated in figure 5.10, one recognizes a characteristic lack of smoothness of the path: a particle would move along a smooth path, but its motion is diverted by imbalances of forces in the combined effect of all the collisions with the surrounding smaller liquid molecules in random thermal motion. This crucial aspect of Brownian motion, the non-smoothness of trajectories of motion, is captured in Camille McPhee's painting *Mutated Brownian Motion II* (see figure 5.11).

Unlike the Markov processes, which are discrete processes that update their state in discrete steps, Brownian motion is a stochastic process with continuous time. Einstein's model of Brownian motion is based on a diffusion equation

Figure 5.11
Camille McPhee, *Mutated Brownian Motion II*, 2011.

for the density of Brownian particles, which gives solutions of the form

$$\rho(x, t) = \frac{\exp\left(-\frac{x^2}{4Dt}\right)}{\sqrt{4\pi Dt}}.$$

Norbert Wiener formulated Brownian motion as a continuous-time stochastic process

$$W_t - W_s \sim N(0, t - s)$$

with *normal distribution*

$$N(\mu, \sigma) = \frac{\exp\left(-\frac{(x-\mu)^2}{2\sigma}\right)}{\sqrt{2\pi\sigma}},$$

where the form and amplitude of the Gaussian exponential (bell-shaped distribution) depend on the parameter σ. The resulting stochastic process has $W_0 = 0$, W_t which is almost surely continuous, and the quantities $W_{t_1} - W_{s_1}$

Figure 5.12
Elena Kozhevnikova, *Brownian Motion II*, ca. 2013.

and $W_{t_2} - W_{s_2}$ are independent random variables for nonoverlapping time intervals $s_1 < t_1 \leq s_2 < t_2$. This last property reflects the randomness caused by collisions that change direction to the Brownian motion of particles.

Another example of pictorial rendering of Brownian motion by a contemporary artist is Elena Kozhevnikova's, *Brownian Motion II* (see figure 5.12). McPhee's portrait of Brownian motion (figure 5.11) tends to focus on the typical nondifferentiable shape of trajectories, while Kozhevnikova's version appears to focus more on representing a random diffusion process governed by a normal distribution.

Figure 5.13
Sol LeWitt, *Wall Drawing 289*, 1978.

5.4 Kinds of Randomness

In discussing the Shannon entropy, I noted that it is maximized by the most uni-
form probability distribution. Artists working with randomness also discussed
the idea of a "uniform" randomness. For example, Sol LeWitt wrote about one
of his wall drawings (see figure 5.13): "Lines not short, not straight, crossing
and touching, drawn at random, using four colors, uniformly dispersed with
maximum density, covering the entire surface of the wall."[3] What does "at ran-
dom ... uniformly dispersed with maximum density" actually mean from the
point of view of probability theory? What *kind of randomness* are we talking
about here?

There are many different kinds of randomness. In the *continuous* case we
have normal distribution, uniform distribution, triangular distribution, and so
forth. In the *discrete case*, we have Bernoulli distribution, Poisson distribution,
hypergeometric distribution, and so on. The different shape of these distribu-
tions affects the "kind of randomness" they give rise to.

So what does it mean for something to be *truly* random? Does that corre-
spond to our intuition of randomness? Consider the randomness tests in fig-

[3] This description was originally included as longer title of Sol LeWitt's artwork *Wall Drawing
65*, 1971. Dorothy and Herbert Vogel Collection, National Gallery of Art.

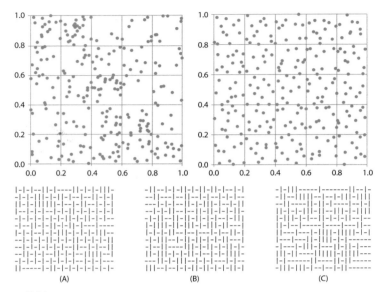

Figure 5.14
Peter Norvig, *Randomness Tests*, 2012.

ure 5.14: which of the two plots in the first row is obtained using the *uniform* distribution? One would be tempted to say that the second figure looks more "uniformly" random than the first one. However, what one perceives there as uniformity is, in fact, more regularity, that is, the existence of correlations. These regularities and correlations take us toward lower values of the Shannon entropy, while uniform randomness, as in the first figure, does not exhibit any correlation pattern between the positions of the points.

A similar example occurs with the plots in the second row of figure 5.14, where we can interpret each pattern as a string of text composed with an alphabet of two characters, a vertical bar and a horizontal bar. We want to identify which of these three patterns follows a uniform Bernoulli distribution, which means that both letters of the alphabet occur with a probability of $1/2$ and the next choice is independent of the previous ones. Intuitively, people generally perceive (A) or (B) to be more "uniformly random" than (C). However, in (A) the lines flip between the two positions (horizontal and vertical) three-fourths of the time, and in (B) they flip two-thirds of the time, while in (C) they flip half of the time, which is what one expects in the uniform case.

Randomness is not always what meets the eye. This is an interesting point when one wants to use randomness in the visual arts. Our brain naturally tends

to perceive as "patterns" those irregular clusters that form in a random arrange-
ment, while it is more likely to perceive an evenly distributed set of points as
"random" even when that "evenness" is, in fact, an indicator of nonrandom
structures and the presence of strong correlations.

5.4.1 The Poisson Distribution

For a discrete, integer-valued, random variable X, the Poisson distribution as-
signs as the probability of having $X = k$ the value

$$P_k = \frac{\lambda^k}{k!}e^{-\lambda},$$

where $\lambda > 0$ is an adjustable parameter. For a small λ, the distribution is more
peaked at smaller values, while for a large λ it is more spread out and peaks at
larger values.

The Poisson distribution was famously used by the musician Iannis Xenakis,
to compose his work *Achorripsis* (the name comes from the Greek $A\chi o\varsigma$,
"sound," and $\rho\iota\psi\eta$, "cast," as in throwing dice). In this musical composi-
tion (see figure 5.15), Xenakis distributed different "sound densities" over the
28×7 "cells" with probabilities generated by the Poisson distribution with
$\lambda = 0.6$. Versions of *Achorripsis* with different values of the parameter of the
Poisson distribution create different moods and feelings to the sound pattern
and a different musical experience. A detailed analysis of *Achorripsis* can be
found in the article by Linda Arsenault listed in the references at the end of the
chapter.

Figure 5.15
Iannis Xenakis, *Musical Score of Achorripsis*, 1957.

Xenakis was an engineer and architect, who worked with Le Corbusier, be-
fore dedicating himself to music and becoming one of the most famous mu-
sic composers of postwar Europe. His writings in *Formalized Music* about
mathematics and music provide a wealth of information on his approach and
especially on his use of stochastic processes as an integral part of musical com-
position. Xenakis thought of different probability distributions as different in-
struments with which one can create music, each with its own color and its own
special feeling. In particular, in *Formalized Music* he wrote: "*Every probabil-
ity function* is a particular stochastic variation, which *has its own personality*...
Poisson, exponential, normal, uniform, Cauchy, logistic distributions."

5.5 All the Colors of Noise

A random signal $x(t)$ can be decomposed into frequencies, using a truncated
Fourier transform:

$$\hat{x}_T(\omega) = \frac{1}{\sqrt{T}} \int_0^T x(t) e^{-i\omega t} dt.$$

The spectral density (expectation value) $\hat{x}_T(\omega)$ describes the different distribu-
tion of frequencies in the random noise. Again, one can distinguish between
several kinds of randomness in noise. *Power-law noise* refers to spectral den-
sities of the form $1/\omega^\alpha$, for some exponent α. The best known examples of
different forms of power-law noise are given by

- White noise: $\alpha = 0$
- Pink noise: $\alpha = 1$
- Brown noise (Brownian): $\alpha = 2$
- Blue noise: $\alpha = -1$

White noise occurs, for example, in the "snow effect" of analog TV screens.
In pink noise, also referred to as $1/f$ noise, the lower frequencies are louder
than the higher frequencies, but it is usually perceived as being more "uniform"
than white noise, because it results in equal power per octave. In blue noise, on
the contrary, the energy of the signal increases with the frequency, increasing
by three decibels in each successive octave. Brown noise is the signal noise
of Brownian motion. Like pink noise, but even more so, it has more energy at
lower frequencies. It can be produced as an integral of white noise.

A white noise-inspired abstract painting by the British artist and architect
Susan Laughton is shown in figure 5.16. The painting suggests the "snow ef-
fect" of the white noise of communication and at the same time hints at a large
dark shape in the background, which is hidden by the noise: communication
noise as concealment. In fact, the viewer of the painting is left wondering

Figure 5.16
Susan Laughton, *White Noise I*, 2010.

whether the shapes are purely an effect of randomness or whether the randomness is hiding deterministic shapes, blurring them beyond recognition. This fits with our previous discussion of our intuitive perceptions of randomness versus regularity that make the language of randomness so feasible for art. The fact that the painted square is off-centered in the canvas adds a dynamical effect to the perception, which hints at randomness as a process rather than a stationary event. An elaborate use of various types of noise incorporated in paintings and installations can be seen in the work of the artist and movie director Laura Poitras in her *Astro Noise* installation series (see figure 5.17). This is an exhibition centered on the theme of mass surveillance and state violence, a theme she returned to frequently in her work, including the documentary movie *Citizenfour*, which was dedicated to the Snowden case. The term "Astro Noise" is a reference to the Cosmic Microwave Background noise, and at the same time a reference to the name given by Snowden to the file containing the evidence of the mass surveillance conducted by the U.S. National Security Agency (NSA).

In the piece of the *Astro Noise* series reproduced here, it is interesting how the term "Anarchist" is referring to the intercepting of government data (in this case satellite tracking), while at the same time it appears to be a reference to the noise filters, a kind of obfuscation action, an interference with the structures of power of society. Poitras is close to the anarchist cypherpunk movement, which engages in actions of electronic obfuscation and "sousveillance," to expose invasive government surveillance and control.

Figure 5.17
Laura Poitras, *ANARCHIST: Data Feed with Doppler Tracks from a Satellite (Intercepted May 27, 2009)*, Astro Noise series, 2016.

5.6 Chaos versus Randomness

Chaos theory developed from early ideas of Poincaré (in the 1880s) about nonperiodic orbits of dynamical systems. As a mathematical theory, it came to prominence in the 1960s, after Edward Lorenz discovered a *strange attractor* in the trajectories of fluid dynamics equations used in meteorology. The strange attractor has the property that trajectories that start near each other will typically end up moving around and in the proximity of the attractor, but their trajectories may vary significantly after a period of time, and they can end up in different regions of the attractor. Typical trajectories, moreover, as they get close to the attractor, jump seemingly unpredictably from one to the other of the attractor's two main spiral regions.

The attractor itself, shown in figure 5.18, has a very complicated structure, which is representative of a fractal geometry. It seems at first, by observing the trajectories of a system like the Lorentz attractor, that the motion is governed by a random process, but this is, in fact, not the case. It is a *chaotic* motion, but chaos does *not* mean randomness. Indeed, in most cases chaos is deterministic. What chaos means is *sensitive dependence on the initial condition*, that is, trajectories that start nearby will end up diverging quickly from each other. This in particular means that small errors in the determination of the initial conditions are amplified by the dynamics of the system, making it effectively unpredictable, even though the system itself remains fully deterministic.

Figure 5.18
Anders Sandberg, *The Lorenz Attractor*, 2006.

As in the case of the Lorentz attractor, the strange attractor sets of chaotic dynamical systems are typically *fractals*. This creates a close connection between chaos theory and fractal geometry. As we already discussed in a chapter 3, fractals are spaces of noninteger dimension: curves of dimension between one and two, surfaces of dimension between two and three, and so on. The fractal dimension detects how the measure of the set scales with its size. Fractals typically exhibit a self-similarity property that describes this scaling: the space looks identical to a union of scaled copies of itself.

Figure 5.19
Jackson Pollock, *One: N.31* (full work and detail), 1950.

5.6.1 The Fractal Dimension of Pollock's Drip Paintings

A series of papers, which appeared in prestigious research journals at the end of the 1990s and during the first decade of this century, proposed an intriguing possibility of identifying a specific "signature" in Jackson Pollock's drip paintings (such as figure 5.19) by considering their fractal dimension (see the references at the end of this chapter). It was observed that the fractal dimension of Pollock's paintings increased from $D \sim 1$ in 1943 to $D = 1.72$ in 1952. This seems to coincide with the increased complexity of the paintings over that same period of time. This observation could lead to a possible reliable method for dating Pollock's paintings, in the absence of other, more specific information. More intriguingly, and certainly more controversially, it may also provide a way to detect the authenticity (or lack thereof) of paintings attributed to Pollock.

In 2003, a set of 32 putative Pollock paintings were found by Alex Matter in the estate of his later father, Herbert Matter, who had been a friend of Jackson Pollock and Lee Krasner. Taylor, one of the authors of the first study on Pollock paintings and fractal dimension, claimed that these 32 purported

Pollock paintings were, in fact, fakes, based on fractal analysis. Naturally, this generated considerable controversy in the art world. Two other physicists, Jones-Smith and Mathur, later criticized the methodology used by Taylor. In 2008, Coddington, Elton, Rockmore, and Wang analyzed Pollock's paintings using *entropy dimension*, *local dimension* and *multifractal analysis* as a way of measuring "structured randomness." Their results confirmed Taylor's claim that the disputed paintings are fake.

The main point of this fractal analysis approach is that *deterministic* fractals are very homogeneous and have the same fractal dimension everywhere. Moreover, for such fractals, different notions of fractal dimension agree. On the contrary, *random* fractals (like the example in figure 5.20) typically have a varying local dimension and are best described via a stratification by subfractals, that is, by *multifractal* analysis.

Here is where fractal geometry, which is usually associated with deterministic systems with chaotic dynamics, merges with randomness, giving rise to a class of "random fractals" that combines the qualities of both randomness and chaos. The Pollock paintings certainly have a random structure, due to the drip technique itself; hence, an analysis based on fractal geometry and fractal dimensions is best achieved using the mathematical theory of random fractals.

Figure 5.20
John Shier and Paul Bourke, *Random Fractal: Mixture of Circles and Squares*, 2013.

Fractals of this type do not necessarily always have the same fractal dimension everywhere and are better understood in terms of a *local* dimension.

The *box counting dimension* of a fractal set X is obtained by covering the shape with grid boxes of small sizes ϵ, and computing

$$\dim_b(X) = -\lim_{\epsilon \to 0} \frac{\log N(\epsilon)}{\log(\epsilon)},$$

where $N(\epsilon)$ is the number of boxes of size ϵ that are needed to cover the set. The box counting dimension is usually only an approximation from above to the fractal dimension.

The *entropy dimension* is a refinement of the box counting dimension, whereby you take a measure μ supported on the fractal X. For example, if X is an image at a certain resolution, μ may be counting how many pixels are in a certain region of the image. Then, when covering X by grid boxes of size ϵ as before, we compute the entropy

$$S_\epsilon(\mu, X) = -\sum_{i=1}^{N(\epsilon)} \mu(B_i) \log \mu(B_i),$$

where B_i are the grid boxes of size ϵ used to cover X. Then we obtain the entropy dimension as

$$\dim_e(\mu, X) = -\lim_{\epsilon \to 0} \frac{S_\epsilon(\mu, X)}{\log(\epsilon)}.$$

The *local dimension* at a point x of a fractal X compares the growth of the measure μ of balls $B_r(x)$ of radius r centered at x with the growth of the radius,

$$D(\mu, x) = \lim_{r \to 0} \frac{\log \mu(B_r(x))}{\log r}.$$

If the local dimension is constant (or constant with a probability of one) then the entropy dimension and the fractal dimension are the same. However, in the case of random fractals, where typically the local dimension varies, the entropy dimension is a different invariant of the fractal geometry.

In the case of Pollock's paintings, as one can see by examining them in closer detail (as in figure 5.19), there is an intricate interplay of several overlapping structures with their own different local dimensions of fractality. The *multifractal analysis* corresponds to separating out "strata" of constant local dimension and computing the entropy dimension of each. This method provides more detailed information than simply computing a single average value of the fractal dimension.

Other mathematical methods were also applied to the analysis of Pollock drip paintings. In particular, the work of Herczyński, Cernuschi, and Mahade-

van used *fluid dynamics*, which allows for a description of how patterns in fluids form as they fall, depending on viscosity and speed. This is a way of capturing specific signatures in the drip paint techniques of Pollock that would be particular to his own personal style.

There is no clear conclusion, no silver bullet that would uniquely identify the specific style of the artist in a measurable mathematical way, that can completely resolve questions of authenticity. However, this is not surprising, for it is hard to find a single complete invariant that characterizes any complicated structure. Even if mathematical analysis alone is not sufficient to authenticate Pollock's paintings with complete certainty, it still provides interesting methods for studying them.

Chapter Appendix: Bibliographical Guide

A.1 Guide to the Artists

The following bibliographical list provides additional reading material concerning the work of the artists discussed in this chapter.

- Rudolf Arnheim, *The Genesis of a Painting: Picasso's Guernica*, University of California Press, 2006.
- Herschel Browning Chipp and Javier Tusell, *Picasso's Guernica: History, Transformations, Meanings*, University of California Press, 1988.
- Georges Mathieu, *De la révolte à la Renaissance: au-delà du Tachisme*, Gallimard, 1973.
- Georges Mathieu, *La réponse de l'abstraction lyrique et quelques extrapolations d'ordre esthétique, éthique et métaphysique*, La Table ronde, 1975.
- Édouard Lombard, "La Nature Calligraphique de l'Oeuvre de Georges Mathieu," in *Georges Mathieu—le Site Officiel* (online).
- Emilio Vedova, *. . .Cosiddetti Carnevali. . .*, Skira, 2013.
- Carlo Bertelli, *Emilio Vedova*, Charta, 2006.
- Adrian Duran, *Painting, Politics, and the New Front of Cold War Italy*, Ashgate Publishing, 2014.
- Juan José Gómez Gutiérrez, *The PCI Artists: Antifascism and Communism in Italian Art, 1944–1951*, Cambridge Scholars Publishing, 2015.
- Gail Levin, *Inside Out: Selected Works by Janet Sobel*, Gary Snyder Fine Art, 2003.
- Gail Levin, "Janet Sobel: Primitivist, Surrealist, and Abstract Expressionist," *Woman's Art Journal* 26, no. 1 (2005): 13.
- Ellen G. Landau and Jeffrey D. Grove, *Lee Krasner: A Catalogue Raisonné*, Abrams, 1995.
- Gail Levin, *Lee Krasner: A Biography*, Harper Collins, 2011.

- Richard Howard, *Lee Krasner: Umber Paintings, 1959–1962*, Robert Miller Gallery, 1993.

- Joan M. Marter, Gwen F. Chanzit, and Irving Sandler, *Women of Abstract Expressionism*, Yale University Press, 2016.

- Will Kitson, "Dr. Regina Valluzzi: The Grand Experiment—Bridging the Gap between Science and Art," *Seymour Magazine*, 2015 (online).

- Hiroshi Kawano, "What is Computer Art?" 1975; in *Artist and Computer*, ed. Ruth Leavitt, Harmony Books, 1976 (available at Atari Archives online).

- Ruth Leavitt, ed., *Artist and Computer*, One Park Avenue, Harmony Books, 1976.

- Camille McPhee, *Thesis Exhibition Statement*, 2012 (online).

- Wilson Wong, *Geometry Becomes a Universal Language in the Paintings of Russian Artist Elena Kozhevnikova*, Agora Gallery, 2015 (online).

- Christianna Bonin and Erica DiBenedetto, *Sol LeWitt: The Well Tempered Grid*, Williams College Museum of Art, 2013.

- Gary Garrels, *Sol LeWitt: A Retrospective*, San Francisco Museum of Modern Art, Yale University Press, 2000.

- Susan Laughton, *Measured Space*, Duckett and Jeffreys Gallery, Malton, North Yorkshire, UK, 2010.

- Susan Laughton, *Traveling Light*, Quercus Gallery, Bath, UK, 2015.

- Laura Poitras, *Astro Noise: A Survival Guide for Living under Total Surveillance*, Yale University Press, 2016.

Regarding Iannis Xenakis and his work on musical composition based on stochastic processes, as well as his work in art and architecture, the reader can consult the following references. The last reference in this list presents a broader perspective on algorithmic methods and random processes in musical composition.

- Iannis Xenakis, *Formalized Music: Thought and Mathematics in Music*, Pendragon Press, 1992.

- Iannis Xenakis, *Musique de l'architecture*, Parenthèses, 2004.

- Linda M. Arsenault, "Iannis Xenakis's Achorripsis: The Matrix Game," *Computer Music Journal* 26, no. 1 (2002): 58–72.

- Sharon E. Kanach, *Performing Xenakis*, Pendragon Press, 2010.

- Sharon E. Kanach and Carey Lovelace, *Iannis Xenakis: Composer, Architect, Visionary*, Drawing Center, 2011.

- Gerhard Nierhaus, *Algorithmic Composition: Paradigms of Automated Music Generation*, Springer Verlag, 2009.

The following references cover Jackson Pollock's paintings, the multifractal analysis approach, and the controversy surrounding the 32 disputed paintings.

- Ellen G. Landau, *Jackson Pollock*, Abrams, 2010.

- Kirk Varnedoe, *Jackson Pollock*, Museum of Modern Art, 1998.

- Randy Kennedy, "Is This a Real Jackson Pollock?" *New York Times*, May 29, 2005.
- Tom Zeller Jr., "Purported Pollock Paintings: Still a Pickle," *New York Times*, January 31, 2007.
- Richard P. Taylor, Adam Micolich and David Jonas, "Fractal Analysis of Pollock's Drip Paintings," *Nature* 399 (1999): 422–423.
- Kate Jones-Smith and Harsh Mathur, "Fractal Analysis: Revisiting Pollock's Drip Paintings," *Nature* 444 (2006): E9.
- Jim Coddington, John Elton, Daniel Rockmore, and Yang Wang, "Multifractal Analysis and Authentication of Jackson Pollock Paintings," *Computer Image Analysis in the Study of Art* (2008): 68100F.
- Andrzej Herczyński, Claude Cernuschi, and L. Mahadevan, "Painting with Drops, Jets, and Sheets," *Physics Today* 64, no. 6 (2011): 31–40.
- D.-J. Feng and Y. Wang, "A Class of Self-Affine Sets and Self-Affine Measures," *Journal of Fourier Analysis and Applications* 11 (2005): 107–124.

A.2 Guide to the Theory of Randomness

A broad philosophical discussion on the notion of randomness and its role in the arts and literature can be found in Stanislaw Lem's book *The Philosophy of Randomness*. Unfortunately, the book was never translated into English, although a Russian and a German translation are available, in addition to the original Polish edition. Some other references on randomness from a more philosophical perspective, with some attention to the role in artistic and literary expression, are collected here.

- Stanislaw Lem, *Filozofia Przypadku* (The philosophy of chance), 1968.
- Prasanta S. Bandyopadhyay, *Philosophy of Statistics*, Elsevier, 2011.
- Katja Kwastek, *Aesthetics of Interaction in Digital Art*, MIT Press, 2013.
- Juan J. Romero, *The Art of Artificial Evolution: A Handbook on Evolutionary Art and Music*, Springer Verlag, 2008.
- Peter Swirski, *Of Literature and Knowledge: Explorations in Narrative Thought Experiments, Evolution and Game Theory*, Routledge, 2007.
- N. Katherine Hayles, *Chaos and Order: Complex Dynamics in Literature and Science*, University of Chicago Press, 2014.

A general introduction to the mathematical theory of probability and random processes can be found in the following references, ordered in increasing technical difficulty.

- Don S. Lemons, *An Introduction to Stochastic Processes in Physics*, Johns Hopkins University Press, 2002.
- Arthur Engel, *Processus aléatoires pour les débutants*, Cassini, 1976.
- Gregory F. Lawler, *Random Walk and the Heat Equation*, American Mathematical Society, 2010.
- Geoffrey Grimmett and David Stirzaker, *Probability and Random Processes*, Oxford University Press, 2001.

- Daniel A. Klain, Gian-Carlo Rota, *Introduction to Geometric Probability*, Cambridge University Press, 1997.

The following references cover tests of randomness and different kinds of random noise, starting with science popularization references and moving toward more detailed accounts.

- Meghan Neal, "The Many Colors of Sound," *The Atlantic*, 2016 (online).
- Bart Kosko, *Noise*, Penguin, 2006.
- Peter Norvig, "Warning Signs in Experimental Design and Interpretation," 2012 (online).
- Terry Ritter, "Randomness Tests: A Literature Survey," 2002 (online).
- Hector Zenil, *Randomness through Computation: Some Answers, More Questions*, World Scientific, 2011.
- M. R. Schroeder, "Noises: White, Pink, Brown, and Black," in *Fractals, Chaos, Power Laws*, W. H. Freedman, 1991.
- Bernard Chazelle, *The Discrepancy Method: Randomness and Complexity*, Cambridge University Press, 2000.

About random fractals, multifractals, and the relation between fractal geometry and deterministic chaos theory, the reader can consult some of the following references.

- Manfred R. Schroeder, *Fractals, Chaos, Power Laws: Minutes from an Infinite Paradise*, Dover, 2012.
- Paul S. Addison, *Fractals and Chaos: An Illustrated Course*, CRC Press, 1997.
- Dietrich Stoyan and Helga Stoyan, *Fractals, Random Shapes, and Point Fields: Methods of Geometrical Statistics*, Wiley, 1994.
- Kenneth Falconer, *Fractal Geometry: Mathematical Foundations and Applications*, John Wiley, 2013.
- John Shier and Paul Bourke, "An Algorithm for Random Fractal Filling of Space," *Computer Graphics Forum* 32, no. 8 (2013): 89–97.

The following references discuss randomness in cosmology, especially the Cosmic Web structures and the possible presence of multifractality in cosmology.

- J. Richard Gott, *The Cosmic Web: Mysterious Architecture of the Universe*, Princeton University Press, 2016.
- Andrea Gabrielli, F. Sylos Labini, Michael Joyce, and Luciano Pietronero, *Statistical Physics for Cosmic Structures*, Springer Verlag, 2006.
- V. Springel, S. D. M. White, A. Jenkins, C. S. Frenk, N. Yoshida, L. Gao, J. Navarro, R. Thacker, D. Croton, J. Helly, J. A. Peacock, S. Cole, P. Thomas, H. Couchman, A. Evrard, J. Colberg, and F. Pearce, "Simulations of the Formation, Evolution and Clustering of Galaxies and Quasars," *Nature* 435 (2005): 629.
- Matilde Marcolli, *Noncommutative Cosmology*, World Scientific, 2018.

6 Plentiful Nothingness: The Void in Modern Art and Modern Science

In this chapter we are going to approach the concept of *vacuum*, the *void*, and the crucial role it plays in both modern art and modern science. In art, I will show how philosophical reflections on the notion of emptiness came to inform several important moments in the early 20th century avant-garde period, as well as in the postwar artistic movements. The artists' quest for a representational role for the void, in the context of modern nonfigurative art, parallels some deep reflections on the nature of the vacuum in quantum physics and in general relativity.

6.1 The Vacuum

From the point of view of both art and science, the main change of paradigm happened in replacing the classical notion of the vacuum as passive and undifferentiated, with a modern notion in which the vacuum is active, differentiated, and dynamical. The main concept I will analyze in this chapter is the idea that *the vacuum has structure*.

6.1.1 The Classical Vacuum

By "classical" I refer to the context of traditional (prior to the 20th century) figurative art, as well as to the scientific worldview associated with classical (pre-quantum and pre-relativistic) physics.

In this classical setting, empty space is a fixed frame of reference, a Cartesian coordinate system, a receptacle or container for movements of particles or the representations of figures and bodies. The void is a set stage on which action takes place, an absolute and immutable rigid grid of coordinates.

A good image of this idea of empty space is depicted in Dürer's engraving, *The Drawing Frame* (figure 6.1), where the artist is represented in the act of filling with action and representation the rigid grid of empty space, which serves as an absolute reference frame.

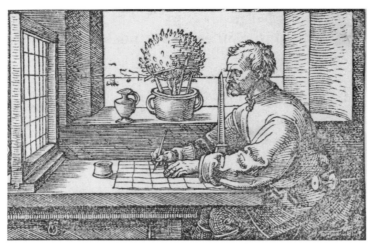

Figure 6.1
Albrecht Dürer, *The Drawing Frame (Draughtsman Drawing a Recumbent Woman)* (detail), 1525.

6.1.2 The Suprematist Void

The first significant break from the classical role of empty space as immobile canvas and fixed frame of reference occurred in the Russian avant-garde, especially with the Suprematist movement and Malevich's numerous representations of "the void." In 1918, Malevich writes: "the square—sensation, the white field, the void beyond sensation."[4] When we view the famous *Black Square* (figure 6.2) in this interpretive key, we notice that it is not only the contrast of the black foreground shape on the white background that is significant, but also the more subtle contrast between the fact that in the painting, the black square has a thick *texture*, while the white background is flat.

We can see a similar role of texture in the painting *White on White* (figure 6.3), where a smaller white square, tilted at an angle, is inscribed inside a larger one. The different texture of the two white figures plays an important role in the image, as does the dynamical effect of the tilting angle. The texture, as in the case of the *Black Square* hints at the presence of "content" and "structure" in the vacuum, and the geometry of the relative position of the two squares suggests a relational view of space.

[4] R. Herbert, *Modern Artists on Art*, Prentice Hall, 1964.

Figure 6.2
Kazimir Malevich, *Black Square*, 1913.

Figure 6.3
Kazimir Malevich, *Suprematist Composition: White on White*, 1918.

The presence of texture elements in Malevich paintings, when used as a way to fill the void with structure, is representative of a whole change of perspective in thinking about the void. To phrase it as the physicist Isaak Pomeranchuk did in 1950: "the vacuum is filled with the most profound physical content."[5] This is indeed the modern scientific point of view about the vacuum, as I will discuss more in detail in the rest of this chapter.

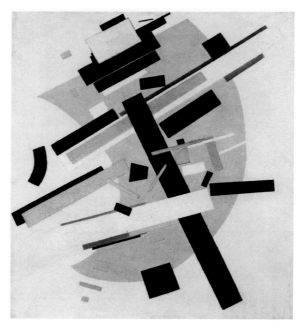

Figure 6.4
Kazimir Malevich, *Supremus 58 (Suprematism: Yellow and Black)*, 1916–1917.

The use of geometry to highlight the relative positions and interaction of shapes can be seen very prominently in the painting *Supremus 58* (see figure 6.4). In Malevich's paintings, space is clearly not an absolute frame of reference: it is entirely defined relationally by the shapes (which are the analog of the matter, fields, and energy of physicists) that occupy it and by their modes of interactions.

[5] L. B. Okun, "Vacua, Vacuum: The Physics of Nothing." In *History of Original Ideas and Basic Discoveries in Particle Physics* (Eds. H. B. Newman, T. Ypsilantis), Plenum Press, 1996.

6.2 Gravity and the Geometry of Empty Space

In modern physics the void, meant here as empty space, has shape because *gravity is geometry*. The metric and the curvature describe the *gravitational field* in Einstein's theory of general relativity, and the vacuum of empty space simply means that the gravitational field encounters no *matter* to interact with.

The Einstein-Hilbert action functional for gravity,

$$S = \frac{1}{2\kappa} \int R \sqrt{-g} d^4 x,$$

is a function of the scalar curvature R. The equations of motion of the gravitational field are given by the variational problem for this functional (Euler-Lagrange equation),

$$R_{\mu\nu} - \frac{1}{2} g_{\mu\nu} R = 0;$$

in other words, the Einstein field equations in vacuum.

This way of describing physics in terms of an *action functional* and its *variational equations* represents a very broad general point of view: the *principle of least action*, according to which the classical (as opposed to quantum) laws of motion of a physical system are the trajectories that minimize the action. This principle was first developed in the context of the laws of optics, and then generalized to classical mechanics, to the relativistic theory of gravity, and to various (classical) field theories.

The solutions of Einstein's field equations in vacuum describe a *curved space*. The equations assume the choice of a fixed background *topological* space, which also has a given *smooth* structure, and the Einstein equations only affect the form of the *metric* on this type of background.

When gravity couples with matter, the action functional acquires additional terms that describe what kinds of particles and forces are present in the matter sector of the theory and how they interact with gravity. The typical form of the action functional for matter minimally coupled with gravity is

$$S = \int (\frac{1}{2\kappa} R + \mathcal{L}_M) \sqrt{-g} \, d^4 x,$$

where the term \mathcal{L}_M (the Lagrangian of the matter sector) is the part that described matter in a gravitational background, and the Einstein field equations are correspondingly modified as

$$R_{\mu\nu} - \frac{1}{2} g_{\mu\nu} R = \frac{8\pi G}{c^4} T_{\mu\nu},$$

with G the gravitational constant, c the speed of light and $\kappa = 8\pi G/c^4$, where the *energy-momentum tensor*

$$T_{\mu\nu} = -2\frac{\delta\mathcal{L}_M}{\delta g^{\mu\nu}} + g_{\mu\nu}\mathcal{L}_M$$

is derived from the matter content of the theory.

Solutions of Einstein's equation in vacuum can have different curvature: there can be positively curved, negatively curved, and flat universes. The geometry of our physical universe, in particular what kind of curvature it has, can be detected by measurements of the Cosmic Microwave Background (CMB), obtained first by high-altitude balloons (the "Boomerang" experiment) and by increasingly accurate measurement obtained through subsequent generations of satellites, including COBE, WMAP, and Planck. The results of the Boomerang experiment first confirmed that the geometry of the universe is flat (or nearly flat, as it may be slightly positively curved). However, knowing the geometry (curvature) of the universe is only a local type of information, which does not determine necessarily the global topological shape. For example, the universe may be flat and still not (spatially) infinite: it could be shaped like a *flat torus*. The local geometry of a torus is indistinguishable from that of infinite flat space, but *topologically* they are not equivalent spaces. This is the *cosmic topology problem* mentioned in chapter 3. We will return to discuss it at length in chapter 9.

Cosmologists trying to address the problem of cosmic topology created simulated versions of the map of the CMB radiation, as they would appear in different candidate cosmic topologies: tori and Bieberbach manifolds (quotients of tori) in the flat case, and various spherical space forms like the Poincaré dodecahedral space (quotients of the three-dimensional sphere, figure 6.5) in the positively curved case. The simulated CMB sky in a dodecahedral space universe is illustrated in figure 6.6. The negatively curved cases appear to be strongly disfavored by current cosmological data derived from the CMB.

All the possible candidate cosmic topologies considered by theoretical cosmologists rely on two very strong assumptions about the geometry of the cosmos: *homogeneity* and *isotropy*. The first property, homogeneity, consists of the assumption that the cosmos looks the same at all locations, and the second, isotropy, that it looks the same in all directions. Requiring both assumptions to hold at the same time is regarded as the standard cosmological principle. These assumptions are very strong, in the sense that they force the three-dimensional space to be of constant curvature, hence in the positive curvature case a spherical space form (quotient of the sphere), in the negatively curved case a hyperbolic three-manifold (quotient of three-dimensional hyperbolic space) and in

Figure 6.5
Poincaré homology sphere (dodecahedral space), drawn with Jenn3D.

the flat case a torus or Bieberbach manifold (quotient of a torus). This means that all of these spaces are *locally* indistinguishable from either a sphere or flat Euclidean space, or a hyperbolic space: it is only the differences in global topology (the way in which the space folds over onto itself in a nontrivial way) that distinguish them.

Dropping the isotropy assumption while maintaining homogeneity leads to some very interesting models of cosmologies, called mixmaster universes, that exhibit a chaotic behavior of alternating phases of expansion and contraction, called Kasner epochs (see figure 6.7). During each epoch the three spatial directions undergo a series of alternating cycles of expansion and contraction, with one direction driving the overall expansion and the other two oscillating. At the end of each epoch the role of the three directions is exchanged and another such series of cycles begins. The dynamics of these homogeneous but nonisotropic mixmaster universes is modeled by a discrete dynamical system defined in terms of the continued fraction expansion of real numbers.

Figure 6.6
S. Caillerie et al., *Dodecahedral Space Simulated CMB Sky*, 2007.

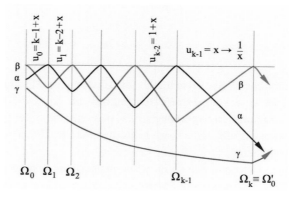

Figure 6.7
Lyudmil Antonov, *Kasner Epochs and Eras*, 2009.

On the other hand, retaining isotropy and dropping homogeneity leads to fractal models of cosmology known as the "Packed Swiss Cheese Cosmology," which look like the fractal residual set that remains after a packing of balls of space is removed from an initial isotropic and homogeneous cosmology. The resulting space looks like a three-dimensional analog of the Apollo-

Figure 6.8
Apollonian circle packing.

nian packing of circles (see figure 6.8). These cosmological models, based on Apollonian sphere packings, provide an example of occurrence of fractal and multifractal structures in cosmology, since the residual set of an Apollonian packing of circles or of higher dimensional spheres (which is what is left after the interior of all the circles/spheres is removed) is a fractal set of noninteger dimension.

Dropping both homogeneity and isotropy leads to arbitrary geometries with variable curvature. One can speculate about what a simulated CMB sky would look like in a universe that is neither homogeneous nor isotropic. Some of the late sculptures of Ken Price (see figures 6.9 and 6.10) seem tantalizingly reminiscent of a CMB sky, complete with scattered irregularities due to temperature fluctuations, over a curved ceramic backgrounds. These "skies" are drawn over highly nonhomogeneous and nonisotropic shapes of variable curvature and different nontrivial topologies.

Figure 6.9
Ken Price, *Fats*, 1999.

Figure 6.10
Ken Price, *Underhung*, 1997.

6.2.1 The Void Is Dynamical

The Einstein equations in vacuum, that we discussed briefly above, lead to solutions that describe nonstatic universes that expand or contract with time. At first, this was considered a disadvantage of the theory and static solutions were sought by adding a term in the equation, depending on a cosmological constant, that could be adjusted to create static solutions. Such solutions are unstable though, and small changes to the value of the cosmological constant would cause them to turn into nonstatic universes. Einstein's equations in vacuum with cosmological constant take the form

$$R_{\mu\nu} - \frac{1}{2}g_{\mu\nu}R + g_{\mu\nu}\Lambda = 0.$$

These correspond to modifying the action functional of general relativity by an additional term, so that it becomes

$$S = \int (\frac{1}{2\kappa}R - 2\Lambda)\ \sqrt{-g}\,d^4x.$$

The cosmological constant has an effect on the expansion or contraction of the universe. It can act as a "repulsive force" countering the attractive force of gravity: it can cause the universe to expand, contract, or remain stationary, depending on the overall balance of forces. The cosmological constant is therefore interpreted as measuring the *energy of empty space,*

$$\rho_{\text{vacuum}} = \frac{\Lambda c^2}{8\pi G},$$

where c is the speed of light and G the gravitational constant. As I will discuss later in this chapter, this "energy of empty space" receives contributions from *particle physics,* and it is an important mystery of cosmology why its value appears to be extremely small, while contributions from particle physics would be expected to make it large.

6.2.2 Empty Space Has Singularities

Singularities in cosmology include the initial singularity (the Big Bang) and singularities created by black holes. While the usual notion of a black hole involves the gravitational collapse of stellar objects, which require a nonempty space populated with matter in order to arise, it is possible that *primordial black holes* might have formed in the very early universe. These would not be stellar objects, as they would have predated the formation of structures like stars and galaxies, but they are believed to have formed as a result of the collapse of dense regions of space itself in the early phases of the universe.

Figure 6.11
Lucio Fontana, *Concetto spaziale, attese 58 T 2*, 1968.

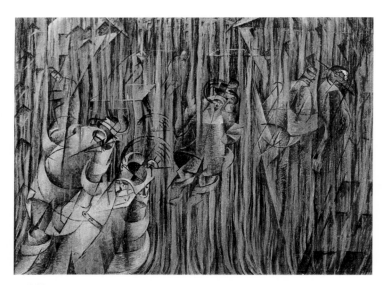

Figure 6.12
Umberto Boccioni, *Stati d'animo, quelli che restano*, 1911.

As discussed in chapter 4, Penrose's Weyl curvature hypothesis argues that the increase in entropy of the universe along its evolution from an initial low-entropy Big Bang coincides with an increasing concentration of Weyl curvature caused by the accumulation of black holes.

6.2.3 The Spatialist Void

An echo of the concept of singularities tearing at the structure of space and increasingly filling it, as in Penrose's Weyl curvature hypothesis model, and of increasing entropy related to a higher density of singularities can be found expressed very powerfully in the works of Lucio Fontana (see figure 6.11), who founded the Spatialism artistic movement in the late 1940s. In his first manifesto, Fontana clearly stated that art should embrace science and technology. This meant both the use of novel materials (as in a series of sculptures realized with curved neon light tubes) and the use of concepts, like that of space itself, as envisioned by the contemporary developments in science. Most of Fontana's works on canvas have the programmatic title *Concetto spaziale*, or *spatial concept*, as a reminder that the exploration of the concept of space is a fundamental purpose of contemporary art. Many of these "spatial concepts" present a variously colored background (often uniform, or with superimposed areas of nearly uniform colors), while the main structure is created by a series of cuts, of singularities tearing apart the ambient flat space, which usually reveal a black background, created by a darkly colored second layer behind the holes.

In the work of figure 6.11, a 1968 piece *Concetto spaziale, attese*, the configuration of the cuts, the color chosen for the background and the subtitle "Attese," that is "the times of waiting," appear to be a likely reference to Umberto Boccioni's painting *Stati d'animo, quelli che restano* (states of mind, those who stay; see figure 6.12). "Those who stay" also translates as "those who remain," and that is indeed what the accumulating singularities do in Penrose's Weyl curvature cosmos: they are what ultimately remains in the high-entropy late time of the universe.

We see the accumulation of singularites in empty space, as well as its growing entropy, depicted in another of Fontana's spatial concepts, from 1952 (see figure 6.13), where dark and empty space is progressively filled by a growing constellation of singularities, like a whole galaxy of holes punctuating the canvas, orbiting around a large dark central object rendered visible only by its thick, black texture of round circles against a uniform flat black background.

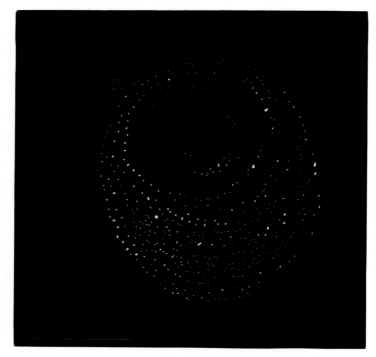

Figure 6.13
Lucio Fontana, *Concetto spaziale*, 1952.

6.3 The Void in Quantum Physics

In both quantum field theory and string theory processes of field interactions
are described *diagrammatically*. The development of this important graphical
tool for making calculations in high-energy physics has its origin in Feynman
integrals and was largely developed and popularized within the community of
physicists by Freeman Dyson. A detailed historical account of the develop-
ment of diagrammatical methods in theoretical physics can be found in the
references listed in the bibliography at the end of this chapter.

There is an important difference between the diagrams used to label Feyn-
man integrals in perturbative quantum field theory and the diagrams used in
string theory. In the first case, the diagrams are graphs, while in the second
case they are two-dimensional surfaces (see figure 6.14). In chapter 3 I dis-
cussed the difference between these two classes of topological spaces, graphs
and two-dimensional surfaces. In particular, we have seen that, despite the
fact that they are higher dimensional, surfaces are simpler topological spaces

Figure 6.14
World lines and world sheet: Diagrams in quantum field theory and string theory.

to classify than graphs. Correspondingly, the fact that string theory deals with such surface diagrams rather than with the more complicated graph diagrams of quantum field theory, is considered a major advantage in the theory, which technically eliminates several serious divergence problem related to the "renormalization" of Feynman graphs.

6.3.1 Quantum Field Theory and Feynman Graphs

In perturbative quantum field theory, one describes the theory by assigning a classical action functional

$$S(\phi) = \int \mathcal{L}(\phi)d^D x = S_{\text{free}}(\phi) + S_{\text{interaction}}(\phi)$$

where the Lagrangian density $\mathcal{L}(\phi)$ is a function of the fields, usually taken to be of the form

$$\mathcal{L}(\phi) = \frac{1}{2}(\partial\phi)^2 + \frac{m^2}{2}\phi^2 + \mathcal{L}_{\text{interaction}}(\phi)$$

where the interaction term $\mathcal{L}_{\text{interaction}}(\phi)$ is a polynomial in the field ϕ describing the self-interaction of the field. In the case of a theory with several different interacting fields, more complicated interaction terms involving the couplings of the different fields are also included. Specifying the action functional only gives a classical field theory. Quantum effects are accounted for by a series of terms labeled by graphs (Feynman graphs) that describe processes of particle interactions: this leads to an *effective action* that accounts for all the quantum corrections for the classical action and is a formal series with one term for each

diagram describing a possible interaction process,

$$\mathcal{S}_{eff}(\phi) = \mathcal{S}_{\text{free}}(\phi) + \sum_{\Gamma} \frac{U(\Gamma, \phi)}{\#\text{Aut}(\Gamma)}.$$

Each term $U(\Gamma, \phi)$, which counts the contribution of a certain Feynman graph Γ, is an integral over momenta flowing through the graph. Thus, each graph should be thought of as a diagram, describing a certain event involving particle (field) interactions. Such diagrams typically have a number of "external edges," which specify which particles, with which momenta, are incoming at the beginning of the interaction process and which are outgoing at the end of it. In between, several events can take place, where particles merge or split, are created and annihilated, and exchange other particles (forces).

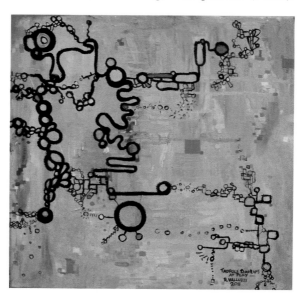

Figure 6.15
Regina Valluzzi, *Tadpole Diagrams at Play*, 2011.

The interpretation given by physicists to the diagrams vary: they are either considered as purely computational devices, which keep track of the terms in the perturbative expansion of the effective action, or else they can be thought of as a *material plenum* of interactions between fields (e.g., photons and electrons in the case of quantum electrodynamics).

This graphical aspect of computations in high-energy physics has its own aesthetic appeal. An artist who is also a physicist, Regina Valluzzi, has rep-

resented this graphical aspect of quantum field theoretic computations in her painting *Tadpole Diagrams at Play* (see figure 6.15). Physicists know that even for a very small number of loops, computations of Feynman integrals become extremely difficult to perform, hence the presence of a large number of loops in the fictitious Feynman diagram represented in the painting certainly hints at a something tantalizingly beyond the limits of accessible computations. The playfully mocking title not only hints at "playfulness" itself (the diagrams are "at play") but refers to the image as a "tadpole" diagram, where the term specifically designates only the "simplest" single-loop diagram. It appears as if a bunch of simple and computable tadpole diagrams have coalesced together to produce a complex, many-loop diagram, as if to mock the physicist attempting to perform the computation.

The creation and annihilation processes that happen in the graphical diagrams in particular involve *virtual particles*: transient fluctuations that look like particles, but that are created out of the vacuum and disappear almost immediately back into the vacuum. Virtual particles correspond to the "internal edges" of the graph: at the end of the process, only the outgoing external edges will remain as actual particle results of the interaction, but during the interaction, especially in a diagram with many loops, many virtual particles are created and annihilated, nearly instantaneously, until the final outcome is achieved. Virtual particles are not bound to satisfy the mass-energy relations that are expected of real particles: instead, they can be "off-shell."

In recent years, theoretical physicists and mathematicians have discovered a surprising and unexpected connection between the computations of Feynman diagrams in quantum field theory and a type of numbers of significance in the mathematical field of number theory. These numbers, called *periods*, are obtained by integration of algebraic functions subject to a set of algebraic constraints over a geometric space that is a (possibly singular) algebraic variety. I briefly discussed algebraic geometry and algebraic varieties as one of the various possible models of spaces in mathematics in chapter 3, and we will return to discuss various types of numbers and their relation to physics in chapter 7. It should be noted that the algebrogeometric spaces associated in this way to Feynman diagrams capture geometrically the particle events encoded in the Feynman graph, but are not describing an underlying spacetime geometry in which the events take place.

6.3.2 Vacuum Bubbles

Processes in quantum field theory that only involve virtual particles emerging from the vacuum, interacting with each other and with themselves, and then disappearing again back into the vacuum are represented by graphs that have

Figure 6.16
Regina Valluzzi, *Vacuum Energy*, 2010.

no external edges. These Feynman graphs without external legs are called the
vacuum bubbles. They contribute to the computation of the "partition function"
(the probability distribution of the energy levels) of the quantum field theory.

Thus, from the point of view of quantum field theory, the vacuum is filled
with virtual particles and their interactions: it is a dynamical entity teeming
with a continuous bubbling into life of particles whose energies are "borrowed"
from the vacuum and quickly returned to it, when the virtual particles disappear
back into the vacuum. This incessant dance of creation and annihilation out of
the vacuum is what gives it an interesting and intricate structure, which can be
detected by the partition function of the theory.

The phenomenon of "vacuum bubbles" is specific to quantum field theory
and the very small scales at which these quantum phenomena are taking place.
However, it also affects the large scales of cosmology, since vacuum bubbles
have an effect on the cosmological constant. This fact was first noticed by
the theoretical cosmologist Yakov Zeldovich in 1967: the continuous bubbling
of virtual particles out of the vacuum of quantum field theory contribute to
the cosmological constant Λ through the existence of a nontrivial zero-point

energy of a harmonic oscillator

$$E = \frac{1}{2}\hbar\omega.$$

The vacuum is the ground state of a collection of harmonic oscillators describing the independent degrees of freedom of the quantum field. For instance, the quantum electrodynamics (QED) vacuum energy can be seen as the contribution of all the harmonic oscillators that describe the degrees of freedom of the electromagnetic field,

$$E = \langle 0|\hat{H}|0\rangle = \langle 0|\frac{1}{2}\int(\hat{E}^2 + \hat{B}^2)\,d^3x|0\rangle = \delta^3(0)\int\frac{1}{2}\hbar\,\omega_k\,d^3k,$$

where the volume is regularized with limit for $V \to \infty$ given by

$$\frac{E}{V} \to \frac{\hbar}{8\pi^2c^3}\int_0^{\omega_{max}}\omega^3\,d\omega,$$

with \hbar the Planck constant, normalized by dividing by 2π, and c the speed of light. The problem is that all these contributions would lead to an enormously large cosmological constant Λ (in fact, a divergent one), while we know from cosmological observation that the cosmological constant is enormously small. The problem of justifying an incredibly small value for the cosmological constant is regarded as a central problem in theoretical cosmology.

The *Vacuum Energy* painting of Regina Valluzzi (see figure 6.16) shows a bubbling of virtual particles from the vacuum that draws the shape of a macroscopic-scale landscape, like the vacuum energy contributing to the cosmological constant, hence to the shape of spacetime through the Einstein field equations of general relativity.

6.4 The Void in Quantum Gravity

Quantum field theory has been extremely successful at providing a quantization of particles and forces, culminating in the complete description of the Standard Model of elementary particle physics, whose experimental verification was completed with the observation of the Higgs boson (predicted theoretically by the model, but never before observed) at the Large Hadron Collider (LHC) in 2012. We will return to discuss particle physics models in chapter 8. The descriptions of the Standard Model and the quantum theory, which allow for the computational predictions of results of collider experiments were a major achievement of 20th-century physics. However, the remaining force that shapes the universe, *gravity*, is not accounted for in a fully quantum description. Indeed, the problem of developing a fully consistent theory of *quantum gravity* is still one of the major goals of theoretical physics. Currently, possi-

ble approaches to a quantum theory of gravity include string theory, which is at present certainly the one that is most broadly developed, and other concurrent models, such as loop quantum gravity, dynamical triangulations, twistor theory, Euclidean quantum gravity and noncommutative geometry. I will not review these approaches here: I simply want to highlight one aspect of quantum gravity, that is common to all these approaches in some way.

Figure 6.17
M. Weiss, *Quantum Foam*, NASA's Chandra X-ray Observatory, 2015.

The classical (in the sense of nonquantum) spacetime of general relativity is a smooth manifold of a fixed topological shape, on which the metric describes the (dynamical) gravitational field. This is indeed what spacetime looks like at large scales. However, this picture dramatically changes when spacetime is considered at very small scales. The Planck scale, which is of the order of 10^{-35} meters, is the level of "smallness" at which quantum effects in gravity should become prominent. Current technology cannot probe that small a scale directly, hence one can only infer by theoretical predictions how physics would look like there. At the quantum level, down at the Planck scale, spacetime becomes a *quantum foam* (see figure 6.17) of shapes bubbling out of the vacuum, with variable topologies, emitted and reabsorbed by the vacuum, as in the case of the virtual particles of quantum field theory.

These quantum foams can have arbitrarily complicated topologies, just as the graph diagrams of virtual particles can have a large number of loops. The more energetic the quantum foam that bubbles out of the vacuum, the more complicated the topological shapes it can involve. In figure 6.17 one sees configurations of varying topological complexity in quantum foams.

At the quantum gravity level, spacetime looks more like a sponge than like a smooth surface.

6.4.1 Yves Klein's Void

Figure 6.18
Yves Klein, *Relief éponge bleue RE 19*, 1960.

The contrast between the large-scale smooth structure of spacetime and the small-scale sponge-like structure resonates very strongly with the blue sponge reliefs of Yves Klein (see figure 6.18), where a flat, uniformly smooth blue background space breaks into a growth of sponge structures, which are painted in the same blue color to denote the fact that the flat background and the "quantum foam" sponges are both aspects of the same spatial entity.

Yves Klein had a general interest in the theme of "the void" in his work, most famously represented in his photographic self-portrait, *Leap into the Void*. He described his paintings by saying that there was "nothing there at all, just the Void." While this has been interpreted by some as a mocking satire of modern art, in fact it is a more serious statement. Klein's paintings do indeed represent the void, in all its differentiation and complexity, from the uniform texture of the large scales to the bubbling structures of the small scales. Klein's art is one

of the best renderings in contemporary art of the intricate nature of the concept of the void.

If we look at the case of Klein's blue sponge relief in figure 6.18, we see that the upper part of the canvas space looks uniformly flat, like spacetime does at the larger scales, but when we start to move downward toward the lower part of the canvas, we see the emergence of the quantum foam structure typical of the lower scales. This is how one should envision the transition from classical to quantum in the theory of gravity.

Klein's own visions of the void were partly influenced by a combination of cultural interests that included Rosicrucian mysticism and the practice of Eastern martial arts. He talked about his own work as an immaterial pictorial zone that has issued from the depths of the void. It is in particular his quest to express what he referred to as the subtle energies of the void that is most in tune with the quantum foam image. He explained his choice of the blue monochrome coloring as some kind of field energy. He envisioned the viewing experience as a two-step process where the viewer first takes in the uniform, color-filled background and then zooms on to the presence of a further level of structure into this monochrome void, created by the relief sponge forms. It is this vision that is very much in tune with the idea of a bubbling of structures out of the void when zooming into the lower scales.

6.5 The Void Has Energy

Earlier I discussed an interpretation of the cosmological constant as an effect of the energy of the vacuum, and I have mentioned how in quantum physics, virtual particles continuously bubble in and out of the vacuum. The existence of an energy associated with the vacuum is not only a theoretical consequence of quantum physics, but also a concrete and observable effect that can be measured experimentally.

The *Casimir effect* provides experimental evidence of the existence of a *vacuum energy*: it was theoretically predicted in 1948, but only measured experimentally in 1996.

6.5.1 The Casimir Effect

In the experiment shown in figure 6.19, two conducting plates are placed parallel to each other at a submicron-scale distance. In the gap between the plates, only virtual photons with a wavelength equal to a multiple of the distance can contribute to the vacuum energy, while outside the gap between the plates there is no constraint on the wavelength, so all wavelengths can contribute. This results in an imbalance between virtual photons inside and outside the gap, and

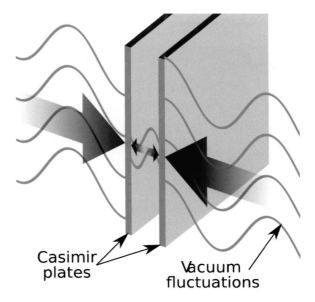

Casimir plates · Vacuum fluctuations

Figure 6.19
The Casimir effect.

this imbalance results in an attractive force between the two plates. In coordinates in the (x, y)-plane, the electromagnetic waves are of the form

$$\psi_n = e^{-i\omega_n t} e^{ik_x x + ik_y y} \sin(\frac{n\pi}{a} z)$$

$$\omega_n = c \sqrt{k_x^2 + k_y^2 + \frac{n^2 \pi^2}{a^2}},$$

where a is the small distance between the two plates. The vacuum energy (by unit area and zeta-regularized to eliminate divergencies) is given by

$$E(s) = \hbar \int \frac{dk_x dk_y}{(2\pi)^2} \sum_n \omega_n |\omega_n|^{-s} = -\frac{\hbar c^{1-s} \pi^{2-s}}{2a^{3-s}(3-s)} \sum_n |n|^{3-s},$$

with a limit of

$$\lim_{s \to 0} E(s) = -\frac{\hbar c \pi^2}{6a^3} \zeta(-3).$$

This results in a force of

$$F = -\frac{d}{da} E = -\frac{\hbar c \pi^2}{240\, a^4}$$

exerted on the two plates: an attractive force between the plates caused only by the vacuum!

6.5.2 Mark Rothko's Void

Figure 6.20
Mark Rothko, *Black on Maroon*, 1958.

One encounters this notion of the energy of the void as a force, manifesting itself in a narrow gap in between adjacent regions, in the powerful paintings of Mark Rothko.

Rothko presents us with a vision of a luminous vacuum created by the contrast of dark maroon or black regions. The *Black on Maroon* painting (figure 6.20) creates a sense of a powerful force localized in the narrow black strip in between the two maroon rectangles. The perceptive contrast created by the two brighter regions in close proximity and the narrowness of the middle strip, make it appear more luminous than the two external black regions connected to it, which stretch to the sides of the painting and surround the two maroon areas. This apparent perceptive difference between the narrow black strip at the center and the two larger black regions at the sides creates a sensation of an imbalance, of force, emanating from the painting, which is a typical feature of the Rothko paintings of these later years.

A similar perceptive contrast of luminosity is present in the narrow red strip in between the two horizontal black rectangular regions in *Light Red over Black* (figure 6.21). There again one finds a perceived imbalance between the large outside regions and the tiny central strip, which is quite evident despite the fact that both regions are painted with the same shade of red. This imbal-

Figure 6.21
Mark Rothko, *Light Red over Black*, 1957.

ance creates a sense of a force emanating from the energy of these regions of vacuum.

6.6 False Vacua: The Higgs Field

A false vacuum occurs when a field is not at its true stable equilibrium, its true ground state (the true vacuum), but at an unstable equilibrium, from where it can still slide down to the true vacuum. An important example is the case of the Higgs field in the Standard Model of elementary particles. The energy potential

Figure 6.22
The Higgs potential.

that describes the self-interactions of the Higgs field is a quartic potential,

$$S(\phi) = \int \frac{1}{2}|\partial\phi|^2 - \lambda(|\phi|^2 - v^2)^2,$$

which is shaped as in figure 6.22. It has an unstable equilibrium at the center of figure 6.22 and a circle of different possible stable equilibria. When the field rolls down from the unstable to the stable equilibrium, a *symmetry breaking* phenomenon occurs: the position at the top is perfectly symmetric with respect to the circle symmetry, but the moment one particular position is chosen on the circle below as the final resting place, the circle symmetry is broken.

The coupling of the Higgs field to matter, for instance with a gauge boson field A, is described by terms in the action functional of the form

$$S(\phi, A) = \int -\frac{1}{4}F^{\mu\nu}F_{\mu\nu} + |(\partial - iqA)\phi|^2 - \lambda(|\phi|^2 - v^2)^2 \, dv.$$

One derives from this expression the fact that the coupling with the Higgs field and the presence of a nontrivial Higgs vacuum state create a *mass term* in the action, of the form $\frac{1}{2}q^2v^2A^2$, where the mass is given by $m = qv$. This is the mechanism through which the Higgs field "gives masses" to particles.

The painting *Dance of the Gauge Bosons in Vacuum* by Regina Valluzzi (see figure 6.23), portrays this coupling between the gauge bosons and the Higgs field and the Higgs vacuum, which realizes the mass terms of the W and Z bosons of the weak interactions.

Figure 6.23
Regina Valluzzi, *Dance of the Gauge Bosons in Vacuum*, 2013.

Besides the case of the Higgs boson and its role in the Standard Model of elementary particles, another theory in which false vacua play an important role is cosmic inflation. This is the hypothesis that a very rapid expansion occurred in the very early universe, which accounts for the overall flatness or near-flatness of the geometry of the observed universe and the high degree of homogeneity of the background radiation. A possible model of inflation postulates the existence of a field with a false vacuum, like a Higgs field. In the very early universe, the field finds itself near this unstable equilibrium. When it is at or near this nontrivial false vacuum, the field drives a rapid inflation of the universe, whereas after rolling down to the true (stable) vacuum, it causes the end of this inflationary phase. The model is called "slow-roll inflation."

6.7 A Proliferation of Vacua: The Multiverse Landscape

The multiverse hypothesis originates from a combination of several considerations. To begin with, there is a *fine-tuning problem* in theoretical physics, which means that there are parameters in the physical models that have to be adjusted very precisely to match their experimental value and are not predicted a priori by the theory. It is argued that some of these parameters may have the value they experimentally have, since different values would not give rise to a universe suitable for life, hence in any universe with other values there would

Figure 6.24
Sonja Delaunay, *Design*, ca. 1938.

be no observers to notice. This reasoning is called the *anthropic principle*.
If it smells like a tautology, this is because it largely is. It acquires explana-
tory value, however, if we assume that there is, in fact, a whole landscape of
different universes, a *multiverse*, with variable physical parameters, where the
universe we observe is but a region: the region suitable for life, where ob-
servers like us can exist. Another origin of a multiverse hypothesis is the fact
that string theory predicts a very large (*very* large, in the order of 10^{500}) number
of different possible vacua. Among all these possible choices that constitute
a multiverse landscape, lies the vacuum that most closely matches the lower
energy physics we observe, the Standard Model of elementary particles as we
know it. It is reasonable to ask whether the multiverse should be regarded as
physics or metaphysics. If there is a whole landscape of different universes
with significantly different forms of physics, but these are not causally con-
nected to each other, meaning that one cannot influence by experiment or de-
tect by observation what is happening in other regions of the multiverse, in
what sense is this a scientific hypothesis? Does Popper's falsifiability, viewed

Figure 6.25
Vasily Kandinsky, *Several Circles*, 1926.

as a prerequisite for science, apply to such a setting? Is there at least a Bayesian selection argument that can be applied to grant a degree of plausibility to the multiverse hypothesis? These questions have been debated at length in recent years within the theoretical physics community.

One of the proposed models of multiverse arises as a model of inflationary cosmology: Andrei Linde's theory of *eternal inflation* describes a mechanism of cosmic evolution that gives rise to a chaotic bubbling off of new universes, possibly with different physical constants.

Visions of a self-reproducing cosmos, with universes bubbling off from other universes, have been variously explored in the course of modern and contemporary art history by different artists. The circle pattern designs of the Orphism movement painter Sonja Delaunay (see figure 6.24) and of Kandinsky (see figure 6.25), for instance, exhibit a structure akin to a self-reproducing set of cosmic bubbles and envisioned by inflationary cosmology.

A recent painting, which is more directly and explicitly inspired by the physical theory of bubbling universes, is Camille McPhee's *Bubbles of Space* (see figure 6.26).

It is also worth comparing the bubbling universes of Sonja Delaunay (figure 6.24), Vasily Kandinsky (figure 6.25), and Camille McPhee (figure 6.26)

Figure 6.26
Camille McPhee, *Bubbles of Space*, 2011.

Figure 6.27
David Weir, *First Order Phase Transition in the Early Universe*, 2014.

with another physical model of bubbling in the early universe, illustrated in figure 6.27. In this model, bubbles of Higgs field formed in the very early universe. Where the boundaries of these bubbles met, they generated ripples of spacetime that were potentially detectable in a faint echo left in the gravita-

tional waves they produced. The simulation of figure 6.27 shows the behavior of these early universe Higgs bubbles and the shock waves they produce. More precisely, in the very early phases of the evolution of the universe after the Big Bang phase transitions happen involving a coupling of the Higgs field with a hot relativistic cosmic fluid of particles, generated through a phase of bubble nucleation and expansion followed by a bubble collision and coalescence phase, as shown in figure 6.27. Gravitational waves are produced by the resulting compression waves in the fluid: the sound of the collisions and merging of the Higgs bubbles. The expected spectrum of gravitational waves can be computed from the simulation and is potentially detectable in experiments such as the ongoing LISA mission of gravitational wave detection in space.

6.7.1 The Abstract Expressionist Void

In the physical model of eternal inflation, the early universe quantum fluctuations of a scalar field create domains with large peaks, while the field classically rolls down to a minimum. A second field, which was introduced for symmetry breaking, makes physics different in different domains, so that the resulting domains can give rise to bubble universes where the physical constants can have different values. The cosmologist Andrei Linde, who developed this model of the multiverse, created a computer simulation of the behavior of these fields, which he called *The Kandinsky Universe* (see figure 6.28). Needless to say, this does not look at all like a Kandinsky. Rather, it points to a different artistic movement that more closely matches this type of random fluctuations and evolving different regions of space: Abstract Expressionism and a movement that more recently developed from it, Abstract Landscape Art.

Within the broader movement of Abstract Expressionism the technique of action painting was used by several artists, most famously Jackson Pollock but also Willem de Kooning, Franz Kline, Joan Mitchell, and others. Unlike other ramifications of Abstract Expressionism, such as the color field movement, which focused on large color regions that were often associated with regular and semiregular geometric shapes, the action painting technique is more directly connected to the concept of randomness and random fluctuations, as I discussed at the end of the previous chapter in relation to Pollock's drip paintings. Action painting creates images that are evolutions in time of some small, randomly determined initial fluctuations. Indeed, this style of painting records the traces left on the canvas by the trajectory of a gesture that has an element of randomness at its inception.

One of the theoretical initiators of the idea of action painting, the painter Wolfgang Paalen, who came to abstract art from the surrealist movement, had explicitly taken inspiration from the concept of action and action functional in

Figure 6.28
Andrei Linde, *Kandinsky Universe*, 2008.

theoretical physics and from the idea of randomness and fluctuations in quantum physics. Another artist of the action painting movement who was sensitive to these themes was Joan Mitchell (see figure 6.29). Thus, perhaps Linde's Kandinsky Universe should rather be a Wolfgang Paalen, a Jackson Pollock, or a Joan Mitchell Universe. In this as in other Mitchell action paintings we see a nonuniform growth of structures across the canvas, separated by a range of chromatic codings and by different types of color texture and density of signs. In figure 6.29, the upper-left and bottom-right areas of the canvas dominate through a contrast of high and low density. The high-density upper-left area has multiple layers of structure exhibiting what appear to be different types of randomness superimposed on one another, while the low-density bottom-right area, which is dominated by a white near-emptiness, only shows some light random marks. The upper-right and lower-left parts of the canvas mediate between these two contrasting densities and reflect each other through the common chromatic marking by the light purple areas. These color-coded regions, in turn, create the impression of an underlying connected structure that stretches across the canvas and is hidden or distorted by the randomization of the painting gestures.

Figure 6.29
Joan Mitchell, *Untitled*, 1961.

The Abstract Expressionism movement underwent several ramifications and influenced more recent evolutions within the general panorama of contemporary American art. An important painting style that evolved out of the experience of the historical Abstract Expressionism is often referred to as Abstract Landscape Art. This is not quite an artistic movement in the same sense as in the history of 20th century art, which was typically organized around tightly knit groups of artists with a common theoretical vision, often elaborated in the form of artistic manifestos. Abstract Landscape Art is rather a more loosely defined collection of works and artists that recognize a common origin out of the Abstract Expressionism tradition and that to some extent recast within this novel setting of abstract art the older American tradition of landscape art.

Within the Abstract Landscape Art style, one of the painting that most closely seems to convey an idea similar to the bubbling universes of eternal inflation and the evolution and the fluctuations of the fields driving inflation can be found in Kimberly Conrad's *Life in Circles, N.29* (see figure 6.30). This painting combines in an interesting way the theme of the bubbling circles, as in Sonja Delaunay (figure 6.24), Vasily Kandinsky (figure 6.25), and Camille

Figure 6.30
Kimberly Conrad, *Life in Circles, N.29*, 2011.

McPhee (figure 6.26), and an abstract expressionist background of random-ized color fields, closer to the compositions of Andrei Linde (figure 6.28) and of Joan Mitchell (figure 6.29).

Chapter Appendix: Bibliographical Guide

A.1 Guide to the Artists and Artistic Movements

Some excellent general treatments of the theme of the void in contemporary art, seen from a different viewpoint that complements what was presented in this chapter, can be found in the following references.

- Mark Levy, *The Void in Art*, Bramble Books, 2005.
- Paul Schimmel, *Destroy the Picture: Painting the Void, 1949–1962*, Skira Rizzoli, 2012.

Some references on the contrast between absolute and relational notions of space were listed in the bibliographical appendix to chapter 2. Monographs and other references on the work of the artists discussed in this chapter, and the associated artistic movements can be found in the following list.

- Albrecht Dürer, *The Painter's Manual*, Abaris Books, 1977.
- John Berger, *Albrecht Dürer: Watercolours and Drawings*, Taschen, 1994.
- Kasimir Malevich, *The Non-Objective World: The Manifesto of Suprematism*, Dover, 2003.

- John Milner, *Kazimir Malevich and the Art of Geometry*, Yale University Press, 1996.

- Rainer Crone and David Moos, *Kazimir Malevich. The Climax of Disclosure*, Reaktion Books, 1991.

- Stephanie Barron and Lauren Bergman, *Ken Price Sculpture: A Retrospective*, Los Angeles County Museum of Art, 2012.

- Sarah Whitfield, *Lucio Fontana*, University of California Press, 2000.

- Enrico Crispolti, *Fontana e lo spazialismo*, Edizioni Città di Lugano, 1987.

- Umberto Boccioni, *Futurist Painting Sculpture (Plastic Dynamism)*, Getty Research Institute, 2016.

- Will Kitson, "Dr. Regina Valluzzi: The Grand Experiment—Bridging the Gap between Science and Art," *Seymour Magazine*, 2015 (online).

- Pierre Restany, *Yves Klein: Fire at the Heart of the Void*, Spring Publications, 2005.

- Kerry Brougher, *Yves Klein: With the Void, Full Powers*, Walker Art Center, 2010.

- Sidra Stich, *Yves Klein*, Cantz, 1994.

- Mark Rothko, *Writings on Art*, Yale University Press, 2006.

- Mark Rothko, *The Artist's Reality: Philosophies of Art*, Yale University Press, 2006.

- Anna C. Chave, *Mark Rothko: Subjects in Abstraction*, Yale University Press, 1989.

- Anne Montfort, *Sonia Delaunay*, Abrams, 2015.

- Lisa Florman, *Concerning the Spiritual—and the Concrete—in Kandinsky's Art*, Stanford University Press, 2014.

- Wassily Kandinsky, *Complete Writings on Art*, Da Capo Press, 1994.

- Arnold Schoenberg and Wassily Kandinsky, *Letters, Pictures and Documents*, Faber and Faber, 1984.

- James Leggio, *Music and Modern Art*, Routledge, 2014.

- Camille McPhee, *Thesis Exhibition Statement*, 2012 (online).

- Andreas Neufert, *Auf Liebe und Tod, Das Leben des Surrealisten Wolfgang Paalen*, Parthas, 2015.

- Marika Herskovic, *New York School: Abstract Expressionists. Artists Choice by Artists*, New York School Press, 2000.

- Joan M. Marter, Gwen F. Chanzit, and Irving Sandler, *Women of Abstract Expressionism*, Yale University Press, 2016.

- Yilmaz Dziewior, Ken Okiishi, Laura Morris, Isabelle Graw, Jutta Koether, and Yves Michaud, *Joan Mitchell: Retrospective: Her Life and Paintings*, Kunsthaus Bregenz, 2016.

- Sophie Marine, "Spotlight Interview: Kimberly Conrad," *Daily Paintwork News*, 2016 (online).

A.2 Guide to the Void in Modern Science

Some general references about the void in modern physical theories and more detailed references about the Einstein theory of empty space are listed here.

- James Owen Weatherall, *Void: The Strange Physics of Nothing*, Yale University Press, 2016.
- Frank Close, *Nothing: A Very Short Introduction*, Oxford University Press, 2009.
- Jennifer Coopersmith, *The Lazy Universe: An Introduction to the Principle of Least Action*, Oxford University Press, 2017.

On three-manifold topology and specific applications to the problem of cosmic topology, the reader can find some additional information in the following references.

- Jean-Pierre Luminet, *The Wraparound Universe*, CRC Press, 2008.
- Jeffrey R. Weeks, *The Shape of Space*, Taylor & Francis, 2001.
- Michael P. Hitchman, *Geometry with an Introduction to Cosmic Topology*, Jones & Bartlett Learning, 2009.
- S. Caillerie, M. Lachièze-Rey, J.-P. Luminet, R. Lehoucq, A. Riazuelo, and J. Weeks, "A New Analysis of the Poincaré Dodecahedral Space Model," *Astronomy and Astrophysics* 476 (2007): 691–696.
- Matilde Marcolli, *Noncommutative Cosmology*, World Scientific, 2018.
- William P. Thurston, *Three-Dimensional Geometry and Topology*, Princeton University Press, 1997.

The cosmological constant, dark energy, and the energy of the vacuum (including the Casimir effect) are discussed in the following references. The Weyl curvature hypothesis of Roger Penrose was already discussed in chapter 4, and the reader can find some helpful references listed in the appendix to that chapter.

- Helge S. Kragh and James Overduin, *The Weight of the Vacuum: A Scientific History of Dark Energy*, Springer Verlag, 2014.
- Bertrand Duplantier and Vincent Rivasseu, eds., *Poincaré Seminar 2002: Vacuum Energy – Renormalization*, Birkhäuser, 2003.
- Yakov Borisovich Zeldovich, *Selected Works, Volume II: Particles, Nuclei, and the Universe*, Princeton University Press, 2017.

In the following list, the reader can find references on quantum field theory, Feynman diagrams and their crucial role in modern physics, including the role of the Higgs boson. The first two references are general and historical, the following ones are more technical, and the last one is a survey of recent results linking the computation of Feynman diagrams to algebraic geometry and number theory.

- David Kaiser, *Drawing Theories Apart*, University of Chicago Press, 2005.
- Tian Yu Cao, *Conceptual Foundations of Quantum Field Theory*, Cambridge University Press, 2014.

- Roger Wolf, *The Higgs Boson Discovery at the Large Hadron Collider*, Springer Verlag, 2015.
- Freeman J. Dyson, *Advanced Quantum Mechanics*, World Scientific, 2011.
- Martinus Veltman, *Diagrammatica: The Path to Feynman Diagrams*, Cambridge University Press, 1994.
- Vladimir A. Smirnov, *Analytic Tools for Feynman Integrals*, Springer Verlag, 2013.
- Matilde Marcolli, *Feynman Motives*, World Scientific, 2010.

Some references on quantum foams and more general models of quantum gravity are listed next, starting with popularization references, followed by more technical treatments.

- John Archibald Wheeler, *Geons, Black Holes, and Quantum Foam: A Life in Physics*, W. W. Norton, 2010.
- Lee Smolin, *Three Roads to Quantum Gravity*, Basic Books, 2008.
- Claus Kiefer, *Der Quantenkosmos: Von der zeitlosen Welt zum expandierenden Universum*, Fischer, 2008.
- Craig Callender and Nick Huggett, *Physics Meets Philosophy at the Planck Scale: Contemporary Theories in Quantum Gravity*, Cambridge University Press, 2001.
- Gianluca Calcagni, Lefteris Papantonopoulos, George Siopsis, and Nikos Tsamis, *Quantum Gravity and Quantum Cosmology*, Springer Verlag, 2012.
- Claus Kiefer, *Quantum Gravity*, Oxford University Press, 2012.
- Carlo Rovelli and Francesca Vidotto, *Covariant Loop Quantum Gravity: An Elementary Introduction to Quantum Gravity and Spinfoam Theory*, Cambridge University Press, 2014.

Some references on inflationary cosmology and the multiverse are listed here. The last reference is the model of Higgs bubbles in the early universe and their effect on gravitational waves, which was mentioned in the text.

- Alan Guth, *The Inflationary Universe*, Basic Books, 1997.
- Mary-Jane Rubenstein, *Worlds without End: The Many Lives of the Multiverse*, Columbia University Press, 2014.
- Richard Dawid, *String Theory and the Scientific Method*, Cambridge University Press, 2013.
- James Cornell, *Bubbles, Voids and Bumps in Time: The New Cosmology*, Cambridge University Press, 1991.
- Bernard Carr, *Universe Or Multiverse?* Cambridge University Press, 2007.
- Robert H. Sanders, *Deconstructing Cosmology*, Cambridge University Press, 2016.
- Andrei Linde, *Particle Physics and Inflationary Cosmology*, CRC Press, 1990.
- Andrew R. Liddle and David H. Lyth, *Cosmological Inflation and Large-Scale Structure*, Cambridge University Press, 2000.
- Mark Hindmarsh, Stephan J. Huber, Kari Rummukainen, and David J. Weir, "Gravitational Waves from the Sound of a First Order Phase Transition," *Physical Review Letters* 112 (2014): 041301.

7 The Geometry and Physics of Numbers

This chapter deals with the concept of number, and the way in which, over the course of the development of contemporary mathematics, this concept has acquired geometric meaning as well as connections to ideas from theoretical physics. The concept of number and the mathematical structures that different kinds of numbers obey have also been a focus of attention for several contemporary artists, especially within the schools of Conceptual Art and Minimalist Art.

7.1 Kinds of Numbers

In mathematics there are many different kinds of numbers, just as there are many different kinds of spaces, as we discussed in chapter 3. We have seen that the word *space* always comes adorned with an adjective (a topological space, a smooth space, a metric space, a measurable space, and so on). Similarly, the word *numbers* is always endowed with an adjective that clarifies what kind of numbers we are considering. We saw that, in the case of spaces, different notions of space correspond to different kinds of transformations that can be performed on them. Similarly, different classes of numbers correspond to different kinds of operations that can be performed with them. For instance, as mentioned at the beginning of chapter 3, there are the following well-known classes of numbers:

- *natural numbers* (1, 2, 3, 4, ...): these numbers can be added and multiplied.
- *integer numbers* (..., −5, −4, −3, −2, −1, 0, 1, 2, 3, 4, 5, ...): these numbers can be added and subtracted and multiplied (but not, in most cases, divided).
- *rational numbers* (which also include all fractions, such as $\frac{2}{3}$, $\frac{1}{2}$, and so forth): they can be added, subtracted, multiplied, and divided.
- *real numbers*: these also include numbers like $\sqrt{2}$ or π that are not rational. The same operations allowed on rational numbers can be performed on the

Figure 7.1
Roman Opalka, *Infinity Detail*, 1965.

reals, but in addition the operation of taking limits is also allowed (the set of
real numbers is "complete").

- *complex numbers*: these include numbers such as $i = \sqrt{-1}$, and in general,
numbers of the form $a + bi$, where a and b are real numbers. All the previous
operations can be performed, and one can also solve arbitrary polynomial
equations (the set of complex numbers is both "complete" and "algebraically
closed").

Other types of numbers include p-adic numbers (which are also a complete,
but different from the real numbers), algebraic numbers (solutions of polyno-
mial equations with rational coefficients), periods (integrals of algebraic ex-
pressions over an algebraic variety), and numbers that are elements of finite
fields, as well as several more classes of numbers.

The Polish artist Roman Opalka painted increasing sequences (that is, se-
quences in ascending order) of natural numbers, as a way to symbolize the
passing of time and the growth toward an unattained infinity. These paintings
show sequences of large natural numbers, in progressively lighter tones, as a

Figure 7.2
Jennifer E. Padilla, *Two* and *Three*, von Neumann Ordinals series, 2016.

kind of gradual disappearance. Each canvas in the series is called a *Detail* (see for instance the *Infinity Detail* in figure 7.1).

Natural numbers are the first class among those listed previously, and certainly the one that has received most attention from artists. I will show how conceptual artists have been aware of several interesting mathematical properties of natural numbers. The *Detail* paintings series of Opalka focus mostly on two aspects. One is the order relation: given any two different natural numbers one of them is always greater than the other. The other is the fact that the natural numbers are a countably infinite set. The construction of increasing sequences of natural numbers in Opalka's paintings expresses both of these properties: while the painting necessarily represents only a finite subset of the sequence (hence the choice of title: "detail"), the use of fading tones in the painting suggests the continuation of the sequence to infinity. Several other properties of the natural numbers were considered by other conceptual and minimalist artists, as I will discuss next.

7.2 The von Neumann Construction of Natural Numbers

Natural numbers (including zero) can be thought of as arising from an inductive construction of sets. This is known as the von Neumann ordinal construction. One starts with the empty set. The mathematical notation for a set consists of giving, within curly brackets, a list of the elements of the set. Since the empty set has no elements, it is just an empty list { }. One also often uses the symbol \emptyset for the empty set, so $\emptyset = \{\ \}$. We can also agree that, since the empty set has no elements, zero should be the number that counts the number of elements of the empty set. Thus, we simply say that we associate the num-

ber 0 with the empty list { }. This is the first step in the ordinal construction. We then need to know how to go one step further, hence one needs a "successor function." For a given set A we define the successor function as $S(A) = A \cup \{A\}$. Notice how the set A occurs in two different roles in this expression, as a set, so that one can take its union with another set, and as an element of the set $\{A\}$, which is the set containing a single element A.

Figure 7.3
Jennifer E. Padilla, *Six*, von Neumann Ordinals series, 2016.

We proceed in this way to associate the number 1 with the set $S(0) = \emptyset \cup \{\emptyset\} = \{\{ \}\}$. This set is no longer empty: it contains one element. We can equivalently write $1 \leftrightarrow \{\{ \}\}$. When iterating this procedure, the number 2 is associated with $S(1) = 1 \cup \{1\} = \{0, 1\} = \{\{ \}, \{\{ \}\}\}$, the number 3 with the set $S(2) = \{0, 1, 2\} = \{\{ \}, \{\{ \}\}, \{\{ \}, \{\{ \}\}\}\}$, and so forth.

The artist Jennifer E. Padilla used the von Neumann ordinal construction of the natural numbers as the theme for a sequence of artworks in the form of digital images, which visualize the sequence of applications of the von Neumann

successor function. In figure 7.2 we see the two images that correspond to the natural numbers $\{\{\ \},\{\{\ \}\}\} = S(1) = 2$ and $\{\{\ \},\{\{\ \}\},\{\{\ \},\{\{\ \}\}\} = S(2) = 3$, while in figure 7.3 we see the case of $6 = S(5) = S(S(4)) = S(S(S(3))) = S(S(S(S(2)))) = S(S(S(S(S(1))))) = S(S(S(S(S(S(0))))))$.

7.3 The Mystery of Prime Numbers

The very first class of numbers discussed previously, the *natural numbers*, looks extremely simple, but it is already very mysterious.

The addition of natural numbers does indeed have a simple structure. It is easy to get *any* natural number by adding 1 to itself enough times: $1+1 = 2$, $1+1+1 = 3$, $1+1+1+1 = 4$, and so on. This means that *only one* "building block" is needed to obtain any natural number by repeatedly applying the addition operation: the number 1.

Multiplication, however, is a lot more interesting. If one starts with the same number, the number 1, one does not get anywhere, because the product with itself is always the same, $1 \times 1 = 1$. Starting with 2 gives $2 \times 2 = 4$, $2 \times 2 \times 2 = 8$, $2 \times 2 \times 2 \times 2 = 16$: one obtains all the powers of two, that is, the numbers of the form 2^n. There are very few such numbers among all integer numbers.

Indeed, to obtain all natural numbers by multiplication, one needs *infinitely many building blocks*: the *prime numbers*. These are certain special numbers among the natural numbers: a prime number is only divisible by itself and by 1: it cannot be further simplified. They are the basic multiplicative building blocks for natural numbers: any natural number is, in a unique way, a product of prime numbers.

When listed in the ascending order of the natural numbers, the first few prime numbers are 2, 3, 5, 7, 11, 13, 17, 19, 23, 29, 31, 37, 41, 43, 47, 53, 59, 61, 67, 71, 73, 79, 83, 89, 97, 101, 103, 107, 109, 113, 127, 131, 137, 139, 149, 151, 157, 163, 167, 173, 179, 181, 191, 193, 197, 199, 211, 223, 227, 229, 233, 239, 241, 251, 257, 263, 269, 271, 277, 281, 283, 293, 307, and so on (see also the painting by Rune Mields in figure 7.4).

One of the deepest mystery in mathematics is the structure of prime numbers: how they are distributed among the natural numbers. If one inspects the list of the known prime numbers, there does not seem to be any evident pattern that would predict where the next one will occur. "Prime numbers grow like weeds among the natural numbers, seeming to obey no other law than that of chance

Figure 7.4
Rune Mields, *Die Primzahlen*, 2015.

but also exhibit stunning regularity," according to the number theorist Don Zagier.[6]

The problem of identifying primes goes back to Ancient Greece: Eratosthenes' sieve, shown in the following diagram,[7] progressively eliminates all numbers that are divisible by other numbers (other than themselves and 1) and leaves the primes.

When one writes down the first few thousand natural numbers in increasing order, arranged in a rectangular array, applying the sieve of Eratosthenes method and marking the composite numbers that contain certain primes in their multiplicative decomposition gives rise to some very interesting patterns. Some of these patterns, which were based on Eratosthenes' sieve on a 300 × 300 grid were used in a series of paintings from the 1970s by the German artist Rune Mields (see figure 7.5).

[6] Don Zagier, "The First 50 Million Prime Numbers," *The Mathematical Intelligencer*, 1, Supplement 1 (1977): 7–19.

[7] TikZ libraries, LaTeX Stack Exchange, contributed by Todd Lehman.

Figure 7.5
Rune Mields, *Sieb des Eratosthenes III*, 1977.

There are infinitely many prime numbers, so there are arbitrarily *large* ones. At the end of 2018, the largest prime number known was $2^{82589933} - 1$, which has $24,862,048$ decimal digits. This is an example of a Mersenne prime, that is, a prime of the form $2^n - 1$. The Great Internet Mersenne Prime Search (GIMPS) project has been finding increasingly large Mersenne primes.

The German artist Rune Mields based many of her paintings on large prime numbers. During the 1970s she produced a series of paintings based on visualizing prime numbers using the Chinese-Japanese Sanju system, (see figure 7.6). A large prime number discovered by the German mathematician Wilfried Keller in 1984 was used by Mields in her five-piece work *Die Söhne der Mathematik*, with superimposed line drawings inspired by figures from Paolo Uccello, (see figure 7.7). In her 2015 work *Die Primzahlen* (see figure 7.4) one can read, in the background of the list of prime numbers in a sieve of size 100, the sentence "Die Zahlen sind die Drogen" (the numbers are the drugs), a possible hint at the well-known obsessive and addictive quality of the mystery of prime numbers.

Public-key cryptography is based on very large prime numbers and on the factorization of natural numbers into primes: a natural number that is the product of two very large prime numbers can be very difficult to factorize (that is,

Figure 7.6
Rune Mields, *Sanju Primzahlen (2-239)*, 1975.

it is very difficult to reconstruct what the two constituent primes are, when knowing only their product) even with very fast (nonquantum) computers.

A rough idea of how the Rivest-Shamir-Adleman (RSA) cryptosystem algorithm works is the following. Choose at random two very large primes p, q and compute the product $n = p \times q$. The primes p and q are kept secret, while the number n is used to construct both the *public key* and the *private key*. The Euler totient function

$$\phi(n) = n \prod_{p|n} (1 - \frac{1}{p}),$$

Figure 7.7
Rune Mields, *Die Söhne der Mathematik (Der Zweite)*, 1986.

where the product is over all primes dividing n, has a value of $\phi(n) = \phi(p) \times \phi(q) = (p-1)(q-1)$. The value $\phi(n)$ is private. Choose a natural number e such that $1 < e < \phi(n) = (p-1)(q-1)$ with $\gcd(e, \phi(n)) = 1$ (that is, e and $\phi(n)$ are coprime: they have no common prime factor). The *public key* consists of n and e, which are, respectively, called the modulus and the encryption exponent. Solve for d such that $d \times e = 1$ modulo $\phi(n)$ (d is an inverse of e up to a multiple of $\phi(n)$). The *private key* consists of n and the number d, the modulus and the decryption exponent. A message is transmitted as a natural number m with $m < n$ and $\gcd(m, n) = 1$, by first computing the number c (the ciphertext) such that $c = m^e$ modulo n, and then m is recovered by the receiver by computing $m = c^d = (m^e)^d$ modulo n.

Figure 7.8
Prime and composite numbers on a 150 × 150 Ulam spiral.

7.3.1 Ulam Spirals

There are very intriguing phenomena observable in the distribution of prime numbers. In the early 1960s, the mathematician Stanislaw Ulam noticed that strange patterns appear that seem to indicate regularity, but are not predictable by any simple rule. In particular Ulam observed that, when writing the natural number in a grid, spiraling out, and then marking the primes, some diagonal patterns appear, which persist for some time and then disappear, as the spiral of numbers extends further out (see figure 7.8).

To make a comparison between the structure of prime numbers in the Ulam spirals and some more predictable phenomenon, consider the case of "triangular numbers." These are natural numbers of the form

$$T_n = \frac{n(n + 1)}{2}.$$

The first few triangular numbers are 1, 3, 6, 10, 15, 21, 28, 36, 45, 55, 66, 78, 91, 105, and so on. Plotting triangular numbers in a Ulam spiral also produces interesting patters, as shown in figure 7.9, where the bright dots are the triangular numbers arranged along three spirals and the other colors are arranged by degrees of "near triangularity." One can visually see, by comparing these kind of patterns in a Ulam spiral with patterns traced by the prime numbers,

that prime numbers are a lot more mysterious, as the patterns they trace in the Ulam spiral only have an appearance of regularity, which however soon dissipates, just to give rise to other apparent regularities and so on. As I previously remarked, this intermediate region between complete regularity (the case of triangle numbers patterns, for instance) and complete randomness is inhabited by the most interesting phenomena, from both the scientific and the aesthetic viewpoints. Prime numbers are certainly one of the most interesting such cases.

Figure 7.9
Triangle numbers on the Ulam spiral (`Mathematica` plot).

There are other interesting visual patterns related to integer numbers and prime numbers that were also considered by artists. For instance, consider pairs of natural numbers n, m that are coprime, $\gcd(n, m) = 1$, that is, that do not have any common prime factor. One can plot these pairs on a grid, producing what looks like a very regular pattern. However, the structure is, in fact, more complex than it seems at first. Taking the Fourier transform of this pattern yields a much more intricate figure with a rich fractal structure, which was made into a painting by the physicist and computer graphics artist Manfred Schroeder in the 1970s. A more recent version of the Fourier transform of the coprime numbers map, realized by Dmitry Shintyakov, is shown in figure 7.10.

Figure 7.10
Dmitry Shintyakov, *Logarithmic Amplitude of 2D Fourier Transform of the Co-prime Numbers Map*, 2014.

7.4 Primes as Elementary Particles of Arithmetic

Primes are the *basic building blocks* of natural numbers. This observation suggests an analogy with physics, where elementary particles are the basic building blocks of matter. In the course of the development of 20th-century high-energy physics, the investigation of elementary particles led to the Standard Model, at present the most accurate, experimentally confirmed, model of particle physics. Elementary particles and the Standard Model will be discussed more extensively in chapter 8.

Elementary particles in the Standard Model are subdivided into *bosons* (the gauge bosons of the strong and electroweak forces and the Higgs boson) and *fermions*, which are further subdivided into quarks and leptons, depending on how they interact with the strong force. The Lagrangian that describes all the interactions between the particles of the Standard Model is extremely complicated, as we will see in the next chapter. However, for now what matters for

our analogy is the fact that all other particles that are observed in experiments are composites of a small list of elementary particles: the electron, muon, and tau and their associated neutrinos (leptons); the up/down, charm/strange, and top/bottom quarks; and the photon, gluon, Z and W, and Higgs bosons.

Elementary particles combine to form more complicated (composite) particles, such as protons and neutrons, and atoms, through the strong and electroweak forces. In arithmetic, prime numbers combine to form natural numbers through the operation of multiplication. Breaking a number into its prime factors is the analog of breaking a baryon or a meson into its constituent elementary particles. Can we use this very rough analogy between primes and elementary particles to understand more about the primes?

It is first worth making a general observation about the use of such metaphorical thinking. Contrary to what people might expect, metaphors and analogies play a crucial role in mathematical thinking. A typical pattern of development of mathematical creativity proceeds roughly as follows: an initial problem consists of answering a specific question about a specific mathematical object. In trying to find a good approach and a new angle for tackling the question, one starts to reason by analogy, trying to envision other, a priori very different, contexts where something similar to the question of investigation may occur, in a form that is not the same but that is sufficiently related to create the ground for an analogy. Ideally, this will suggest a way to approach and possibly solve the question in the new context, using different tools. Then, by applying the same metaphor again, this resolution method is imported back into the original problem. This "lateral thinking" approach has proved to be one of the most efficient motors of mathematical creativity. Thus, even if at first sight the analogy we are describing here between prime numbers and elementary particles may seem far-fetched and unnatural, it is worth exploring where the metaphor may lead us.

7.4.1 Maxwell-Boltzmann Statistics and the Riemann Gas

If we think of primes as particles, we can study them as a physical system. Given a gas of N particles at varying temperature T, in terms of the inverse temperature variable $\beta = 1/(k_B T)$, where k_B is the Boltzmann constant, the statistical distribution according to the energy levels is given by

$$\frac{N_i}{N} = \frac{m_i\, e^{-\beta E_i}}{Z(\beta)},$$

where the normalization factor is the partition function

$$Z(\beta) = \sum_j m_j e^{-\beta E_j}$$

Figure 7.11
Riemann zeta function (`Mathematica` plot).

and the coefficient m_j is the multiplicity of the energy level E_j. The resulting probability distribution with this normalization factor is the Gibbs measure of the Maxwell-Boltzmann distribution of statistical mechanics.

As we have seen already in a chapter 4, while discussing thermodynamics, at higher temperatures the higher energy levels are activated, while at low temperatures the system freezes onto the ground state (the lowest energy state). This means that the probability distribution written above becomes more and more peaked at the lowest energy state when the inverse temperature β grows to infinity. We are not worrying at this point about whether the particles are bosons of fermions, since, in the classical limit, the respective statistical distributions, Bose-Einstein and Fermi-Dirac, both approximate the Gibbs measure.

Now let us imagine that the natural numbers are the particles of our gas, which we refer to as the *Riemann gas*, for a reason that will be clear in a moment. We assign an energy to a natural number n that depends on the decomposition of that number into its elementary constituent, that is, its multiplicative decomposition into primes. For a number $n = p_1 \cdots p_k$, where the p_i are primes, we set the corresponding energy to be

$$E_n = \log n = \log(p_1) + \cdots + \log(p_k).$$

Figure 7.12
Bart de Smit, *Café Terrace at Night*, van Gogh meets Riemann series, 2006.

The use of the logarithm function simply has the role of ensuring that the contributions to the energy of the various prime factors of n *add up* to the total energy of n, as we expect energy should behave. One can also think of this energy function as estimating the sum of the *lengths* of the prime constituents (in number of binary or decimal digits, if one takes the logarithm in base 2 or 10). The number $n = 1$ is the *ground state*, with the lowest energy $\log(1) = 0$. The larger the primes involved in the factorization of n, the more n is in a higher energy state.

The Maxwell-Boltzmann distribution for the Riemann gas is then given by

$$Z(\beta) = \sum_{n \geq 1} e^{-\beta E_n} = \sum_{n \geq 1} e^{-\beta \log(n)} = \sum_{n \geq 1} n^{-\beta} = \zeta(\beta).$$

This function $\zeta(\beta)$ is the *Riemann zeta function*, whose graph (as a function of β, seen as a variable in the complex plane) is illustrated in figure 7.11.

The mathematician Bart de Smit produced a series of images titled *van Gogh meets Riemann*, in which some famous van Gogh paintings are deformed using the Riemann zeta function. For example, in the work reproduced in figure 7.12, the painting *Café Terrace at Night* by van Gogh is placed in a region of the complex plane and extended to the whole plane by reflections along the border sides. The color $c(z)$ is recorded at each point of the plane. The new image is then created by painting a point $s \in \mathbb{C}$ with the color $c(\log \zeta(s))$, where $\zeta(s)$ is the Riemann zeta function.

7.4.2 The Riemann Zeta Function

The Riemann zeta function, which we encountered in the previous subsection in its role as the partition function of our hypothetical Riemann gas, has been a

crucial object of interest to mathematicians for about two centuries. In particular, the location of the zeros of the Riemann zeta function is related to the distribution of the prime numbers. This means that the mystery of prime numbers we have been discussing above can be recast as a question about the location of the zeros of this zeta function. Riemann showed in 1859 that the number of primes less than a given number can be expressed in terms of a sum over zeros of the Riemann zeta function. It has been an important unsolved problem since then to understand the zeros of this function. The main conjecture, known as the *Riemann hypothesis*, states that, besides a set of "trivial zeros" at -2, -4, -6, ..., all the remaining (nontrivial) zeros of the Riemann zeta function are contained in a vertical line of the form $\frac{1}{2} + it$, called the *critical line*.

The Riemann hypothesis is one of the most famous problems in mathematics. If the Riemann hypothesis is true, then one has the "most regular" possible distribution of prime numbers. More precisely, the *prime number theorem* shows that the number $\pi(x)$ of primes less than or equal to a size x is approximated by the function $f(x) = x/\log(x)$. When x becomes very large, the ratio $\pi(x)/f(x)$ of these two functions tends to 1. Another approximation of the counting function $\pi(x)$ is given by the function

$$\mathrm{Li}(x) = \int_2^x \frac{dt}{\log t}.$$

However, it is estimating the error in these approximations that depends on the behavior of the Riemann zeta function. For instance, it is known that if (and only if) the Riemann hypothesis is true, then the error in the approximation of $\pi(x)$ by $\mathrm{Li}(x)$ has the form

$$\pi(x) = \mathrm{Li}(x) + O(\sqrt{x}\,\log(x)),$$

where the O-notation denotes the same order of magnitude (or lower) in the asymptotic behavior.

7.4.3 Riemann Gas with Supersymmetry

We have seen that elementary particles come in two families: *bosons* and *fermions*. The main difference in the behavior of these two types of particles is the fact that bosons can all occupy the same quantum state at once, while in the case of fermions, no two of them can be in the same state at the same time.

A particle made of an *even* number of fermions is a boson: this is the case of α-*rays*, which are Helium nuclei composed of two protons and two neutrons. Thus, a *sign* given by $(-1)^F$, where F is the *number of fermions*, distinguishes whether the resulting particle is a fermion or a boson. This sign is referred to as the supersymmetry sign.

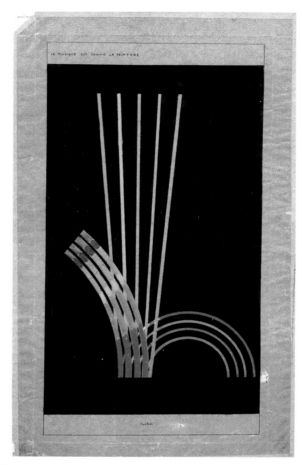

Figure 7.13
Francis Picabia, *Music Is Like Painting*, 1913–1917.

The γ-*rays* are also bosons, since they are photons, while β-*rays* are fermions (electrons). The different behavior of the three types of radiation, alpha, beta, and gamma rays, in the presence of a magnetic field, with paths bending in different directions for the differently charged α and β and not bending at all in the case of the γ rays, has been frequently compared to the painting by Francis Picabia *Music Is Like Painting* (see figure 7.13). As a template for the painting, the artist intentionally used a well-known scientific chart illustrating alpha, beta, and gamma rays that circulated at the beginning of the 20th century, at the time when the painting was made.

We now return to prime numbers. Let us now imagine them as fermions rather than bosons. This means that instead of obtaining all natural numbers by multiplication, we can now only obtain those natural numbers that have no repeated prime factors, because no identical fermion particles in the same state are allowed. Thus, the number $6 = 2 \times 3$ is fine, but $4 = 2 \times 2$ is not. There is indeed a function that corresponds to this situation and that takes into account which numbers can be obtained by composing primes, if the latter behave like fermions, and whether the numbers obtained in this way are fermions or bosons. This function is called the *Möbius function*. It is given by

$$\mu(n) = \begin{cases} 0 & \text{if } n \text{ has repeated prime factors} \\ +1 & \text{if } n \text{ has an even number of prime factors (no repetitions)} \\ -1 & \text{if } n \text{ has an odd number of prime factors (no repetitions)} \end{cases}$$

For the allowed numbers (those n for which $\mu(n)$ is nonzero) the resulting sign is the supersymmetry sign $(-1)^F$.

The partition function of the Riemann gas with supersymmetry is then given by the Möbius inversion formula

$$\sum_n \mu(n) n^{-\beta} = \frac{1}{\zeta(\beta)}.$$

Since the Riemann zeta function $\zeta(\beta)$ now appears as a denominator, the zeros of the zeta function are now poles of the partition functions. Thus, from the physical point of view they can be interpreted as *phase transitions*.

Phase transitions occur in physical systems at certain critical temperatures at which the behavior of the system changes from an ordered to a disordered phase or vice versa, as in the physical phase transition from paramagnetic to ferromagnetic behavior.

7.4.4 Physics, Zeta Functions and Periods

There are other intriguing relations between the Riemann zeta function and physical systems. For instance, when modeling spectra of heavy atoms in nuclear physics, one finds that the spacing between the energy levels of heavy atoms behaves like the spacing between eigenvalues of a random matrix. Moreover, the distribution of zeros of the Riemann zeta function also very much *resembles* the distribution of eigenvalues of random matrices (and hence, also of heavy atoms spectra).

Another very interesting connection between the Riemann zeta function and physical systems was proposed by Freeman Dyson in 2009. Quasicrystals (discussed in chapter 3) are aperiodic solids that can be experimentally realized in physics and that are described mathematically by aperiodic Penrose tilings of

Figure 7.14
Stanley Silver, *Higher Learning III (Riemann Zeta Function)*, 2011.

the plane. There are also one-dimensional quasicrystals, as well as known examples of quasicrystal structures in dimensions two, three, and four. Dyson showed that the Riemann hypothesis is equivalent to the fact that the zeros of the Riemann zeta function form a one-dimensional quasicrystal, where technically his characterization of a quasicrystal is a distribution with discrete support whose Fourier transform also has discrete support.

In addition to the intriguing relations between physics and the Riemann zeta function, many other connections between theoretical physics and number theory have emerged in recent years. One such connection (mentioned in chapter 6) is the fact that computations of Feynman integrals in quantum field theory give rise to certain classes of numbers, called periods, which are integrals of algebraic differential forms in algebraic varieties. In many important cases in quantum field theory, such period integrals belong to a special class, called multiple zeta values, which are obtained as special values at integer points of generalizations of the Riemann zeta function.

Contemporary artists, especially within the Minimalism and Conceptual Art movements, have often engaged with the concept of numbers and prime numbers. Occasionally, artists have also taken inspiration from mathematical objects such as the Riemann zeta function, which is viewed symbolically as a pinnacle of mathematical sophistication, as in the example of Stanley Silver's

Higher Learning III (Riemann Zeta Function) (see figure 7.14). What has remained largely unexplored from the point of view of the contemporary artistic movements is the connection between number theory and physics, which has been a crucial development of the last two decades. The rich interplay of metaphors, analogies, and new ideas that has accompanied the development of this field of research seems especially suitable for a dialog with the artistic imagination. One can also hope that contemporary artists will engage with mathematical structures related to classes of numbers broader than the integers, including the different types of numbers described at the beginning of this chapter: algebraic numbers or *p*-adic numbers, for example, may provide interesting material for artistic creativity. For example, algebraic number fields (extensions of the field of rational numbers obtained by including roots of polynomials) have their own set of prime numbers. Unlike the ordinary prime numbers, which are distributed inside the one-dimensional line of real numbers, the prime numbers of various number fields involve interesting higher dimensional geometries. It would seem like a natural avenue of investigation, in the context of Conceptual Art, how to incorporate this additional geometric aspect.

Chapter Appendix: Bibliographical Guide

A.1 Guide to the Artists

A general discussion of the use of number sequences in contemporary art can be found in the following essay:

- Götz Pfander and Isabel Wünsche, "Exploring Infinity: Number Sequences in Modern Art," *Arkhai: Revue d'Art et de philosophie* (Lausanne), no. 12 (2007): 41–66.

General references on the artists discussed in this chapter can be found in the following references.

- Christine Savinel, Jacques Roubaud, and Bernard Noël, *Roman Opalka*, Editions Dis Voir, 1996.
- Catherine Desprats-Pequignot, *Roman Opalka: Une vie en peinture—suivi de Création et trauma*, Editions L'Harmattan, 1997.
- Rune Mields, *Die apokalyptischen Zahlen*, Film Funk Fernseh Zentrum, 1996.
- Rune Mields *Steinzeitgeometrie*, Niederrheinischer Kunstverein, 1982.
- Noemi Smolik, *Rune Mields*, Art Forum 1988 (online).
- M. R. Schroeder, *Images from Computers*, IEEE Spectrum, 1969.
- F. Dietrich, *Visual Intelligence: The First Decade of Computer Art (1965–1975)*, Leonardo, 1986.
- Bart de Smit, *Van Gogh Meets Riemann*, Bridges Exhibit of Mathematical Art, 2005 (online).

- Roger I. Rothman, "Between Music and the Machine: Francis Picabia and the End of Abstraction," *Tout-fait* 2, no. 4 (2002) (online).
- Stanley Silver, *Breath and Shadow*, Frank Pictures Gallery, 2011 (online).

A.2 Guide to Number Theory and Physics

The reader can find general background material about number theory, prime numbers, and the Riemann zeta function in the following references. The first reference is a popularization book; the remaining ones are also introductory, but with some substantial mathematical content.

- Marcus du Sautoy, *The Music of the Primes*, Harper Collins, 2004.
- Barry Mazur and William Stein, *Prime Numbers and the Riemann Hypothesis*, Cambridge University Press, 2016.
- Manfred R. Schroeder, *Number Theory in Science and Communication: With Applications in Cryptography, Physics, Biology, Digital Information, and Computing*, Springer, 1983.
- Gérald Tenenbaum and Michel Mendès France, *The Prime Numbers and Their Distribution*, American Mathematical Society, 2000.
- R. P. Burn, *A Pathway into Number Theory*, Cambridge University Press, 1997.

The following is a list of further (more specific and advanced) reference books on number theory and its relations to physics, which are especially relevant to the topics mentioned in this chapter.

- J. Von Neumann, "Zur Einführung der transfiniten Zahlen," *Acta Litterarum Ac Scientiarum Ragiae Universitatis Hungaricae Francisco-Josephinae, Sectio Scientiarum Mathematicarum* 1 (1923): 199–208.
- G. J. O. Jameson, *The Prime Number Theorem*, Cambridge University Press, 2003.
- S. J. Patterson, *An Introduction to the Theory of the Riemann Zeta-Function*, Cambridge University Press, 1995.
- Machiel Van Frankenhuysen, *The Riemann Hypothesis for Function Fields*, Cambridge University Press, 2014.
- Klaus Kirsten and Floyd L. Williams, *A Window into Zeta and Modular Physics*, Cambridge University Press, 2010.
- Michel Waldschmidt, Pierre Moussa, Jean-Marc Luck, and Claude Itzykson, *From Number Theory to Physics*, Springer Verlag, 1992.
- Pierre E. Cartier, Bernard Julia, Pierre Moussa, and Pierre Vanhove, *Frontiers in Number Theory, Physics, and Geometry*, Springer Verlag, 2006.
- Yu. I. Manin and Alexei A. Panchishkin, *Introduction to Modern Number Theory*, Springer, 2006.
- Matilde Marcolli, *Arithmetic Noncommutative Geometry*, American Mathematical Society, 2005.

- Alain Connes and Matilde Marcolli, *Noncommutative Geometry, Quantum Fields and Motives*, American Mathematical Society, 2008.
- Matilde Marcolli, *Feynman Motives*, World Scientific, 2010.

In this section the reader can find some research articles that focus on the Riemann gas, the quantum statistical mechanics of prime numbers and its relation to the Riemann zeta function and the Riemann hypothesis and to geometric and topological ideas.

- D. Spector, "Supersymmetry and the Möbius Inversion Function," *Communications in Mathematical Physics* 127 (1990): 239–252.
- B. Julia, "Statistical Theory of Numbers," in *Number Theory and Physics*, Vol. 47 of Springer Proceedings in Physics, Springer Verlag, 1990.
- J. B. Bost and A. Connes, "Hecke algebras, Type III Factors and Phase Transitions with Spontaneous Symmetry Breaking in Number Theory," *Selecta Mathematica*, 1, no. 3 (1995): 411–457.
- A. Connes, C. Consani, and M. Marcolli, "The Weil Proof and the Geometry of the Adèles Class Space," in *Algebra, Arithmetic, and Geometry: in Honor of Yu. I. Manin. Vol. I*, ed. Yuri Tschinkel and Yuri Zahrin, 339–405, Birkhäuser, 2009.
- M. Greenfield, M. Marcolli, and K. Teh, "Twisted Spectral Triples and Quantum Statistical Mechanical Systems," *p-Adic Numbers Ultrametric Analysis and Applications* 6, no. 2 (2014): 81–104.
- M. Marcolli and Y. Xu, "Quantum Statistical Mechanics in Arithmetic Topology," *Journal of Geometry and Physics* 114 (2017): 153–183.

8 Matter and Forces

In this chapter we discuss how, over the course of the 20th century, physics, and in particular the theory of elementary particles, underwent a process of *geometrization*. Not only did geometry play a crucial role in the development of what is now known as the Standard Model of particle physics, it also informs the ongoing efforts to model possible physics beyond the Standard Model and possible approaches to the unification of quantum physics and gravity. The "Geometrization of Physics" is a pervasive and profound aspect of contemporary science. While some contemporary artists, as we shall discuss, have been explicitly inspired by the geometry of physics, this crucial idea has not yet become an established part of the general language of contemporary artistic expression.

8.1 The Standard Model of Particle Physics

The Standard Model describes all the known elementary constituents of matter and all the forces (except gravity) through which they interact (see figure 8.1). The model consists of a set of elementary particles (fermions) that are the basic constituents of matter, subdivided into leptons and quarks, and a set of particles (bosons) that includes the force carriers of the electoweak and strong forces (gauge bosons) and the Higgs field. Quarks interact through the strong force (gluons) and the electromagnetic and weak forces (photons and Z and W bosons), while the charged leptons (the electron and its partners in the other two generations, muon and tau) interact through electromagnetism and weak force, while the neutrinos interact via the weak force only. The Higgs field gives mass to particles it interacts with though the symmetry breaking phenomenon we discussed briefly in chapter 6. All currently known matter is built out of these elementary building blocks.

Some of the questions that are central to contemporary high-energy physics involve what lies beyond the Standard Model: massive neutrinos, supersym-

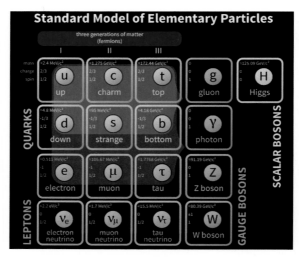

Figure 8.1
The Standard Model of elementary particle physics.

metric partners, dark matter, dark energy? An even more crucial question is the unification of this very successful theory of matter with gravity: what is quantum gravity? Can it be successfully modeled by strings, branes, loops, noncommutative spaces, or something else still?

There are other important questions that involve the Standard Model itself. The model depends on a certain number of parameters, which include the masses of the particles and the "mixing angles" (which allow particles from the three different generations to mix). There are 19 such parameters in the minimal version of the Standard Model and many more in various possible extensions that incorporate candidates for new physics. The values of these parameters are not predicted by the theory and are known only through experimental observations in particle accelerators.

There are puzzling properties of the observed values of these parameters. For example, if one looks at the masses, one sees that there is a very wide range of masses among the particles of the Standard Model. Particles with the same characteristics in different generations can have very different masses, and overall the masses range from extremely small values for neutrinos (which were previously believed to be massless), to the heaviest top quark, a single elementary particle that weights about as much as a whole atom of Tungsten (atomic number 74). It would be highly desirable to have a priori theoretical reasons for the values of these parameters.

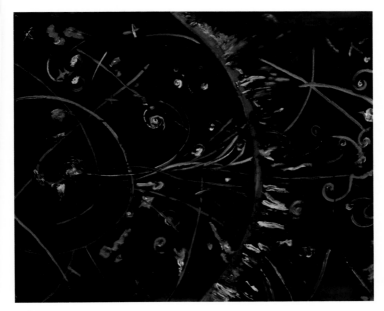

Figure 8.2
Gregory Allen Page, *Cern Atomic Collision Physics and Colliding Particles*, 2007.

Particle colliders are like giant microscopes: by going to increasingly high energies, they can probe increasingly small scales in the structure of matter. Collision events in particle accelerators create large composite particles that decay into their lighter constituents. By analyzing the "debris" produced in these collisions, the momenta of the resulting particles that hit detectors in the accelerator chamber, one can reconstruct the original particles formed in the collisions of the accelerator beams. That is how new particles are discovered and their properties analyzed. The role of theory is to produce a sophisticated computational setting where the result of events can be predicted and compared with what is observed in the accelerators. quantum field theory is the theoretical model behind all these computations.

Artists have incorporated the visual structure of collision events in particle accelerators, like the CERN Large Hadron Collider (LHC), in the form of abstract paintings. We have already seen the work *Collisions II* by Dawn Meson (in figure 3.30), a painting that shows the close connection between particle physics theory and the smooth structure of the four-dimensional spacetime manifold. An example that more closely follows the patterns of lines drawn by particle trajectories in accelerators and the idea of reading the structure of par-

Figure 8.3
Sophie Taeuber-Arp, *Linien Geometrisch und Gewellt*, 1940.

ticle physics from the "debris" of particle collisions, is presented in Gregory Allen Page's painting, *Cern Atomic Collision Physics and Colliding Particles* (in figure 8.2). In chapter 6 I discussed the use of diagrammatic graphical methods in high-energy physics to describe events of particle interactions, collisions, creations and annihilation of virtual particles, exchange of forces, and vacuum bubbles. These techniques play a crucial role in predicting and interpreting events in particle physics and in the phenomenology of the Standard Model. Besides the case of those artists, like Regina Valluzzi (see figures 6.15 and 6.16), who took direct inspiration from the language of Feynman diagrams in theoretical physics, other artists have illustrated ideas related to trajectories, collisions, and interaction events in the language of abstract composition.

This is the case, for example, in the work of Sophie Taeuber-Arp shown in figure 8.3. The extensive collection of Taeuber-Arp's line drawings used the language of abstract painting as a merging of diverse art forms like dance and music, based on compositional rules of symbolic line elements. These graphical symbols are used to describe an equilibrium of shapes or a dynamical abstract dance, a codification of movement, a sequence of sounds, a process broken down into a combination of graphical events depicted by lines of interaction, particles whose mutual relations are coded graphically by their world lines.

$$
\begin{aligned}
\mathcal{L}_{SM} = &-\tfrac{1}{2}\partial_\nu g^a_\mu \partial_\nu g^a_\mu - g_s f^{abc}\partial_\mu g^a_\nu g^b_\mu g^c_\nu - \tfrac{1}{4}g_s^2 f^{abc}f^{ade} g^b_\mu g^c_\nu g^d_\mu g^e_\nu - \partial_\nu W^+_\mu \partial_\nu W^-_\mu - \\
&M^2 W^+_\mu W^-_\mu - \tfrac{1}{2}\partial_\nu Z^0_\mu \partial_\nu Z^0_\mu - \tfrac{1}{2c_w^2}M^2 Z^0_\mu Z^0_\mu - \tfrac{1}{2}\partial_\mu A_\nu \partial_\mu A_\nu - igc_w(\partial_\nu Z^0_\mu(W^+_\mu W^-_\nu - \\
&W^+_\nu W^-_\mu) - Z^0_\nu(W^+_\mu \partial_\nu W^-_\mu - W^-_\mu \partial_\nu W^+_\mu) + Z^0_\mu(W^+_\nu \partial_\nu W^-_\mu - W^-_\nu \partial_\nu W^+_\mu)) - \\
&igs_w(\partial_\nu A_\mu(W^+_\mu W^-_\nu - W^+_\nu W^-_\mu) - A_\nu(W^+_\mu \partial_\nu W^-_\mu - W^-_\mu \partial_\nu W^+_\mu) + A_\mu(W^+_\nu \partial_\nu W^-_\mu - \\
&W^-_\nu \partial_\nu W^+_\mu)) - \tfrac{1}{2}g^2 W^+_\mu W^-_\mu W^+_\nu W^-_\nu + \tfrac{1}{2}g^2 W^+_\mu W^-_\nu W^+_\mu W^-_\nu + g^2 c_w^2(Z^0_\mu W^+_\mu Z^0_\nu W^-_\nu - \\
&Z^0_\mu Z^0_\mu W^+_\nu W^-_\nu) + g^2 s_w^2(A_\mu W^+_\mu A_\nu W^-_\nu - A_\mu A_\mu W^+_\nu W^-_\nu) + g^2 s_w c_w(A_\mu Z^0_\nu(W^+_\mu W^-_\nu - \\
&W^+_\nu W^-_\mu) - 2A_\mu Z^0_\mu W^+_\nu W^-_\nu) - \tfrac{1}{2}\partial_\mu H \partial_\mu H - 2M^2 \alpha_h H^2 - \partial_\mu \phi^+ \partial_\mu \phi^- - \tfrac{1}{2}\partial_\mu \phi^0 \partial_\mu \phi^0 - \\
&\beta_h\left(\tfrac{2M^2}{g^2} + \tfrac{2M}{g}H + \tfrac{1}{2}(H^2 + \phi^0\phi^0 + 2\phi^+\phi^-)\right) + \tfrac{2M^4}{g^2}\alpha_h - \\
&g\alpha_h M\left(H^3 + H\phi^0\phi^0 + 2H\phi^+\phi^-\right) - \\
&\tfrac{1}{8}g^2\alpha_h\left(H^4 + (\phi^0)^4 + 4(\phi^+\phi^-)^2 + 4(\phi^0)^2\phi^+\phi^- + 4H^2\phi^+\phi^- + 2(\phi^0)^2 H^2\right) - \\
&gMW^+_\mu W^-_\mu H - \tfrac{1}{2}g\tfrac{M}{c_w^2}Z^0_\mu Z^0_\mu H - \\
&\tfrac{1}{2}ig\left(W^+_\mu(\phi^0\partial_\mu\phi^- - \phi^-\partial_\mu\phi^0) - W^-_\mu(\phi^0\partial_\mu\phi^+ - \phi^+\partial_\mu\phi^0)\right) + \\
&\tfrac{1}{2}g\left(W^+_\mu(H\partial_\mu\phi^- - \phi^-\partial_\mu H) + W^-_\mu(H\partial_\mu\phi^+ - \phi^+\partial_\mu H)\right) + \tfrac{1}{2}g\tfrac{1}{c_w}(Z^0_\mu(H\partial_\mu\phi^0 - \phi^0\partial_\mu H) + \\
&M\left(\tfrac{1}{c_w}Z^0_\mu\partial_\mu\phi^0 + W^+_\mu\partial_\mu\phi^- + W^-_\mu\partial_\mu\phi^+\right) - ig\tfrac{s_w^2}{c_w}MZ^0_\mu(W^+_\mu\phi^- - W^-_\mu\phi^+) + igs_w MA_\mu(W^+_\mu\phi^- - \\
&W^-_\mu\phi^+) - ig\tfrac{1-2c_w^2}{2c_w}Z^0_\mu(\phi^+\partial_\mu\phi^- - \phi^-\partial_\mu\phi^+) + igs_w A_\mu(\phi^+\partial_\mu\phi^- - \phi^-\partial_\mu\phi^+) - \\
&\tfrac{1}{4}g^2 W^+_\mu W^-_\mu\left(H^2 + (\phi^0)^2 + 2\phi^+\phi^-\right) - \tfrac{1}{8}g^2\tfrac{1}{c_w^2}Z^0_\mu Z^0_\mu\left(H^2 + (\phi^0)^2 + 2(2s_w^2-1)^2\phi^+\phi^-\right) - \\
&\tfrac{1}{2}g^2\tfrac{s_w^2}{c_w}Z^0_\mu\phi^0(W^+_\mu\phi^- + W^-_\mu\phi^+) - \tfrac{1}{2}ig^2\tfrac{s_w^2}{c_w}Z^0_\mu H(W^+_\mu\phi^- - W^-_\mu\phi^+) + \tfrac{1}{2}g^2 s_w A_\mu\phi^0(W^+_\mu\phi^- + \\
&W^-_\mu\phi^+) + \tfrac{1}{2}ig^2 s_w A_\mu H(W^+_\mu\phi^- - W^-_\mu\phi^+) - g^2\tfrac{s_w}{c_w}(2c_w^2-1)Z^0_\mu A_\mu\phi^+\phi^- - \\
&g^2 s_w^2 A_\mu A_\mu\phi^+\phi^- + \tfrac{1}{2}ig_s\lambda^a_{ij}(\bar{q}^\sigma_i\gamma^\mu q^\sigma_j)g^a_\mu - \bar{e}^\lambda(\gamma\partial + m^\lambda_e)e^\lambda - \bar{\nu}^\lambda(\gamma\partial + m^\lambda_\nu)\nu^\lambda - \bar{u}^\lambda_j(\gamma\partial + \\
&m^\lambda_u)u^\lambda_j - \bar{d}^\lambda_j(\gamma\partial + m^\lambda_d)d^\lambda_j + igs_w A_\mu\left(-(\bar{e}^\lambda\gamma^\mu e^\lambda) + \tfrac{2}{3}(\bar{u}^\lambda_j\gamma^\mu u^\lambda_j) - \tfrac{1}{3}(\bar{d}^\lambda_j\gamma^\mu d^\lambda_j)\right) + \\
&\tfrac{ig}{4c_w}Z^0_\mu\{(\bar{\nu}^\lambda\gamma^\mu(1+\gamma^5)\nu^\lambda) + (\bar{e}^\lambda\gamma^\mu(4s_w^2-1-\gamma^5)e^\lambda) + (\bar{d}^\lambda_j\gamma^\mu(\tfrac{4}{3}s_w^2-1-\gamma^5)d^\lambda_j) + \\
&(\bar{u}^\lambda_j\gamma^\mu(1-\tfrac{8}{3}s_w^2+\gamma^5)u^\lambda_j)\} + \tfrac{ig}{2\sqrt{2}}W^+_\mu\left((\bar{\nu}^\lambda\gamma^\mu(1+\gamma^5)U^{lep}_{\lambda\kappa}e^\kappa) + (\bar{u}^\lambda_j\gamma^\mu(1+\gamma^5)C_{\lambda\kappa}d^\kappa_j)\right) + \\
&\tfrac{ig}{2\sqrt{2}}W^-_\mu\left((\bar{e}^\kappa U^{lep\dagger}_{\kappa\lambda}\gamma^\mu(1+\gamma^5)\nu^\lambda) + (\bar{d}^\kappa_j C^\dagger_{\lambda\kappa}\gamma^\mu(1+\gamma^5)u^\lambda_j)\right) + \\
&\tfrac{ig}{2M\sqrt{2}}\phi^+\left(-m^\kappa_e(\bar{\nu}^\lambda U^{lep}_{\lambda\kappa}(1-\gamma^5)e^\kappa) + m^\lambda_\nu(\bar{\nu}^\lambda U^{lep}_{\lambda\kappa}(1+\gamma^5)e^\kappa)\right) + \\
&\tfrac{ig}{2M\sqrt{2}}\phi^-\left(m^\lambda_e(\bar{e}^\lambda U^{lep\dagger}_{\lambda\kappa}(1+\gamma^5)\nu^\kappa) - m^\kappa_\nu(\bar{e}^\lambda U^{lep}_{\lambda\kappa}(1-\gamma^5)\nu^\kappa) - \tfrac{g}{2}\tfrac{m^\lambda_\nu}{M}H(\bar{\nu}^\lambda\nu^\lambda) - \\
&\tfrac{g}{2}\tfrac{m^\lambda_e}{M}H(\bar{e}^\lambda e^\lambda) + \tfrac{ig}{2}\tfrac{m^\lambda_\nu}{M}\phi^0(\bar{\nu}^\lambda\gamma^5\nu^\lambda) - \tfrac{ig}{2}\tfrac{m^\lambda_e}{M}\phi^0(\bar{e}^\lambda\gamma^5 e^\lambda) - \tfrac{1}{4}\bar{\nu}_\lambda M^R_{\lambda\kappa}(1-\gamma_5)\hat{\nu}_\kappa - \\
&\tfrac{1}{4}\bar{\nu}_\lambda M^R_{\lambda\kappa}(1-\gamma_5)\hat{\nu}_\kappa + \tfrac{ig}{2M\sqrt{2}}\phi^+\left(-m^\kappa_d(\bar{u}^\lambda_j C_{\lambda\kappa}(1-\gamma^5)d^\kappa_j) + m^\lambda_u(\bar{u}^\lambda_j C_{\lambda\kappa}(1+\gamma^5)d^\kappa_j) + \\
&\tfrac{ig}{2M\sqrt{2}}\phi^-\left(m^\lambda_d(\bar{d}^\lambda_j C^\dagger_{\lambda\kappa}(1+\gamma^5)u^\kappa_j) - m^\kappa_u(\bar{d}^\lambda_j C^\dagger_{\lambda\kappa}(1-\gamma^5)u^\kappa_j\right) + \tfrac{g}{2}\tfrac{m^\lambda_u}{M}H(\bar{u}^\lambda_j u^\lambda_j) - \\
&\tfrac{g}{2}\tfrac{m^\lambda_d}{M}H(\bar{d}^\lambda_j d^\lambda_j) + \tfrac{ig}{2}\tfrac{m^\lambda_u}{M}\phi^0(\bar{u}^\lambda_j\gamma^5 u^\lambda_j) - \tfrac{ig}{2}\tfrac{m^\lambda_d}{M}\phi^0(\bar{d}^\lambda_j\gamma^5 d^\lambda_j) + \bar{G}^a\partial^2 G^a + g_s f^{abc}\partial_\mu\bar{G}^a G^b g^c_\mu + \\
&\bar{X}^+(\partial^2 - M^2)X^+ + \bar{X}^-(\partial^2 - M^2)X^- + \bar{X}^0(\partial^2 - \tfrac{M^2}{c_w^2})X^0 + \bar{Y}\partial^2 Y + igc_w W^+_\mu(\partial_\mu\bar{X}^0 X^- - \\
&\partial_\mu\bar{X}^+ X^0) + igs_w W^+_\mu(\partial_\mu\bar{Y}X^- - \partial_\mu\bar{X}^+ Y) + igc_w W^-_\mu(\partial_\mu\bar{X}^- X^0 - \\
&\partial_\mu\bar{X}^0 X^+) + igs_w W^-_\mu(\partial_\mu\bar{X}^- Y - \partial_\mu\bar{Y}X^+) + igc_w Z^0_\mu(\partial_\mu\bar{X}^+ X^+ - \\
&\partial_\mu\bar{X}^- X^-) + igs_w A_\mu(\partial_\mu\bar{X}^+ X^+ - \\
&\partial_\mu\bar{X}^- X^-) - \tfrac{1}{2}gM\left(\bar{X}^+ X^+ H + \bar{X}^- X^- H + \tfrac{1}{c_w^2}\bar{X}^0 X^0 H\right) + \tfrac{1-2c_w^2}{2c_w}igM\left(\bar{X}^+ X^0\phi^+ - \bar{X}^- X^0\phi^-\right) + \\
&\tfrac{1}{2c_w}igM\left(\bar{X}^0 X^-\phi^+ - \bar{X}^0 X^+\phi^-\right) + igMs_w\left(\bar{X}^0 X^-\phi^+ - \bar{X}^0 X^+\phi^-\right) + \\
&\tfrac{1}{2}igM\left(\bar{X}^+ X^+\phi^0 - \bar{X}^- X^-\phi^0\right).
\end{aligned}
$$

Figure 8.4
The Standard Model Lagrangian.

The laws that govern the interactions of particles and all the possible observable events that can occur in experiments are derived from the Lagrangian of the Standard Model, see figure 8.4. This is a long and complicated expression in which all the possible forms of interaction between the fundamental particles listed in figure 8.1 are fully specified. We have a formula: does it mean that we understand everything? Here is where the task of the physicist and the mathematician differ. While the main task of the physicist is to extract computational predictions from the Standard Model Lagrangian, the mathematician should pursue a different type of question: is there a *simple* principle behind the complicated expression of the Standard Model Lagrangian? Does

the expression *follow* from a small set of simple principles by computation? In other words, the task is to determine, not what can it predict, but what does it *mean*? We will see that, in the course of modern physics, *geometry* has been a crucially important guiding principle for tackling complexity. Indeed geometry played a crucial role in arriving at the long expression of figure 8.4 and continues to play a crucial role in our efforts to better understand it.

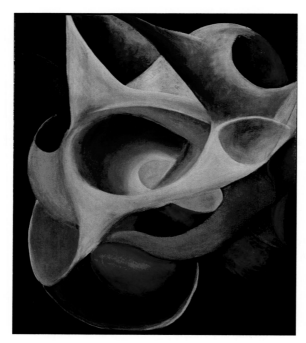

Figure 8.5
Dawn Meson, *Kaluza-Klein (Invisible Architecture III)*, ca. 2005.

8.2 The Geometrization of Physics

Shortly after the geometrization of gravity achieved by Einstein's general relativity, the first instance of geometrization of the physics of other forces occurred with the Kaluza-Klein model of electromagnetism. In general relativity the gravitational field is realized by the metric on a four-dimensional space-time manifold. In Kaluza-Klein theory, electromagnetism is incorporated in the picture by adding a fifth dimension, curled up into circles: a *circle bundle* over spacetime.

The fundamental idea of the Kaluza-Klein theory is that what we experience as forces acting in our ambient four-dimensional spacetime (in this case, the electromagnetic force) is, in fact, geometry in additional dimensions, which are not extended like the spacetime directions, but compactified (in circles in the electromagnetism case). These additional dimensions are responsible for the "internal degrees of freedom" of the physical theory being modeled, which involves the type of forces that can act and the type of particles that interact through those forces.

These invisible curled-up directions, these compactified additional dimensions that are responsible for the particles and forces in the original Kaluza-Klein model and in its modern extensions are portrayed in the painting of Dawn Meson, *Kaluza-Klein (Invisible Architecture III)* (see figure 8.5). The complex shape of the extra dimensions plays a crucial role in more modern theories like string theory, as well as in physical models based on noncommutative geometry. Dawn Meson's painting depicts this fundamental idea, bridging between the original Kaluza-Klein model of electromagnetism based on circles as compactified fibers and the more complex compactified dimensions of string theory given by Calabi-Yau manifolds with more intricate geometry and topology. The "invisible architecture" in the title points to the small size of these compactifications, which renders the compactified dimensions not directly perceivable, unlike the extended spacetime dimensions, though they manifest themselves through the properties of particles and forces.

8.2.1 Evolution of the Kaluza-Klein Idea

Other forces acting on elementary particles, the weak and the strong force, have a different geometry. The fact that electromagnetism gives rise to a circle bundle in the Kaluza-Klein model is related to the fact that the carrier of this force, the photon, can be described mathematically as a $U(1)$ gauge potential, where the gauge group $U(1)$ is the circle, viewed as the complex numbers of modulus one with the multiplication operation. The gauge bosons of the weak and strong force obey similar rules, but the corresponding gauge groups are more complicated groups, termed $SU(2)$ and $SU(3)$, respectively. The general form of the geometry is similar, however. It can be described in terms of *vector bundles* over the four-dimensional spacetime manifold, where a vector space lies on top of each point of the spacetime manifold, describing the inner degrees of freedom. The geometry of these vector bundles describes the physics of the particles of matter and the forces: connections and curvature determine the gauge potentials and the force fields, sections of the vector bundle determine the matter particles (fields), and the symmetries of the bundle are the

gauge symmetries of the physical theory, with the correct symmetry groups replacing the circle of electromagnetism.

A section of a vector bundle is a consistent choice of a vector over each point of the underlying spacetime. Such a section describes a (classical) field, a type of matter particle, depending on what model of matter the geometry of the bundle describes. A connection on a vector bundle is a consistent choice of "horizontal directions" and the curvature of the vector bundle measures how much the choice of horizontal directions fails to be globally flat. The presence of curvature results in a force field that is felt at all points in spacetime where the curvature does not vanish.

Figure 8.6
Regina Valluzzi, *Vector Field*, 2012.

Sections and connections on vector bundles are the key objects underlying a geometric modeling of particle physics. The concept of a vector field (a section of a particular vector bundle: the tangent bundle) has been captured by artists in pictorial representations, as one can see for example in the painting by Regina Valluzzi, in figure 8.6. The notion of connection is perhaps more subtle, but its geometric meaning as a locally variable choice of a horizontal direction can be seen in the *Arrest* series works of Bridget Riley, one of the main exponents of the Op Art movement (see figure 8.7).

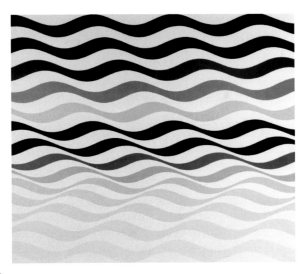

Figure 8.7
Bridget Riley, *Arrest 3*, 1965.

Figure 8.8
Marcia Lyons, *RED Force Fields*, 2011.

The Op Art works of Bridget Riley are based on compositions of straight or curved lines creating optical illusion effects like impressions of movement and vibration, and a general sense of disorientation. Some of the paintings are based on alternating black and white patterns, while others include optical effects based on color contrast. The curved patterns in the *Arrest* series, including the work of figure 8.7, generate a sense of a set of "parallel" directions, which are however not given by straight lines, but by a continuously deformed family of twisted bands that convey the impression of an underlying curved surface on which parallel straight lines are perceived in perspective as deformed. This altered sense of a bending and curved surface results in an apparent sensation of movement. This idea of a parallel family of nonstraight "horizontal directions" is indeed what the mathematical notion of connection is meant to express. Riley herself often pointed out how the optical effects that this type of composition generates turn the space in between the canvas plane and the viewer into an "active" dynamical entity, where the actual perception of the work takes place and how the painting itself can be inhabited and acted upon by the mind's eye of the viewers.

One can think of a connection also as a field: a bosonic field, a force carrier rather than a fermionic matter field. Thus, one can also view a connection (or more precisely the associated curvature) as a force field, where a more concentrated curvature represents a greater intensity of the corresponding force. A similar concept of force field, expressed using patches of brighter or darker red color to represent the idea of varying intensity (more or less curvature), can be seen in the work of Marcia Lyons in figure 8.8.

In the models of particle physics based on the geometry of gauge theories, described above in terms of vector bundles, sections, connections, and gauge groups, composite particles (for instance baryons) arise in terms of elementary particles (quarks) through the mathematical theory of representations of Lie groups (in this case the group $SU(3)$, the gauge group of the strong force). This way of obtaining composite particles from elementary particles corresponds, at the level of the geometry of vector bundles, to ways of constructing vector bundles from group representations and correspondingly obtaining the composite particles as sections.

The physical processes that take place in the interactions between particles of matter and forces can then be seen geometrically (at the classical level) as sections of vector bundles that are solutions to certain equations involving the connection and curvature. A pictorial view of the richness of physical processes arising from the interactions of matter and forces and their geometric

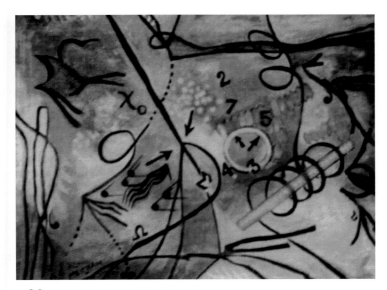

Figure 8.9
Aram Mekjian, *Physical Processes*, 1997.

nature is depicted in the work of the physicist and painter Aram Mekjian in
figure 8.9.

Another more recent evolution of the original Kaluza-Klein idea gave rise to
the geometry underlying string theory. In this setting, instead of a bundle of
circles over the four-dimensional spacetime, the extra dimensions are given by
a six-dimensional geometry, chosen among a class of manifolds called Calabi-
Yau three-fold (the "three" here refers of complex dimension, which means six
real dimensions). The different modes of vibration of strings in such geome-
tries determine the types of matter particles and forces. The very large number
of possible choices of the geometry gives rise to a multiverse of possible uni-
verses with different forms of elementary particles.

Directly inspired by the idea of string vibrating in different background ge-
ometries, the sculptor Craig Clarke created large installations of tangled strings
in various background landscapes, such as *Chaos in Wood* (see figure 8.10).

Another development of the Kaluza-Klein idea gave rise recently to an ap-
proach to particle physics models based on noncommutative geometry. In this
setting the extra dimensions are neither circles, nor other manifolds. They are
a different kind of geometry entirely, a noncommutative geometry (see chap-
ter 3), which is a kind of geometry that incorporates quantum mechanical rules
like the Heisenberg uncertainty principle.

Figure 8.10
Craig Clarke, *Chaos in Wood*, ca. 2010.

Noncommuting variables arise naturally in quantum mechanics because observables are represented by operators, which means by matrices in a finite dimensional case, and matrix multiplication does not commute:

$$\begin{pmatrix} a & b \\ c & d \end{pmatrix} \begin{pmatrix} u & v \\ x & y \end{pmatrix} = \begin{pmatrix} au + bx & av + by \\ cu + dx & cv + dy \end{pmatrix} \neq$$

$$\begin{pmatrix} au + cv & bu + dv \\ ax + cy & bx + dy \end{pmatrix} = \begin{pmatrix} u & v \\ x & y \end{pmatrix} \begin{pmatrix} a & b \\ c & d \end{pmatrix}$$

The fact that observables in quantum mechanics usually do not commute, and in particular that the variables of position and velocity (momentum) do not commute, is the basic mathematical reason behind the Heisenberg uncertainty principle: the possible observed values of a physical quantity are given by the spectrum, hence two observables described by operators that do not commute cannot be simultaneously computed, because the corresponding operators cannot be simultaneously diagonalized to obtain their spectra.

What, then, is a noncommutative space? An example arises naturally when we consider the composition law for spectral lines. It has been one of the fundamental observations leading to the development of quantum physics that the absorption and emission of light by matter (say, the hydrogen atom) happens only at certain frequencies, which are structured in certain series of spectral

lines that can be observed in experiments. These correspond to the amounts of energies that are needed for an electron to jump between energy levels of its bound state as part of the atom. In other words, the energy levels are quantized.

Two successive jumps between energy levels can take place when the level reached after the first jump is the starting level of the second jump. There is a mathematical structure that accounts for this type of composition of successive transitions, which is called a *groupoid*. Two transitions (arrows) in a groupoid can be composed whenever the endpoint of the first is the starting point of the second. The spectral lines of atoms are structured so that a groupoid law describes all the possible transitions.

An advantage of the noncommutative geometry approach to particle physics is that the complicated Standard Model Lagrangian arises from a very simple geometric setting, where the extra dimensions are given by a choice of a *zero-dimensional* noncommutative space (it is zero-dimensional in a sense, but six-dimensional in another sense: noncommutative spaces have more than one notion of dimension). The action functional in these models is given by a simple action functional for non-commutative spaces called the *spectral action*. The finite noncommmutative space that gives rise to the Standard Model Lagrangian has algebra of functions given by $\mathcal{A} = \mathbb{C} \oplus \mathbb{H} \oplus M_3(\mathbb{C})$, where the complex numbers \mathbb{C}, the quaternions \mathbb{H}, and the matrices $M_3(\mathbb{C})$ are responsible, respectively, for electromagnetism and weak force and for the strong force.

8.3 What Is a Good Mathematical Model?

All the approaches we discussed above are geometric in nature and all have a common fundamental idea: the existence of *more dimensions* than the four-dimensions of space and time, which are responsible for the type of matter and forces that exist in the universe and their interaction.

When is a mathematical model a good model of the physical world? There are some fundamental requirements that are generally viewed as a favorable indication.

- *Simplicity*: difficult computations should follow from simple principles.
- *Predictive power*: the model should provide new insight on physics and give rise to new testable calculations.
- *Minimalism*: Ockham's razor, *"entia non sunt multiplicanda praeter necessitatem,"* means that a model should not introduce unnecessary assumptions or an excessive number of new entities and objects that are not strictly required to achieve consistency and satisfy the previous two requirements.

- *Elegance*: there is a general aesthetic guiding principle in mathematics, which expects mathematical theories and explanations of physical reality to be not only consistent and testable, but intrinsically beautiful.

More than one mathematical model may be needed to explain different aspects of the same physical phenomenon, just as physics at different energy scales is described by different mathematics.

In addition to the very general list of properties just mentioned, the construction of a good model should be driven by specific questions. For example, one of the pressing questions is the understanding of dark matter. The existence of a new type of elementary particles is one of the proposed explanation for the excess of matter in the cosmos that is not visible by direct astronomical observations (does not emit light) but is known to affect the gravitational motion of galaxies and larger structures. If supersymmetric extensions of the Standard Model are to be confirmed experimentally, then the lightest supersymmetric particle would be stable and a possible constituent of dark matter. Other proposals for possible dark matter constituents have ranged from small astronomical objects like brown dwarf stars to modifications to the laws of gravity of general relativity, to exotic smoothness. The dark matter question may become one of the most significant guidelines in the development of particle physics models.

A view of forms of dark matter that do not emit light but gravitate is realized by Cornelia Parker's installation, *Cold Dark Matter, An Exploded View* (see figure 8.11). The installation was created by first exploding a garden shed and then suspending the fragments inside a room, as if caught in mid-explosion, illuminated by a single light placed at the center of the scene, the hypothetical origin point of the blast, projecting intricate shadows on the surrounding walls. The "Cold Dark Matter" reference links the mundane level of these objects to the large cosmic scale where dark matter is the unseen mysterious component of the universe, whose presence is only detectable by its gravitational effect, but whose nature remains elusive. The garden shed represents an ordinary presence of daily life, visible but unseen. It provides a space that hides unused old things as well as tools. The fragments in the composition include a range of objects, including tools and children's toys: they are relics of a personal past, in the same way as dark matter is a remnant of the formation of structures in the early universe and carries a memory of the gravitational past. The shapes and elements of the composition and the original forms reduced to fragments in the explosion can only be deduced from the distorted shadows they cast on the outer walls of the room, which change shape and form as the suspended fragments move or rotate ever so slightly about the illuminated

Figure 8.11
Cornelia Parker, *Cold Dark Matter, An Exploded View*, 1991.

center of the composition. This discernibility through faint signals encoded in projected shadows also points to the problem of detectability and identification of the unknown constituents of dark matter, of which we can only perceive the "shadows" of gravitational effects on the rotation curves of galaxies.

8.4 Abstraction and Representation

The artists whose work was mentioned in this chapter come from a very diverse set of backgrounds, as far as artistic styles go. It is interesting that some of the works more explicitly and directly inspired by the world of elementary particle physics, such as the painting of Gregory Allen Page in figure 8.2 or the artwork of the physicist Aram Mekjian in figure 8.9, come from artists who identify with various forms of contemporary Neo-Impressionist and Post-Impressionist movements. In particular, they belong squarely in the tradition of figurative art, rather than abstraction. The same can be said for installa-

tion artists like Cornelia Parker (figure 8.11), or about the sculptures of Craig Clarke, which are usually figurative. On the contrary, the Op Art of Bridget Riley (figure 8.7) is entirely within the 20th century tradition of abstraction, and so is Sophie Taeuber-Arp (figure 8.3). The digital and video art of Marcia Lyons (figure 8.8) fits in a broader artistic movement exploring the concept of virtuality and inspired by philosophical ideas of Virilio. The science-inspired paintings of Dawn Meson (figure 8.5) and Regina Valluzzi (figure 8.6) can be seen as coasting the boundary between figuration and abstraction. Should art that is directly and explicitly inspired by theoretical physics be regarded as figurative or as abstract?

Of course, at some level, the question is ill posed, as the boundary between figuration and abstraction is never entirely clear cut, but there is a valid question about the role of *representation*, which one can formulate in parallel for the world of artistic expression as well as for the use of mathematics in the modeling of physical reality. Mathematics in itself is nonrepresentational, in the very same sense in which abstract art is nonrepresentational. A mathematical theorem, or a mathematical object whose properties a theorem establishes, is an abstraction, in the same way in which an abstract painting is abstract. A mathematical model of a physical theory, on the contrary, is a representational use of mathematics, no matter how theoretical the physics is. Even if the mathematical model is about fairly abstract entities like D-branes living in a multiverse at energies well beyond the scales accessible by experiment, the goal of such ideas is still a possible model of physical reality. A group, as a mathematical object, is an abstraction, and theorems and classification results about groups are, in that sense, nonrepresentational, but the gauge groups of physics that describe forces and interactions between elementary particles are a "representational" (in the art theory sense) use of the mathematical concept of a group. In other words, if you wish, group theory is abstract art but gauge groups are figurative art. It makes sense, in this light, that much of the artwork that is directly inspired by concepts of theoretical physics is performed by figurative rather than abstract artists, even though abstract art is much closer to mathematical concepts than figurative art.

Within the previous question of what is a good mathematical model for theoretical physics, we can then add a further requirement, which is a good balance of "figuration" and "abstraction," which, when referring to mathematics and physics rather than to art, can be thought of as a good balance between the mathematical depth (abstraction) and its capacity to capture the crucial aspects of the physical model (figurative representation).

Chapter Appendix: Bibliographical Guide

A.1 Guide to the Artists

Some general information about the artists whose work is discussed in this chapter, and the movements and ideas behind them, can be found in the following references.

- Angela Di Bello, "Profiles: Gregory Allen Page," *Artis Spectrum* 18 (2007): p.51.

- Jesse Matz, *Lasting Impressions: The Legacies of Impressionism in Contemporary Culture*, Columbia University Press, 2017.

- Karin Schick, Oliver Kornhoff, and Astrid von Asten, *Bewegung und Gleichgewicht: Sophie Taeuber-Arp 1889–1943*, Kerber, 2009.

- Sophie Taeuber-Arp, *Heute ist Morgen*, Scheidegger & Spiess, 2014.

- Naomi Sawelson-Gorse, *Women in Dada: Essays on Sex, Gender, and Identity*, MIT Press, 2001.

- Bibiana Obler, *Intimate Collaborations: Kandinsky and Münter, Arp and Taeuber*, Yale University Press, 2014.

- Raven Hanna, "Dawn Meson: Orders of Magnitude," *Symmetry Magazine*, 2005 (online).

- Will Kitson, "Dr. Regina Valluzzi: The Grand Experiment—Bridging the Gap between Science and Art," *Seymour Magazine*, 2015 (online)

- Bridget Riley, *The Eye's Mind: Collected Writings 1965–2009*, Thames & Hudson, 2009.

- Michael Bracewell and Robert Kudielka, *Bridget Riley: Flashback*, Hayward Publishing, 2010.

- Lynne Cooke and John Elderfield, *Bridget Riley: Reconnaissance*, Dia Center for the Arts, 2001.

- Richard Shiff, *Bridget Riley: Works 1981–2015*, David Zwirner, 2016.

- Rene Parola, *Optical Art: Theory and Practice*, Dover, 1996.

- Marcia Lyons, Woody Vasulka, Jim Campbell, Leo Villareal, and Ben Weiner, *RED Force Fields*, David Richard Contemporary, 2011.

- Ellen Berkovich, *The Effect of Red On The Seeing Body*, Adobe Airstream, 2011 (online).

- Brian Massumi, *Parables for the virtual: movement, affect, sensation*, Duke University Press, 2002.

- Paul Virilio, *Polar Inertia*, SAGE, 1999.

- Aram Mekjian, *Artwork*, Physics Department, Rutgers University, 1997 (online).

- Craig Clarke, *Modern Artist – Sculptor*, 2000 (online).

- Cornelia Parker, *Cold Dark Matter: An Exploded View*, Tate Gallery Interactive Site, 2006 (online).

- Isabel Stevens, *Cornelia Parker*, Apollo Magazine, 2016 (online).

A.2 Guide to the Geometry of Particle Physics

The following references provide an overview of the Standard Model of elementary particle physics, starting with a popularization book and moving on to more detailed and more technical treatments.

- Robert Oerter, *The Theory of Almost Everything: The Standard Model, the Unsung Triumph of Modern Physics*, Penguin, 2006.
- Frank Close, *The New Cosmic Onion: Quarks and the Nature of the Universe*, CRC Press, 2006.
- G. D. Coughlan, J. E. Dodd, B. M. Gripaios, *The Ideas of Particle Physics: An Introduction for Scientists*, Cambridge University Press, 2006.
- W. Noel Cottingham, Derek A. Greenwood, *An Introduction to the Standard Model of Particle Physics*, Cambridge University Press, 1998.
- G. L. Kane, Aaron Pierce, *Perspectives on LHC Physics*, World Scientific, 2008.
- Cliff Burgess, Guy Moore, *The Standard Model: A Primer*, Cambridge University Press, 2007.
- John F. Donoghue, Eugene Golowich, Barry R. Holstein, *Dynamics of the Standard Model*, Cambridge University Press, 1994.

The development of the Kaluza-Klein idea from electromagnetism to gauge theories, and the extra dimensions of string theory are featured in some of the following treatments, along with a general discussion on the role of geometry in modern physics. The first three references are popularization books, and the remaining ones present a more technical discussion.

- Georges Lochak, *La Géométrisation de la Physique*, Flammarion, 1999.
- Shing-Tung Yau and Steve Nadis, *The Shape of Inner Space: String Theory and the Geometry of the Universe's Hidden Dimensions*, Basic Books, 2010.
- Lisa Randall, *Warped Passages: Unraveling the Mysteries of the Universe's Hidden Dimensions*, Harper Collins, 2005.
- Robert Coquereaux and Arkadiusz Jadczyk, *Riemannian Geometry, Fiber Bundles, Kaluza-Klein Theories and All That...*, World Scientific, 1988.
- Ta-Pei Cheng and Ling-Fong Li, *Gauge Theory of Elementary Particle Physics*, Oxford University Press, 1988.
- Joseph Polchinski, *String Theory*, Cambridge University Press, 1998.

The following list of references provides more technical reading material on the geometry of vector bundles: sections, connections, curvature, and their physical meaning.

- Jürgen Jost, *Geometry and Physics*, Springer Verlag, 2009.
- Clifford Henry Taubes, *Differential Geometry: Bundles, Connections, Metrics and Curvature*, Oxford University Press, 2011.
- Mikio Nakahara, *Geometry, Topology and Physics*, Taylor & Francis, 2003.

- M. Göckeler and T. Schücker, *Differential Geometry, Gauge Theories, and Gravity*, Cambridge University Press, 1989.

The noncommutative geometry approach to particle physics models is treated in the following monographs and research papers.

- Walter van Suijlekom, *Noncommutative Geometry and Particle Physics*, Springer Verlag, 2015.

- Wim Beenakker, Thijs van den Broek, and Walter D. van Suijlekom, *Supersymmetry and Noncommutative Geometry*, Springer Verlag, 2015.

- Florian Scheck, Wend Werner, and Harald Upmeier, *Noncommutative Geometry and the Standard Model of Elementary Particle Physics*, Springer Verlag, 2002,

- Alain Connes, and Matilde Marcolli, *Noncommutative Geometry, Quantum Fields and Motives*, American Mathematical Society, 2008.

- Alain Connes, "Gravity Coupled with Matter and the Foundation of Non-Commutative Geometry," *Communications in Mathematical Physics* 182, no. 1 (1996): 155–176.

- Ali Chamseddine and Alain Connes, "Universal Formula for Noncommutative Geometry Actions: Unification of Gravity and the Standard Model," *Physics Review Letters* 77, no. 24 (1996): 4868–4871.

- Ali Chamseddine, Alain Connes, and Matilde Marcolli, "Gravity and the Standard Model with Neutrino Mixing," *Advances in Theoretical and Mathematical Physics* 11, no. 6 (2007): 991–1089.

9 Can You Hear the Shape of the Cosmos?

In this chapter I return to a discussion of the problem of cosmic topology, which we have already touched on in chapters 3 and 6. More generally, we discuss how the problem of the geometry of the cosmos has influenced scientific and artistic thinking.

9.1 The Geometry of the Cosmos

The quest for understanding the geometry of the cosmos is as old as human civilization. The regularities in the motion of the Moon and the planets, the position of the stars, the way it changes with the seasons and with the latitude, the apparent grouping of stars into constellations all contributed to generate the impression of an underlying regular geometry responsible for the structure of the heavens and the motion of celestial bodies. The work of the contemporary Ghanian artist El Anatsui, on connections between the Earth and the Moon (figure 9.1) hints at gravitational attraction and at the cycle of the tides, and is generally symbolic of the periodicities of celestial phenomena that lie at the heart of the human quest for a geometric understanding of the universe.

All cultures in the world, ranging from African cosmologies, to Egyptian, Babylonian and ancient Greek astronomy, and Chinese star maps tried to uncover the regularity of the astronomical events in terms of some form of geometry. The perceptual impression of an immobile Earth at the center of a moving universe generated models based on concentric circles, celestial spheres, carrying the moving bodies of the Moon, the Sun, the planets, and the distant stars. Epicycles and deferents piled up in a sort of analogical Fourier transform (an approximation of motion by a composition of successive circular motions), creating the complex form of the geocentric universe of the Ptolemaic system (see figure 9.2).

Figure 9.1
El Anatsui, *Earth-Moon Connexions*, 1995.

9.1.1 Geometry in the Solar System

In seeking geometric simplicity and better matching with observational data, Copernicus, Kepler, Bruno, and Galilei led the Scientific Revolution, which placed the Sun at the center (or better at a focal point of an ellipse) of the motion of the planets, and removed forever the Earth from any central position in the cosmos. The transition between geocentrism and heliocentrism was not a smooth and immediate transition. In the intermediate stages, several different geometries were tried out as possible models, including the discarded idea, proposed by Kepler, of a cosmos based on nested Platonic solids centered at the Sun, the ratios of their radii supposedly "explaining" the distances between the orbits of the planets. A modern rendering of Kepler's polyhedral cosmology is given in the computer art work of the artist Roberto Graña (see figure 9.3).

Figure 9.2
James Ferguson, *Geocentric Cosmology*, engraved for *Encyclopaedia Britannica*, 1757.

Kepler's model based on the Platonic solids failed to account for the data of the orbit of Mars, and (although this was not known at the time) there are more planets in the solar system than can be accounted for by the five Platonic solids. The model, although intrinsically elegant in its simple geometry, was abandoned by Kepler in favor of a better model based on elliptic orbits.

The idea of a connection between regular geometric shapes like polygons and polyhedra and the mystery of cosmic structures remained part of our cultural inheritance though, even if the simple proposal of Kepler was discarded. Many contemporary artists have developed their work around the idea of cosmologies based on polyhedral structures. Max Bill's painting *Variation* (figure 9.4) appears to be a direct reference to the Kepler cosmos, in a two-dimensional universe. It is interesting how, unlike Kepler's solids but more like Kepler's ellipses, the polygons in Max Bill's painting are off-center, with each one sharing an edge (rather than a barycenter) with the previous.

The contemporary Chinese artist Liang Manqi produced a series of recent paintings where she elaborates on the idea of polyhedral geometries of the universe (see figure 9.5). As I will show, polyhedra would indeed remain relevant to the cosmos, not at the scales of the solar system, but at much larger scales. The polygonal and polyhedral shapes in Liang Manqi's paintings not only have

Figure 9.3
Roberto Graña, *Polyhedron, Kepler's Cosmos*, 2010.

Figure 9.4
Max Bill, *Variation 14*, 1937.

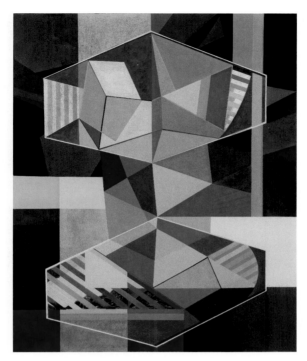

Figure 9.5
Liang Manqi, *Polygon Magnifier*, 2016.

a cosmic significance as shapes of the universe, but also refer indirectly to the pleasurable and playful nature of geometry, hence casting our quest for a geometric universe in the background of aesthetic beauty and playful imagination, suggesting an elaborate abstract construction game.

Our understanding of the structure of the solar system developed much further than the basic understanding of the elliptic orbits of the planets around the sun achieved at the time of Kepler. It incorporated more sophisticated mathematical ideas about chaotic and quasiperiodic motion, resonance effects, and collective dynamical phenomena, that occur when large, massive bodies like Jupiter affect the orbits of the other bodies in the solar system. A simulation of the Sun-Earth-Jupiter system showing chaos in the solar system is shown in figure 9.6, where the Poincaré return map is shown with a plot dot for each time the Earth passes Jupiter while both orbit the Sun, with coordinates showing the distance of the Earth from the Sun-Jupiter center of mass and the velocity component in the direction toward Jupiter.

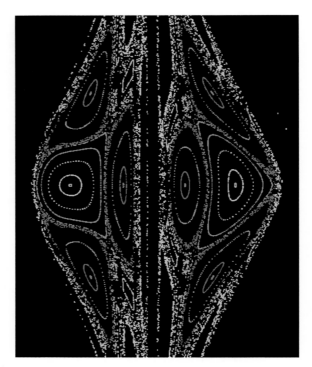

Figure 9.6
James P. Sethna, *Poincaré Return Map: Sun–Earth–Jupiter System*, 1996.

A hint at the mutual gravitational interactions between different orbiting bod-
ies in the solar system is present in the piece *Double Orbit View* by the artist
Olafur Eliasson (see figure 9.7). A chaotic geometry like the one shown in
figure 9.6 is very far removed from simple polyhedral shapes. The painting by
Picabia titled *El sol en la pintura* (figure 9.8) appears much more consonant to
our modern understanding of the complicated dynamics of orbits in the solar
system, than any simple polyhedral model the early astronomers would have
hoped for.

9.1.2 Spacetime Geometry and Cosmology

The general quest for a geometry of the cosmos extended beyond the solar sys-
tem. Modern cosmology involves geometry in a profound way, starting with
the geometrization of gravity achieved by general relativity. Questions con-
cerning the past and future evolution of the universe, the shape of the universe
(closed, open, curved, flat), and the interactions of matter and forces (gravity,

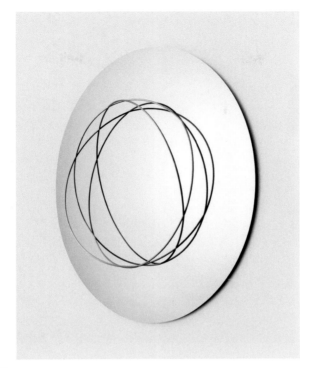

Figure 9.7
Olafur Eliasson, *Double Orbit View*, 2013.

quantum gravity, particle physics, dark matter, dark energy) are expected to have a geometric nature.

The theme of the possible existence of large geometric structures in the universe was developed in a series of artworks by Clint Fulkerson, whose geometric shapes of nebulae and clusters capture the quest for an understanding of cosmic structures in regular geometric terms (see figures 9.9 and 9.10). Fulkerson's *Nebulae* series shows a discrete geometry, based on a mesh of polygonal shapes, and a dual triangulation (see figure 9.9) where the varying shapes of the triangles in the triangulation give an indication of the varying curvature properties of the spacetime represented. A mathematical method for performing computations in general relativity, based on discretized geometries and triangulations, is known as Regge calculus. In Fulkerson's *Nebulae* series, zones of higher density and smaller more concentrated tiles suggest the merging of different bubbles of spacetime, while zones of lower density and larger tiles suggest expansion. Thinking of the polygonal shapes as Voronoi cells (see

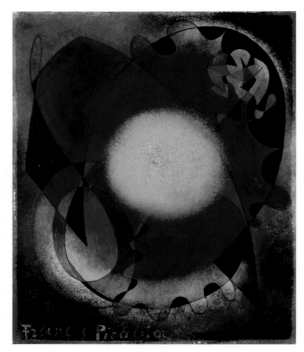

Figure 9.8
Francis Picabia, *El sol en la pintura*, 1945.

chapter 3), suggests a distribution of point objects, like stars in a nebula, along irregularly shaped surfaces of varying metric and curvature.

At the level of galaxies and clusters of galaxies there is a large-scale structure called the *Cosmic Web* (see figure 5.6), which, however, has a fractal structure rather than a regular polyhedral geometry. The scale at which a possible regular geometry may indeed take place is larger still: it is at the level of the farthest object we can see in the cosmos: the background radiation (CMB).

Einstein's general relativity established certain important general principles that have shaped our understanding of the cosmos. The very first crucial idea is that space and time are not separate concepts but rather are part of a single geometry of a four-dimensional spacetime manifold. Moreover, the gravitational field curves this spacetime manifold. Causality is built into the structure of spacetime, where causally connected regions are determined by light cones. The finite speed of light implies that only certain parts of spacetime can be causally related and the Lorentzian geometry of Minkowski space shows how to express the notion of causality geometrically in terms of cones. The dynam-

Figure 9.9
Clint Fulkerson, *Blue Nebula*, 2014.

ical nature of the universe, its expansion or contraction, are also determined geometrically in terms of the Einstein field equations (possibly with a nontrivial cosmological constant). These equations again depend on the metric and the curvature of spacetime (see chapters 3 and 6), and are explicitly of the form

$$R_{\mu\nu} - \frac{1}{2}Rg_{\mu\nu} + \Lambda g_{\mu\nu} = \frac{8\pi G}{c^4}T_{\mu\nu},$$

where T is the energy-momentum tensor describing the interaction of gravity with matter (see chapter 6). They are the variational equations of the Einstein-Hilbert action for matter coupled to gravity

$$S = \int_X (\frac{1}{2\kappa}(R - 2\Lambda) + \mathcal{L})dv, \quad \text{with } \kappa = 8\pi G/c^4,$$

where \mathcal{L} is the Lagrangian for matter minimally coupled to gravity.

Evidence for the expansion of the universe comes from the red-shift of galaxies (Hubble, 1929), with more distant galaxies receding faster. The hypothesis of an initial Big Bang singularity was motivated by extrapolating backward. It was confirmed by the discovery of the background radiation, the echo of the Big Bang that is everywhere in the cosmos (Penzias and Wilson, 1964). The future destiny of the universe depends on the balance of matter and energy, including the mysterious dark matter and dark energy, which can lead to contraction, expansion, or accelerated expansion. The latter appears to be favored by our current understanding.

Figure 9.10
Clint Fulkerson, *Limits + Fields*, 2015.

Inflation in the early universe is also part of our current understanding of cosmology (see chapter 6). A phase of accelerated expansion justifies why the universe is so homogeneous: such distant zones would not be causally connected, unless causally connected regions in the very early universe were expanded exponentially by a very accelerated expansion (inflation).

Observing further away in the cosmos also means going backward in time, as the signals that come to us from distant objects have traveled across space at the speed of light. The most distance and most ancient object we can see is the Cosmic Microwave Background (CMB). This is the *last scattering surface*, beyond which (which means even further back in time) the early universe was "opaque" to light. Indeed, the very early universe was so hot that all matter was fully ionised, with electrons not bound to atoms, and photons of light would be continuously scattered by matter. After sufficient cooling electrons would begin to combine into atoms (recombination era) and photons would eventually

propagate freely making the universe "transparent" to light. Thus, we cannot directly see the earlier universe hiding behind the last scattering surface of the CMB, but properties of that very early universe can be deduced from traces they leave on the CMB. The fluctuations in the CMB are extremely faint: just one part in 100,000 (of 2.73 degree Kelvin average temperature). Three generations of satellites, COBE (1989), WMAP (2001), and Planck (2009), have obtained increasingly precise measurements and mappings of the background radiation.

Within the context of modern cosmology, the question on the geometry of the universe has become the question of "cosmic topology," which we discussed already briefly in chapters 3 and 6.

9.2 The Shape of Space

General relativity described the curvature of space, but there can still be many different topological shapes that correspond to the same curvature, and that are not distinguished directly by the Einstein field equations. Finding a way to distinguish different possible topologies on the basis of observable cosmological data is the *problem of cosmic topology*.

Figure 9.11
Anonymous, *Flammarion Engraving*, 1888.

In earlier philosophical speculations about the geometry of the universe, people reached the conclusion that the spatial extension of the universe should necessarily be infinite, else one would encounter a "boundary" somewhere and the inevitable question of what lies across that boundary would lead to a paradoxical situation, as depicted in the often-mentioned *Flammarion Engraving* (figure 9.11). This reasoning is clearly flawed because it confounds the notion of *compact manifold* with that of *manifold with boundary*: modern mathematics shows that there is indeed a very rich and interesting theory of compact manifolds *without* any boundary. There is no contradiction at all between having a spatially compact cosmos and no boundary. When Kant proposed a universe that would be finitely extended spatially and homogeneous and based on Euclidean geometry, this proposal was criticized on the same ground as the faulty argument about the "boundary of the universe" just described. In fact, the Kant model would be perfectly compatible with a three-dimensional torus or a Bieberbach manifold (a quotient of a torus by the action of a finite group of isometries). This does not make Kant's model necessarily correct, but it certainly does not make it impossible. One still occasionally encounters dubious mathematical claims made in relation to the geometry of the cosmos, such as statements that a negatively curved (hyperbolic) geometry would necessarily mean a spatially infinitely extended universe, while in fact *compact* hyperbolic three-manifolds are the largest and most interesting class of three-manifolds.

The Earth in a Kantian universe shaped like a three-dimensional torus would appear as if inside an infinite gallery of mirrors in each of the three directions in which the torus folds up periodically. Because of the periodicity of space in all three directions, looking in any of these directions one would see repeated images of the Earth as in a gallery of mirrors, except that they are not mirror images, they are translates in each of the three directions. If you look to your right in a three-dimensional torus, you would see images of your left side repeated infinitely many times at a regular distance of each other (you would, in fact, see only finitely many of them due to the finite speed of light). Similarly, looking upward you would see repeated copies of your bottom side, and looking forward you would see repeated copies of your back side. The universe inside a different type of compact three-manifold would exhibit a different form of periodicity. We have seen (figures 6.5 and 6.6) a view of the cosmos in a positively curved universe with dodecahedral symmetry.

A vision of the interior of a universe based on a polyhedral topology was constructed in the installation of the artist Olafur Eliasson using polyhedral lamps and their projected shadows (see figure 9.12).

Figure 9.12
Olafur Eliasson, *Black Yellow Double Polyhedron Lamp*, 2011.

The CMB data constrain the geometry of the universe (see chapters 3 and 6). In particular, the negatively curved case, although the most prevalent among three-manifolds in terms of the mathematical classification, is, in fact, disfavored in terms of cosmological data. The geometry of the universe, as measured in the CMB, is either flat or almost flat but very slightly positively curved. Model geometries for these two cases would be the torus and the sphere. More precisely, under the assumptions of isotropy and homogeneity, this means that the corresponding three-manifold is a flat or positively curved homogeneous manifold of constant curvature, which means (if compact) either a torus or a Bieberbach manifold (flat case) or else a sphere or a spherical space form (positive curvature case). The spherical space forms are quotients of a sphere by a finite group of isometries: they include spaces obtained by gluing together faces of certain spherical polyhedra embedded in the three-dimensional sphere. Among them are the Poincaré dodecahedral space and the octahedral space mentioned in chapters 3 and 6.

Cosmologists have looked for signatures of possible different topologies in the CMB by trying to identify multiple images effects due to the periodicities coming from the realization of three-manifolds by gluing together faces of polyhedra, analogous to the "gallery of mirrors" periodicity effects in a three-dimensional torus. For instance, in the case of Bieberback manifolds, the patterns of repeated images would be similar to the three-dimensional torus but with an additional half-turn or quarter turn in some of the three di-

rections. Simulations of CMB skies in different possible flat and positively curved topologies were obtained by several cosmologists, including Luminet, Lehoucq, Lachièze-Rey, Riazuelo, and Uzan. An example of their simulated CMB skies for a positively curved dodecahedral space is given in figure 6.6.

A search for statistically matching "circles in the sky" that would correspond to one of these topological candidates have so far delivered inconclusive evidence. Some candidates, like the dodecahedral space, remain among the most promising but no definite confirmation of a particular topology was achieved yet with this methods. This calls for the development of other possible methods for identifying traces of different cosmic topologies that can be read off the CMB data.

A possible other approach to the problem of cosmic topology is based on the slow-roll model of inflation, where cosmic inflation in the early universe is governed by a scalar field that rolls down from a false vacuum (inflationary phase) to a true vacuum (end of the inflationary epoch). It is known that the shape of the slow-roll potential of the inflationary model is related to certain quantities (the slow-roll parameters) that can be read from the CMB data. Thus, if in some suitably model of gravity the shape of the inflation potential would come to depend on the underlying cosmic topology, then that would make topology detectable in the CMB data, in a way that is different from the "circles in the sky" method. What is the "model of gravity" that we need for this purpose?

Recall that the noncommutative geometry approach to particle physics reconstructs the Standard Model Lagrangian from some simple geometric principles, and from a natural action functional called the *spectral action* (see chapter 8). This is, in fact, an action functional for gravity coupled to matter, and in particular one can look just at the gravity part. It gives an action functional that incorporates the Einstein-Hilbert action of general relativity, with cosmological constant, as well as additional curvature terms. Such models are known as *modified gravity*. Theoretical cosmologists have been developing several possible models of modified gravity that would incorporate general relativity, but allow for new modifications of the laws of gravity on certain scales. Such models may provide an answer to some of the mysteries about dark matter and dark energy.

The idea of the argument, then, is the following. The spectral action functional determines interactions of matter, energy, and gravity. In particular, one shows that certain fluctuations of the spectral action determine a slow-roll potential for a scalar field. This slow-roll potential determines shape of inflation and, in turn, depends on the underlying cosmic topology. There are very strong

constraints on the slow- roll potential from the observational data of the CMB, hence the possibility arises of constraining the possible candidate topologies through the values of the slow- roll parameters for the potential derived from the spectral action. This is a valid reasoning, under the assumption that the spectral action is the correct model of modifi ed gravity, which is certainly speculative at this point.

9.3 The Universe Like a Drum

The basic idea behind the spectral action functional is to imagine the universe as some kind of a " drum," that can vibrate on certain characteristic frequencies, a spectrum of frequencies. The spectral action sums up all the frequencies of vibration of the space, which includes both spacetime and the noncommutative extra dimensions. One writes the action as

$$S = \text{Tr}(f(D/\Lambda)) = \sum_{\lambda \in \text{Spec}(D)} f(\lambda/\Lambda),$$

where D is the Dirac operator (which is defi ned on a large class of manifolds and of noncommutative spaces), whose spectrum gives the frequencies λ of vibration. The quantity Λ here denotes an energy scale (the frequencies here have the physical units of an energy). When the energy scale Λ becomes very large, the spectral action recovers the Einstein- Hilbert action of general relativity, with certain additional modifi ed gravity terms, and (for a particular choice of the noncommutative extra dimensions discussed in chapter 8) it recovers also the Standard Model Lagrangian coupled with gravity.

Figure 9.13
Isospectral drums.

Figure 9.14
Clint Fulkerson, *Points in Space*, Accretion Disc series, 2014.

Knowing the frequencies is not sufficient to reconstruct the space. This observation goes back to a well known problem, which was formulated as the question: "Can you hear the shape of a drum?" This means the question of whether the frequencies determine the shape of the space. This question was answered negatively and many different examples of isospectral but not isometric manifolds were constructed. An explicit example of two different drum shapes that vibrate on exactly the same frequencies but are not geometrically equivalent is provided by the Gordon, Webb, and Wolpert example shown in figure 9.13.

In the case of the spectral action, the slow-roll potential is obtained from fluctuations that replace D^2 by $D^2 + \phi^2$, where ϕ is a scalar field. The height of the flat region of the potential, as well as the shape of the well, is different for different spherical space forms and tori and Bieberbach manifolds, hence, in principle, it would make topology detectable in the CMB by a different method than the matching circles.

The idea of distinguishing different shapes of the universe like vibrations in a drum can be found in one of the paintings of the *Accretion Disc* series of Clint Fulkerson (see figure 9.14), where the different figures in the drum shapes can be seen as varying shapes of eigenfunctions of a Laplacian (or Dirac) operator, that is, the harmonics on which the drum vibrates. At the same time, each circular drum shape in this work of Fulkerson is drawn so as to be reminiscent of the same networks of cosmic structures depicted in the author's Nebulae work (see figures 9.9 and 9.10).

In the case of isotropic but nonhomogeneous cosmologies, like the Packed Swiss Cheese Cosmology model mentioned in chapter 6, the spectral action model of inflationary cosmology can be extended, using the fact that it is possible to define Dirac operators on fractal geometries.

Figure 9.15
Paul Bourke, *Apollonian Spheres*, 2006.

For fractal cosmologies that look like Apollonian packings of spheres (figure 9.15), the resulting shape of the potential is modified with respect to the case of a single spherical geometry, by correction terms that detect the presence of fractality. Thus, within the same model of modified gravity based on the spectral action, the same test based on measuring the slow-roll parameters could be used to detect the possible presence of fractality in the large scale

structure of the universe. In cases with nontrivial cosmic topology, like fractal arrangements of dodecahedra, similar fractal structures are possible and can likewise be distinguished using the spectral action.

Chapter Appendix: Bibliographical Guide

A.1 Guide to the Artists

In the following references he reader will find more information about the artists discussed in this chapter.

- El Anatsui, *When I Last Wrote to You about Africa*, University of Washington Press, 2011.
- Susan Vogel, *El Anatsui: Art and Life*, Prestel, 2012.
- Amanda Gilvin and John R. Stomberg, *El Anatsui: New Worlds*, Mount Holyoke College Art Museum, 2015.
- Roberto Graña, "Artist Statement," *Imaginary, Open Mathematics*, 2008 (online).
- Valentina Anker, *Max Bill ou la recherche d'un art logique*, L'Age D'Homme, 1979.
- Liang Manqi, "Imaginary Practice," *Contemporary* by Angela Li, 2016 (online).
- Liang Manqi, "Process of Energy," *Antenna Space*, 2014 (online).
- Madeleine Grynsztejn, *Olafur Eliasson*, Phaidon, 2002.
- Francis Picabia, *I Am a Beautiful Monster: Poetry, Prose, and Provocation*, MIT Press, 2007.
- Daniel Kany, "Clint Fulkerson: Geometrically Meandering in the PMA Family Space," *Portland Press Herald*, 2014 (online).
- Joseph Ashbrook, "Astronomical Scrapbook: About an Astronomical Woodcut," *Sky & Telescope* 53, no.5 (1977): 356–407.
- Camille Flammarion, *L'atmosphère: Météorologie populaire*, Paris Hachette, 1888.

A.2 Guide to the History of Cosmology

Here is a general account of the development of astronomy and cosmology from ancient to modern times, which provides historical details on all the facts referred to in this chapter.

- John North, *Cosmos: An Illustrated History of Astronomy and Cosmology*, University of Chicago Press, 2008.

A.3 Guide to the Geometry of the Cosmos

Readers interested in the historical origins of the geometric approach to cosmology can consult some of the following references.

- J. V. Field, *Kepler's Geometrical Cosmology*, Bloomsbury Publishing, 2013.

- Bruce Stephenson, *The Music of the Heavens: Kepler's Harmonic Astronomy*, Princeton University Press, 2014.
- Marc Lachièze-Rey and Jean-Pierre Luminet, *Celestial Treasury: From the Music of the Spheres to the Conquest of Space*, Cambridge University Press, 2001.

The presence of chaos in celestial mechanics and in the dynamics of the solar system is discussed in the following references, listed in increasing order of technical sophistication.

- Barry Parker, *Chaos in the Cosmos*, Basic Books, 2008.
- Ivars Peterson, *Newton's Clock: Chaos in the Solar System*, Macmillan 1993.
- V. I. Arnold, V. V. Kozlov, and A. I. Neishtadt, *Mathematical Aspects of Classical and Celestial Mechanics*, Springer Verlag, 2006.
- Rudolf Dvorak, F. Freistetter, and Jürgen Kurths, *Chaos and Stability in Planetary Systems*, Springer Verlag, 2005.

On the problem of cosmic topology the reader can look at the following references.

- Jean-Pierre Luminet, *The Wraparound Universe*, CRC Press, 2008.
- Jeffrey R. Weeks, *The Shape of Space*, Taylor & Francis, 2001.
- Michael P. Hitchman, *Geometry with an Introduction to Cosmic Topology*, Jones & Bartlett Learning, 2009.
- S. Caillerie, M. Lachièze-Rey, J.-P. Luminet, R. Lehoucq, A. Riazuelo, and J. Weeks, "A New Analysis of the Poincaré Dodecahedral Space Model," *Astronomy and Astrophysics* 476 (2007): 691–696.

On isospectral drums, isospectral manifolds, and the problem of "hearing the shape of a drum," the reader can find additional information and precise mathematical results in the following references.

- Mark Levi, *Classical Mechanics with Calculus of Variations and Optimal Control: An Intuitive Introduction*, American Mathematical Society, 2014.
- Mark Kac, "Can One Hear the Shape of a Drum?" *American Mathematical Monthly* 73, no. 4, pt. 2 (1966): 1–23.
- C. Gordon, D. Webb, S. Wolpert, "Isospectral Plane Domains and Surfaces via Riemannian Orbifolds," *Inventiones Mathematicae* 110, no. 1 (1992): 1–22.

On the *spectral action* and Dirac operators as models of gravity with applications to cosmology and cosmic topology, the reader can consult the following monographs and research papers.

- Joe Várilly, *An Introduction to Noncommutative Geometry*, European Mathematical Society, 2006.
- Matilde Marcolli, *Noncommutative Cosmology*, World Scientific, 2017.
- Alain Connes and Matilde Marcolli, *Noncommutative Geometry, Quantum Fields and Motives*, American Mathematical Society, 2008.

- Giampiero Esposito, *Dirac Operators and Spectral Geometry*, Cambridge University Press, 1998.

- W. Kalau and M. Walze, "Gravity, Non-Commutative Geometry and the Wodzicki Residue," *Journal of Geometry and Physics* 16, no. 4 (1995): 327–344.

- Matilde Marcolli and Elena Pierpaoli, "Early Universe Models from Noncommutative Geometry," *Advances in Theoretical and Mathematical Physics* 14, no. 5 (2010): 1373–1432.

- Matilde Marcolli, Elena Pierpaoli, and Kevin Teh, "The Spectral Action and Cosmic Topology," *Communications in Mathematical Physics* 304, no. 1 (2011): 125–174.

- Adam Ball and Matilde Marcolli, "Spectral Action Models of Gravity on Packed Swiss Cheese Cosmology," *Classical and Quantum Gravity* 33, no. 11 (2016): 115018

- Farzad Fathizadeh, Yeorgia Kafkoulis, and Matilde Marcolli, "Bell Polynomials and Brownian Bridge in Spectral Gravity Models on Multifractal Robertson-Walker Cosmologies," arXiv:1811.02972.

10 The Train and the Cosmos: Visionary Modernity

This chapter has a different character from the previous parts of the book. It is aimed at presenting an overview of a grand vision of science and technological progress that developed within the artistic avant-garde movements at the dawn of the 20th century, rooted in the anarcho-socialist tradition, envisioning an upcoming broad transformation of humankind and society. It is also an exploration and a personal reflection on the author's own roots and cultural upbringing within this context of Visionary Modernity.

10.1 Mythopoesis and Modernity

Mythopoesis is the capacity of the human mind to spontaneously generate symbols, myths, and metaphors. The use of analogies and metaphors is important not only in the artistic expression, but as a guideline in the development of novel scientific theories and ideas, as shown in several examples in the previous chapters.

Psychology, especially in the work of C. G. Jung, showed that the human mind, through the incessant work of the unconscious, continuously generates a complex language of symbols and mythology. Jung identified these as archetypes of the collective unconscious: a deep, shared, largely nonverbal language common to our human heritage.

The use of symbolic images and mythology is commonly seen in all the many different forms of religion developed throughout the course of human history, and it is often studied in that context. By religion I mean here any form of belief that invokes, at some level, the supernatural. However, mythopoesis does not require religion: it can be abstractly symbolic, metaphoric, lyrical, or visionary, without involving any reference to any form of supernatural.

In particular, in this chapter I focus on what I call *Visionary Modernity*, a form of mythopoesis that has its roots in the socialist, communist, and anarcho-socialist version of the mythology of progress of the late 19th and early 20th

centuries. This is perhaps the best example of a nonreligious form of mythopoesis.

I will articulate this analysis in three parts, following three distinct but closely intertwined iconological themes: trains, the mechanical body, and the city.

10.2 Futurist Trains

Trains are one of the most powerful symbols of modernity. With the massive development of the railways during the 19th century, the world became suddenly connected on a global scale, like never before. This highly connected long-distance structure brings with it the promise of freedom and opportunity: easier circulation of people, breaking down the isolation and the conservatism of small communities, networks linking even remote areas to big-city hubs.

The symbolism intrinsic in the image of the train is threefold: connectedness, collectivity, and fast-forward movement toward the future. Trains are perceived, at the turn of the 20th century, as collectively driving humankind into the new modern epoch. The image of the train also relates to another powerful symbol of modernity: electricity.

In particular, the train symbolism as a signifier of modernity plays an important role in the anarcho-socialist philosophy of the late 19th and early 20th centuries, and in particular in the closely related artistic context of the Italian and Russian futurist avant-garde. Even though Italian Futurism is known for its many ideological and political ambiguities, with the movement split between a left-wing anarcho-socialist component and a right-wing component that allied itself with the fascists, many of the iconological themes used extensively by the Italian futurists are in tune with their anarcho-communist Russian counterparts. Among the several common themes of these two futurist movements is the pervasive use of the train symbolism.

We can start to analyze this theme by comparing two representations of the train symbol, the 1910 painting *Composition with Train* by Olga Rozanova (figure 10.1) and the 1912 drawing *Dynamism of a Train* by Luigi Russolo (figure 10.2). The comparison between these two images captures at once the different main aspects of the train symbolism. In Rozanova's painting, the train represents the connectedness aspect of the symbolism. The plumes of smoke of the locomotive conjure an elaborate configuration of colorful crisscrossing paths across the foreground of the painting, forming knotted and interlinked patterns, as if to stress the role of the railway in creating a new form of interconnectedness. The colors suggest a frozen winter landscape, with touches of warmer colors emerging from the pattern drawn by the train's movement. The

Figure 10.1
Olga Rozanova, *Composition with Train*, 1910.

Figure 10.2
Luigi Russolo, *Dynamism of a Train*, 1912.

Figure 10.3
Luigi Russolo, *Revolt*, 1913.

train is an emergent reality, the creation of new opportunities, a benevolent generator of networking structures.

Russolo's painting focuses on another important aspect of the train symbolism: that of might and speed. The train is seen at the same time as a massive artifact, a large, heavy mass of metal, and yet also as an elegant, fast-moving, aesthetically beautiful machine. Dynamism is a crucial concept of futurist painting: representing movement as it is happening, capturing in a static two-dimensional canvas surface the concepts of motion, speed, and acceleration.

In the early 1970s, the Italian singer songwriter Francesco Guccini, in his famous song "La Locomotiva" (the locomotive), described the deep connections between the train symbolism in early 20th-century Futurism and the history of Anarchism. He sings of how the train itself looked like a myth of progress, launched over the continents, the locomotive resembling a strange monster tamed by human thought and human hands. The roaring sound of a passing train, speeding over enormous distances, is compared to the power of dynamite itself. However, the song immediately remarks, another mighty force was unfolding its wings at the time: words that claim all people are equal, kings blown up by proletarian bombs, and the roads lit up by the torch of Anarchism. Meanwhile, the locomotive stands ready on the tracks, a pulsing machine like something alive. Although written several decades later, at the time of the revolutionary upheavals of 1970s Italy, "La Locomotiva" perfectly captures the anarchist roots of the dynamism, might, and speed represented by the train in

the futurist avant-garde and provides the appropriate context for an interpretation of artwork in the style of Russolo's drawing (shown in figure 10.2).

We can clearly see this connection between Anarchism and the symbolism of the train as dynamism and might by comparing the compositional structure of *Dynamism of a Train* (figure 10.2) with another work of Russolo from the same years, his 1913 *Revolt* (figure 10.3). In the latter, we see a very similar pattern of diagonal lines, with a similar alternation of warm (red/orange) and cold (blue/purple) colors, signifying the dynamical movement. Here, however, what is represented as fast movement breaking into the future is a street protest, a collectivity of people organized into a revolutionary direct action. The striking similarity between the two compositions suggests the reading of the train as a symbol of collectivity and of the strength of revolutionary action. Notice also how in both works one can see the image of a cityscape background emerging behind and in between the diagonal pattern describing motion. In both cases the action takes place in an urban context. Later in this chapter I will show how this connection between the train symbolism, the revolutionary ideology behind it, and the urban environment is another key ingredient in the mythology of Visionary Modernity.

In a similar way, we can compare the compositional structure of two other paintings of Italian Futurism: Corona's own version of a train image (in this case a streetcar, see figure 10.4) and one of the most famous works of the Italian Futurism, Carrà's 1911 painting, *Funeral of the Anarchist Galli* (see figure 10.5). Notice that the chromatic palette of the two paintings is quite similar: both are dominated by a combination of black and red (in the case of Carrà's painting, this is also a reference to the colors of the anarchist flag), with brighter insertions of aquamarine and blue, with some insertions of bright yellow. In the case of Corona's painting, the oil version of 1963 (figure 10.4) is based on an earlier tempera version of 1915–1919, where these brighter color insertion are even more evident. It is also interesting to see how the representation of dynamism and motion is obtained. One sees again the use of diagonal patterns of lines that we have seen in Russolo's work. In both Corona's streetcar and Carrà's funeral painting, one also sees the use of repeated slightly displaced copies of the same image (the front of the streetcar in Corona and the banners and waiving arms in Carrà), which create a sort of stroboscopic effect, representing a moving scene as a collection of successive and overlapping still images. In the compositional similarity, with the slightly later Corona painting possibly echoing the previous and already famous work of Carrà, we can see again a close iconological connection between the train symbolism and the anarchist roots of Futurism.

Figure 10.4
Vittorio Corona, *Il tranvetto*, 1963 (based on a 1915–1919 version).

Figure 10.5
Carlo Carrà, *Funeral of the Anarchist Galli*, 1911.

Figure 10.6
David Burliuk, *Railway Bridge*, 1921.

In this way, the train becomes an image of a collective voyage into the radiant future of humanity. This can be seen in the frequent pairing of the train image with that of the sun, where the train is either traveling (flying) toward the sun or emerging from the sun as the emanation of the new epoch that is rising. The rising sun stands for the future new society that the anarcho-socialist and the communist revolutions promise to build, and the train, in this context, represents modern technology as a way to achieve that goal. A connection between this symbolic use of the train image and a "cosmic" destiny was retained in later Soviet iconology, well past the avant-garde period.

As examples of the "solar image" and "cosmic destiny" of the train images, we can examine two works, one by the Ukrainian futurist David Burliuk (figure 10.6), and one by the Italian futurist Fortunato Depero (figure 10.7). In Burliuk's drawing we see a bright, multicolored landscape that features a bridge, an advancing electricity power line, a forest in the left foreground and mountains in the distant background, and a train flying high above the bridge, under the eyes of a bright rising sun. The tension between nature and technology is hinted at by the presence of the natural elements in the landscape, trees and mountains, while bridges and electricity point to the connectivity aspect of the train symbolism. The sun image is personalized and endowed with multiple pairs of large human eyes, pointing to both collectivity and the idea of revolutionary technology as fundamentally a humanist project dressed in cos-

Figure 10.7
Fortunato Depero, *Treno partorito dal sole*, 1924.

mic mythological images. Depero's painting provides a similar mythological setting: a train flies out of the sun, surrounded by a landscape mostly populated by images of nature, including trees and a pelican. The title itself, according to which the sun gives birth to a train, immediately shows the mythological nature of the cosmic connection of the train symbolism. The train is presented through a creation myth, where modernity and technology emerge among and above the natural world. At the time of the futurist avant-garde, both Italy and Russia were experiencing a transition from a mostly rural society to one of rapid industrialization, mostly confined to a few urban centers. In both settings, the railway had an important role in creating a bridge between the rural and the industrialized part of the country. Both manifestations of Futurism created an appropriate mythological setting where the momentous nature of this

transition could be represented. Generated by the sunrise of the radiant future, modernity erupts into society as a mythological birth. In both the Burliuk and Depero works, the train bursts out of the sun and flies high above the land. It is a mystical coming, a savior myth, where technological progress is seen as a radical transformation of society that breaks the continuum of the natural agrarian landscape through an act of creation signifying the intervention of human creativity. This coming into existence of the modern world through such a cosmic act of birth echoes the revolutionary ideas about the birth of a new society as a rising sun over the ruins of the old order.

The connectedness aspect of the train symbolism is often represented by the use of a combination of trains and bridges. The networks of railways that connected the world in the late 19th and early 20th centuries had a transformative effect, both on society and on the imagination, similar to that achieved by the connectedness created by the World Wide Web in our epoch. Bridges best represent the new structures that are able to link previously disconnected realities, literally bridging between them, opening new venues of communication, shortening distances, and giving rise to an overall different perception of space, time, and movement.

In the context of the train as symbol of connectedness, a special symbolic meaning is attached to the longest railway road in the world, the Trans-Siberian, which was completed in the late 19th century. In 1913 the Swiss-French poet Blaise Cendrars and the Orphist painter Sonja Delaunay published the book *La prose du Transsibérien et de la Petite Jehanne de France*, a long illustrated poem about a journey through Russia on the Trans-Siberian Express in 1905, during the first Revolution (see figure 10.8). The work combines themes of trains as connectedness and as revolutionary force, with some dark overtones reflecting the looming horizon of civil wars, revolutions, and conterrevolutions.

These images blend with images of trains carrying soldiers back and forth from the front during World War I, reflecting the deep ideological split within the Italian Futurism movement, which first manifested itself in the divide between the prowar and the antiwar fronts. In a similar way, the Russian Futurism foresaw and perhaps even suggested the crucial role that trains came to play in the Russian Revolution and in the civil war that followed. One such example is provided by the work of Goncharova (figure 10.9) showing a plane carried on top of a train, suggestive of military operations, and at the same time reinforcing the connection between the parallel developments, in modern technology, of railroad and flight.

Images of trains as a symbol of connectedness (especially in combination with bridges) and of dynamism, rupture with the past, and glorification of

Figure 10.8
Sonja Delaunay, *La Prose du Transsibérien et de la Petite Jehanne de France*, 1913.

modernity continued through the 1920s in the futurist avant-garde. The train image and its symbolism eventually disappeared from Italian art, after the fascist regime effectively banned the avant-garde in favor of more conservative figurative propaganda art, imposing an aggressively antimodern ideology. On the contrary, the train symbolism was maintained, absorbed and continuously reelaborated in the context of Soviet art, where it became an established part of the official iconology, even after the Stalinist regime similarly abandoned and persecuted the avant-garde movements favoring a conservative Socialist Realism. One can see the "solar image" and "cosmic destiny" of the train reappear in Soviet poster art from the 1960s and 1970s, where it becomes a

Figure 10.9
Natalia Goncharova, *Plane on a Train*, 1913.

somewhat abused cliché of communist iconology, with no remaining memory of the original anarchist connection.

10.3 The Body Electric

Another main theme in the iconology of Visionary Modernity is the glorification of electricity and the closely related theme of the body as machine. The construction of the electric grid across cities and countries was another important network of connectedness, like the railways. The electric grid of a city was equated to the nervous system of a living organism. The connective network it provided was seen as a new, large-scale structure in society and a symbol of progress, of power and energy.

We can see how the painters of Futurism captured the transformative effect of electric lighting on the city in the example of Balla's 1909 painting, *Street Light* (figure 10.10), where a newly installed electric light floods the street with a shower of light rays that outshine the moonlight and part the darkness, relegating the night to a vague contour of shadows at the margins of the painting. Similarly, in Severini's 1912 painting, *Expansion of Light* (figure 10.11), the novelty of artificial electric illumination is seen as a dance of light, a composition of brightness that provides a new way of looking at the world. The painting hints at the pointillist movement, which developed a painting technique based on a scientific theory of color mixing, contrast, and light. However, unlike the earlier pointillist paintings, where light was a medium for the representation of

Figure 10.10
Giacomo Balla, *Street Light*, 1909.

traditional figurative scenes, in Severini's piece, light itself is the subject, not the means, but rather the goal of representation. Light is portrayed as an abstract physical phenomenon, as energy, power. It is, at the same time, power in the physical sense of electric power, and in the sense of the empowering transformative effect that it has on society, vanquishing the night, and extending people's agency and freedom.

In addition to powering cities and illuminating the streets, electricity becomes a household good, a part of people's daily existence, which nowadays the developed nations of the world take completely for granted, save for the occasional and exceptional power outage due to rare events. The ensuing trans-

Figure 10.11
Gino Severini, *Expansion of Light*, 1912.

formation of private life, the possibility of extending the day into the late hours, with much better illumination than ever possible before electricity, had a pro-found influence on how we organize our lives, allowing for the creation of new spaces, outside and beyond the working day, where other activities can be fit-ted, where reading and writing becomes much easier. The prominent role of electricity in transforming the daily lives of people is depicted in Goncharova's 1913 painting *Electric Lamp* (figure 10.12), where a simple table lamp with flowery shade emits powerful globes of light that shine like radiant suns.

Power plants are another commonly seen symbol of modernity. In the early 1910s, the futurist Italian architect Antonio Sant'Elia produced drawing after drawing of fantastical electric power plants (figure 10.13), with rising tow-ers, slender shapes, mighty turbines: a whole mythological bestiary of electric

Figure 10.12
Natalia Goncharova, *Electric Lamp*, 1913.

dreams. It does not matter whether Sant'Elia's drawings were realistic from the engineering perspective, as they were primarily symbolic and visionary in nature. They were aimed at developing a poetic language of electricity, an aesthetics of power production. They contributed to the creation of a new aesthetics of modernity. The power plant is the pulsing heart of the modern world, the vital pump that sustains its life by providing it with energy. The balance of energy production and energy consumption for the first time becomes part of the collective consciousness of modern society. The insistent images of power plants created by the artists of Futurism literally illuminate a bright future of humanity, envisioned at the time with an infinite optimism that was soon to be curtailed by the horrors of World War I, in which Sant'Elia himself died after having volunteered for the front.

In socialist ideology, one also encounters the nearly mythical status of electricity best exemplified by Lenin's famous quote: "Communism is electrifi-

Figure 10.13
Antonio Sant'Elia, *Drawing of Electric Powerplant*, 1914.

cation of the whole country." It is interesting to compare two different renderings, by avant-garde artists of the time, of Lenin's electrification program: Baljasnij's 1930 poster, *Electrification of the Whole Country* (figure 10.14) and Filonov's drawing from the same year, with the same title (figure 10.15). Baljasnij gives us the official propaganda iconology, with a red silhouette of the typical Lenin pose, showing the way toward the bright future. The silhouette rendering turns the figure of Lenin into a perfectly flat, two-dimensional surface, a red banner in human form. There is no subtlety there, no hues of color, no three-dimensional shadows. Everything is laid out and plain. Behind the red Lenin-flag, one sees cranes, cables, roads, and flaming power plants: a world being built, modernity in the making.

Filonov's drawing (figure 10.15), by contrast, is far more subtle. The electricity grid has become a chaotic mesh of crisscrossing lines, that hints at shapes of cities, but appears more randomly growing than carefully planned. Lenin is still standing in the foreground, but no longer sporting his forward-looking inciting pose. His figure seems to be spontaneously emerging from the lines of the grid, rather than being directing its creation. He stands in the middle of it, as if uncertain of "what needs to be done," and appears to have lost control of his own creation. His pose is more questioning than assertive, as if the end result of his grand electrification plan, and by synecdoche the whole

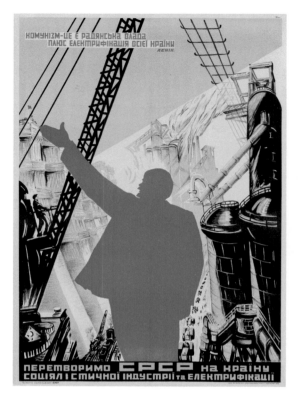

Figure 10.14
Mikhail Baljasnij, *Electrification of the Whole Country*, 1930.

creation of the Soviet state, had revealed itself to be quite different from what was originally planned.

It is also interesting to compare Filonov's drawing, *Electrification of the Whole Country* (figure 10.15) with another famous image of the avant-garde, the German Bauhaus artist Oskar Schlemmer's *Figure in Space* (figure 10.16). Schlemmer was directly influenced by both the Russian and the Italian avant-garde, partly through the Italo-Slovenian artist Avgust Černigoj. Notice how the pose of the human figure in Schlemmer's drawing is the same as the un-usual iconology of the pose of the Lenin figure in Filonov's drawing. In both works the structure of lines dominates the drawing, but in Schlemmer's case it is its high degree of symmetry that immediately captures the viewer's attention, in contrast to the chaotic and highly asymmetric form that the pattern of lines takes in Filonov's drawing. To further emphasize the breaking of symmetry,

Figure 10.15
Pavel Filonov, *Electrification of the Whole Country*, 1930.

with respect to Schlemmer's geometry, the Lenin figure in Filonov's drawing is intentionally off-centered and slightly turned to the side, while the human figure is perfectly axially symmetric in the Schlemmer work, almost an echo of the Renaissance Vitruvian man. What has been off-centered, in Filonov's representation, is the whole humanistic project of the socialist revolution as a path toward a new humanity. While Schlemmer's Vitruvian reference, with the prominent use of symmetry, echoes the humanistic tradition, Filonov detects the breaking down of that vision into a messy tangle of broken lines whose structure and purpose have become indiscernible.

Figure 10.16
Oskar Schlemmer, *Figure in Space with Plane Geometry and Spacial Delineations*,
1921.

Figure 10.17
Oskar Schlemmer, *Drawing of Man as Dancer*, 1921.

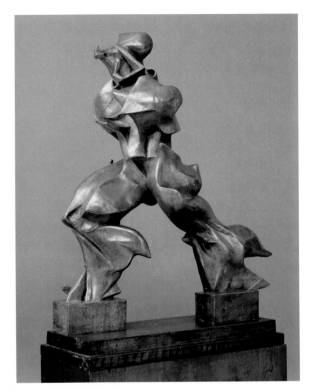

Figure 10.18
Umberto Boccioni, *Unique Forms in the Continuity of Space*, 1913.

Schlemmer presents the human body as emerging from the space created by the grid of lines, which may again be a reference to an electricity grid, as the source of energy and power. Space itself is defined by it. While the electrified city is seen as an organism coming to life, conversely, a new vision of the human body emerges, which views it as an automaton, a machine, and celebrates its dynamism and its mechanical beauty. Another drawing by Oskar Schlemmer, *Man as Dancer* (figure 10.17), captures very well this idea of the human body as a mechanical device: the dance is viewed as mechanical movement, and the human body continues into the surrounding space in the form of a pattern of curved lines, which hint at the dancer's motion and rhythm, and also suggest the possibility of the body as a puppet, whose motion is directed and determined by the curvature of surrounding space, an abstract and impersonal puppet master. Body and geometry merge one into the other. The beauty of the dancing body is the beauty of geometry itself.

Figure 10.19
Marcel Duchamp, *Nude Descending a Stairway*, 1912.

The view of the body as mechanism follows the development of a long tra-
dition in European culture, which gradually replaced the body-soul distinction
with an emphasis on a materialist view of the mind as embodied. Descartes
had already advocated a view of the body as mechanical, but with a twisted
perspective that relegated the bodies of all nonhuman animals to mere soul-
less automata, with terrifying ethical consequences on their treatment. The
modernist point of view instead turns the table on the Cartesian dualism by
embracing the human as machine, relinquishing a separate role for a soul, and
in that way breaking down the barriers, not only between human and machine,

Figure 10.20
Oskar Schlemmer, *Triadic Ballet*, 1920.

but also at the same time between the human and the nonhuman animal. Every (human or nonhuman) body is an automaton, everybody is a machine. Ethical treatment of humans and animals alike becomes independent of the attribution of a putative soul, and the mechanical nature of the body is seen as the very source of its intrinsic beauty.

In particular, in this mechanical conception of the body, the human form is frequently represented as movement. The parts and articulations of the human body are dynamical possibilities subject to constraints, and the unfolding of motion resulting from these degrees of freedom provides the configuration space of possibilities of existence of body in space. One of the most famous representations of the human body as movement is Boccioni's sculpture *Forme uniche nella continuità dello spazio* (*Unique Forms in the Continuity of Space*, see figure 10.18). We can also see the same dynamical approach to the representation of the body in Duchamp's *Nude Descending a Stairway* (figure 10.19). In both these nearly contemporary artworks, the body is represented through an unfolding in space of its dynamical possibilities, the articulations of the body clearly presented as constraints to the possibilities of motion, like a display of levers and joints. The body's unfolding through space

Figure 10.21
Enrico Prampolini, *Geometry of Sensualness*, 1922.

and time is dictated by the laws of classical mechanics: a trajectory on the manifold of constrained motions.

In a similar vein, Oskar Schlemmer's ballets (see figure 10.20) emphasize the body as machine and its mechanical motion through a visual amplification of the body mechanics achieved via the introduction of geometric elements attached to the body that underline its directions of motion and its configurations of equilibrium. Embracing this view of the body as machine is seen as a form of liberation: it frees humanity from the yoke of the disembodied soul, conjured up by the religious imagination. The freed mechanical human dances away in a celebratory geometric ballet, proud of this newly conquered freedom.

The aesthetic and even erotic allure of the mechanical body can be seen, for example, in the painting *Geometria della Voluttà* (*Geometry of Sensualness*) of the Italian futurist Prampolini (figure 10.21), where the body, apparently shown in a traditionally erotic pose, is in fact decomposed into a geometry of volumes and mechanical articulations, as if to reveal the true origin of the sensualness in the abstraction of geometry and mechanical motion: geometry as the source of sensualness.

In particular, within this general iconological theme, the bicycle acquires a special symbolic meaning as mechanical enhancement and continuation of the mechanical human body. The bicycle is also a symbol of dynamism in futurist iconology. We can see how these associations of the bicycle iconol-

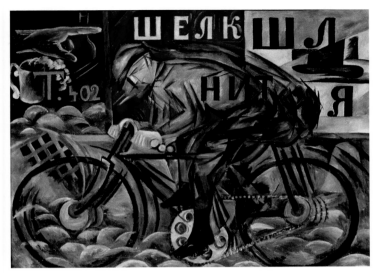

Figure 10.22
Natalia Goncharova, *Cyclist*, 1913.

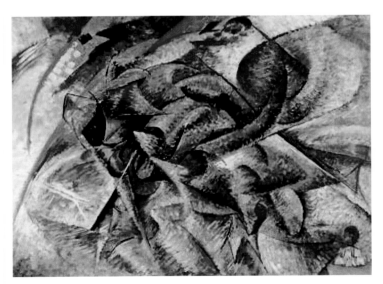

Figure 10.23
Umberto Boccioni, *Dynamism of a Cyclist*, 1913.

Figure 10.24
Vinicio Paladini, *May Day*, 1922.

ogy manifest themselves in two futurist bicycle paintings from the same year, one by Goncharova and one by Boccioni (see figures 10.22 and 10.23). While some of the themes evoked in these bicycle paintings are the same that we have encountered in the representation of trains—motion, dynamism, connectedness—there are important differences. The bicycle is an individual rather than a collective form of transportation, so the symbolism lacks the reference to collectivity that is crucial in the case of trains. Also, the bicycle is powered directly by the human body, and hence it is a direct mechanical extension of the body, much like the geometric extensions used in Schlemmer's ballets. Moreover, as in the mechanical ballets, it works because of a delicate dynamical balance of forces and equilibrium in motion. The bicycle is geometry and mechanics, like the human body, and it is also aesthetic beauty.

The human/machine theme eventually merges with the "electrification" theme in the symbolic figure of the robot that made its appearance in 1920, with Karel Čapek's play, *R.U.R. Rossum Universal Robots*. Since the beginning, the fig-

Figure 10.25
Fortunato Depero, *Solidity and Transparency*, 1917.

ure of the robot has come endowed with a political connotation related to the revolutionary workers' movement, starting with the word "robot" itself, which is based on the Slavic word for work and worker. Čapek's play features a violent workers' uprising in which the exploited robots rebel against their human oppressors. Images of robots, resembling human machines, in connection with workers' struggles also emerge in the Italian Futurism movement (see figure 10.24) at around the same time as Čapek's play introducing the robot figure. The debate around work and automation remained a crucial part of anarcho-socialist philosophy, and still constitutes a fundamental issue today, when the rise of artificial intelligence and more elaborate and extensive forms of automation, beyond simple repetitive manual tasks, is forcing a rethinking of the very notion of human labor and the traditional connection between wages and labor.

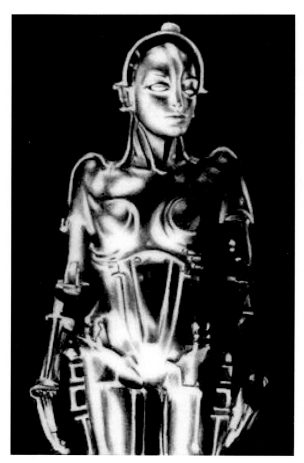

Figure 10.26
Fritz Lang, *Metropolis*, 1927.

The symbolic triad of animal, human, and machine is already apparent in these literary and figurative works: Karel Čapek's later novel, *War with the Newts* (1936), sees an intelligent animal species being enslaved and exploited by humans, taking the place of the mechanical robots of his play *R.U.R.* This interchangeability of animals, humans, and machines, the idea of a fundamentally similar nature of their intelligence, and the mechanistic materialism underlying their embodiment, prefigure much of the contemporary debate about topics such as artificial intelligence or animal cognition. We see a somewhat humorous rendering of the permeable boundaries between the animal, the hu-

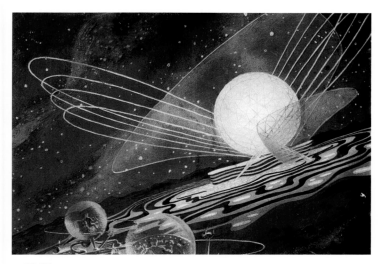

Figure 10.27
Andrei Sokolov, *Electronic Brain*, ca. 1970.

man, and the machine in the drawing *Solidity and Transparency* by Depero
(figure 10.25), where a discernible human/machine form and a mechanical bird
share (and blend with) the stage, which is populated by other mechanisms, such
as dented wheels, pipes, and turbines (a power plant allusion perhaps). In this
drawing, all elements partake of the same automaton nature.

Perhaps the most famous robot of early modernism is the one that appears in
Fritz Lang's film *Metropolis* (see figure 10.26). It is also associated with the
story of a workers' revolt, with which the robot theme is intrinsically entan-
gled. It also shows the overlap between the symbolic image of the *body/machine*
and that of *electricity* as power of animation. Overall, in the Futurism iconol-
ogy, the image of the robot becomes a symbol of empowerment, related to
workers' struggle and revolutionary movements. Its mechanical nature and its
electrical wiring are symbols of strength. It is interesting also to notice how
empowering body/machine images of modernism are often gendered as fem-
inine. The connection between women, empowerment, and the cyborg figure
was explored at length in more recent years by the philosopher Donna Har-
away and has become an integral part of current posthuman philosophy and of
the Cyberfeminist movement.

The theme of body, automaton, and robot gets a new life after the information
theory and cybernetic revolutions of the late 1940s and early 1950s.

Figure 10.28
Umberto Boccioni, *The City Rising*, 1910.

One witnesses a blending of the *automaton/robot* image with the new concept of the *computer* as information-processing machine, as modern robotics and cybernetics replace the traditional puppet/automaton view of the mechanical body. The symbolic connotations associated with the human-machine boundary remain throughout the 20th century, where they connect to the contemporary views on artificial intelligence and brain/computer interfaces.

At the same time, the symbolic role of *electricity* in the early 20th century is similarly taken over by *electronics* during the second half of the century. We see a representation of this new sensitivity, with the emphasis shifted from the automaton/robot animated by electricity to the computer as artificial brain embodied in electronics, in the 1970s paintings of the Soviet author Andrei Sokolov (see figure 10.27).

10.4 The City and the Stars

The *city* is probably the ultimate symbol of modernity. It is viewed metaphorically as an organism that *grows*, with its public transportation system (trains once again) as a kind of circulatory system of blood vessels, its electricity grid a nervous system, and with architectural structures like abstract geometries, a sustaining mechanical skeleton (like the body/machine symbol). The city is *dynamical*: continuously in transformation, a catalyst of all renewal and innovation in society and in culture. The city is the hub of technological progress and scientific discovery.

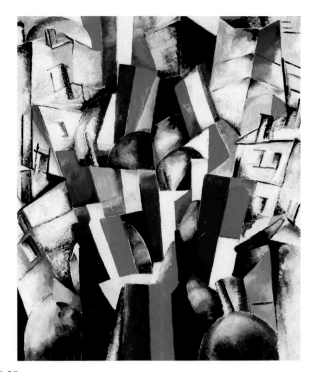

Figure 10.29
Alexandra Ekster, *Cities*, 1913.

The anarcho-socialist movement of the 19th and the early 20th centuries was a fundamentally urban phenomenon, prevalent among industrial workers, tied with to visions of technoscientific progress, and with little connection to rural realities beyond some lip service paid to farm workers. All ideological brands of modernism have been intrinsically urban.

A typical depiction of the city as the locus of dynamical accelerated growth is given in Boccioni's *La città che sale* (*The City Rising*, see figure 10.28). The connection between urban space and industrial space, implicitly pointing to the mastery of technological progress, is emphasized in several of the early futurist paintings, such as Ekster's *Cities* or Rozanova's *Factory Bridge* (see figures 10.29 and 10.30).

In comparing the two paintings of Alexandra Ekster, *Cities* (figure 10.29) and *Composition* (figure 10.31), we perceive clearly the permeable boundaries between the architectural structures of city space and the abstract compositions of Cubofuturism, Suprematism, and Constructivism. Cities are perceived as

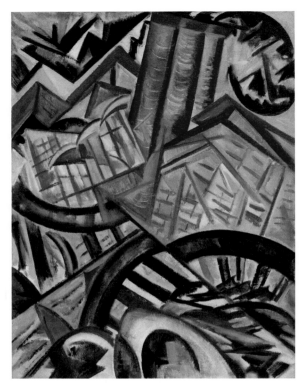

Figure 10.30
Olga Rozanova, *Factory Bridge*, 1913.

abstract compositions of space, and at the same time abstract compositions are lived spaces in themselves, imaginary inner cities of the mind, an inhabitable alternative cosmos. The aesthetic quality of abstract composition mirrors the aesthetic quality of the urban space, no longer seen as the oppressive, crowded, unhealthy environment of the Industrial Revolution, but as a space of novelty and possibility, a space of modernity, a new type of space for the human mind to inhabit.

It is easy to see in Alexandra Ekster's *Composition* (figure 10.31) a superposition of the city/body/machine/robot paradigm of visionary modernism. The insistent use of bright primary colors in cityscapes and in urban-like abstract landscapes invokes ideas of alertness, mobility, and an overall joyous atmosphere, very unlike the bleak dark grey urban landscape of the Industrial Revolution. In Alexandra Ekster's *Cities* (figure 10.29), vertical growth is emphasized, with rapid development hinted at in the many layers of overlapping

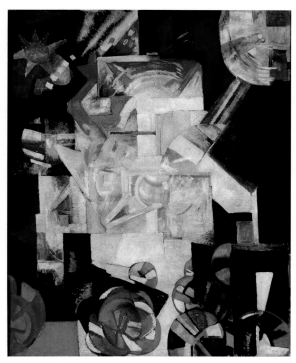

Figure 10.31
Alexandra Ekster, *Composition. Color Dynamics*, 1914.

structures and diagonal lines, a typical symbol for dynamism in futurist paintings. A similar choice of symbolism, with structures piled on structures in ever-growing layers, and a similar mode of expression emphasizing the city as a bright dynamical environment, can be seen a few years later in the painting by Fernand Léger, *The City* (see figure 10.32). This work by Léger can also be directly compared, both for a similar choice of chromatic palette and in terms of compositional structure, with Rozanova's *Factory Bridge* (figure 10.30). The map of the city, in Ekster's painting, is no longer a two-dimensional projection, but rather a fully immersive three-dimensional space that grows all around the city dweller and is simultaneously experienced in all of its different points of view, in accord with the cubist tradition of superpositions of views at different angles. Ekster's *Composition* is pure space, whose functionality is not represented. Only the spatial relations between different volumes, different planes, and viewing angles are depicted. City is a theater of space perception.

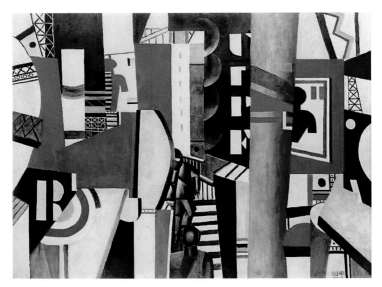

Figure 10.32
Fernand Léger, *The City*, 1919.

Even in a painting like Olga Rozanova's *Factory Bridge* (figure 10.30), where the architectural structures explicitly refer to factories and industrial production, the use of bright primary colors suggests the positive progressive nature of the industrial landscape, its revolutionary impact on modern history, and its potential for the realization of a future workers' utopia.

10.4.1 City as Abstract Form

Along the history of the Russian avant-garde movement, the interplay between space, cityscapes, geometry, and abstraction develops into a crucial underlying dialog. In the 1920s, we see the development of abstract compositions (Klucis, Popova, Rodchenko, Stepanova, and Tatlin) that clearly evoke the shapes and volumes of urban architecture. These works of the Constructivism movement (see, for instance, Gustavs Klucis's *Construction*, in figure 10.33) suggest perspective drawings of architectural blueprints, where at the same time diagonal lines reproduce the dynamism symbolism already familiar from the avant-garde paintings of the previous decade. The compositions form a dialog of different volumes and spatial structures, again as one can envision in the context of urban space, as a superposition of spatial perspectives and interacting dense architectural volumes. The city visions of the Russian avant-garde have a counterpart in the German expressionism of the same decade. The drawings

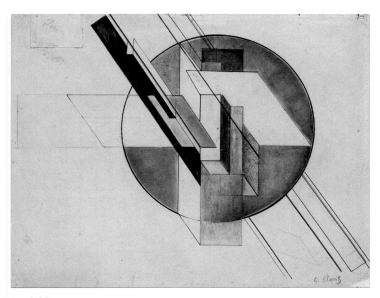

Figure 10.33
Gustavs Klucis, *Construction*, 1921.

of urban landscapes for Fritz Lang's *Metropolis* are similarly based on a vision of city as spatial composition, as a polyphony of geometric volumes.

It is interesting to compare, for example, the volume composition in Kudriashev's abstract *Construction with Rectilinear Motion* (figure 10.34) with the famous Metropolis landscape of figure 10.35. Both images present an interplay of vertical growth and diagonal dynamism. In Kudriashev's work, the latter is combined with the color contrast between the bright primary red of the foreground and the dark grey and brown background to create the "motion" effect: the growing and advancing urban future. In the black and white Metropolis scene, the diagonal lines are emphasized by contrasts of lights and shadows, which underline the three-dimensionality of the architectural elements, which are seen as massive interwoven volumes, again suggesting vertical growth and expansion. The metropolis image in figure 10.35 became iconic of the urban utopianism of modernism. Later works, such as Depero's *Skyscrapers and Tunnels* (figure 10.36), contain clearly identifiable references to the *Metropolis* imagery.

The various cityscape images that appear in Fritz Lang's *Metropolis* show a significant use of repeated geometric arrangements of vertical and diagonal lines to suggest growth, with vertical skyscrapers seen as walls of win-

Figure 10.34
Ivan Kudriashev, *Construction with Rectilinear Motion*, 1925.

dows completely filling the view in layer after layer, and the mobility and dynamism of transportation often represented by diagonal lines crisscrossing the city views: suspended railroad lines in the foreground (where once again the train appears as a primary symbol of progress) and road bridges carrying automobiles in the background.

Well into the early 1930s, when both the Italian and the Russian avant-garde were already deeply compromised with the fascist and the Stalinist authoritarian regimes, visions of cityscapes as tributes to the geometry of (urban) space still persisted, as one can see, for example, in the *Skyscrapers and Tunnels* painting of Depero (figure 10.36), or in the architectural fantasies of Chernikhov (figure 10.37). The Stalinist regime continued to pay lip service to the language of progressive modernism in its official rhetoric, while at the same time it was dismantling and suppressing whatever was left of the avant-garde. The Italian fascists, on the other hand, had little sympathy for urban and industrial realities, which they rightly regarded as hotbeds of socialism

Figure 10.35
Erich Kettlehut, *Sketch for Fritz Lang's Metropolis*, 1926.

Figure 10.36
Fortunato Depero, *Skyscrapers and Tunnels*, 1930.

Figure 10.37
Yakov Chernikhov, *Architectural Fantasy*, 1933.

and antifascism, and eagerly suppressed progressive modernism, promoting more primitivist visions based on regressive agrarian fantasies.

10.4.2 From the City to the Cosmos

The theme of the city as abstract geometry, as exploration of urban space, grows alongside and often appears intertwined with another vision of space and of exploration: the development of a mythology of *outer space*. This has its origin in the Russian Cosmism movement of the early years of the 20th century and progressed into the mythology of the mid-20th-century Space Age, from the symbolic and utopian level to the actual technological advances in space exploration of the Soviet space program.

The idea of technological development leading to the colonization of extraterrestrial space has a prominent place in the Russian avant-garde movement alongside the symbolic image of the city as developed in early modernism. The

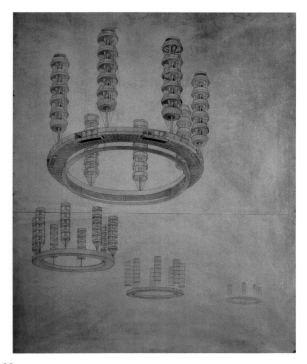

Figure 10.38
Georgii Krutikov, *Flying City*, 1928.

first visions of space travel often involve images of "cities in space"; see, for instance, the future space cities (or "flying cities") imagined by Krutikov (figure 10.38).

Perhaps the most famous interplay between cubofuturist avant-garde art and the science-fiction imagination took place in Yakov Protazanov's 1924 film realization of *Aelita the Queen of Mars*, which was based on the 1923 science-fiction novel by Aleksey Tolstoy. The Martian landscapes (in fact cityscapes) and costumes in the movie draw largely from cubofuturist art, with evident references to the theme of mechanical body images typical of Oskar Schlemmer's ballet figures. In the science-fictional imagination of the Russian avant-garde, outer space is urban space.

The early 20th-century Russian and then Soviet philosophy of *Cosmism*, which counts among its main figures both the mystic philosopher Nikolai Fyodorov and the scientist and father of the Soviet space program Konstantin Tsiolkovsky, played a crucial role in fostering the development of the Space

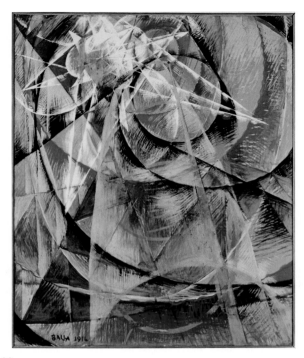

Figure 10.39
Giacomo Balla, *Mercury Transits in Front of the Sun*, 1914.

Age and its mythology of outer space. In the form of *Biocosmism*, this utopian movement also combined the ideal of space exploration with that of mechanical and biological enhancement of human beings and a dream of technologically achieved immortality. These are all closely intertwined themes that resurfaced, in the late 20th century and early 21st century, in various transhumanism and posthumanism movements.

Cosmism was a complex and multifaceted cultural phenomenon, incorporating very diverse influences, ranging from religion-inspired mysticism to a diverse framework of anarcho-communist and revolutionary ideological positions. Common aspects revolved around a strong aspiration for a science-driven fight against the very essence of human mortality and the quest for a human presence in the cosmos. "Storm the heavens and conquer death," an often-quoted motto, summarizes the cosmist pursuit.

The Italian Futurism, on the other hand, never developed the same great cosmic vision that the Russian avant-garde displayed, which is interwoven with the emerging technology of space exploration. Konstantin Tsiolkovsky's work

on the rocket equation dates back to 1911. It powerfully linked the artistic and philosophical visions of human progress in space to the scientific aspects of its technical realization. Tsiolkovsky also worked on first studies of air resistance and high-speed train projects, again providing a real technoscientific background for the visions of trains as symbols of dynamism, speed, and connectedness. The brief appearance of cosmic themes in Italian Futurism, as in the painting *Mercury Transits in Front of the Sun* by Balla (figure 10.39), remained purely at the evocative symbolic level. Balla's painting portrays celestial motion, the geometry of orbits, trajectories of light, and the gravitational interaction between bodies in motion. It depicts outer space as a geometric place, a theme that is also very deeply ingrained in similar cosmic paintings of the Russian avant-garde. The premises appeared very similar indeed, but the paths of historical development crucially diverged during the decade of the 1920s.

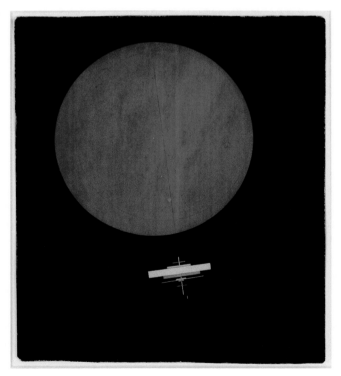

Figure 10.40
Ilya Chashnik, *Red Circle and Suprematist Cross*, 1925.

The art-science-engineering connection that powered the Russian avant-garde never developed in Italy. The technoenthusiasm of the early Italian Futurism fell short of that vital spark needed to sustain the vision beyond the level of exuberant artistic statements. The calls for the beauty of modernity and technology remained a missed opportunity and were soon silenced by the fascist reaction promoting antimodernity. There was no vision of humanity in space in the Italian futurist imagination, no rockets, and no cosmism.

On the contrary, the interplay between space and the imagination in the Soviet avant-garde was profound and widespread. As in the case of the visions of urban spaces, abstraction and representation continuously supported and complemented each other, creating a complex vision of outer space as an abstract geometry, a conceptual network of spatial relations, a place that is at once symbolic and technologically approachable, abstractly definable, and poetically expressible.

It is especially within the Suprematism movement of the Russian avant-garde that the more mystical and poetical aspects of cosmism manifest themselves in the language of abstract geometric compositions. Chashnik's 1925 painting *Red Circle and Suprematist Cross*, also known with the title *Cosmos* (figure 10.40), is an abstract composition, an interesting dynamical balance of geometric forms on a dark background. At the same time it inevitably suggests a vision of spaceships (or space cities) and planets. It is evocative, not representational. There is no actual planet and no actual cosmic explorer in the painting, only geometry. The geometry is designed so as to generate a sense of awe in the viewer, a sense of cosmic depth and of mystery. It is an abstract painting and at the same time a cosmic vision.

Both Suprematism and Constructivism further developed several aspects of the visual language of the Russian avant-garde that we have already discussed, such as the use of diagonal elements in geometric compositions to suggest motion and dynamism, accompanied by a prevalent use of bright primary colors. Again geometric composition generally suggests, at some deeper nonfigurative level, a cosmic vision, possibly the abstract geometric form of a "city in space."

In the 1921 painting *Space Force Construction* by Popova (figure 10.41), orbits and motion of cosmic objects is suggested, somewhat similarly to what we have seen in Balla's painting *Mercury Transits in Front of the Sun* (figure 10.39). Pavel Filonov's 1922 painting *Cosmos* was later retitled *The Results of the First Five Year Plan* (figure 10.42). The same painting also went by a later, more elaborate title, *Universal Shift in the Flowering of the World via the Russian Revolution*. As in the case of the same artist's painting titled *Elec-*

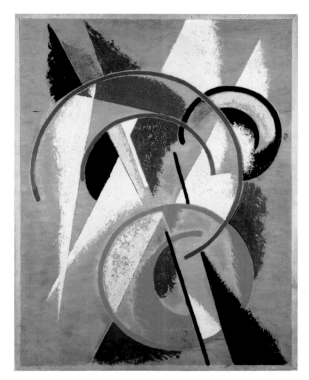

Figure 10.41
Ljubov Popova, *Space Force Construction*, 1921.

trification of the Whole Country (figure 10.15) discussed previously, one can detect an underlying level of irony in the image. The painting cleverly skirts the boundary between abstract and figurative. A chaotic dance of shapes suggest planetary bodies, rockets, construction cranes, mechanisms, and building sites, while all at the same time disappearing into a composition of abstract forms, an intricate tangle of geometries. The changing title of the painting suggests the link between the cosmic perspective, the dream of space exploration, and the aspirations of the postrevolutionary Soviet society: the dynamical, colorful, but at the same time fragmented and chaotic depiction given in the painting underlines the stark contrast between the grand aspirations and the realities of that society.

A more figurative representation of this cosmic connection can be seen in Yuon's 1921 painting *A New Planet* (figure 10.43), where the cosmic and the human perspectives are closely intertwined and the appearance of new looming

Figure 10.42
Pavel Filonov, *Cosmos*, 1922.

celestial bodies in the sky mirrors the upheavals of human society. The social-
ist revolutionary tradition is full of references to a cosmic perspective, from
the rising sun of the radiant future to the new world built by the revolution
(literally a new planet). The aspirations of cosmic exploration, and the bio-
cosmist ideals about perfecting human nature and vanquishing suffering and
death, merge with the socialist idea of the new humanity and the technosci-
entific path to mastery of nature and the cosmos. Unlike Filonov's painting,
with its intricate possibilities and ironical undercurrents, Yuon's adheres more
closely to an idealist narrative of revolutionary and cosmist enthusiasm.

The cosmic imagination remained a significant part of Soviet culture long
after the time of the avant-garde had passed. The space program embodied
and realized some of those early aspirations and kept the cosmist dreams alive
beyond their original mystical inclinations. The science-fiction imagination
bloomed into a rich tradition of writers, from Ivan Yefremov to the brothers
Arkady and Boris Strugatsky. Beyond the survival in the context of Soviet ide-

Figure 10.43
Konstantin Yuon, *A New Planet*, 1921.

ology of several of the themes analyzed in this chapter (trains, human/machine interfaces, urban and cosmic spaces), it is interesting to follow how these ideas and their connection to the early anarcho-socialist political movement evolved since the days of the avant-garde.

10.5 The Modern Destiny of Visionary Modernity

The ideal of space exploration gave rise to the Space Age enthusiasm of the late 1950s and the 1960s. The idea of the human body as a mechanism and its possible enhancements and interfacing with machines also resurfaced in the 1950s and 1960s in the context of cybernetics, which proposed a general information-based theory of the animal, the human, and the machine. It also resurfaced again, near the end of the 20th century and in the new century, within the philosophical currents of *transhumanism* and *posthumanism*.

On the socialist side, Marxist philosophy received an injection of antiscientific postmodernism during the 1980s and 1990s, from which it never fully recovered. The association of technology with the military-industrial complex and the danger posed by capitalism to the environment and the planet itself had already contributed, through the environmentalist movements of the 1970s, to depicting technology (and science by extension) as a problem rather than a solution. Progressive modernism survived, in those decades, in some Western European social-democracies and in some communist political formations that carried Soviet cultural influences, such as the large and powerful Italian

Figure 10.44
Anarcho-Transhumanism, 2015.

Communist Party, whose science enthusiasm and techno-optimism carried a Soviet influence even though its general political positions did not. In more recent times, as antiscience positions are once again becoming more and more closely associated to the fascist extreme right, and its religious fundamentalist close allies, the socialist and communist left is undergoing a reconciliation with modernist visions of the progressive role of science and technology. In recent years, ideas related to Left-Accelerationism, Xenofeminism, and Techno-Utopianism have gained significant traction inside the radical left.

Anarchism, in turn, is, by its very nature, a complex and multifaceted phenomenon. There have been many different currents within the anarchist movement, both historically and in the present days. During the second half of the 20th century, several movements within Anarchism took a darker turn toward forms of nihilism, anti-civilization, and neo-primitivism, and all but abandoned any connection to modernism and any historical link to the avant-garde. Progressive modernity within anarchism barely survived in anarcho-socialist and anarcho-communist formations, but has become more prominent again within new movements, such as Solarpunk Anarchism and Anarcho-Transhumanism (see figure 10.44). The Solarpunk vision developed in response to the darker visions of the future generated by the cyberpunk literary movement of the

1980s and 1990s. Cyberpunk typically depicts a dystopian, extreme capitalist world of advanced digital technology, a world ruled by brutal corporations and populated by outcasts and pirates struggling to survive. In contrast, the Solarpunk aesthetics (which is mostly literary and artistic) aims at presenting a future world of advanced technology at the service of the well-being of people and society, within a Murray Bookchin-type "post-scarcity anarchism" scenario. Anarcho-Transhumanism is the modern current of anarchism that is closest in spirit to the futurist and cosmist avant-garde. It also projects a vision of a future where science and technology enable the establishment of a post-scarcity anarchist society. It incorporates within this vision the ideas of "morphological freedom," the modification of the human body and mind through technology, the aspirations of space exploration, the merging of human and machines, the posthuman extension of rights and ethical responsibilities to all intelligences (human and nonhuman, biological and nonbiological). The Anarcho-Transhumanist movement advocates the use of science and technology, including computer hacking, biohacking, networked communities, and mathematical modeling, as ways of increasing people's agency and freedom, and as tools to fight oppression and fascism. Anarcho-Transhumanism views science as the natural aspiration of the human mind to know itself and the cosmos, and as the natural path to the development of a free and egalitarian society.

Chapter Appendix: Bibliographical Guide

A.1 Guide to the Artists and the Artistic and Philosophical Movements

This list includes general references on the Italian and the Russian avant-garde, as well as specific monographs and papers on the individual artists discussed in this chapter.

- Marjorie Perloff, *The Futurist Moment*, University of Chicago Press, 1986.
- John E. Bowlt and Olga Matich, eds., *Laboratory of Dreams: The Russian Avant-garde and Cultural Experiment*, Stanford University Press, 1996
- Victor Margolin, *The Struggle for Utopia: Rodchenko, Lissitzky, Moholy-Nagy, 1917–1946*, University of Chicago Press, 1997.
- Giovanni Lista, *Arte e politica: il futurismo di sinistra in Italia*, Mudima, 2009.
- Günter Berghaus, *Futurism and Politics: Between Anarchist Rebellion and Fascist Reaction, 1909–1944*, Berghahn Books, 1996.
- Gemma Bigi, *Il futurismo? Un movimento vitale tra anarchia e socialismo*, Patria Indipendente, Associazione Nazionale Partigiani d'Italia, 2009 (online).
- Christine Poggi, *Inventing Futurism: The Art and Politics of Artificial Optimism*, Princeton University Press, 2009.
- Christina Lodder, *Russian Constructivism*, Yale University Press, 1983.

- Stephen Bann, *The Tradition Of Constructivism*, Da Capo Press, 1990.
- Kasimir Malevich, *The Non-Objective World: The Manifesto of Suprematism*, Dover, 2003.
- John E. Bowlt and Matthew Drutt, *Amazons of the Avant-Garde: Alexandra Exter, Natalia Goncharova, Liubov Popova, Olga Rozanova, Varvara Stepanova, and Nadezhda Udaltsova*, Guggenheim Museum, 2000.
- Nina Gurianova, *Exploring Color: Olga Rozanova and the Early Russian Avant-Garde 1910–1918*, Routledge, 2012.
- Luciano Chessa, *Luigi Russolo, Futurist: Noise, Visual Arts, and the Occult*, University of California Press, 2012.
- Enrico Crispolti, *Vittorio Corona attraverso il futurismo*, Celebes, 1978.
- Alessandro Del Puppo, "I funerali dell'Anarchico Carrà," in *Modernità e Nazione*, Quodlibet (2012): 15–58.
- Natella Voiskounski, "Futurism and After: David Burliuk (1882–1967)," *The Tretyakov Gallery Magazine*, 2009 (online).
- Roberta Cremoncini, *Fortunato Depero: Carnival of Colour*, Lowry Press, 2000.
- Anne Montfort, *Sonia Delaunay*, Harry N. Abrams, 2015.
- Blaise Cendrars and Sonia Delaunay, *La prose du Transsibérien et de la petite Jehanne de France*, Beinecke, 2008.
- Anthony Parton, *Goncharova: The Art and Design of Natalia Goncharova*, Antique Collectors' Club, 2010.
- Marina Tsvietaieva, *Natalia Goncharova: Retrato de una pintora rusa*, Ediciones Era, 2000.
- Fabio Benzi, *Giacomo Balla: Genio futurista*, Electa, 2007.
- Simonetta Fraquelli, *Gino Severini: From Futurism to Classicism*, Hayward Gallery, 1999.
- Esther da Costa Meyer, *The Work of Antonio Sant'Elia: Retreat into the Future*, Yale University Press, 1995.
- David King, *Russian Revolutionary Posters: From Civil War to Socialist Realism, From Bolshevism to the End of Stalinism*, Harry N. Abrams, 2012.
- Robert Chandler, "Pulsating Crystals: Pavel Filonov Was One of the Greatest Russian Artists of the 20th Century: So Why Isn't He Better Known?" *Prospect Magazine*, 2013 (online).
- Oskar Schlemmer, *Théâtre et abstraction*, L'Age D'Homme, 1978.
- Umberto Boccioni, *Futurist Painting Sculpture (Plastic Dynamism)*, Getty Publications, 2016.
- Isabelle Fleuriet, *The Grand Old Lady of Modern Art: Marcel Duchamp's Nude Descending a Staircase*, Readymade Press, 2013.
- Giovanni Lista, *Enrico Prampolini futurista europeo*, Carocci, 2013.

- Wolfgang Jacobsen and Werner Sudendorf, *Metropolis: A Cinematic Laboratory for Modern Architecture*, Menges, 2000.
- Michael Minden and Holger Bachmann, *Fritz Lang's Metropolis: Cinematic Visions of Technology and Fear*, Camden House, 2002.
- William K. Hartmann, Ron Miller, and Andrei Sokolov, *In the Stream of Stars: The Soviet/American Space Art Book*, Workman Publications, 1990.
- Georgiy Kovalenko, *Alexandra Ekster*, Galart, 1993.
- Christian Derouet, Maria Gough, Spyros Papapetros, and Jennifer Wild, *Léger: Modern Art and the Metropolis*, Yale University Press, 2013.
- Iveta Derkusova, Frans Peterse, and Irěna Bužinska, *Gustavs Klucis (1895–1938)*, Gemeentemuseum Den Haag, 2008.
- Ross Wolfe, "Ivan Kudriashev's Interplanetary-Dynamic Abstractions (1917–1928)," *The Charnel-House*, 2014 (online).
- Wolfgang Jacobson and Jörg Schöning, "Erich Kettelhutt – Film Architekt und die Liste seiner Filmbauten," *Cine-Graph* 5, no. 1 (1985): D1-D6.
- Ross Wolfe, "The Speculative Constructivism of Iakov Chernikhov's Early Architectural Experiments, 1925–1932," *The Charnel-House*, 2013 (online).
- Selim Omarovich Khan-Magomedov, *Georgii Krutikov: The Flying City and Beyond*, Tenov Books, The University of Chicago Press, 2015.
- John Frost Bowit and Matthew Frost Bowit, *Ilya Chashnik and the Russian Avant-Garde: Abstraction and Beyond*, University of Texas, 1981.
- Christina Lodder, "Liubov Popova: From Painting to Textile Design," *Tate Papers no. 14*, Tate Gallery, 2010 (online).
- Pavel In, "Konstantin Yuon," *Art Context*, 2011 (online).

A.2 Guide to Anarchism and Modernism

Some references on the connections between anarchism and modernism and the avant-garde movements follow.

- Nina Gourianova, *The Aesthetics of Anarchy: Art and Ideology in the Early Russian Avant-Garde*, University of California Press, 2012.
- Patricia Leighten, *The Liberation of Painting: Modernism and Anarchism in Avant-Guerre Paris*, University of Chicago Press, 2013.
- Allan Antliff, *Anarchist Modernism*, University of Chicago Press, 2007.
- Allan Antliff, *Anarchy and Art: From the Paris Commune to the Fall of the Berlin Wall*, Arsenal Pulp Press, 2007.
- Aleš Erjavec, *Aesthetic Revolutions and the Twentieth-Century Avant-Garde Movements*, Duke University Press, 2015.
- Neala Schleuning, *Artpolitik: Social Anarchist Aesthetics in an Age of Fragmentation*, Autonomedia, 2012.
- Murray Bookchin, *Post-Scarcity Anarchism*, AK Press, 2004.

A.3 Guide to Trains and Electrification as Symbols of Modernity

Here the reader will find some references on the theme of trains in Futurism and modernism. The anarchist song "La Locomotiva" (The Locomotive) mentioned in the text and other works of the Italian singer songwriter Guccini are collected in the last reference listed here.

- Braden R. Allenby and Daniel Sarewitz, *The Techno-Human Condition*, MIT Press, 2011.
- Tim Harte, *Fast Forward: The Aesthetics and Ideology of Speed in Russian Avant-Garde Culture, 1910–1930*, University of Wisconsin Press, 2009.
- Andrew Thacker, *Moving through Modernity: Space and Geography in Modernism*, Manchester University Press, 2003.
- Steven D. Spalding and Benjamin Fraser, *Trains, Literature, and Culture: Reading and Writing the Rails*, Lexington Books, 2012.
- Kyle Gillette, *Railway Travel in Modern Theatre*, McFarland, 2014.
- Francesco Guccini, *Stagioni: Tutte le canzoni*, Einaudi, 2007.

This section includes some references on the role of electrification in the shaping of modernity and on electricity as a symbolic theme in avant-garde movements.

- Günter Berghaus, *Futurism and the Technological Imagination*, Rodopi, 2009.
- Frederik Nebeker, *Dawn of the Electronic Age: Electrical Technologies in the Shaping of the Modern World, 1914 to 1945*, John Wiley & Sons, 2009.
- Thomas Parke Hughes, *Networks of Power: Electrification in Western Society, 1880–1930*, Johns Hopkins University Press, 1993.
- Jonathan Coopersmith, *The Electrification of Russia, 1880–1926*, Cornell University Press, 2016.

A.4 Guide to the Mechanical Body in the Avant-Garde

The development of the theme of the mechanical body, the robot, and the cyborg in the avant-garde movement and beyond, into the later Information Age, can be followed in the references in this section.

- Owen Hatherley, *Militant Modernism*, Zero Books, John Hunt Publishing, 2009.
- Rolf Hellebust, *Flesh to Metal: Soviet Literature and the Alchemy of Revolution*, Cornell University Press, 2003.
- Matthew Biro, *The Dada Cyborg: Visions of the New Human in Weimar Berlin*, University of Minnesota Press, 2009.
- Katia Pizzi, *Pinocchio, Puppets, and Modernity: The Mechanical Body*, Routledge, 2011.
- Harold B. Segel, *Pinocchio's Progeny: Puppets, Marionettes, Automatons and Robots in Modernist and Avant-garde Drama*, Johns Hopkins University Press, 1995.
- Lydia H. Liu, *The Freudian Robot*, University of Chicago Press, 2011.

- Donna Haraway, *Simians, Cyborgs, and Women: The Reinvention of Nature*, Routledge, 2013.
- Chris Hables Gray, Steven Mentor, and Heidi Figueroa-Sarriera, *The Cyborg Handbook*, Routledge, 1995.
- Stefano Franchi and Güven Güzeldere, *Mechanical Bodies, Computational Minds: Artificial Intelligence from Automata to Cyborgs*, MIT Press, 2005.
- Phil Husbands, Owen Holland, and Michael Wheeler, *The Mechanical Mind in History*, MIT Press, 2008.

A.5 Guide to Cosmism, Automata, and Cybernetics

On Russian Cosmism and its influence on the Space Age and the theme of space exploration in contemporary culture, the reader can consult the following references.

- George M. Young, *The Russian Cosmists*, Oxford University Press, 2012.
- Boris Groys, *Russian Cosmism*, MIT Press, 2018.
- E-Flux Journal, *Art without Death: Conversations on Russian Cosmism*, Sternberg Press, 2017.
- James T. Andrews, *Red Cosmos*, Texas A&M University Press, 2009
- Asif A. Siddiqi, *The Red Rockets' Glare: Spaceflight and the Russian Imagination, 1857–1957*, Cambridge University Press, 2010.
- James T. Andrews and Asif A. Siddiqi, *Into the Cosmos: Space Exploration and Soviet Culture*, University of Pittsburgh Press, 2011.
- Slava Gerovitch, *Soviet Space Mythologies*, University of Pittsburgh Press, 2015.
- E. Maurer, J. Richers, M. Rüthers, and C. Scheide, *Soviet Space Culture: Cosmic Enthusiasm in Socialist Societies*, Springer Verlag, 2011.

The historical connection between the Russian avant-garde motif of the mechanical body and the automaton, and the early development of system theory in Bogdanov's work and the later development of cybernetics can be seen in some of the following references.

- George Gorelik, *Bogdanov's Tektology, General Systems Theory, and Cybernetics*, Hemisphere Publishing, 1987.
- Nikolai Krementsov, *A Martian Stranded on Earth: Alexander Bogdanov, Blood Transfusions, and Proletarian Science*, The University of Chicago Press, 2011.
- Zenovia A. Sochor, *Revolution and Culture: The Bogdanov-Lenin Controversy*, Cornell University Press, 1988.
- Slava Gerovitch, *From Newspeak to Cyberspeak: A History of Soviet Cybernetics*, MIT Press, 2004.
- Andrew Pickering, *The Cybernetic Brain: Sketches of Another Future*, University of Chicago Press, 2010.
- Eden Medina, *Cybernetic Revolutionaries*, MIT Press, 2014.
- Ronald R. Kline, *The Cybernetics Moment*, Johns Hopkins University Press, 2015.

A.6 Guide to Transhumanism and Posthumanism

In this section the reader can find some general references on the transhumanist and posthumanist movements of the early 21st century, their relation to anarchism and socialism, and their connection to the 20th-century avant-garde.

- James Hughes, *Citizen Cyborg*, Basic Books, 2004.

- Max More and Natasha Vita-More, *The Transhumanist Reader*, John Wiley & Sons, 2013.

- Murray Shanahan, *The Technological Singularity*, MIT Press, 2015.

- N. Katherine Hayles, *How We Became Posthuman: Virtual Bodies in Cybernetics, Literature, and Informatics*, University of Chicago Press, 2008.

- Rosi Braidotti, *The Posthuman*, John Wiley & Sons, 2013.

- Francesca Ferrando, *Il postumanesimo filosofico e le sue alterità*, Edizioni ETS, 2016.

- Kris Notaro, Benjamin Abbott, Matilde Marcolli et al., eds., "Anarcho-Transhumanist Manifesto," 2017 (online).

11 Mathematical Illuminations

This final chapter is more personal in nature and discusses the author's personal use of artistic expression in relation to mathematical work, in the form of watercolor "illuminations" of mathematical notebooks. This theme will be used as a guideline to introduce and investigate the historical use of artistic illumination of scientific texts and the influence of this practice on contemporary artists.

11.1 Between Meditation and Scientific Illustration

Illumination of manuscripts is a form of visual *decoration* accompanying a written text and occasionally superimposed on it. It takes many different forms, including initials, marginalia, and miniature illustrations. The earliest examples date back to around 400–600 CE, after codices replaced scrolls. The medium could be papyrus (a lass durable material of which there are rare surviving samples), or vellum and other parchment and, starting in late Middle Ages, paper. The illumination techniques include the use of graphite powder, ink, gold leaf, and paint. The use of illuminated manuscripts was especially widespread in the European Middle Ages, and in the Islamic Renaissance, but illumination as a form of art continues in modern times.

While people tend to associate illuminations to Christian religious texts, this is in general not necessarily the case. There are illuminations of ancient Greek and Roman literature, and of many kinds of philosophy and science texts. In fact, it is the connection between illumination and science that we are going to be focusing on here.

What is the general purpose of illumination? For the reader the illustrations enrich and highlight specific aspects of text. In the case of scientific texts, scientific illustrations (in botany, medicine, and anatomy) often have greater explanatory power than the accompanying written text. Sometimes the purpose is purely the amusement of the reader through aesthetic decorations (floral

Figure 11.1
Ambrosian *Iliad*, 5th century.

motifs, decorated initials of paragraphs, fantastic animals). From the point of view of the artist, on the other hand, illumination is a form of meditation on a text using the creation of visual images as amplification.

An early example of manuscript illumination on vellum comes from ancient Greek literature: an illustration of the Iliad from the 5th century (see figure 11.1). Illustrations accompanying literary texts typically are figurative renderings of some of the scenes described in the lines of the text. The most ancient examples we have of illuminated manuscripts are of this kind.

Another class of ancient illuminated texts consists of philosophical treatises, including those deriving from the traditions of neoplatonism and gnosticism. An example of this kind is the *Homiliae in Numeri* of Origen, of which a 7th-century manuscript exists (Burney 340 of the British Library). Often the use of illuminations in these early more philosophical works is limited to decorated initials of paragraphs, which are used as a way to create emphasis around certain sections of the text.

By the 8th century, one encounters illuminations in arithmetic texts, as in the case of Boethius, *De Institutione Arithmetica* (figure 11.2). It is interesting that in such texts the illuminations are not, as one might expect with a more modern sensitivity, mathematical diagrams or other forms of scientific illustration, but realistic pictorial scenes of the same kind that one finds accompanying literary texts in manuscripts of the same epoch.

Medical treatises are the first example of illuminations whose primary purpose is to directly illustrate a scientific concept. In the 10th-century *De Materia*

Figure 11.2
Boethius, *De Institutione Arithmetica*, 8th century.

Medica (figure 11.3), for example, the Greek text on medical plants is accompanied by accurate reproductions of the form of the plants for the purpose of recognizing them. In this way, illumination leaves the purely decorative function and acquires a functional explicatory role.

Along with texts on medicinal plants, a growing interest in the listing of animals in "bestiaries" led to the production of several illuminated manuscripts, like the *Aberdeen Bestiary* of the 12th century (figure 11.4) or the *Ashmole Bestiary*, of the 13th century. Unlike medical botany, where accuracy of illustration is crucial, the medieval bestiaries collected illustrations of animals both real and fantastic, without much distinction between the existent and the mythological and imaginary.

A further development of the expressive form of manuscript illumination, which is much closer to our modern concept of scientific illustration, took place around that same period of time within the context of astronomical texts, like Ptolemy's *Almagest* (figure 11.5). In these scientific works of the time of

Figure 11.3
Dioscurides, *De Materia Medica*, 10th century.

the Islamic Renaissance, we see the modern use of graphical form of mathematical arguments: the illustration of mathematical concepts by means of diagrams is exactly in the form in which we still mean it in our modern understanding and practice.

Another "functional" use of illuminations developed at around that historical time with the growing use of scores, to record music in written form. One can find early examples in the 14th-century *Old Hall Manuscript*, for instance. The development of a sufficiently elaborate musical system of graphical notation to accurately store music in written form marked a very significant development in cultural history.

The connections between illumination of manuscripts and scientific texts also involved geographic atlases, which started to become more widespread and detailed as Europeans embarked into longer and more substantial voyages,

Figure 11.4
Aberdeen Bestiary, 12th century.

ushering a long era of colonialism and exploitation. While older hand-drawn maps already included medieval reproductions of Roman cartography, European cartography started to acquire greater prominence and greater accuracy around the 14th century. The *Catalan Atlas* (14th century) is a significant example of this use of the illumination technique.

A very interesting mixture of scientific facts, philosophical reflections, and magical and religious speculations occurred with the development of alchemy. With it came a production of several texts, alchemical treatises, typically illustrated by a wealth of symbolic images, referring to chemical processes, as well as to spiritual stages of a form of mystical enlightenment, which is, however, entirely based in the observation of nature and in experimenting with natural material (the precursor of modern chemistry). The *Lumen Naturae*, which refers to the light emanating, not from a transcendental deity, but from a deeper understanding of matter and nature, is released through the alchemical process. It is a form of entirely natural enlightenment, a nonsupernatural transcendence, capable of profoundly transforming the self. One of the most famous alchemical texts is *Aurora Consurgens*, which dates back to the 15th century.

Figure 11.5

Nasir Al-din Tusi, *Tahrir al-Majisti* (commentary on Ptolemy's *Almagest*), *Burndy Codex #7*, 13th century.

Carl Gustav Jung famously reinterpreted the alchemical process and the images of alchemical texts as symbolic representations of psychological processes and the "individuation process" of the Self. Many of the symbols used in alchemy, such as the green lion that eats the sun (figure 11.6) taken from another famous alchemical texts, the *Rosarium Philosophorum* of the 16th century, lend themselves to many different levels of interpretation. At some levels they are a language of pictorial symbols for specific processes of transformation of matter. At this level, one can argue that the modern language of chemical formulae and chemical reactions is much simpler and more transparent, and has the advantage of being quantitative, not qualitative: not only does it give us signifiers denoting which process of transformation of matter we are referring to, it also gives us a way to quantitatively assess the process, and a precise description of what is happening based on atomic and molecular models of matter. At another level, however, as Jung pointed out, the alchemical symbols stand for symbols of an internal process, more akin to stages of enlightenment in Eastern philosophical traditions. This significance was entirely lost when the language of alchemical symbols was replaced by the language of chemical reactions. Thus, the image of the green lion refers to the distillation of green vitriol (Iron(II) sulfate, $FeSO_4 \cdot 7H_2O$) and the eating of the sun stands

Figure 11.6
The green lion eats the sun, *Rosarium Philosophorum*, 16th century.

for the precipitation of gold by green vitriol, while in Jungian psychology these become symbols of the Ego and the Self.

By the end of the 18th century, the illumination of manuscripts reappeared, most significantly in the visionary poetry of William Blake, who combined words and images to create a special resonance between handwritten text and painted images, which blend one into the other. This illumination technique is used extensively in *Visions of the Daughters of Albion* of 1793 and in the *Songs of Experience* of 1794. Blake's mystical visions and evocative use of illumination explicitly opposed the scientific use of manuscript illustration. Blake himself opposed the new materialistic and nonreligious visions of the Enlightenment, and portrayed Newton as part of an "infernal trinity," along with Francis Bacon and John Locke. This portrait of Newton (figure 11.7), realized by Blake in 1795, shows the scientist as a naked figure with a white drape on his side, suggesting the ancient Greek roots of the modern science of the Enlightenment era. He is bent forward, in the act of drawing geometric figures, and illustrating what appears to be the scroll of a scientific manuscript, a reference to the use of illumination for scientific purposes. The author's ideological position notwithstanding, we can interpret this image as witnessing, even if reluctantly, the transition to modern science and the double use of illustration as simultaneously a poetic and a scientific technique.

In even more recent times, illuminated manuscripts reappear in the context of psychoanalysis. We have already mentioned Jung's interest in alchemical manuscripts and illustrations. In the years 1915–1930, Jung himself engaged in

Figure 11.7
William Blake, *Newton*, 1795.

Figure 11.8
Carl Gustav Jung, illustration from *The Red Book*, 1915–1930.

Figure 11.9
Max Ernst, *L'évadé*, Histoire Naturelle series, 1926.

a very sophisticated use of illumination techniques, in his long manuscript, *The Red Book*, which was only recently published in its entirety (see figure 11.8). Based on his own dreams and visions, active imaginations, and reflections, the collection of illuminations of *The Red Book* constitutes probably the most elaborate use of the technique in modern times. The images are at the same time a meditation technique and a way of amplifying unconscious contents. Their wealth of symbolism, ranging from gnosticism to alchemical references, is elaborate and extremely interesting. Jung viewed the illumination technique primarily as a method of exploration of the unconscious. In his writings, he explicitly rejected the artistic quality of his illustrations of *The Red Book*, even though they clearly are of considerable interest from a purely aesthetic point of view, and he preferred to attribute to them a purely "scientific" connotation, in relation to understanding the workings of depth psychology.

This continuous dialog between the artistic and the scientific aspects across the history of manuscript illuminations, which has unfolded through different historical epochs, was taken over again, in the 20th century by Max Ernst, in his *Natural History* series (see figure 11.9). In this portfolio of 34 collo-types realized with his "frottage" technique, Ernst refers to the tradition of scientific illustration in encyclopedias and to the ancient tradition of "Natural History" compendiums (such as that by Pliny the Elder) of botany and animal life. However, while the folio is designed so as to evoke the style of these tra-

Figure 11.10
Max Ernst, *Maximiliana, or the Illegal Practice of Astronomy,* 1964.

ditional forms of illustration, the resemblance is immediately dispelled by the surrealistic style of the illustrations and the aleatory elements introduced by the use of frottage. This technique consists of placing various textured objects like wood or leaves under a sheet of paper and rubbing (frotter) over the paper with a pencil of crayon so that the underlying structure becomes visible, in a new and often not immediately recognizable form, on the paper.

Max Ernst further developed this interplay of references to scientific illustration, manuscript illumination, and visionary surrealistic imagery in his later work *Maximiliana ou l'exercise illégale de l'astronomie* (figure 11.10). Even the title hints at an improper use of the scientific reference and to an overstepping of boundaries into forbidden territory. Seen in the light of the extreme territoriality one often encounters in the scientific community, Max Ernst's title seems even more ironical, and intentionally aimed at poking fun at ostentatious power figures of the scientific establishment. In the work, fragments of poetry lines alternate with cosmic images, allusions to scientific diagrams, and mysterious scripts in an incomprehensible alphabet.

Another contemporary example of art combining illumination techniques on a background of scientific texts and printouts is given by the conceptual artworks of Sonya Rapoport (see figure 11.11). Throughout the 1970s she produced several series of works combining mixed media and painting superimposed on geological survey charts, or discarded computer printouts from the University of California at Berkeley Department of Mathematics. Her later

Figure 11.11
Sonya Rapoport, *Survey Chart No. 19*, 1971.

Anasazi series used computer printouts with data of an anthropologist's analysis of symmetry patterns in Anasazi pottery as background for illuminations based themselves also on an elaboration of Anasazi designs. A recurrent theme throughout Rapoport's entire career was the interplay between scientific data and artistic intervention of re-elaboration, with the use of drawing, color, and other media.

11.2 Illuminated Mathematical Notebooks

A mathematician's notebook is a sketchpad for thoughts, calculations, examples that are worked and reworked, diagrams, and drafts of arguments, all merging and superimposed on one another, coasting on the verge of the unintelligible: it is a laboratory on paper, a chaotic evolution of ideas, a cauldron, like the alchemist's vessel, out of which a clean final result will hopefully eventually emerge.

There are several intermediate stages in between what gets written in the notebooks and what ends up in a publishable paper. These many processes of reworking, refining, and writing happen elsewhere. The notebook provides only the *prima materia*. However, throughout the process one keeps returning to this raw material, revisiting it anew. Often it is during these stages that the

Figure 11.12
Matilde Marcolli, *DG-kites*, Notebooks series, 2015.

illumination of notebooks takes place. At other times it happens after the whole process is completed, again while revisiting the original material in search of new thoughts and ideas for a different project.

Abstract thought requires abstract art. The underlying writing in the notebooks provides shape and illumination provides color, in a kind of synesthesia: is mathematics naturally colored? The technique should be simple and suitable for a written background on pages of thin paper that must remain readable once the images are superimposed on it: wax pastels or watercolors. All the examples discussed in the rest of this chapter are taken from the author's own mathematical notebooks of the years 2014–2016.

A first example of such illuminations (figure 11.12) accompanies computations involving DG-algebras. These mathematical objects combine an algebra structure (a multiplication operation) with a compatible differential and homology structure. The concepts of complexes and homology/cohomology play a fundamental role in modern mathematics. The origin of the idea is geometric: mapping a manifold or a triangulation to its boundary (or to zero if it has no boundary) combined with the crucial fact that the boundary of a boundary is zero (a boundary has no further boundary of its own). A cycle is a formal combination of geometric objects such that its overall boundary is zero, but it needs

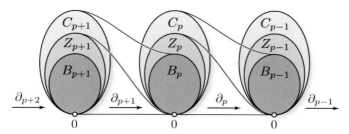

Figure 11.13
Chain complexes and homology.

not itself be a boundary. This makes it possible to measure the discrepancy between cycles and boundaries, which is called "homology." It measures the number of "holes" of a given dimension in a given geometric space (topological space, simplicial sets, smooth manifold). The resulting form of a complex consists of a sequence of vector spaces (one in each dimension) with a boundary maps that lowers the dimension by one (a surface has a one-dimensional boundary, so an N-dimensional manifold has an $(N - 1)$-dimensional boundary). The boundary maps send the whole vector space of formal combinations of N-dimensional objects (called N-chains) to $(N - 1)$-dimensional boundaries and send N-dimensional cycles and N-dimensional boundaries to zero. Homology at each level is determined by those cycles that are not boundaries (see figure 11.13).

In mathematics it is customary to describe algebraic operations through diagrams that illustrate the properties of those operations: for example a multiplication operation that has an identity element is illustrated by a diagram

The painted image in figure 11.12 hints at the mathematical structure of a DG-algebra that combines the homology structure described previously and the multiplication structure mentioned here.

A second example of notebook illustration accompanies a computation of a zeta function of a Dirac operator associated with an Apollonian packing of spheres. Dirac operators are very natural operators in the theory of smooth and Riemannian manifolds. We already encountered them in previous chapters, in discussing the spectral action functional, where we mentioned that they can also be defined on other kinds of geometric objects, like noncommuta-

Figure 11.14
Spinors on the circle.

tive spaces or fractals. However, their primary existence is in the world of smooth geometry. They are, in fact, related to the geometry of *spinors* (figure 11.14). These entities, which are roughly illustrated in the image as pointing arrows, are somewhat mysterious objects. The mathematician Michael Atiyah described the mysterious concept of spinors as a "square root of geometry."[8]

In previous chapters I showed that a smooth manifold can be endowed with a metric structure (Riemannian manifold) and that the metric is used crucially in general relativity to describe the gravitational field. We have also seen that one can consider the spectrum of an operator defined by the metric (Laplace operator) as the basic frequencies of vibration of our space, thought of as a drum. The same can be done with the Dirac operator, which is a square root of the Laplacian, acting on the spinors (which is the reason why one should regard spinors as "a square root of geometry"). One can see this idea of a geometric square root in figure 11.14 in the double twist introduced over the circle by the Möbius band structure. These frequencies, which constitute the spectrum of the Dirac operator, can be assembled together to form a function. We have seen this in the case of the spectral action. Another, closely related,

[8] Graham Farmelo, *The Strangest Man: The Hidden Life of Paul Dirac, Quantum Genius*, Faber & Faber, 2009: p. 430.

Figure 11.15
Matilde Marcolli, *Sphere Packing Zeta*, Notebooks series, 2015.

function formed from these frequencies is the *zeta function*,

$$\zeta_D(s) = \text{Tr}(|D|^{-s}) = \sum_{\lambda \in \text{Spec}(D)} \lambda^{-s}.$$

When the underlying geometry is a circle, this zeta function is the Riemann zeta function we discussed in a chapter 7.

The specific computation of the zeta function in this illustrated notebook section (see figure 11.15) comes from a cosmological model already discussed briefly in chapter 9, the fractal Packed Swiss Cheese Cosmology obtained from an Apollonian packing of spheres (see figure 9.15). The painted forms in figure 11.15 suggest the spinors on which the Dirac operator acts, the underlying smooth manifolds, and the beginning steps of a packing construction, with packed configurations of spheres of varying radii. The *length spectrum* is the list of the radii of all the spheres in the packing \mathcal{P}_D,

$$\mathcal{L} = \mathcal{L}(\mathcal{P}_D) = \{a_{n,k} : n \in \mathbb{N}, 1 \le k \le N(D,n)\}$$

where the numbers $a_{n,k}$ are the radii of spheres $S^{D-1}_{a_{n,k}}$ in the n-iterative step in the construction of the Apollonian packing and in the k-th place in the list of all the spheres that contribute to the same level n of the packing. The number $N(D,n) = (D+2)(D+1)^{n-1}$ is the total number of spheres that are added

Figure 11.16
Matilde Marcolli, *Bianchi IX*, Notebooks series, 2015.

in the *n*-th step of the iterative construction of the Apollonian packing. The number $D - 1$ is the dimension of the spheres. In the cosmological models this is either three (when considering spatial sections) or four when considering the full spacetime. There is a zeta function formed out of these radii, called the zeta function of the "fractal string" (Lapidus),

$$\zeta_{\mathcal{L}}(s) = \sum_{n=1}^{\infty} \sum_{k=1}^{N(D,n)} a_{n,k}^{s}.$$

For an *s* that is a sufficiently large real number, this series converges. The boundary of the set of values of *s* that give convergence (the Melzak's packing constant) is related to the fractal dimension of the resulting Apollonian packing.

 As discussed in chapter 9, these Packed Swiss Cheese Cosmology models are an elaborate example of what happens if one replaces the standard cosmological assumptions of homogeneity and isotropy of the universe with a situation where the isotropy assumption is retained but the requirement of homogeneity is removed. Moreover, if one proceeds in the opposite way and retains homogeneity but drops isotropy, then another interesting class of cosmological model arises, the Bianchi IX cosmologies (and the related mixmaster universe

models). The next example from the notebooks is an illumination that accompanies computations performed in one of these homogeneous but nonisotropic Bianchi IX cosmological models (see figure 11.16). In particular, the kind of spacetimes considered here are *gravitational instantons*: these are solutions to the Einstein equations in vacuum, where the metric satisfies a self-duality condition. These solutions look like a flat four-dimensional spacetime from far away (asymptotically). There are several classes of examples: Taub-NUT, Multi Taub-NUT, Eguchi-Hanson, and more general Bianchi IX spacetimes that include the previous ones as special cases. For example, the Taub-NUT spacetimes have a shape that exhibits a number of singularities and a global symmetry as shown in figure 11.16. The general form of the metric in Bianchi IX spacetimes is given by

$$g = F(d\mu^2 + \frac{\sigma_1^2}{W_1^2} + \frac{\sigma_2^2}{W_2^2} + \frac{\sigma_3^2}{W_3^2}),$$

with an overall conformal factor F and with three different scaling factors W_1, W_2, W_3 in the three independent spatial directions σ_i. These different scaling factors W_1, W_2, W_3 are responsible for the anisotropy of these spacetime models. The asymptotical behavior of these Bianchi IX spacetimes that satisfy the Einstein equations and a "self-duality" equation (gravitational instantons) recovers the Eguchi-Hanson and Taub-NUT solutions, when two of the scaling factors come together:

$$W_1 \sim \frac{\pi}{2}, \quad W_2 \sim W_3 \sim \frac{1}{\mu + q_0}.$$

This is the calculation that lies in the background and motivates the image in figure 11.16.

11.3 Some Further Readings

There are two recent books covering in depth the relation between contemporary art, especially abstract art, and the sciences, that the reader may find of interest in relation to the material covered in this book. Both are listed at the end of the bibliographical notes for this chapter.

Gamwell's book, *Mathematics and Art: A Cultural History* is a very substantial scholarly volume that discusses mathematical ideas and themes in modern art. Gamwell's book takes a strictly historical viewpoint and follows the development of the modern artistic movements identifying specific points of connection with mathematics. It complements the alternate viewpoint that we have been following here, which is organized instead around specific themes. The

selection of art covered in Gamwell's book is also largely nonoverlapping with the works analyzed here.

Kandel's book, *Reductionism in Art and Brain Science*, on the other hand, is more similar in spirit to what I have been aiming for here, in the sense that it also represents the personal view of a research scientist who analyzes the work of artists directly from the perspective and the interpretive lens of his own scientific work. In this case, the science involved is not mathematics or theoretical physics, however, but neuroscience. This provides an entirely different viewpoint and interpretation of modern and abstract art.

Chapter Appendix: Bibliographical Guide

A.1 Guide to the Art and the Artists

On the history of illuminated manuscripts and illustration in the contexts described in this chapter, we refer the reader to some of the following additional reading suggestions.

- Minta Collins, *Medieval Herbals: The Illustrative Traditions*, University of Toronto Press, 2000.
- Sarah R. Kyle, *Medicine and Humanism in Late Medieval Italy*, Routledge, 2016.
- Sarah Kay, *Animal Skins and the Reading Self in Medieval Latin and French Bestiaries*, University of Chicago Press, 2017.
- Ron Baxter, *Bestiaries and Their Users in the Middle Ages*, Sutton, 1998.
- Nicolas Bell, *Music in Medieval Manuscripts*, University of Toronto Press, 2001.
- Benjamin Anderson, *Cosmos and Community in Early Medieval Art*, Yale University Press, 2017.
- Eric M. Ramírez-Weaver, *A Saving Science: Capturing the Heavens in Carolingian Manuscripts*, Penn State Press, 2016.
- Anna Contadini, *Arab Painting: Text and Image in Illustrated Arabic Manuscripts*, Brill, 2010.
- Rudolf Gamper and Thomas Hofmeier, *Alchemische Vereinigung: das Rosarium Philosophorum und sein Besitzer Bartlome Schobinger*, Chronos Verlag, 2014.
- Marie-Luise von Franz, *Alchemy*, Inner City Books, 1980.
- Carl Gustav Jung, *Psychology and Alchemy*, in *Collected Works of C.G. Jung*, Vol.12, Princeton University Press, 1980.
- Carl Gustav Jung and Wolfgang Pauli, *Atom and Archetype: The Pauli/Jung Letters, 1932–1958*, Princeton University Press, 2014.
- Carl Gustav Jung, *The Red Book. Liber Novus*, W. W. Norton & Company, 2009.
- Kathryn S. Freeman, *A Guide to the Cosmology of William Blake*, Taylor & Francis, 2016.
- Max Ernst, *Histoire Naturelle*, Thames and Hudson, 1972.

- Max Ernst, *Maximiliana: The Illegal Practice of Astronomy*, New York Graphic Society, 1974.
- Max Ernst, *Journal d'un Astronaut Millénaire*, Alexandre Iolas, 1968.
- M. E. Warlick, *Max Ernst and Alchemy: A Magician in Search of Myth*, University of Texas Press, 2013.
- Terri Cohn, *Pairing of Polarities: The Life and Art of Sonya Rapoport*, Heyday Berkeley, 2012.
- Matilde Marcolli, "A Drifter of Dadaist Persuasion," in Anna Kepes Szemerédi, ed., *Art in the Lives of Mathematicians*, pp. 223–244, American Mathematical Society, 2015.
- Matilde Marcolli, "The Wolf and the Street: Narrative Encounters with Mathematics," in Michele Emmer, ed., *Imagine Math 3*, pp. 225–234, Springer Verlag, 2015.

A.2 Guide to Graphical Language in Science

The following references collect different viewpoints on the use of graphical symbols and visualization in science. The last reference in this list discusses the use of music notation in contemporary classical music.

- Brian Scott Baigrie, *Picturing Knowledge: Historical and Philosophical Problems Concerning the Use of Art in Science*, University of Toronto Press, 1996
- Nikolaus Gansterer, *Drawing a Hypothesis: Figures of Thought*, 2nd ed., De Gruyter, 2017.
- Don S. Lemons, *Drawing Physics*, MIT Press, 2017.
- Joseph Mazur, *Enlightening Symbols: A Short History of Mathematical Notation and Its Hidden Powers*, Princeton University Press, 2014.
- Nancy J Nersessian, *Creating Scientific Concepts*, MIT Press, 2010.
- Caroline A. Jones, Peter Galison, *Picturing Science, Producing Art*, Psychology Press, 1998.
- Theresa Sauer, *Notations 21*, Mark Batty Publisher, 2009.

A.3 Guide to the Mathematical Results Mentioned in This Chapter

The mathematical results that provide the context for the notebook illuminations discussed in the last section of this chapter are published in the following research papers.

- Matilde Marcolli and Gonçalo Tabuada, "Noncommutative Numerical Motives, Tannakian Categories, and Motivic Galois Groups," *Journal of the European Mathematical Society (JEMS)* 18, no. 3 (2016): 623–655.
- Adam Ball and Matilde Marcolli, "Spectral Action Models of Gravity on Packed Swiss Cheese Cosmology," *Classical and Quantum Gravity* 33, no. 11 (2016): 115018.
- Wentao Fan, Farzad Fathizadeh, and Matilde Marcolli, "Spectral Action for Bianchi Type-IX Cosmological Models," *Journal of High Energy Physics*, no. 10 (2015): 085.
- Yuri I. Manin and Matilde Marcolli, "Symbolic Dynamics, Modular Curves, and Bianchi IX Cosmologies," *Annales de la Faculté des Sciences de Toulouse* 25, nos. 2–3 (2016): 313–338.

A.4 Guide to Further General Readings

As mentioned in the text, here are two general references for the readers who enjoyed this book, which I think accompany and complement it in interesting ways that partly overlap in scope, but from very different perspectives.

- Lynn Gamwell, *Mathematics and Art: A Cultural History*, Princeton University Press, 2015.
- Eric R. Kandel, *Reductionism in Art and Brain Science: Bridging the Two Cultures*, Columbia University Press, 2016.

Acknowledgments

Individuals and Institutions

What I know about contemporary art and art history owes much to the teachings, over the span of many years, of Annarosa Cotta, Attilio Marcolli, and Enrico Meroni. Many other encounters that I had with people within the Italian art scene between the late 1970s and the early 1990s also contributed greatly to form my appreciation of modern and contemporary art. Especially influential among them were Giulio Carlo Argan, Gillo Dorfles, Bruno Munari, and Nanni Valentini, as well as Anna Canali and her Arte Struktura gallery and cultural center in Milan.

I wish to thank Century Books in Pasadena, as well as Revolution Books in Berkeley and Los Angeles, for having hosted several of these lectures, and for repeatedly encouraging me to present additional new ones. I especially want to express my solidarity to the Berkeley Revolution Books bookstore that was repeatedly targeted with violent attacks by fascist thugs during this recent dark period of our history. I also thank all those who attended my talks at these locations, who asked many interesting and stimulating questions on both the arts and the sciences.

I am especially grateful to my former student Eugene Ha, who strongly encouraged me to write it all up in book form; to Paolo Aluffi, for providing a lot of feedback on the lectures and on the writing of the book and for his continuous support; and to Michael Gellert, for encouraging me to complete this book project. The writing of this book also owes much to the support of my friend Leon Kot, who passed away recently. I also wish to thank Jermey Matthews at MIT Press for all his continuous help and support throughout the realization of this project, and the three anonymous referees, who offered many comments and much constructive criticism that helped in improving the final version of the book.

I also wish to thank my current academic institutions, Caltech, the University of Toronto, and the Perimeter Institute for Theoretical Physics. I am especially grateful to the University of Toronto for offering a peaceful, very welcoming, and safe space where to continue my work and research during these difficult years, and to Caltech for the patience and understanding with which it accepted my prolonged absence and temporary self-imposed exile. Without their support and understanding, all this work would not have been possible. The Perimeter Institute played a crucial role in facilitating my return to Caltech: I thank them for simplifying an otherwise very difficult decision.

Funding Agencies

The author's research is supported by the following agencies:

- National Science Foundation (NSF), grant DMS-1707882
- Natural Sciences and Engineering Research Council of Canada (NSERC), Discovery Grant RGPIN- 2018-04937 and Accelerator Supplement Grant RGPAS-2018-522593
- FQXi Foundation, grant FQXi-RFP-1 804
- The University of Toronto
- The Perimeter Institute for Theoretical Physics

Generous funds from the University of Toronto covered the costs of copyright clearance and permissions for reproducing the images in this book. Without their support this publication would have never been possible.

Images Sources

Copyright and ownership of the images in this text, and permission to reproduce them are acknowledged here. I thank Jermey Matthews, Gabriela Bueno Gibbs, and Laura Rodriguez at MIT Press, as well as the Lumina company, for all their help with the long and difficult process of obtaining these permissions. A small number of images in the text for which it was impossible to locate the copyright owner are reproduced under Fair Use.

- 02.01, Margareta Haverman, *Still Life: A Vase of Flowers*, 1716. Oil on canvas, 79.4 × 60.3 cm, Metropolitan Museum of Art. Public Domain.
- 02.02, Ori Gersht, *Blow Up 03*, Lightjet 2007, Ori Gersht.
- 02.03, Cornelis de Heem, *Still Life with Oysters, Lemons and Grapes*, ca. 1660. Oil on oak, 37 × 45 cm, Residenzgalerie, Salzburg, Austria. Public Domain.
- 02.04, Roy Lichtenstein, *Still Life with Oysters*, 1973 ©Estate of Roy Lichtenstein.

- 02.05, Pieter Claesz, *Tabletop Still Life*, 1625. Oil on panel, 42.5 × 74 cm, private collection. Public Domain.
- 02.06, Pieter Claesz, *Still Life with Musical Instruments*, 1623. Oil on canvas, 69 × 122 cm, Louvre Museum: Ecoles du Nord, room 38. Public Domain.
- 02.07, Georges Braques, *Still Life with Violin*, 1914. Oil on canvas, 92.71 × 66 cm, Los Angeles County Museum of Art. ©2020 Artists Rights Society (ARS), New York / ADAGP, Paris, Digital Image ©2020 Museum Associates/LACMA. Licensed by Art Resource, NY.
- 02.08, Juan Gris, *Still Life with Guitar*, 1920. Oil on canvas, 50.3 × 61 cm, Saint Louis Art Museum, St. Louis, MO, US. Public Domain.
- 02.09, Pieter Claesz, *Still Life with Skull and Writing Quill*, 1628. Oil on wood, 24.1 × 35.9 cm, The Metropolitan Museum of Art. Public Domain.
- 02.10, Pablo Picasso, *Still Life*, 1945. Oil on canvas, 88.5 × 130 cm, private collection. ©2020 Estate of Pablo Picasso / Artists Rights Society (ARS), New York, *Still Life*, 1945 (oil on canvas) Picasso, Pablo (1881–1973), Credit: Private Collection/Bridgeman Images.
- 02.11, Max Ernst, *Sea Shell*, 1928. Oil on canvas, 64.8 × 54 cm, ©2020 Artists Rights Society (ARS), New York / ADAGP, Paris, Photo credit: The Philadelphia Museum of Art/Art Resource, NY.
- 02.12, Adriaen Coorte, *Still Life with Seashell*, 1698. Oil on panel, 17 × 22.5 cm, Rose-Marie and Eijk van Otterloo Collection. Public Domain.
- 02.13, Adam Bernaert, *Vanitas*, 1660. Oil on panel, 42.5 × 56.6 cm, Acquired by Henry Walters with the Massarenti Collection, 1902. Walters Art Museum. Public Domain.
- 02.14, Hans Holbein, *The Ambassadors*, 1533 (oil on panel) (detail of 122676)/Holbein the Younger, Hans (1497/8–1543), Credit: National Gallery, London, UK/Bridgeman Images.
- 02.15, Umberto Boccioni, *Development of a Bottle in Space*, 1913, cast 1950. Bronze, 39.4 × 60.3 × 39.4 cm, Bequest of Lydia Winston Malbin, 1989. The Metropolitan Museum of Art. Public Domain.
- 02.16, Renato Guttuso, *Still Life with Cans* 1966. Varese, Fondazione Pellin ©2020 Artists Rights Society (ARS), New York / SIAE, Rome.
- 02.17, Picasso, *Still Life*, 1947. Oil on canvas, 81 × 100 cm, Louise Leiris Gallery, Paris, France. ©2020 Estate of Pablo Picasso / Artists Rights Society (ARS), New York, Photo credit: Cameraphoto Arte, Venice/Art Resource, NY.

- 02.18, Fernand Léger, *Nature morte aux éléments mécaniques*, 1918. Oil on canvas, 70.1 × 50.2 cm, private collection. ©2020 Artists Rights Society (ARS), New York / ADAGP, Paris.
- 02.19, Giorgio Morandi, *Still Life*, 1929–1930. Oil on canvas, 42 × 50.5 cm, private collection. ©2020 Artists Rights Society (ARS), New York / SIAE, Rome, Photo credit: Mondadori Portfolio/Art Resource, NY.
- 02.20, Paul Cezanne, *Nature morte avec rideau et pichet fleuri*, 1899. Oil on canvas, 55 × 74.5 cm, Hermitage Museum, Saint Petersburg, Russia. Public Domain.
- 02.21, Henri Matisse, *Fruits and Bronze*, 1910. Oil on canvas, 90 × 118 cm. Photo credit: Scala/Art Resource, NY.
- 02.22, Henri Matisse, *Still Life with Blue Tablecloth*, 1909. Oil on canvas, 88.5 × 116 cm. ©2020 Succession H. Matisse/Artists Rights Society (ARS), New York, Photo credit: The State Hermitage Museum, St. Petersburg.
- 02.23, Georges Braques, *Still Life with Violin and Jug*, 1910. Oil on canvas, 117 × 73 cm. ©2020 Artists Rights Society (ARS), New York / ADAGP, Paris, Photo credit: bpk Bildagentur/Kunstmuseum, Basel, Switzerland/Hans Hinz/Art Resource, NY.
- 02.24, Giorgio Morandi, *Metaphysical Still Life*, 1918. Oil on canvas, 33.7 × 27.5 cm. ©2020 Artists Rights Society (ARS), New York / SIAE, Rome, Photo credit: Mondadori Portfolio/Art Resource, NY.
- 02.25, Man Ray, *Still Life Composition for "Minotaure,"* 1933. Three-color carbon transfer print, 30.6 × 23.8 cm. ©Man Ray 2015 Trust / Artists Rights Society (ARS), NY / ADAGP, Paris [2020], The J. Paul Getty Museum, Los Angeles.
- 02.26, Giorgio De Chirico, *Metaphysical Vision of New York*, 1975. Oil on canvas 105 × 80 cm. ©2020 Artists Rights Society (ARS), New York / SIAE, Rome, Photo credit: Mondadori Portfolio/Art Resource, NY.
- 02.27, Giorgio De Chirico, *Still Life*, ca. 1920. Oil on canvas. ©2020 Artists Rights Society (ARS), New York / SIAE, Rome.
- 02.28, Joseph Cornell, *Planet Set, Tête Etoilée, Giuditta Pasta (dédicace)*, 1950. Glass, crystal, wood and paper, 30.5 × 45.7 × 10.2 cm. ©2019 The Joseph and Robert Cornell Memorial Foundation/Licensed by VAGA at Artists Rights Society (ARS), NY, ©Tate, London/Art Resource, NY.
- 03.01, Annarosa Cotta, *Signs*, 1986. Lithography, 70 × 50 cm, private collection. ©Annarosa Cotta.
- 03.02, Paul Klee, *Unstable Equilibrium*, 1922. Watercolor and pencil on paper on cardboard borders with watercolor and ink, 31.4 × 15.7 cm. ©2020 Artists Rights Society (ARS), New York, Photo credit: akg-images.

- 03.19, Marcus Sendlinger, *Tristar*, 2008, mixed media on canvas, 160 × 289.6 cm, CHG Meridian AG Company Collection, Weingarten, Germany.
- 03.20, Hajime Kinoko, *Cell*, 2014. Rope sculpture. ©Hajime Kinoko.
- 03.21, Subway System in San Francisco and in Moscow. Public Domain.
- 03.22, Matthew Gress, *Internet Graph*, 2014. Digital image. ©The Opte Project (2014).
- 03.23, Matjuska Teja Krasek, *Double Star GA*, 2003. Digital print. ©Matjuska Teja Krasek.
- 03.24, Klein Bottle and Genus 4 Surface (drawn by Mathematica).
- 03.25, Max Bill, *Endles Ribbon*, 1953. Granite sculpture, Baltimore Museum of Art, Baltimore, Maryland, USA. ©2020 Artists Rights Society (ARS), New York / ProLitteris, Zurich, Photo credit: CNAC/MNAM/Dist. RMN-Grand Palais/Art Resource, NY.
- 03.26, Alan Bennett, *Single Surface*, 1995. Glass sculpture, Science Museum Group Collection. ©Alan Bennett.
- 03.27, Alan Bennett, *Klein Bottle*, 1995. Glass sculpture, Science Museum Group Collection. ©Alan Bennett.
- 03.28, Torsten Asselmeyer-Maluga and Jerzy Król, *Stages of a Casson Handle*, 2018. Digital image. ©Torsten Asselmeyer-Maluga and Jerzy Król.
- 03.29, Niles Johnson, *A Slice of S^7*, 2012. Digital image. ©Niles Johnson.
- 03.30, Dawn Meson, *Collisions II*, 2000. Acrylic paint on archival canvas, 60.9 × 45.7 cm, private collection. ©Dawn Meson (Dawn Neal).
- 03.31, Will Hohyon Ryu, *Voronoi Map of World Weather Stations*, 2011. Digital image.
- 03.32, The unit ball in the ℓ^2 and ℓ^4 metric (drawn by Maple).
- 03.33, Kjell André, *Light Cones in Minkowski Space*, 2004. Digital image. ©Kjell André.
- 03.34, Peter Kogler, *Untitled*, 2011. Computer motifs projected in the interior of Dirimart gallery, Istanbul, Turkey. ©Peter Kogler.
- 03.35, Attilio Pierelli, *Theory of the Universes: Octahedral Universe*, 1979. Steel and wood sculpture, 45 × 45 × 22 cm, Collezione Pierelli.
- 03.36, Kazuko Miyamoto, *Black Poppy*, 1978. Installation view, EXILE, 2009. Hand-dyed wool and nails, 280 × 280 × 290 cm. Courtesy Kazuko Miyamoto and EXILE. Photography by Christian Siekmeier.
- 03.37, Fractal art generated with Scott Draves' ElectricSheep, 2017. Digital image. ©Scott Draves.
- 03.38, Attilio Marcolli, *Deconstruction of Red*, 1986. Acrylic paint on canvas, 60 × 60 cm, private collection. ©Attilio Marcolli.

- 03.39, Penrose Tiling. Inductiveload, Public Domain.
- 03.40, Matjuska Teja Krasek, *Quasicube*, 2005. Acrylic paint on canvas, 70 × 82 cm, private collection. ©Matjuska Teja Krasek.
- 03.41, Tony Robbin, *Pattern 1999-4*, 1999. Acrylic on canvas, 142.24 × 177.8 cm, private collection. ©Tony Robbin.
- 04.01, Hans Arp, *Constellation III*, 1932. Painted wood relief, 83 × 38 × 6 cm. ©2020 Artists Rights Society (ARS), New York / VG Bild-Kunst, Bonn, Photo credit: The Solomon R. Guggenheim Foundation/Art Resource, NY.
- 04.02, Fernand Léger, *Mechanical Composition (Movement Cart)* 1925. Crayon, China ink and gouache, 34 × 45 cm. ©2020 Artists Rights Society (ARS), New York / ADAGP, Paris, Mechanical Composition, 1922 (gouache on paper)/Leger, Fernand (1881–1955), Credit: Private Collection, Photo ©Christie's Images/Bridgeman Images.
- 04.03, C. Anthony Huber, *Entropy IVa*, Abstract Constructionism series, 2014. Oil, enamel, ink, paper on canvas, 50.8 × 50.8 cm, private collection. ©C. Anthony Huber.
- 04.04, Roberto Quintana, *QnTm/FM 2043*, Quantum Foam series, 2014. Acrylics on canvas, 22.8 × 30.5 cm, private collection. ©Roberto Quintana/Art & Soul Productions.
- 04.05, C. Anthony Huber, *Entropy II*, Abstract Constructionism series, 2014. Oil and graphite on canvas, 60.9 × 50.8 cm, private collection. ©C. Anthony Huber.
- 04.06, P. F. Damasceno, M. Engel, S. C. Glotzer, *High Entropy Ordered Structure*, 2012. Digital image ©P. F. Damasceno, M. Engel, and S. C. Glotzer, University of Michigan.
- 04.07, Roberto Quintana, *QnTm/Fm 230*, QuantumFoam series, 2014. Acrylics on canvas, 35.6 × 45.7 cm, private collection. ©Roberto Quintana/Art & Soul Productions.
- 04.08, Roberto Quintana, *QnTm/FM 2040*, QuantumFoam series, 2014. Acrylics on canvas, 22.8 × 30.5 cm, private collection. ©Roberto Quintana/Art & Soul Productions.
- 04.09, Ruth Asawa, *Untitled (S.065)*, 1962. Copper and brass wire, 238.8 × 44.5 × 44.5 cm, Photo credit: Laurence Cuneo.
- 04.10, Ruth Asawa, *Untitled (S.039)*, 1959, monel wire, 213.4 × 61 × 61 cm, Photo credit: Laurence Cuneo.
- 04.11, Mika Tajima, *Negative Entropy*, 2012. Cotton, polyester, rayon, wood, wool acoustic baffling felt. ©Mika Tajima.

- 04.12, Dean Fleming, *Tunis*, 1964. Gouache on paper, 13 × 13 cm, David Richard Gallery, New York, USA. ©Dean Fleming.
- 04.13, Tamara Melcher, *Untitled*, 1965. Acrylic on canvas, 152.4 × 152.4 cm. ©Tamara Melcher.
- 04.14, Vladimir Bulatov, *Bending Hyperbolic Kaleidoscopes*, 2011. Digital image. ©Vladimir Bulatov.
- 04.15, Hans Hinterreiter, *Kreis Komposition*, 1978. Silkscreen, 11.5 cm diameter, private collection. ©2020 Artists Rights Society (ARS), New York / ProLitteris, Zurich, Hans Hinterreiter Foundation.
- 04.16, Hans Hinterreiter, *Opus 1* (painting and pencil construction), 1945. ©2020 Artists Rights Society (ARS), New York / ProLitteris, Zurich, Hans Hinterreiter Foundation.
- 04.17, Dennis Michael Callahan Jr., *Desired Constellations*, 2010. Digital image. ©Dennis Michael Callahan Jr.
- 04.18, Marina Apollonio, *Circular Dynamics 4S*, 1968, enamel on wood and rotating mechanism, 100 cm diameter, private collection. ©Marina Apollonio.
- 05.01, Pablo Picasso, *Guernica*, 1937. Oil on canvas, 349.3 × 776.6 cm, Museo Reina Sofía, Madrid, Spain. ©2020 Estate of Pablo Picasso/Artists Rights Society (ARS), New York; Photo credit: Erich Lessing/Art Resource, NY.
- 05.02, World War II in London (1944), Warsaw (1945), Berlin (1945), Photo credit: INTERFOTO/Alamy Stock Photo, and Stalingrad (1943), Photo credit: RIA Novosti archive, image # 602161 / Zelma / CC-BY-SA 3.0.
- 05.03, Georges Mathieu, *Evanescence*, 1945. Oil on canvas, 97 × 80 cm. ©2020 Artists Rights Society (ARS), New York / ADAGP, Paris, ©Fondation Gandur pour l'Art, Genève. Photographers: Philippe Migeat and Georges Meguerditchian.
- 05.04, Emilio Vedova, *Image of Time (Barrier)*, 1951. Egg tempera on canvas, 130.5 × 170.4 cm. The Solomon R. Guggenheim Foundation Peggy Guggenheim Collection, Venice, 1976, 76.2553.162. ©Fondazione Emilio e Annabianca Vedova, Venice.
- 05.05, Janet Sobel, *Milky Way*, 1945. Enamel on canvas, 114 × 75.9 cm. Digital Image ©The Museum of Modern Art/Licensed by SCALA/Art Resource, NY.
- 05.06, Volker Springel, *Millennium Simulation—The Cosmic Web*, 2005. Springel et al. (2005)/ Max Planck Institute for Astrophysics.

- 05.07, Lee Krasner, *Composition*, 1949. Oil on canvas, 96.7 × 70.6 cm. ©2020 The Pollock-Krasner Foundation / Artists Rights Society (ARS), New York, Photo credit: The Philadelphia Museum of Art/Art Resource, NY.
- 05.08, Regina Valluzzi, *Structure Evolution*, 2010. Ink and art marker (Prismacolor) on acid free Bristol Board, 22.9 × 30.5 cm, private collection. ©Regina Valluzzi.
- 05.09, Hiroshi Kawano, *Design 31: Color Markov Chain Pattern*, 1964. Gouache on paper, handcolored, Computer: OKITAC 5090A. ©Hiroshi Kawano, ©Foto: ZKM | Zentrum für Kunst und Medien Karlsruhe, Foto: Franz Wamhof.
- 05.10, Paths of Brownian Motion, DiGama, `Mathematica` plot.
- 05.11, Camille McPhee, *Mutated Brownian Motion II*, 2011. Mixed media on board, 30.5 × 30.5 cm, private collection. ©Camille McPhee.
- 05.12, Elena Kozhevnikova, *Brownian Motion II*, 2013. Mixed media. Artwork by Elena Kozhevnikova; `elena-Kozhevnikova.com`.
- 05.13, Sol LeWitt, *Wall Drawing 289*, 1978. ©2020 The LeWitt Estate / Artists Rights Society (ARS), New York, Sol LeWitt (1928–2007), 4th wall: 24 lines from the center, 12 lines from the midpoint of each of the sides, 12 lines from each corner, 1976, from the series Wall Drawing # 289. Wax crayon, graphite pencil, and paint on wall, dimensions variable. Whitney Museum of American Art, New York; purchase with funds from the Gilman Foundation, Inc. 78.1.4.
- 05.14, Peter Norvig, *Randomness Tests*. ©Peter Norvig.
- 05.15, Iannis Xenakis, *Musical Score of Achorripsis*, 1957. Collection Famille Xenakis DR.
- 05.16, Susan Laughton, *White Noise I*, 2010. Acrylic, gouache and plaster on canvas, 40 × 40 cm, private collection. ©Susan Laughton.
- 05.17, Laura Poitras, *ANARCHIST: Power Spectrum Display of Doppler Tracks from a Satellite (Intercepted May 27, 2009)*, 2016. Pigmented inkjet print on aluminum, 114.3 × 164.5 cm. Courtesy of artist.
- 05.18, Anders Sandberg, *The Lorenz Attractor*, 2006. Digital image. ©Anders Sandberg.
- 05.19, Jackson Pollock, *One: N.31* (full work and detail), 1950. Oil and enamel paint on canvas, 269.5 × 530.8 cm. ©2020 The Pollock-Krasner Foundation / Artists Rights Society (ARS), New York, Digital Image ©The Museum of Modern Art/Licensed by SCALA/Art Resource, NY.

- 05.20, *Random Fractal: Mixture of Circles and Squares*, 2013 — John Shier and Paul Bourke.
- 06.01, Albrecht Dürer, *The Drawing Frame (Draughtsman Drawing a Recumbent Woman)* (detail) 1525. Woodcut, 8 × 22 cm, Graphische Sammlung Albertina, Vienna, Austria. Public Domain.
- 06.02, Kazimir Malevich, *Black Square*, 1913. Oil on canvas, 109 × 109 cm, The State Tretyakov Gallery, Moscow.
- 06.03, Kazimir Malevich, *Suprematist Composition: White on White*, 1918. Oil on canvas, 72.5 × 72.5 cm. Digital Image ©The Museum of Modern Art/Licensed by SCALA/Art Resource, NY.
- 06.04, Kazimir Malevich, *Supremus 58 (Suprematism: Yellow and Black)*, 1916–1917. Oil on canvas, 79.5 × 70.5 cm, Russian State Museum, St. Petersburg, Russia. Photo credit: Scala/Art Resource, NY.
- 06.05, Poincaré homology sphere (dodecahedral space), drawn with Jenn3D.
- 06.06, S. Caillerie et al., *Dodecahedral Space Simulated CMB Sky*, 2007. ©S. Caillerie, M. Lachièze-Rey, J.-P. Luminet, R. Lehoucq, A. Riazuelo, and J. Weeks, "A New Analysis of the Poincaré Dodecahedral Space Model," *Astronomy and Astrophysics* 476 (2007): 691–696.
- 06.07, Lyudmil Antonov, *Kasner Epochs and Eras*, 2009. Digital image. ©Lyudmil Antonov.
- 06.08, Apollonian circle packing. Todd Stedl (https://creativecommons.org/licenses/by-sa/4.0/).
- 06.09, Ken Price, *Fats*, 1999. Acrylic on fired ceramic, 38.7 × 54.6 × 44.5 cm, Franklin Parrasch Gallery. ©Ken Price.
- 06.10, Ken Price, *Underhung*, 1997. Fired and painted clay, 59.7 × 54.7 × 40.7 cm, collection of the artist. ©Ken Price.
- 06.11, Lucio Fontana, *Concetto Spaziale, Attese 58 T 2*, 1968. Aniline on canvas, 98 × 135 cm. ©2020 Artists Rights Society (ARS), New York / SIAE, Rome, Courtesy Fondazione Lucio Fontana.
- 06.12, Umberto Boccioni, *Stati d'animo, quelli che restano*, 1911. Oil on canvas, 70.8 × 95.9 cm. Digital Image ©The Museum of Modern Art/Licensed by SCALA/Art Resource, NY.
- 06.13, Lucio Fontana, *Concetto spaziale*, 1952. Oil on card mounted on stretcher, 80 × 80 cm, private collection. ©2020 Artists Rights Society (ARS), New York / SIAE, Rome, Photo ©Christie's Images/Bridgeman Images.
- 06.14, World lines and world sheet: diagrams in quantum field theory and string theory. Reproduced with permission.

- 06.15, Regina Valluzzi, *Tadpole Diagrams at Play*, 2011. Oil on canvas, 40.6 × 40.6 cm, private collection. ©Regina Valluzzi.
- 06.16, Regina Valluzzi, *Vacuum Energy*, 2010. Oil on canvas with alkyd impasto, 50.8 × 61 cm, private collection. ©Regina Valluzzi.
- 06.17, M. Weiss, *Quantum Foam*, NASA's Chandra Xray Observatory, 2015. Illustration: NASA/CXC/M.Weiss.
- 06.18, Yves Klein, *Relief éponge bleue RE 19*, 1960. Sponge, stone and pigments on wood and canvas, 145.0 × 116.0 cm, Städel Museum, Frankfurt am Main, Germany. ©Succession Yves Klein c/o Artists Rights Society (ARS), New York / ADAGP, Paris 2020, Photo credit: Erich Lessing / Art Resource, NY.
- 06.19, Casimir effect. Emok (https://creativecommons.org/licenses/by-sa/3.0/deed.en).
- 06.20, Mark Rothko, *Black on Maroon*, 1958. Oil paint, acrylic paint, glue tempera and pigment on canvas, 266.7 × 381.2 cm. ©1998 Kate Rothko Prizel & Christopher Rothko / Artists Rights Society (ARS), New York, Photo credit: Tate, London/Art Resource, NY.
- 06.21, Mark Rothko, *Light Red over Black*, 1957. Oil paint on canvas, 230.6 × 152.7 cm. ©1998 Kate Rothko Prizel & Christopher Rothko / Artists Rights Society (ARS), New York, Photo credit: Tate, London/Art Resource, NY.
- 06.22, The Higgs potential. Rupert Millard, Gnuplot diagram, Public Domain.
- 06.23, Regina Valluzzi, *Dance of the Gauge Bosons in Vacuum*, 2013. Oil on linen, 91.4 × 121.9 cm, private collection. ©Regina Valluzzi.
- 06.24, Sonja Delaunay, *Design*, 1938. Pochoir print on paper, 48.9 × 39.4 cm, private collection.
- 06.25, Vasily Kandinsky, *Several Circles*, 1926. Oil on canvas, 140.3 × 140.7 cm. ©2020 Artists Rights Society (ARS), New York, Photo credit: The Solomon R. Guggenheim Foundation/Art Resource, NY.
- 06.26, Camille McPhee, *Bubbles of Space*, 2011. Mixed media on paper, 12 × 17 cm, private collection. ©Camille McPhee.
- 06.27, David Weir, *First Order Phase Transition in the Early Universe*, 2014. Digital image. ©David Weir.
- 06.28, Andrei Linde, *Kandinsky Universe*, 2008. Digital image. Andrei Linde and Dimitri Linde.

- 06.29, Joan Mitchell, *Untitled*, 1961. Oil on canvas, 228.9 × 206.1 cm, Collection of the Joan Mitchell Foundation, New York. ©Estate of Joan Mitchell.
- 06.30, Kimberly Conrad, *Life in Circles, N.29*, 2011. Acrylic painting on watercolor paper, 20.3 × 25.4 cm, private collection. Kimberly Conrad. www.kimberlyconradfineart.com.
- 07.01, Roman Opalka, *Infinity Detail*, 1965. Synthetic polymer paint on canvas, 196 × 135 cm. ©2020 Artists Rights Society (ARS), New York / ADAGP, Paris, Courtesy Muzeum Sztuki (Lodz) et Estate Opalka.
- 07.02, Jennifer E. Padilla, *Two* and *Three*, The von Neumann Ordinals series, 2016. Digital print. ©Jennifer E. Padilla.
- 07.03, Jennifer E. Padilla, *Six*, The von Neumann Ordinals series, 2016. Digital print. ©Jennifer E. Padilla.
- 07.04, Rune Mields, *Die Primzahlen*, 2015. Acrylic on canvas, 150 × 90 cm.
- 07.05, Rune Mields, *Sieb des Eratosthenes III*, 1977. Acrylic on canvas.
- 07.06, Rune Mields, *Sanju Primzahlen (2239)*, 1975. Fiber pen on paper, 80 × 60 cm, private collection.
- 07.07, Rune Mields, *Die Söhne der Mathematik (Der Zweite)*, 1986. Acrylic on canvas, 200 × 130 cm ©2020 Artists Rights Society (ARS), New York / VG Bild-Kunst, Bonn, Photo credit: akg-images.
- 07.08, Prime and composite numbers on a 150 × 150 Ulam spiral (Mathematica plot).
- 07.09, Triangle numbers on the Ulam spiral (Mathematica plot).
- 07.10, Dmitry Shintyakov, *Logarithmic Amplitude of 2D Fourier Transform of the Coprime Numbers Map*, 2014. Digital image.
- 07.11, Riemann Zeta Function (Mathematica plot).
- 07.12, Bart de Smit, *Café Terrace at Night*, van Gogh meets Riemann series, 2006. Digital print. ©Bart de Smit.
- 07.13, Francis Picabia, *Music Is Like Painting*, 1913–1917. India Ink on board, 122 × 66 cm, private collection. ©2020 Artists Rights Society (ARS), New York / ADAGP, Paris, Photo credit: Mondadori Portfolio/Art Resource, NY.
- 07.14, Stanley Silver, *Higher Learning III (Riemann Zeta Function)*, 2011. Oil, latex and pencils on panel, 76.2 × 97.8 cm, private collection. ©Stanley Silver.
- 08.01, The Standard Model of elementary particle physics. Public Domain.

- 08.02, Gregory Allen Page, *Cern Atomic Collision Physics And Colliding Particles*, 2007. Oil on canvas, 50.8 × 61 cm, author's collection. Gregory Allen Page; `GregoryAllenPage.com`.

- 08.03, Sophie Taeuber Arp, *Linien Geometrisch und Gewellt*, 1940. Colored pencil on paper, 26 × 34.4 cm. ©2020 Stiftung Arp e.V., Berlin/Rolandswerth / Artists Rights Society (ARS), New York, Arp Museum Bahnhof Rolandseck, Photo: Mick Vincenz.

- 08.04, The Standard Model Lagrangian. ©A. Connes, M. Marcolli, *Noncommutative Geometry, Quantum Fields and Motives*, American Mathematical Society, 2008.

- 08.05, Dawn Meson, *KaluzaKlein (Invisible Architecture III)*, 2005. Acrylic paint on archival canvas, 106.7 × 91.5 cm, private collection. ©Dawn Meson (Dawn Neal).

- 08.06, Regina Valluzzi, *Vector Field*, 2012. Oil on canvas, 76.2 × 76.2 cm, private collection. ©Regina Valluzzi.

- 08.07, Bridget Riley, *Arrest 3*, 1965. Emulsion on canvas, 175 × 192.5 cm, private collection. ©CSG CIC Glasgow Museums and Libraries Collections, ©Bridget Riley 2018. All rights reserved.

- 08.08, Marcia Lyons, *RED (Force Fields)*, 2011. Installation, projected live feed of the Earth's seismic data, digital painting on the walls of gallery space. David Richard Gallery, New York, NY, USA. ©Marcia Lyons.

- 08.09, Aram Mekjian, *Physical Processes*, 1997. ©Aram Mekjian.

- 08.10, Craig Clarke, *Chaos in Wood*, 2010. Installation. ©Craig Clarke, `CraigClarke.com`.

- 08.11, Cornelia Parker, *Cold Dark Matter, An Exploded View*, 1991. Wood, metal, plastic, ceramic, paper, textile and wire, 400 × 500 × 500 cm. Cold Dark Matter: An Exploded View, Cornelia Parker. Provenance. Photo Credit: ©Tate, London 2018, Courtesy the artist and Frith Street Gallery, London

- 09.01, El Anatsui, *Earth-Moon Connexions*, 1995. Wood, paint, 90 × 84.4 × 3 cm. Smithsonian Institution, National Museum of African Art, purchased with funds provided by the Smithsonian Collections Acquisition Program, ©El Anatsui.

- 09.02, James Ferguson, *Geocentric Cosmology*, 1757. James Ferguson, *Astronomy explained upon Sir Isaac Newton's principles, and made easy to those who have not studied mathematics*, 1757. Public Domain.

- 09.03, Roberto Graña, *Polyhedron, Kepler's Cosmos*, 2010. Digital image. ©Roberto Graña.

Rome, Digital Image ©The Museum of Modern Art/Licensed by SCALA/Art Resource, NY.

- 10.06, David Burliuk, *Railway Bridge*, 1921. Holt Burliuk Art Galleries.
- 10.07, Fortunato Depero, *Treno Partorito dal Sole*, 1924. Gouache, 24 × 17 cm. ©2020 Artists Rights Society (ARS), New York/SIAE, Rome.
- 10.08, Sonia Delaunay, *La prose du Transsibérien et de la Petite Jehanne de France*, 1913. Watercolor applied through pochoir and relief print on paper, 200 × 35.6 cm, Princeton University Art Museum. Public Domain.
- 10.09, Natalia Goncharova, *Plane on a Train*, 1913. ©2020 Artists Rights Society (ARS), New York / ADAGP, Paris, Photo credit: Erich Lessing/Art Resource, NY.
- 10.10, Giacomo Balla, *Street Light*, 1909. Oil on canvas, 174.7 × 114.7 cm. ©2020 Artists Rights Society (ARS), New York / SIAE, Rome, Digital Image ©The Museum of Modern Art/Licensed by SCALA/Art Resource, NY.
- 10.11, Gino Severini, *Expansion of Light*, 1912. Oil on canvas, 65 × 43.3 cm. ©2020 Artists Rights Society (ARS), New York / ADAGP, Paris, Photo credit: Museo Nacional Thyssen-Bornemisza/Scala/Art Resource, NY.
- 10.12, Natalia Goncharova, *Electric Lamp*, 1913. ©2020 Artists Rights Society (ARS), New York / ADAGP, Paris, Photo credit: CNAC/MNAM/Dist. RMN-Grand Palais/Art Resource, NY.
- 10.13, Antonio Sant'Elia, *Drawing of Electric Powerplant*, 1914. Antonio Sant'Elia, *La Città Nuova*, colored ink and pencil on paper, 52.5 × 51.5 cm, Pinacoteca Civica di Como, Italy. Public Domain.
- 10.14, Mikhail Baljasnij, *Electrification of the Whole Country*, 1930. Lithograph, 70.5 × 23.5, Ne Boltai! Collection.
- 10.15, Pavel Filonov, *Electrification of the Whole Country*, 1930. ©State Russian Museum, St. Petersburg, 2020.
- 10.16, Oskar Schlemmer, *Figure in Space with Plane Geometry and Spacial Delineations*, 1921. Photo credit: INTERFOTO/Alamy Stock Photo.
- 10.17, Oskar Schlemmer, *Drawing of Man as Dancer*, 1921. Photo credit: INTERFOTO/Alamy Stock Photo.
- 10.18, Umberto Boccioni, *Unique Forms in the Continuity of Space*, 1913. Bronze sculpture, 111.2 × 88.5 × 40 cm, The Museum of Modern Art, New York, NY, USA. Public Domain.
- 10.19, Marcel Duchamp, *Nude Descending a Stairway*, 1912. Oil on canvas, 147 × 89.2 cm. ©Association Marcel Duchamp / ADAGP, Paris / Artists

Rights Society (ARS), New York 2020, Photo credit: The Philadelphia Museum of Art/Art Resource, NY.

- 10.20, Oskar Schlemmer, *Triadic Ballet*, 1920. ©Bauhaus Archive Berlin.
- 10.21, Enrico Prampolini, *Geometry of Sensualness*, 1922. Oil on canvas, 100 × 150 cm, private collection. Photo credit: akg-images/Cameraphoto.
- 10.22, Natalia Goncharova, *Cyclist*, 1913. Oil on canvas, 78 × 105 cm. ©2020 Artists Rights Society (ARS), New York / ADAGP, Paris, Photo credit: bpk Bildagentur/Russian State Museum, St. Petersburg, Russia/Roman Beniaminso/Art Resource, NY.
- 10.23, Umberto Boccioni, *Dynamism of a Cyclist*, 1913. Oil on canvas, 70 × 95 cm, Gianni Mattioli Collection, on long-term loan to the Peggy Guggenheim Collection, Venice, Italy. Public Domain.
- 10.24, Vinicio Paladini, *May Day* [Primo Maggio], 1922. Drawing.
- 10.25, Fortunato Depero, *Solidity and Transparency*, 1917. Charcoal on paper, 49 × 35 cm, MART, Museo di arte moderna e contemporanea di Trento e Rovereto, Italy. ©2020 Artists Rights Society (ARS), New York / SIAE, Rome.
- 10.26, Fritz Lang, *Metropolis*, 1927. Photo credit: Adoc-photos/Art Resource, NY.
- 10.27, Andrei Sokolov, *Electronic Brain*, 1970. Moscow Design Museum.
- 10.28, Umberto Boccioni, *The City Rising*, 1910. Oil on canvas, 199.3 × 301 cm, The Museum of Modern Art, New York, NY, USA. Public Domain.
- 10.29, Alexandra Ekster, *City*, 1913. Oil on canvas, 88.5 × 70.5 cm. Public Domain.
- 10.30, Olga Rozanova, *Factory Bridge*, 1913. Oil on canvas, 83.2 × 61.6 cm, The Museum of Modern Art, New York, NY, USA. Public Domain.
- 10.31, Alexandra Ekster, *Composition. Color Dynamics*, 1914. Oil on canvas, Trekiakov Gallery, Moscow. Public Domain.
- 10.32, Fernand Léger, *The City*, 1919. Oil on canvas, 231.1 × 298.4 cm. ©2020 Artists Rights Society (ARS), New York / ADAGP, Paris, Digital Image ©The Museum of Modern Art/Licensed by SCALA/Art Resource, NY.
- 10.33, Gustavs Klucis, *Construction*, 1921. Pencil, colored ink, gouache, and egg varnish on paper, 49.3 × 62.7 cm. State Art Museum of Republic Latvia, Riga. ©2020 Estate of Gustav Klutsis / Artists Rights Society (ARS), New York, Photo credit: HIP/Art Resource, NY.

- 10.34, Ivan Kudriashev, *Construction with Rectilinear Motion*, 1925. Oil on canvas, 66.5 × 70.7 cm. ©State Museum of Contemporary Art, Costakis Collection.
- 10.35, Erich Kettlehut, *Sketch for Fritz Lang's Metropolis*, 1926. ©Deutsche Kinemathek – Museum für Film und Fernsehen, Sammlung Erich Kettelhut.
- 10.36, Fortunato Depero, *Skyscrapers and Tunnels*, 1930. Tempera on cardboard, 68 × 102 cm. ©2020 Artists Rights Society (ARS), New York / SIAE, Rome.
- 10.37, Yakov Chernikhov, *Architectural Fantasy # 67*, 1933.
 Yakov Chernikov, *Architectural Fantasies: 101 Compositions*, book with letterpress illustrations, pages 29.9 × 20.5 cm, Publisher: Mezhdunarodnaia kniga, Leningrad, 1933.
- 10.38, Georgii Krutikov, *Flying City*, 1928. VKhUTEMAS diploma project, 1928; republished in Selim Omarovich Khan-Magomedov, *Georgii Krutikov: The Flying City and Beyond*, Tenov Books, 2015. ©Schusev State Museum of Architecture.
- 10.39, Giacomo Balla, *Mercury transits in front of the Sun*, 1914. Tempera on paper lined with canvas, 120 × 100 cm, Peggy Guggenheim Collection in Venice, Italy. ©2020 Artists Rights Society (ARS), New York / SIAE, Rome, Photo credit: Erich Lessing/Art Resource, NY.
- 10.40, Ilya Chashnik, *Red Circle and Suprematist Cross*, c.1925 (India ink & w/c on paper)/Chashnik, Ilya Grigorevich (1902–29), Credit: Mead Art Museum, Amherst College, MA, USA, Gift of Thomas P. Whitney (Class of 1937)/Bridgeman Images.
- 10.41, Ljubov Popova, *Space Force Construction*, 1921. Oil with wood dust on plywood, 112.3 × 112 cm, George Costakis Collection, State Museum of Contemporary Art, Thessaloniki, Greece, Photo credit: SPUTNIK/Alamy Stock Photo.
- 10.42, Pavel Filonov, *Cosmos*, 1922. Oil on canvas, 186 × 186 cm. ©State Russian Museum, St. Petersburg, 2020.
- 10.43, Konstantin Yuon, *A New Planet*, 1921. Tempera on cardboard, 101 × 71 cm, Tretyakov Gallery, Moscow, Russia. Konstantin Yuon, ©2019 Estate of Konstantin Yuon/RAO, Moscow/VAGA at ARS, NY, Photo credit: Scala/Art Resource, NY.
- 10.44, Anarcho-Transhumanism. Public Domain.
- 11.01, Ambrosian Iliad, 5th century, Public Domain.
- 11.02, Boethius, *De Institutione Arithmetica*, 8th century. Public Domain.

- 11.03, Dioscurides, *De Materia Medica*, 10th century. The Morgan Library & Museum, New York.
- 11.04, Aberdeen Bestiary, 12th century. Photo credit: Visual Arts Library/Art Resource, NY.
- 11.05, Nasir al-Din Tusi, *Tahir al-Majisti*.The Huntington Library, San Marino, California.
- 11.06, The Green Lion Eats the Sun, *Rosarium Philosophorum*, 16th century. Public Domain.
- 11.07, William Blake, *Newton*, 1795. Monotype, 46 × 60 cm. ©Tate, London/Art Resource, NY.
- 11.08, Carl Gustav Jung, illustration from *The Red Book*, 1915–1930. Published in Carl Gustav Jung "The Red Book" (Sonu Shamdasani, Ed.) Philemon, W. W. Norton & Company; 1st edition (October 19, 2009).
- 11.09, Max Ernst, *L'évadé*, Histoire Naturelle series, 1926. One from a portfolio of 34 collotypes after frottage, composition: 25.7 × 42.3 cm, sheet: 32.3 × 49.8 cm. ©2020 Artists Rights Society (ARS), New York / ADAGP, Paris, Digital Image ©The Museum of Modern Art/Licensed by SCALA/Art Resource, NY.
- 11.10, Max Ernst, *Maximiliana, or the Illegal Practice of Astronomy*, 1964. Illustrated book with twenty-eight etchings (nine with aquatint) and six aquatints, pages: 41.3 × 30 cm, Publisher: Le Degré 41 (Iliazd), Paris, 1964. ©2020 Artists Rights Society (ARS), New York / ADAGP, Paris, Digital Image ©The Museum of Modern Art/Licensed by SCALA/Art Resource, NY.
- 11.11, Sonya Rapoport, *Survey Chart No. 19*, 1971. Gouache and graphite on found antique survey chart, 22 × 18 in. In collection of University of California, Berkeley Art Museum and Pacific Film Archive, Berkeley, CA. courtesy of estate of Sonya Rapoport.
- 11.12, Matilde Marcolli, *DG-kites*, Notebooks series, author generated.
- 11.13, Chain complexes and homology. ©Paolo Aluffi, *Algebra: Chapter 0*, American Mathematical Society, 2009.
- 11.14, Spinors on the circle. Slawekb (https://creativecommons.org/licenses/by-sa/3.0/deed.en).
- 11.15, Matilde Marcolli, *Sphere Packing Zeta*, Notebooks series, author generated.
- 11.16, Matilde Marcolli, *Bianchi IX*, Notebooks series, author generated.

Index